BISON
BOOKS

SCULPTURE FROM THE SHELDON MEMORIAL ART GALLERY

EDITED BY KAREN O. JANOVY

With forewords by Norman A. Geske and Janice Driesbach
Introduction by David Cateforis

Essays by Daniel A. Siedell
and
Peter Boswell, David Cateforis, Nancy H. Dawson, Janice Driesbach, Lonnie Pierson Dunbier,
Charles C. Eldredge, Norman A. Geske, Wendy J. Katz, Christin J. Mamiya, Ingrid A. Sepahpur,
Robert Spence, Michael R. Taylor, and Karen Tsujimoto

UNIVERSITY OF NEBRASKA PRESS
LINCOLN AND LONDON

Published in collaboration with the Sheldon Memorial Art Gallery and Sculpture Garden, University of Nebraska–Lincoln, and the Nebraska Art Association, the Sheldon's dedicated support group.

∞

Library of Congress Cataloging-in-Publication Data
Sculpture from the Sheldon Memorial Art Gallery / edited by Karen O. Janovy; with forewords by Norman A. Geske and Janice Driesbach; introduction by David Cateforis; essays by Daniel A. Siedell . . . [et al.] .
 p. cm.
 Includes bibliographical references and index.
 ISBN-13: 978-0-8032-7629-1 (paper, 13-digit isbn: alk. paper)
 ISBN-10: 0-8032-7629-X (paper, 10-digit isbn: alk. paper)
 1. Sculpture, Modern—20th century. 2. Sculpture—Nebraska—Lincoln. 3. Sheldon Memorial Art Gallery. I. Janovy, Karen O., 1940– II. Siedell, Daniel A., 1966–
 NB198.S3517 2005
 735'.23'07478282—dc22 2005008512

Set in Garamond 3 by Joanna Price.
Designed by Joanna Price.
Printed by SNP LeeFung.

CONTENTS

FOREWORD

--

SCULPTURE AT SHELDON: THE EARLY YEARS

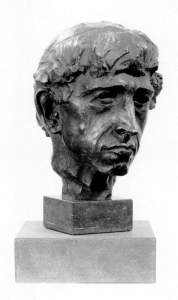

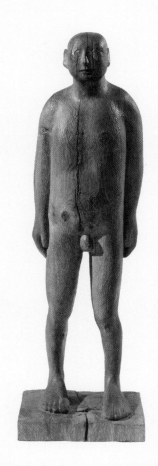

Looking back at the years of my tenure at the University of Nebraska, I find that the development of the sculpture collection has been a continuous priority. In 1950 two works were acquired, the *Portrait of John Marin*, by Gaston Lachaise, and one of the many *Horsemen* by Marino Marini. A year later we purchased Henry Moore's *Family Group*. Although previous acquisitions had been limited to the work of American artists, it was felt at the time that the expansion of the collection to include work by foreign artists was appropriate.

In 1953, the very year that saw the announcement of the Frances Sheldon bequest, the University Gallery—still in Morrill Hall—acquired Ernst Barlach's *The Young Wife* (*Standing Woman with Folded Arms*), a rare example of the artist's extraordinary carving in wood. With the fortuitous collaboration of Naomi Jackson Groves, an authority on Barlach and a translator of his writings, the gallery organized the first exhibition of the artist's work outside Germany, and a year later the University Theater put on the first production outside Germany of his play *The Dead Day*.

Subsequently it was possible for us to acquire Rodin's *Portrait of Charles Baudelaire*, Medardo Rosso's *Bambino Ebreo* (*Jewish Boy*), and works by Barbara Hepworth, Kenneth Armitage, and Reg Butler.

The addition of sculpture by Americans has, of course, been a primary concern. In the years before the opening of the Sheldon Gallery, two works by William Zorach, Elie Nadelman's *Man in the Open Air*, Saul Baizerman's *Serenity*, and Leonard Baskin's *Youth*, an homage in a way to Barlach, were added. Outstanding for me in terms of the sheer serendipity of its discovery, quite by accident in a dealer's storeroom, was the wonderful *Horse* by an anonymous American carver, acquired in 1957.

Throughout these developments, it should be remembered, the acquisitions program of the Gallery has been entirely supported by private funding, from gifts and bequests to the University of Nebraska–Lincoln, and by the independent acquisitions of the Nebraska Art Association. There has never been any distinction drawn between the collections of the university and the association.

--

Aside from the considerable gratification of being involved in the creation of the Sheldon Gallery, I had an unusual opportunity to add to the sculpture collection. The acquisition of Brancusi's *Princess X* was certainly among my greatest lifetime experiences. First seen during a casual afternoon visit to the Staempfli Gallery in New York with Mrs. Sheldon, the *Princess* immediately laid claim to her imagination in a way that tolerated no indecision. A note to me, a telephone call to Nebraska, and the matter was settled. A personal gift in memory of her husband, Adams Bromley Sheldon, it was only the first of a number of important gifts to the collection over the years.

Not only is the *Princess X* in itself a superlative work of art, but it also has a background that provides the Sheldon Gallery with an intriguing link to the history of twentieth-century art. The *Princess* was first exhibited in New York in 1916 in both marble and bronze versions. The marble version was bought by John Quinn, the most adventurous collector of the day. With the sale of the Quinn collection, the marble *Princess* returned to France, in the custody of Marcel Duchamp, to its new owner, Henri-Pierre Roché.[1] In 1920 one of the bronze casts of the *Princess* was shown in the exhibition of the Society of Independent Artists, where it immediately aroused protests for its undeniable phallicism. Both Matisse and Picasso are said to have commented on it in public statements. The exhibition management asked Brancusi to remove the cast, which he did, indignantly. In the ensuing fracas, artists and critics rallied to Brancusi, and the *Princess* was returned to the exhibition.

The identity of *Princess X* has never been satisfactorily determined. Most frequently named is Princess Marie Murat-Bonaparte, a descendant of Napoleon and a prominent figure in Parisian society. Of the considerable number of Brancusi's female subjects, we know only three by name: Margit Pogany, a Hungarian student of painting who first sat for Brancusi in 1910 and never thereafter, the subject of thirteen portraits entitled *Mademoiselle Pogany*;[2] a famously beautiful American, Eileen Lane, whose portrait Brancusi kept for himself until his death; and Mrs. Eugene Meyer Jr.,

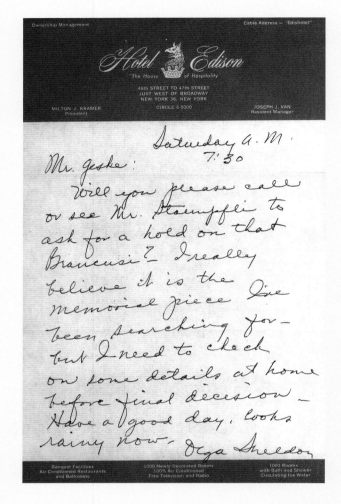

an American friend and patron, the subject of a monumental portrait in black marble.[3]

But the identity of the original subjects of these portraits is, after all, of little importance. In *Princess X* we have a likeness that transcends reality altogether. It is only in the twentieth century that portraiture has aspired to describe the multitudinous generality of the individual. In Brancusi's own words, "It [*Princess X*] is Woman, the very synthesis of Woman. It is the eternal female of Goethe, reduced to her essence."[4]

Again in Mrs. Sheldon's company, I was taken to see Isamu Noguchi's *Song of the Bird* in the dark recesses of a storage warehouse

ABOVE: OLGA SHELDON, LETTER TO NORMAN GESKE REGARDING THE ACQUISITION OF PRINCESS X. SHELDON MEMORIAL ART GALLERY ARCHIVES.
OPPOSITE PAGE: CONSTANTIN BRANCUSI, PRINCESS X, 1909–16. UNL, GIFT OF MRS. OLGA N. SHELDON IN MEMORY OF ADAMS BROMLEY SHELDON.

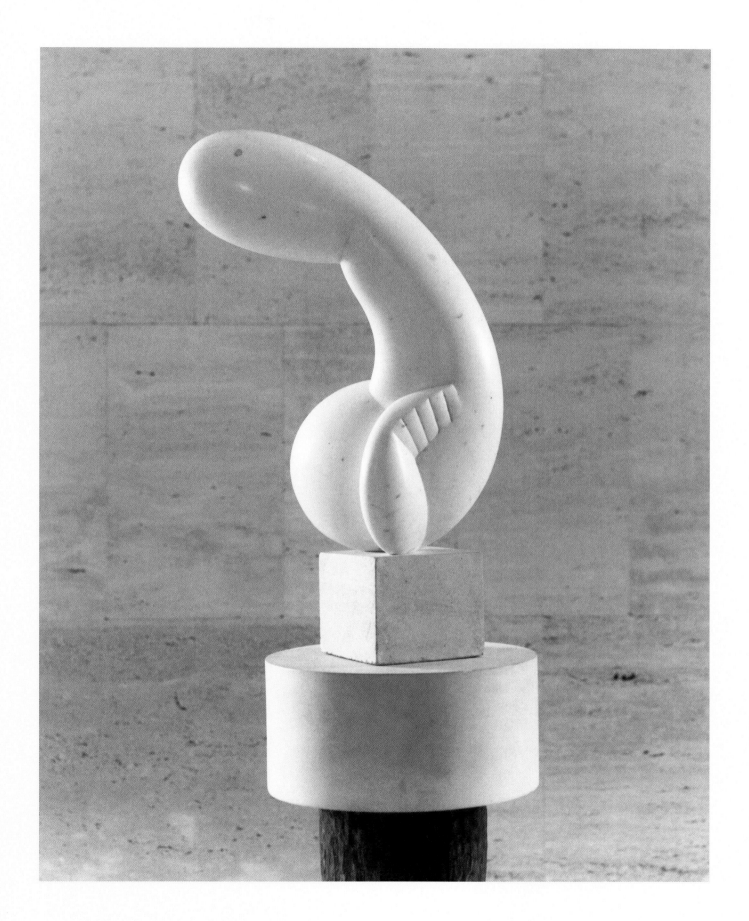

on New York's Upper West Side. Originally commissioned for the open court of the Lever Building on Park Avenue, it had been eliminated from the project for unknown reasons. For us it was the perfect complement to *Princess X*, a demonstrable lesson in the continuity of inspiration from master to pupil.[5]

The selection of other sculptures to complete the Gallery and establish the Sculpture Garden was not difficult. Considering the basically historical organization of the collection it seemed desirable to bridge the formative years of European modernism to the American scene. Jacques Lipchitz is surely among the masters of Cubism, a seminal force that cannot be ignored. Elie Nadelman and Gaston Lachaise, intensely personal talents, explored the resources of the primitive, the folk, the sensuous, in works that proclaim, perhaps for the first time in American sculpture, a truly worldly sophistication.

Fortunately, we were able to add two works by Alexander Calder, a hanging mobile, *Sumac II*, and a stabile, *Red Disk and Black Lace*, to the bronze *Snake on Arch*, which was an early purchase for the F. M. Hall Collection.

Two genuinely American sculptors, the Smiths—David and Tony—carried abstraction to the level of a purely American definition. In the instance of David Smith's *Superstructure on 4* there was a memorable wintertime visit to Bolton Landing, where, with Jon Nelson, then the Gallery's assistant director, the selection was made on a hillside deep in snow.

Last, but by no means least, among the works acquired from the Sheldon bequest was Reuben Nakian's *Birth of Venus*, a masterpiece of sensuous expressionism. From prosaic materials Nakian accomplished a metamorphosis of spirit that is nearly unique in American art.

In 1968 the Sheldon Gallery was chosen by the International Exhibitions Program of the Smithsonian to organize the official exhibition for the American pavilion at the 34th Venice Biennale. The chosen theme for the exhibition was "The Figurative Tradition in Recent American Art." Ten artists were chosen—five painters and five sculptors. The sculptors were Leonard Baskin, Robert Cremean, Frank Gallo, Red Grooms, and Reuben

Nakian, who, with Edwin Dickinson, demonstrated the longevity of the theme. All but Grooms—then at the beginning of his career as a master celebrant of popular culture—were chosen on the basis of the commitment already demonstrated by works in the Gallery's permanent collection.

Two years later, with the official dedication of the Sculpture Garden as part of a campus plan for the university, the Sheldon Gallery undertook one of its most ambitious exhibition projects to date, an exhibition of American sculpture from its beginnings to the present. It included 174 works, the nucleus drawn from the permanent collection and supplemented by loans from other museums, private collectors, dealers, and the artists themselves. The exhibition filled the entire Gallery and expanded beyond the Sculpture Garden to include Lincoln's Centennial Mall, which extends from the State Capitol to the university campus. A sculpture forum brought eight artists represented in the exhibition to Lincoln for public programs: Louise Nevelson, Theodore Roszak, William King, Tony Smith, George Rickey, George Sugarman, Richard Hunt, and Michael Hall.

The collection has continued to grow in all its aspects—the Neoclassic sculptors of the early nineteenth century, the masters of the "Golden Age," anonymous folk carvers, and the sculptors of Nebraska and the region. It is a demonstration of our national effort, idealism, and, perhaps, genius.

NORMAN A. GESKE
DIRECTOR, 1953–1983

NOTES

1. Henri-Pierre Roché was a well-known figure in the Parisian art scene. He was the author of a single novel, *Jules and Jim*, which was eventually made into a film by François Truffaut.

2. National Museum of Modern Art at the Centre Pompidou, Paris.

3. National Gallery of Art, Washington DC.

4. Natalia Dumitresco and Alexandre Istrati, "Brancusi: 1876–1957," in Pontus Hulten, Dumitresco, and Istrati, *Brancusi* (New York: Harry N. Abrams, 1987), 130.

5. Noguchi worked as an assistant to Brancusi for a month in 1927. See Hulten, Dimitresco, and Istrati, *Brancusi*, 381–82.

FOREWORD

SCULPTURE AT SHELDON: THE LAST TWENTY YEARS

A sculptor himself, George Neubert—director of the Sheldon Gallery from 1983 through 1999—is distinguished for his contributions to the sculpture, notably outdoor sculpture, collections at the University of Nebraska–Lincoln. In identifying potential acquisitions, Neubert early aspired to represent artists who "redefined sculpture and the public monument" as the medium flourished and assumed a new presence from about 1970. Neubert realized that many notable works by artists then practicing in the United States could not be accommodated in the museum's landmark Philip Johnson building, and soon looked to the campus as a potential gallery—prizing the ability to take art "beyond the walls in a university environment." Seeking to acquire "the best archetypal work that symbolized an artist's contribution," Neubert takes justifiable pride in the examples by Mark di Suvero, Richard Serra, Michael Heizer, and Claes Oldenburg and Coosje van Bruggen he installed on campus.

Di Suvero's *Old Glory*, one of Neubert's early acquisitions, was secured in part because of his long-standing friendship with the artist. Neubert had been instrumental in helping di Suvero resettle in the United States following his extended sojourn in Europe, and a purchase he oversaw in the 1970s, while curator at the Oakland Museum of California, allowed the artist to acquire a much-needed crane for his studio in nearby Petaluma. By the time Neubert arrived at the Sheldon, di Suvero was acknowledged as one of America's leading sculptors, and his major works were in great demand. Although the Sheldon's endowment generated limited sums annually, Neubert was committed to securing "one of the artist's best pieces," envisioning a magnificent sculpture "under the Nebraska sky." He describes missing one opportunity, declining the offer of a sculpture that was "not right," and finally devoting nearly two years' acquisition funds for *Old Glory*. Neubert takes credit for siting this monumental work and enjoys recounting a visit by Richard Bellamy, di Suvero's New York gallery dealer, soon after it was installed. Bellamy, who was a strong force in the development of contemporary sculpture in America, lay down under the sculpture at night. Looking upward toward the moon and stars, Bellamy pronounced his experience "an epiphany."

Old Glory ranks as one of the "pivotal pieces, symbolically and personally" that Neubert purchased for the Sheldon, an accomplishment soon matched by his acquisition of Richard Serra's *Greenpoint*. Again, Neubert recalls that an extended time elapsed before he identified the piece he wanted to acquire. He had looked for a major example by the artist for years, until, on a visit to New York on other business, he toured a Brooklyn warehouse where Serra's work was stored. There he saw and made an offer on *Greenpoint*, underwriting the considerable expense to move the sculpture onto a truck for transport. His decision proved prescient, however, as *Greenpoint* was purchased just before prices for the artist's work escalated. It is also an important example by Serra, not only in its compelling form but in its transitional position between his objects and subsequent circular and elliptical pieces.

Before Serra came to Lincoln to oversee the placement of *Greenpoint*, he had already installed a smaller version of the sculpture in a Baroque courtyard in Munster, Germany. Armed with that experience, he was eager to create what Neubert describes as an "in/out feeling" here, evoking both the safety of a structure or building while retaining the effect of open space. By its siting on an axis with the University of Nebraska bell tower, *Greenpoint* connects the tower to campus as well as to other outdoor sculptures.

Neubert had commissioned a sculpture by Michael Heizer for a park in northern California before pursuing a work for our Lincoln campus. He had long admired Heizer's place in American sculpture and believed the Sheldon collection should include artists whose practice defied installation within museum walls. First Neubert had considered commissioning one of Heizer's "drag-mass" pieces for Nebraska. This idea, which he believes would have been an "exciting representation" of the artist's accomplishments, proved too complicated, so Neubert "went back to the drawing board."

Heizer was then creating objects, so *Prismatic Flake Geometric* manifests the artist's pursuits at the time. It also reflects Heizer's heritage as the son of a distinguished anthropologist and

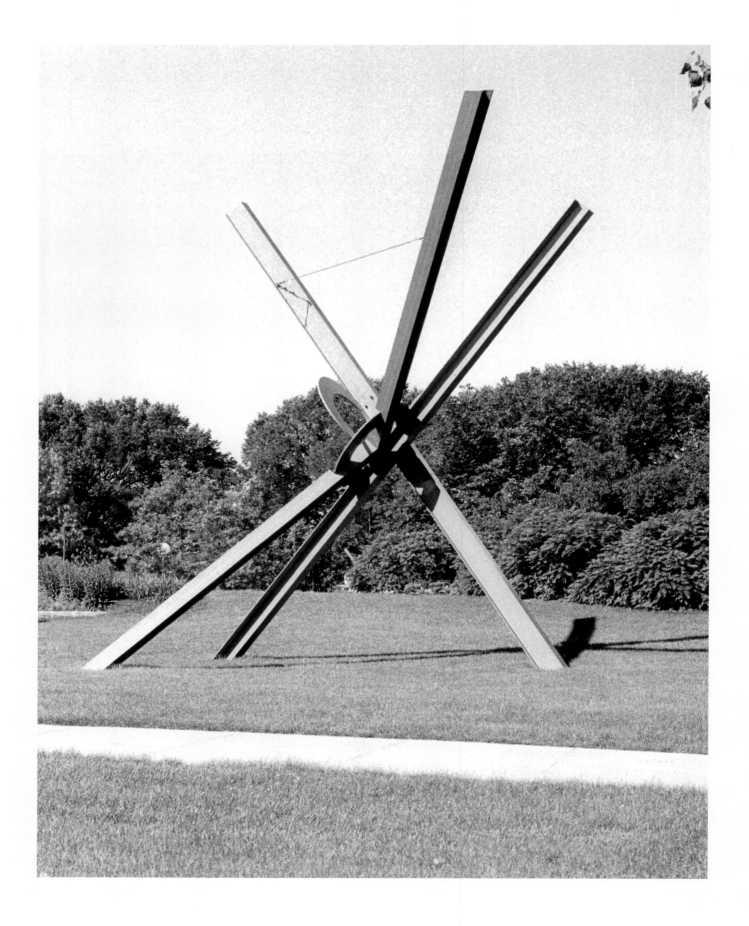

grandson of a western mining engineer. According to Neubert, Heizer considers himself to have created the first contemporary *American* sculpture, distinguishing his sources from the European antecedents to which others responded. In its form, *Prismatic Flake Geometric* reflects Heizer's earthwork as well as his respect for indigenous people. The two-sided bifaced prism, realized after the artist made drawings from specimens at the American Museum of Natural History in New York, alludes to one of humankind's earliest technological achievements. Although Heizer visited campus and selected the general area to install *Prismatic Flake Geometric*, Neubert oversaw its placement northeast of the Sheldon, which he views as appropriately extending toward the State Museum, the repository for the university's anthropological collections.

Claes Oldenburg and Coosje van Bruggen were commissioned for the sculpture realized as *Torn Notebook*. Neubert describes Oldenburg as the pivotal artist in redefining the public monument in the twentieth century. His own goal in pursuing Oldenburg was to reactivate the corner of 12th and R Streets, on the edge of campus, "to touch the urban environment." *Torn Notebook* is an eminent example of the efforts of Oldenburg and van Bruggen to create works that not only engage viewers but relate to their context. Following Neubert's initial contact, the artists visited Lincoln while they were working on a project in Kansas City. Among the images they initially explored were a roller skate (inspired by a visit to a local restaurant) and a coffee cup. However, when they were editing the notes each records in small notebooks (copying ideas they wanted to keep and tearing up the remainder), one of these notebooks was caught by a gust of wind, which led to the ultimate form of the sculpture. In addition to being a favored piece connecting the university campus with an adjacent business strip, *Torn Notebook* is replete with local references: a tear the shape of the Platte River and texts by Oldenburg and van Bruggen recording their individual personal responses to the local environment. "L-bow" references the crooked arm of the *Sower* sculpture atop the nearby State Capitol building, and the mangled spine the form of a tornado funnel. The artists also made several visits to Lincoln and invited

the input of artists, patrons, and others, fully engaging the community in the project.

As a longtime curator at the Oakland Museum, Neubert was familiar with the accomplishments of northern California artists and was able to add excellent examples, often by gift. In addition to an outstanding marble sculpture that was acquired, for instance, five bronzes by Manuel Neri were donated, and strong pieces by Jeremy Anderson, Bruce Conner, George Herms, Tom Holland, and Alvin Light also entered the collection. Neubert was conscious of acknowledging the seminal contributions of West Coast artists to the ceramic medium, notably their leadership in the development of clay sculpture, by acquiring examples by Peter Voulkos, Robert Arneson, Stephen de Staebler, John Mason, Tom Rippon, and Richard Shaw.

In addition to addressing contemporary art forms, Neubert also made a conscious effort to "fill in," securing works by Augustus Saint-Gaudens, Alexander Archipenko, Man Ray, and Marcel Duchamp, as well as a "great piece" by John Storrs. He prized the Saint-Gaudens *Diana*, which he describes as a Paris cast of the artist's smaller version of his famous figure, as representing an early example of a public sculpture that provoked controversy.

Neubert's wide-ranging interests in American sculpture thus inspired acquisitions that ranged from securing pieces by key, but at the time little understood, figures in Minimalist art (Carl Andre, Dan Flavin, Donald Judd, and Sol LeWitt) to works by artists such as Ibram Lassaw, which he viewed as establishing connections to earlier artists. He focused as well on representing developments nationwide, for instance carefully adding examples by Larry Bell and John McCracken to reflect the more "Zen," or sensuous, approach of West Coast sculptors to the Minimalist aesthetic.

In Neubert's view, sculpture has often been overlooked in American art and literature and so have the accomplishments of women, which he also sought to represent during his tenure. Thus he brought examples both by early practitioners such as

Malvina Hoffman and by outstanding contemporaries, among them Deborah Butterfield and Judith Shea, to the Sheldon. One of the most important of these acquisitions was the striking figure by Louise Bourgeois, whom Neubert had come to know personally. He describes visiting her studio when he was organizing an exhibition in San Francisco and seeing the artist seated in her studio in front of a cluster of her personages. Neubert remembered this evocative vision and later returned to pursue one of the stunning figures for our collection, consciously choosing an example in the more durable bronze over her wood sculptures.

In their individual ways, Norman Geske and George Neubert left considerable legacies to the sculpture collections at the Sheldon Memorial Art Gallery. Just as these were built on the vision and enthusiasm of earlier generations, so they should inspire future collecting. Looking backward, it should be acknowledged that the Sheldon has benefited from a long history of collecting in Lincoln, Nebraska, which predates the institution by more than seventy years. Following the deaths in 1928 of the early benefactors Mr. and Mrs. F. M. Hall, who were responsible—among other things—for awarding Daniel Chester French the commission to create the sculpture of Lincoln for our Capitol lawn, works by both French and Bessie Potter Vonnoh came into our collection. More important, the Halls' bequest to the university provided funds to make purchases from invitational exhibitions assembled each year by the Nebraska Art Association. In addition to the paintings, drawings, and prints acquired through their generosity, these funds were also responsible for the addition of works by Maurice Sterne (1942), Jose de Creeft (1943 and 1946), Robert Laurent (1947), and Gaston Lachaise (*Portrait of John Marin*). Significantly, many of these sculptures were purchased only shortly after they had been created.

Since my arrival at the Sheldon in September 2000, I have been awed both by the accomplishments of my predecessors and by the enthusiasm for sculpture among private collectors and arts audiences in Lincoln. With sculpture assuming a pivotal role in the current art dialogue, many of our most important recent acquisitions have been in this area. My first foray was to purchase Catherine Ferguson's *Arietta II*, which had been installed on loan outdoors, on the path to my office. Impressed by its strong form and associations with cultures indigenous to our region, I also felt its acquisition allowed us to better represent the achievements of artists in our area.

In assessing the collections, I admired the breadth of the holdings but discerned that it would be important to continue to seek earlier examples to fill gaps in the collections. Through the generosity of Carl Rohman, we were fortunate to receive Theodore Roszak's *Transverse Polar* as a gift in honor of George Neubert; unfortunately, we cannot easily afford many works by early twentieth-century masters of quality comparable to our current holdings. At the other end of the spectrum, a university museum in proximity to a strong studio art department has a responsibility to address current developments. Thus, we seek to consider works by artists younger than those featured in our collections. Consequently, Joseph Havel's *Silk Drape* was purchased recently, an outstanding work by Lesley Dill was recently acquired, and Roxy Paine was commissioned to create a forty-two-foot-tall tree to be installed in a central location on campus.

In 2002 we pursued two special opportunities to acquire artworks by established sculptors. After seeking a Martin Puryear sculpture for some time, I encountered *The Nightmare* on view in a group exhibition at his New York gallery just before our reopening following renovations. It was an impressive example and a significant presence in our newly installed contemporary art gallery. Soon after, an exhibition exploring Anne Truitt's distinguished career resulted in the purchase of one of her elegant recent columns, allowing us to demonstrate both its affinities to and differences from works by other artists considered Minimalists, such as Andre, Judd, and LeWitt.

As the Sheldon Memorial Art Gallery continues to acquire sculpture, the acquisition of individually impressive works of art and sculptures that can advance understanding of major aesthetic developments in the United States will be pursued with a vision of continuing to enrich the outstanding collections in Lincoln for the enjoyment and edification of our audiences at the university, in the community, and beyond.

JANICE DRIESBACH
DIRECTOR

ACKNOWLEDGMENTS

University of Nebraska, President, Dr. James B. Milliken
University of Nebraska–Lincoln, Chancellor,
 Dr. Harvey Perlman

SHELDON MEMORIAL ART GALLERY AND
SCULPTURE GARDEN STAFF

Monica Babcock, Administrative Technician I; Mack Beatty, Custodian; Neil Christensen, Exhibition Assistant; Lynn Doser, Chief of Security; Janice Driesbach, Director; Sharon Gustafson, Sheldon Statewide Exhibition Coordinator; P. J. Jacobs, Administrator; Karen O. Janovy, Curator of Education; Shannan Kelly, Associate Registrar; Jessica Kennedy, Marketing Manager; Sarah MacMillan, Hixson-Lied College of Fine and Performing Arts Fellow; Terry Nygren, Development Director; Ed Rumbaugh, Senior Exhibits Designer; Daniel A. Siedell, Curator; Laurie Sims, Project Assistant; Stacey Skold, Collections Manager; Vonni Sparks, Museum Store Manager; Jackie Toman, Accounting Technician

NEBRASKA ART ASSOCIATION OFFICERS, 2004–2005

President: Robert Nefsky
Vice President/President-Elect: Rhonda Seacrest
Treasurer: Jean Jeffrey
Secretary: Tom Tallman

SHELDON BOARD, 2004–2005

John Angle, Lucy Buntain Comine, Robert Duncan, Herbert Howe, Jean Jeffrey, Colleen Jones, Christin Mamiya, Robert Nefsky, Giacomo "Jack" Oliva, Martha Richardson, Carl H. Rohman, Rhonda Seacrest, Liz Shea-McCoy, Clay Smith, Jon Strope, John Wiederspan, Donna Woods

FUNDING SOURCES

Nebraska Art Association; National Endowment for the Arts; Cooper Foundation, Lincoln; Elizabeth Firestone Graham Foundation; Institute of Museum and Library Services; Paul Klein Art Works; Henry Luce Foundation American Collections Enhancement (ACE) Program; and the University of Nebraska Foundation

This publication documents a selection of the more than 350 sculpture works in the Sheldon collection. All holdings, including provenance and exhibition history, can be accessed via the Sheldon Gallery's Web site.

Grateful appreciation is extended to catalogue project assistants Sheri Hager and Lisa Nun, without whose dedication early on the project could not have been completed; student interns Mary Hunter, Samantha Pawley, Kris Robinson, Pamela Sept, and Angela Simon; museum volunteers Mary Quayle and Allison Petersen; former Sheldon staff members George Neubert, Cynnamon Jones, Kari Stofer, Karen Merritt, Steve Jensen, Karen Williams, Angela Nelson, Gwen Bedient; and Norman A. Geske, Director Emeritus of the Sheldon Gallery, whose phenomenal capacity for recalling detailed facts has simplified many extensive research problems.

Invaluable assistance was provided by Elizabeth Burke, Luce Visiting Scholar coordinator; Stuart Wheat, Museum Technology Coordinator; Colleen Heavican, Library Research Associate; Angela Nelson, Staff Secretary II; Stacey Skold, Collections Manager; and Shannan Kelly, Associate Registrar for the collections.

Among the many institutions that provided special assistance and expertise, some were called on repeatedly and deserve special mention. They are the Archives of American Art, Washington DC; Grace Borgenicht Gallery, New York; Braunstein/Quay Gallery, San Francisco; Christophe de Menil, New York; Edition Schellmann, New York; The Forum Gallery, New York; Gallery Paule Anglim, San Francisco; Gemini G.E.L., Los Angeles; The Getty Center for the History of Art and the Humanities, Santa Monica, California; The Henry Moore Foundation, London; Kazuyo Yamashita, Kaz International, Washington DC; Klein Art Works, Chicago; The Lachaise Foundation, Boston; The Los Angeles County Museum of Art; Margit Rowell, The Museum of Modern Art, New York; The Metropolitan Museum of Art, New York; Robert Miller Gallery, New York; Musée Rodin, Paris; Smithsonian Art Museum, Washington DC; Primarius Ltd.

ACKNOWLEDGMENTS

Promotion, Minneapolis; Tate Gallery, London; the Tony Smith Estate, New York; and Zabriskie Gallery, New York.

Special gratitude is expressed to the artists whose works are documented as part of the exemplary Sheldon collection and without whose invaluable assistance this publication would not have been possible. Among those are Alice Aycock, Bruce Beasley, Wolfgang Behl, Fletcher Benton, Roy Gussow, David Gilhooly, Lyman Kipp, Richard McDermott Miller, Claes Oldenburg and Coosje van Bruggen, Robert Rauschenberg, Tony Rosenthal, Wade Saunders, Jeff Schlanger, David Seyler, Judith Shea, Francois Stahly, Brian Wall, Daniel Whetstone, and William Wiley.

Unless otherwise noted, the color transparencies were made by John Spence, Spence Film Productions, Lincoln, Nebraska. The black and white images are from the Sheldon Memorial Art Gallery archive.

INTRODUCTION

MODERN AND CONTEMPORARY SCULPTURE IN THE SHELDON MEMORIAL ART GALLERY AND SCULPTURE GARDEN

The Sheldon Memorial Art Gallery and Sculpture Garden's extensive sculpture collection documents the development of this art form in the United States from the mid-nineteenth century to the present. Complementing the collection's American emphasis are fine examples of modern European sculpture by such masters as Auguste Rodin, Medardo Rosso, Constantin Brancusi, Ernst Barlach, Jacques Lipchitz, Barbara Hepworth, Henry Moore, Marino Marini, and Eduardo Chillida. This essay will serve as an introduction to and overview of the Sheldon collection by considering its most important works in the larger context of the history of modern and contemporary sculpture, beginning with a consideration of its nineteenth-century background.

SCULPTURE IN THE NINETEENTH CENTURY: IDEALISM AND NATURALISM

Although in the late eighteenth and early nineteenth centuries American painters such as Gilbert Stuart, John Trumbull, John Vanderlyn, and Washington Allston achieved artistic and professional distinction, no American sculptor of comparable stature emerged during the same period. Native artisans who specialized in gravestone carving, furniture decoration, or the production of shop signs and ship's figureheads were occasionally called on to carve portrait busts or allegorical figures, but major commissions for public statuary routinely went to European professionals. The Frenchman Jean-Antoine Houdon, for example, was commissioned to make a marble statue of George Washington for the Virginia State Capitol in 1788, and the Italian Antonio Canova created a portrait of the same subject for the North Carolina State Capitol in 1818–21.

The first American school of sculpture emerged after 1825, when Horatio Greenough traveled to Italy seeking training in the art. He was followed by Thomas Crawford, who arrived in Rome in 1835, and by Hiram Powers, who settled in Florence in 1837. In Italy these men found resources for the development of sculpture that were lacking in their home country: great collections of ancient sculpture to study and emulate, established masters to provide training, models willing to pose in the nude, and expert carvers able to translate the artist's conception from the plaster model into marble.

Greenough, Crawford, and Powers all mastered the then fashionable Neoclassical style, which was based on ancient Greek and Roman art. Working in the Neoclassical mode they produced public monuments; "ideal" figures based on sources in literature, history, mythology, or the Bible; portrait busts; and genre pieces depicting typical characters or scenes from everyday life. An ambitious example of the latter is the Sheldon's *Truants*, by Thomas Crawford, which was carved in Rome for an American collector. The life-size sculpture shows a prepubescent boy and girl who tenderly examine a bird's nest and its two baby occupants instead of going to school—a destination symbolized by the books at the boy's waist. The smoothly carved marble, the partially nude torso of the boy, and the children's vaguely classical garb impart a Neoclassical flavor to the group, while the mildly sweet facial features and sentimental narrative are thoroughly Victorian.

In the century's middle decades, even as a second generation of American sculptors followed Greenough, Crawford, and Powers to Italy, others sought to nurture a national school of sculpture on native soil. One was Henry Kirke Brown, who after four years of study in Florence and Rome in the 1840s returned to the United States and renounced Neoclassicism for a naturalistic style that he considered more appropriate for a country seeking to declare cultural independence from Europe. Brown for a time also dedicated his art to the indisputably native subject of the American Indian—a theme that subsequently made the reputation of his former assistant John Quincy Adams Ward, who, like Brown, sought to record American subject matter in a straightforwardly naturalistic idiom. The Sheldon owns a cast of Ward's breakthrough work *The Indian Hunter*, which won praise from contemporary critics for its anthropological accuracy, dramatic presence, and suggestion of movement.

An equally powerful sense of movement animates Augustus Saint-Gaudens's imposing *The Puritan*—also quintessentially American in its evocation of the New England past—who strides purposefully forward with a staff in one hand and a Bible in the other. While modeled with a sense of naturalism equal to that of Ward's *Indian Hunter*, Saint-Gaudens's work achieves greater

plastic drama through its rippling surfaces and strong contrasts of light and shadow, created through the interplay of projecting and receding volumes. These qualities reflect Saint-Gaudens's mastery of the Parisian academic manner, which in the later decades of the nineteenth century replaced Neoclassicism as the dominant foreign influence on American sculpture. American sculptors of Saint-Gaudens's generation largely turned from marble to bronze and instead of Florence or Rome went to Paris—Saint-Gaudens studied there in 1867–70 at the Ecole des Beaux-Arts under François Joffroy—absorbing the new style that they would bring back to the United States and apply to the creation of both public monuments and small sculptures in bronze. The first version of *The Puritan* was erected as a heroic scale bronze in Springfield, Massachusetts, in 1887. The reduction in the Sheldon collection was produced twelve years later.

Another sculpture that Saint-Gaudens originally conceived on a large scale and later reproduced in lesser dimensions was his *Diana of the Tower*, first designed in 1891 as an eighteen-foot-high weather vane for Madison Square Garden and subsequently issued in an edition of small bronzes. In contrast to the naturalistic *Puritan*, the graceful *Diana* is an idealized figure whose physical beauty achieves a level of perfection seldom, if ever, found in nature.

The subject of Diana was also treated by Frederick MacMonnies, who served as a studio assistant to Saint-Gaudens from 1880 to 1884 before leaving for Paris, where he studied under Alexandre Falguière and Antonin Mercié at the Ecole des Beaux-Arts. MacMonnies's *Diana*, which received an honorable mention at the Paris Salon of 1889, is a highly naturalistic figure that presents a striking contrast to Saint-Gaudens's idealized rendition of the goddess. Saint-Gaudens's *Diana* is graceful but static, serenely poised on a small orb as she elevates effortlessly on an extended leg and calmly draws back her arrow. So perfectly balanced and harmonious is her pose that it seems truly godlike and eternal; it is difficult to imagine her ever releasing that arrow. MacMonnies's *Diana*, by contrast, has just let her arrow fly and is shown in mid-stride as she rushes after her prey. Her flexed

limbs and unstable pose convey a sense of physical dynamism at odds with the frozen perfection of Saint-Gaudens's goddess. And the sensuous naturalism with which MacMonnies describes her face and naked body makes her seem much more a real, flesh-and-blood woman than Saint-Gaudens's comparatively abstract *Diana*, with her smoothed-out limbs and idealized features. The unabashed nudity of this and many other figures by MacMonnies, while acceptable in France, where he spent much of his career, shocked many Americans, and his works often stirred controversy when they were exhibited in his native country.

Less controversial were the many public monuments—some commemorative portraits, some allegories, some war memorials—that MacMonnies designed for American cities and parks during the late nineteenth and early twentieth centuries. Another major producer of public statuary during this period was Daniel Chester French, whose training included study under John Quincy Adams Ward in New York (1870), Thomas Ball in Florence (1874–76), and Antonin Mercié in Paris (1886–87). While French's best known work is his colossal seated Lincoln in the Lincoln Memorial in Washington DC (1922), his earlier standing portrait of Lincoln, created for the Nebraska State Capitol in 1912 and also issued in a bronze reduction (an example is in the Sheldon collection), is in many ways a more moving and human rendition of the Great Emancipator.

The greatest European contemporary of Saint-Gaudens, Mac-Monnies, and French was Auguste Rodin, who, like them, received numerous commissions for public monuments. In 1892 Rodin was chosen to create a funerary monument to the poet Charles Baudelaire for Montparnasse Cemetery in Paris, a project ultimately abandoned for a lack of funds. Unlike French's later memorials to Lincoln, Rodin's projected monument was not to feature a full figure of its subject but only his head, because, as the sculptor explained, Baudelaire "lived only by his brain."[1] For the striking head of Baudelaire that he created in 1892, in the Sheldon collection, Rodin used as his model a young artist, Louis Malteste, who he felt closely resembled the author of *Les fleurs du mal*. But Rodin was less concerned with creating an outward

OPPOSITE PAGE: AUGUSTUS SAINT-GAUDENS, *THE PURITAN*, 1899. UNL, F. M. HALL COLLECTION.

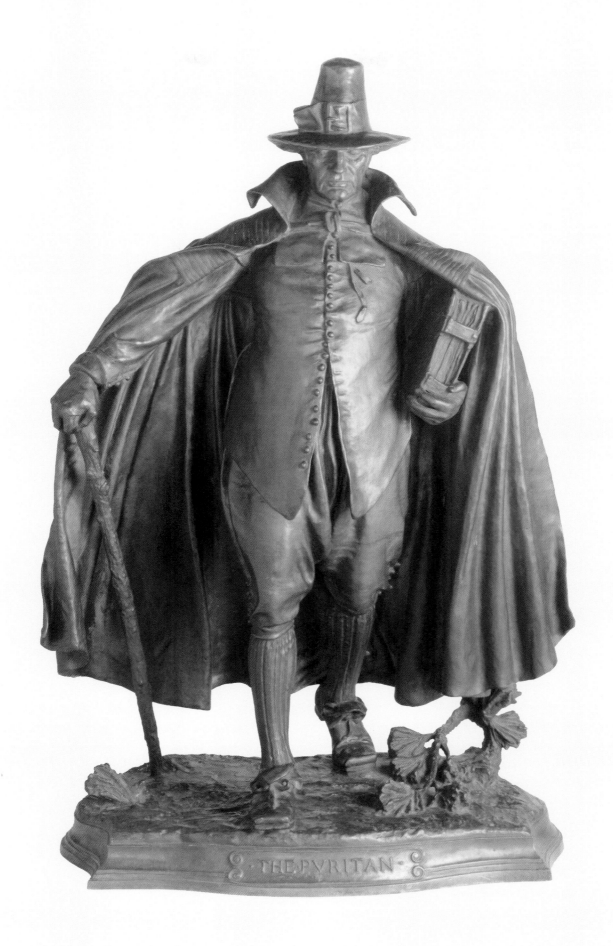

likeness of Baudelaire than he was with evoking the poet's complex inner character, which seems most clearly revealed in the portrait's intense, visionary gaze. A remarkable feature of the work is the long lump of clay—here translated into bronze—that the sculptor left on the forehead. While Rodin may have intended this clay as a tangible sign of Baudelaire's intense mental activity, it also serves as a frank declaration of the materiality of the artist's medium—a hallmark of modernism, which Rodin helped to inaugurate in sculpture.

Another pioneer of modernism in sculpture was the Italian Medardo Rosso, who spent much of his active career in Paris. Rosso is often classified as an Impressionist because of his interest, parallel to that of the Impressionist painters, in capturing an effect of motion and in dissolving solid form to convey a vague and momentary impression rather than a precise and durable description of the subject. In the Sheldon's *Bambino Ebreo*, Rosso used his favorite medium of wax to replace the usual hardness of sculpture with qualities of softness and evanescence, modeling subtle surface transitions that suggest the merger of the figure with the atmosphere of light and shadow that surrounds it.

The American sculptor Bessie Potter Vonnoh also sought to create the effect of a quick and spontaneous impression through the use of momentary poses and flickering surfaces, as seen in the Sheldon's *Girl Dancing*. Characteristic of Vonnoh's art is the statuette's theme of upper-middle-class leisure, greatly appealing to the elite patrons who made Vonnoh one of the most successful genre sculptors of her day.

Vonnoh's devotion to genteel, feminine themes—at that time considered appropriate for a female artist—found its foil in Mahonri Young's concentration on subjects of lower-class, masculine labor. While Vonnoh's dainty dancer performs a graceful curtsey in what we imagine to be a polite setting, Young's robust, bare-chested *The Laborer* strains with exertion as he bends to shovel a heavy load of dirt. Albeit rendered in the same small, table-top scale as Vonnoh's piece, Young's richly modeled figure possesses a feeling of monumentality far exceeding its actual

physical size. Although no political radical, Young, like many reformers of the period, felt great sympathy for the laboring classes and used his art to bring attention to their struggle to achieve better working and living conditions. The Sheldon figure, first exhibited in plaster in 1903, was one element of a multifigured *Monument to Labor* that Young conceived in 1902–3 but never executed.

EARLY MODERNIST SCULPTURE: THE ABSTRACTED FIGURE

While Young and other artists of his generation carried on the naturalistic tradition of the nineteenth century well into the twentieth, a growing number of sculptors were turning away from naturalism to create abstracted figures whose formal originality would resonate with the revolutionary changes then occurring in all spheres of human endeavor. Paradoxically, many of the pioneers of modernist sculpture drew their primary aesthetic inspiration not from contemporary sources but from ancient and "primitive" art—the latter comprising that of traditional African, Oceanic, and pre-Columbian American cultures as well as folk art and children's art.

The simplified and highly stylized art of archaic or preclassical Greece, for example, strongly influenced the American sculptor

ABOVE: PAUL MANSHIP, *SALOME*, 1915. UNL, GIFT OF MARY RIEPMA ROSS, EX-32.

Paul Manship, who discovered archaic art while studying in Rome in the early 1910s and adapted it to the needs of modern expression. The angular pose, rhythmic drapery patterns, and intricate surface ornamentation of Manship's *Salome* create an effect both archaic and exotic, fitting to the subject of the biblical femme fatale.

The Polish-born sculptor Elie Nadelman, who worked in Paris between 1904 and 1914 and then immigrated to the United States, drew not on archaic but on classical and Hellenistic Greek art for the idealized features and graceful poses of such figures as his *Man in the Open Air*. Nadelman combined these antique elements, however, with a modern interest in geometrically simplified and streamlined forms. Also thoroughly up-to-date was the subject of the debonair, bowler-hatted dandy.

The Russian-born Alexander Archipenko also combined ancient and contemporary references in his *Sarcophagus of Angelica*, which evokes Etruscan funerary sculpture of the seventh century BC even as it portrays the artist's (then still living) wife, nude but wearing pearls and a fashionable 1920s-style coiffure. In order to enhance the fluency of the figure's contour, Archipenko omitted Angelica's left arm and the legs below the upper thighs,

sacrificing anatomical completeness to the most aesthetically effective composition—a good example of the modernist use of the "partial figure," first introduced into the vocabulary of advanced sculpture by Rodin in the late nineteenth century.

Stylized female nudes were the specialty of the French-born Gaston Lachaise, who around 1902 found his ideal of womanhood in Isabel Dutaud Nagle, a married woman ten years his senior whom he met in Paris, followed to the United States, and eventually married after she divorced her first husband. Isabel's voluptuous figure inspired such creations as Lachaise's *Floating Figure*, whose ample thighs, hips, buttocks, and breasts are set in relief by the small head, narrow waist, and tapered wrists and ankles. In a further instance of a modernist sculptor finding formal inspiration in art outside the Western canon, the *Floating Figure*'s graceful hand gestures echo those of the Indian Buddhas that Lachaise greatly admired.

The angular stylizations of traditional African carvings played an important role in the development of Cubism, pioneered in painting by Georges Braque and Pablo Picasso in the years before World War I and extended into sculpture by Picasso and other artists. In Cubist sculptures such as Jacques Lipchitz's *Bather*, the human body's organic volumes and continuous surfaces are broken into a complex arrangement of simplified masses and abrupt planes that, while still evoking the figure, ultimately command our attention as a purely artistic creation.

DIRECT CARVING

The early twentieth-century modernists thus far considered—Manship, Nadelman, Archipenko, Lachaise, and Lipchitz—all worked primarily as modelers, first creating their works in malleable clay or plaster and subsequently having them cast in bronze. In this they followed the example not only of Rodin but also of more conventional, academic sculptors of the later nineteenth century, who would typically model works that would then be cast, or sometimes carved, by assistants. In the years around 1910 numerous modernist sculptors rejected this "indirect" method of making sculpture and turned to "direct carving," whereby the

ABOVE: SALOME (BACK VIEW)

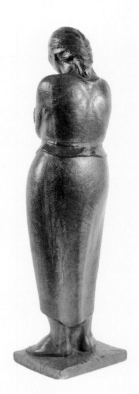

sculptor creates directly by cutting natural materials such as wood or stone without the use of preliminary models and without the help of assistants. The adherents of direct carving believed that their method yielded sculpture that was more authentic, because the sculptor did all the work him- or herself, and more honest, because every artistic decision was definitively revealed in the wood or stone, which did not permit the possibility of endless revision and reworking available to the sculptor in clay.

One of the first European modernist sculptors to embrace direct carving was the German Ernst Barlach, who sculpted his first wooden figure in 1907 and, despite continuing to use bronze and ceramic, preferred from then on to carve wood in a forceful, simplified style. The stiff, vertical posture and self-contained pose of Barlach's *The Young Wife (Standing Woman with Folded Arms)* intimately relate the figure to the rectangular block of linden wood from which it was cut, while the coarse handling of the surface, stylistically apposite to the simple, peasant subject, accentuates the grainy quality of the material.

A major Parisian exponent of direct carving was Constantin Brancusi, who after arriving in the French capital from his native Romania worked briefly as an assistant to Rodin before rejecting that master's style and developing his own idiom of

ABOVE LEFT: ERNST BARLACH, *THE YOUNG WIFE (STANDING WOMAN WITH FOLDED ARMS)*, 1922. UNL, F. M. HALL COLLECTION. © ERNST BARLACH LIZENZVERWALTUNG RATZEBURG. *ABOVE RIGHT:* THE YOUNG WIFE (BACK VIEW).

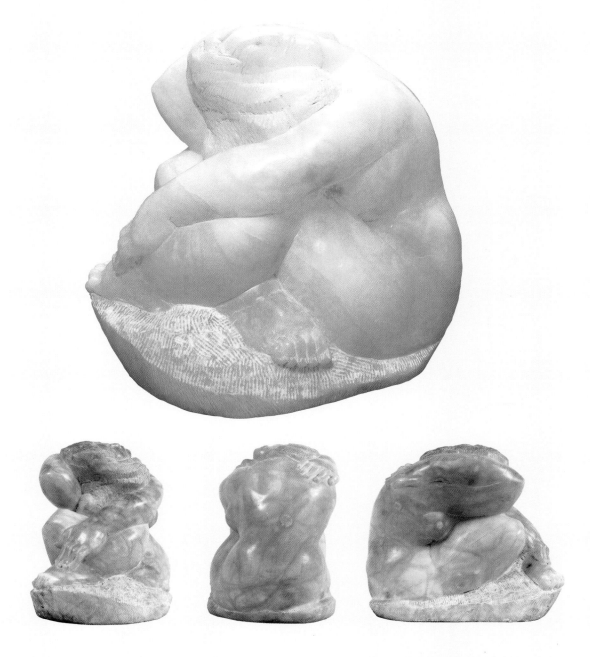

extreme formal and conceptual simplicity. This shift was apparently motivated by the philosophy of Plato, who held that all physical things are imperfect imitations of perfect and eternal Ideas. Brancusi's idealism led him to seek to capture not the momentary, external appearance of his subjects but their enduring, inner spirit. Of his radically simplified portrait *Princess X*, the sculptor declared, "My statue is of Woman, all women rolled into one, Goethe's Eternal Feminine reduced to its essence."[2] While the portrait demonstrates Brancusi's consummate skill in carving and polishing marble into smooth and streamlined per-

fection, the roughly cut wooden column that supports it manifests his antithetical interest in "primitive" carving—an interest influenced by the folk traditions of his native country as well as by African art.

"Primitive" sources also were important to Robert Laurent, the French-born American sculptor who introduced direct carving into American modernist art. Laurent's first carvings, made in the early 1910s, were stylized relief panels and heads inspired by African art. In the 1920s, encouraged by the example of Gaston

TOP: ROBERT LAURENT, *SEATED NUDE*, 1946. UNL, F. M. HALL COLLECTION. COURTESY KRAUSHAAR GALLERIES FOR THE ESTATE OF ROBERT LAURENT.
BOTTOM, LEFT TO RIGHT: *SEATED NUDE* (SIDE VIEW), *SEATED NUDE* (BACK VIEW), *SEATED NUDE* (SIDE VIEW)

Lachaise, he adopted the subject of the female nude, which he often carved in alabaster. Characteristic of such work is his *Seated Nude*, whose self-contained pose, compact forms, and closed contours display a respect for the inherent qualities of the material from which she is carved, and whose sensuousness is heightened by the softness and translucency of the polished stone.

Another pioneer of direct carving in America was William Zorach, who worked as a painter before turning to sculpture in the late 1910s. Like Laurent, Zorach first made wood carvings inspired by African art, and from the early 1920s he worked primarily in stone. He also shared with Laurent and with Lachaise, their mutual friend, a commitment to the subject of the female nude. Zorach, however, rendered the nude in a more chaste and severe manner than either of the French-born artists. This is demonstrated in the Sheldon's elegant *Torso*, which Zorach originally carved in Labrador granite and later cast in bronze—a translation that indisputably violates the direct carver's ideal of "truth to material" but is justified by the artist's wish to reproduce a composition he considered particularly successful.

The third major exponent of direct carving in America was John B. Flannagan, who began working in wood in the mid-1920s but by the end of the decade had adopted stone as his preferred material. Rather than quarried blocks, Flannagan used fieldstones gathered in the countryside, each one chosen with an eye toward liberating the image he sensed existing within it. Often, as in the case of his *Elephant*, that image was of an animal whose compact form Flannagan would describe through the most minimal cutting, in order to preserve the basic shape of the stone.

A far more complex and sophisticated example of direct carving is the remarkable *Figurative Abstraction* by John Storrs, a Chicago-born sculptor who moved to Paris in 1912 and, after a period of study with Rodin, began to develop a more abstract, Cubist-influenced style. Carving five of the six faces of a twenty-inch-high block of marble, Storrs created a composition that wraps around the stone, its principal faces portraying, respectively, a seated female nude and a standing nude child, both seen from the back,

so that they appear to face and embrace one another within the block. The treatment of the bodies in terms of blunt, geometric shapes and flattened planes evinces the influence of Cubism and points toward the completely abstract style Storrs would create in the 1920s in his architectonic series "Forms in Space."

A leading exponent of direct carving in England during the middle decades of the twentieth century was Barbara Hepworth, who first learned to work in marble in 1925 while studying in Italy. After carving a series of figurative works in a simplified style similar to that of her friend Henry Moore, Hepworth in the early 1930s began to create completely abstract works based on a limited vocabulary of basic forms such as the ovoid, the sphere, and the cylinder. These sculptures often consist of multiple parts, as in the Sheldon's *Small Form Resting*, a two-part sculpture whose refined forms and smoothly polished surfaces epitomize the formal perfection of Hepworth's art. As is typically the case with Hepworth's sculpture, *Small Form Resting* offers visual surprises to the viewer who walks around it to investigate it from all sides. The upper element, for example, looks from some vantage points to be essentially spherical, but when seen from other angles changes radically in appearance owing to the spiraling groove scooped out of its midsection. Meanwhile, the sculpture's lower element incorporates a deep, oval indentation that is visible only from one side of the sculpture.

Equally committed to the creation of formally elegant abstractions through the direct carving of stone was the Japanese-American sculptor Isamu Noguchi, whose aesthetic was powerfully shaped by his experience as a studio assistant to Brancusi in Paris in 1927. Carved in 1958, the year following Brancusi's death, Noguchi's two-part *Song of the Bird* pays homage to the Romanian master in its twisting, knobbed, granite pylon, a complex variation on Brancusi's famous *Endless Column*, and in its abstract, marble bird form, which recalls Brancusi's career-long involvement with avian themes. At the same time, the sculpture unmistakably expresses the unique sensibility of Noguchi himself, called by one critic the late twentieth century's "finest lyric poet in stone."[3]

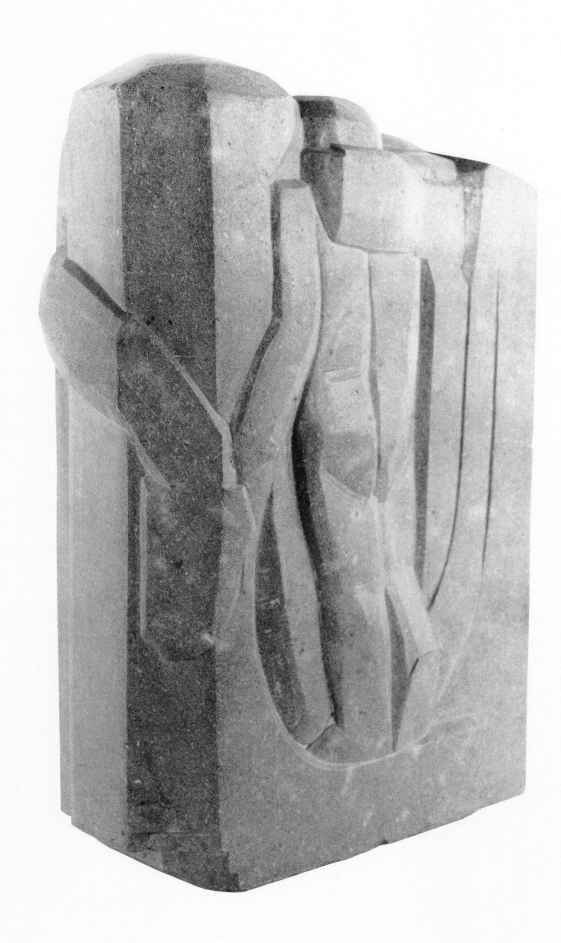

ASSEMBLAGE AND CONSTRUCTED SCULPTURE

The technique of assemblage, whereby a sculpture is composed out of preformed pieces of material or found objects, provided twentieth-century sculptors with an appealing alternative to the traditional methods of carving, modeling, and casting. Largely responsible for introducing assemblage into the repertory of modern sculpture was Picasso, who in 1912 began to construct three-dimensional Cubist compositions out of scrap wood, sheet metal, and other materials. One year later, the French artist Marcel Duchamp—at that point a Cubist painter—attached the fork and wheel of a bicycle to the seat of a wooden stool to create the first "assisted readymade," his term for an assemblage of manufactured objects selected and combined by the artist but otherwise unaltered. In 1914 Duchamp produced his first pure, or "unassisted," readymade when he purchased a bottle-drying rack and designated it a work of art. Following his move to New York in 1915, Duchamp selected several more readymades, including the infamous *Fountain* (1917), a porcelain urinal turned on its back and signed with the pseudonym "R. Mutt." This work was rejected by the supposedly liberal hanging committee of the Society of Independent Artists, which Duchamp had helped to found.

Duchamp's provocative gesture of submitting a urinal to an art exhibition was made in the spirit of Dada, an international avant-garde movement of the later 1910s and early 1920s that employed spontaneity, irreverent humor, and irrationality to attack the sanctity of traditional art and the conventional thinking of its bourgeois patrons. The Dadaists' rejection of traditional artistic values led them to adopt a wide variety of new methods, including assemblage, that liberated them from the shackles of conventional artistic technique. Inspired by the example of his close friend Duchamp, the American Dadaist Man Ray produced a number of surprising assemblages, the most famous of which, *Cadeau*, consists of a flatiron whose face is lined with sharp tacks.

Assemblage remained a vital resource for the sculptors of the Surrealist movement, who inherited from Dada a commitment to the values of spontaneity and irrationality, and added to these a more programmatic interest in exploring the realms of dreams and fantasy, which they considered expressions of the unconscious. The essential aim of the Surrealists was to unite the conscious and unconscious, conjoining the fantastic and the rational to create an absolute or *sur*reality.

In pursuit of this ideal the Surrealists often created works of art that combined apparently unrelated objects and images in enigmatic juxtapositions of the kind we experience in our dreams. While Salvador Dalí, René Magritte, and other painters depicted such juxtapositions on their canvases, sculptors such as Joseph Cornell used the technique of assemblage to realize them with actual objects. Cornell, who was strongly influenced by the Surrealists and exhibited alongside them in New York in the 1930s and 1940s, specialized in small glass-fronted box constructions in which he displayed a variety of obscure and ephemeral objects, images, and texts, collected from Manhattan's bookshops, antique stores, and flea markets as well as on walks along the beaches of Long Island. The piece of driftwood in the bottom of Cornell's *Pipe Box* undoubtedly came from such a walk; it is set behind a broken clay soap-bubble pipe—evoking lost childhood pleasures—and among an array of white-painted nails. Above is a painted cork sphere that rolls freely on two horizontal metal rods, alluding to the movements of the planets and to the passage of time. The bluish-green painted background and painted constellations on the top of the box resonate with Cornell's lifelong fascination with medieval and Renaissance astrology, while the fragment of an obscure Italian text pasted to the back of the box manifests Cornell's fascination with language and its relation to the unknowable.

In the hands of abstract artists, assemblage developed into Constructivism, a movement launched in the Soviet Union after World War I that soon spread internationally. Constructivism, broadly defined, is a form of assemblage featuring abstract, geometric forms, typically made of manufactured materials such as metal, plastic, and glass, which associate the artwork with the values of modern industry. Exemplary of the Constructivist aesthetic in American sculpture are Theodore Roszak's *Transverse Polar* and Ibram Lassaw's *Intersecting Rectangles*. Roszak's vertical composition of ferrous and aluminum metal and lathe-turned painted wood elements is streamlined and aerodynamic, while Lassaw's cruciform arrangement of four open welded steel rectangles around a central vertical axis is severely rectilinear. Although Roszak's sculpture retains the traditional sculptural emphasis on mass and closed volumes, Lassaw's more innovative,

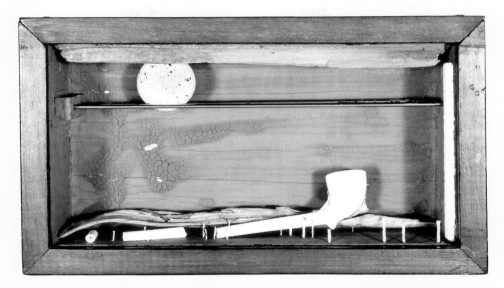

cagelike composition redefines sculpture as an art of space rather than mass. This quality of openness is amplified by Lassaw's incorporation of Lucite—a translucent material—into the two smallest rectangles.

The American sculptor Alexander Calder devised a highly personal variant of Constructivism through his invention of the mobile, a sculpture composed of thin sheets of metal suspended from wire rods and carefully balanced so that its elements move freely through space when set in motion by a wind current or touch of the hand. Thus activated, Calder's mobiles, such as *Sumac II*, do not simply occupy space but interact with it as their components bob, swing, and rotate in unpredictable courses. The work constantly changes in appearance as the three traditionally fixed dimensions of sculpture—height, width, and depth—are modified by a variable fourth: time. The organic shapes of the metal components, inspired by the biomorphic Surrealist styles of Jean Arp and Joan Miró, enhance the fluid motion of the mobile while also giving it a quality of whimsy reflective of the playful personality of its creator, who was a prolific toymaker.

Second in importance only to Calder in the development of kinetic, or moving, sculpture in America was George Rickey, who worked as a painter for twenty years before making his first Calder-inspired mobile in 1949. By the early 1960s Rickey had developed a strictly geometric style very different from the biomorphic language of Calder. As exemplified by *Six Lines in a Column*, Rickey's signature pieces feature long, tapering, three-sided spars of welded stainless steel, attached with bearings to fixed supports and precisely balanced so that the slightest breeze or touch of the hand will cause them to oscillate in a smooth, stately motion.

Rickey first learned welding from his friend and colleague David Smith, a fellow Indiana native and later his Upstate New York neighbor, whose mature work was also rooted in the Constructivist tradition. Smith and Rickey shared a commitment to the medium of stainless steel and to animating that material's surfaces through disk-ground swirls and random markings that catch and reflect ambient light. Unlike Rickey's kinetic works, which are resolutely nonobjective, Smith's static, welded steel constructions, while abstract, often evoke the human figure, as does his *Superstructure on 4*, whose composition suggests a boxy torso sprouting a head and other appendages and rising on stilt-like legs.

FIGURATION AT MIDCENTURY

Concurrent with the development of both geometric and organic abstraction, stylized figuration remained a vital impulse in both American and European modernist sculpture of the mid-twentieth century, its expressive qualities informed both by its practitioners' subjective concerns and by an awareness of larger historical events such as World War II and the subsequent cold war.

Best known today for her assemblages of discarded wooden elements arranged in boxes, painted a uniform black, white, or gold, and stacked to produce wall-scaled reliefs, Louise Nevelson

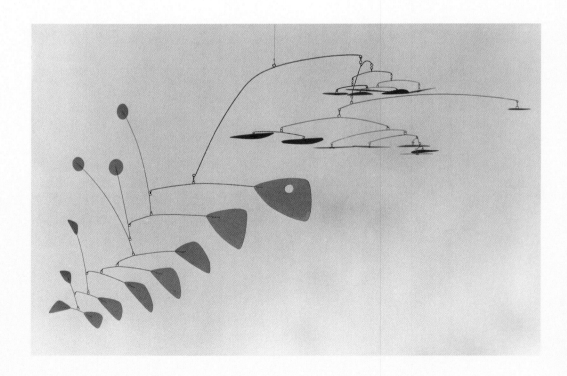

ABOVE: ALEXANDER CALDER, *SUMAC II*, 1952. NAA, GIFT OF MR. AND MRS. FREDERICK S. SEACREST. © 2004 ESTATE OF ALEXANDER CALDER/ARTISTS RIGHTS SOCIETY(ARS), NEW YORK.

began her sculptural career creating abstracted figures in wood, stone, bronze, and terra-cotta. Characteristic of her work in the latter medium is *Mountain Figure*, a totemlike personage composed of three stacked black-painted terra-cotta segments. The sculpture's blocky volumes reflect the stylistic influence of Cubism, which Nevelson absorbed as a student of the painter Hans Hofmann in the early 1930s, while the craggy, pitted surfaces and crudely incised facial and anatomical features reveal her interest in primitivism.

Also informed by primitivism are the early, roughly hewn sculptures of Louise Bourgeois, a French immigrant to New York who in the 1940s carved and assembled numerous life-size, elongated, and highly abstracted wooden figures that she arranged into groups and described as "the people I left behind in Paris."[4] No slave to the notion of "truth to materials," Bourgeois later had several of these works, including the stiffly standing *Observer*, cast in bronze and patinated to resemble the original painted wood.

The enigmatic presence of Bourgeois's *Observer* suggests affinities with Surrealism, many of whose leading practitioners, including the "pope" of Surrealism himself, André Breton, came to New York at the turn of the 1940s to escape the world war in Europe. Although Bourgeois, recently arrived from France herself, kept her distance from the Surrealists in exile, some young American artists developed close ties to them. Among these was David Hare, a photographer who joined Breton's circle and began in 1942 to make Surrealist sculptures, such as *Catch*, that conjure up bizarre, sexualized creatures composed of human, animal, and mechanical parts.

Although by no means intended as a comment on historical events, Hare's violent distortion of the human image resonates within the context of the recently ended World War II, whose horrific carnage and devastation had a profound impact on mid-century art. Among the more hopeful responses to the war was the work of the great English sculptor Henry Moore, who between 1945 and 1949 created a series of bronze "Family Groups" that express optimism for the postwar renewal of human civilization. In works such as the Sheldon's *Family Group*, Moore's fusion of the parents and children into a fluent, organic whole suggests the ideal not only of a cohesive family but of human solidarity.

In the 1950s the younger English sculptor Kenneth Armitage accentuated this quality of collective humanity by creating an even more complete merger of several figures into a single mass. The three simplified personages of *The Seasons* share a lumpy, fused torso from which rigid limbs and knoblike heads protrude like branches from a tree trunk. Compared with Moore's *Family Group*, Armitage's figures appear more anonymous and impersonal and, despite their merged midsection, less intimately connected; rather than sitting together and holding each other in the manner of Moore's family, they stand on stiltlike legs and thrust their arms in straight vertical and horizontal gestures lacking any clear purpose. Nor do Armitage's figures share the smooth, organic style of Moore's, but are instead stiff and roughly modeled, their scraped and gouged surfaces suggesting both physical and psychological scarring. Unlike Moore, Armitage seems to speak not of the renewal of human existence but of its precariousness, even absurdity, in a postwar age of doubt and disillusionment. Fittingly, Armitage was represented in a 1962–63 exhibition in Germany entitled "Zeugnisse der Angst in der moderne Kunst" (Evidences of anxiety in modern art).

Also included in that exhibition was Marino Marini, Italy's leading postwar figurative sculptor. Marini's highly personal treatments of the horse-and-rider theme, exemplified in the Sheldon's *Horseman*, replace the outworn myth of the confident mounted victor with an anxious awareness of modern humanity's loss of mastery—seen, too, in Armitage's work and very characteristic of postwar European art. In Marini's *Horseman*, that loss of mastery is communicated by the stationary pose and unheroic anatomy of both horse and rider, and by the opposing directions of their gazes, suggesting indecision or even disorientation. While Marini's sculptures, no more than those of Hare, Moore, or Armitage, do not directly comment on historical circumstances, they do resonate poetically with the dominant concerns of his era. "My statues of riders express the anguish provoked by the events of my age," declared the artist in 1968. "My works have been intended to be tragic rather than heroic."[5]

FROM ABSTRACT EXPRESSIONISM TO MINIMALISM

Abstract Expressionism, the major development in American modernist painting of the 1940s and 1950s, was paralleled by a new sculptural tendency that also emphasized the qualities of both abstraction and expressionism, or the communication of

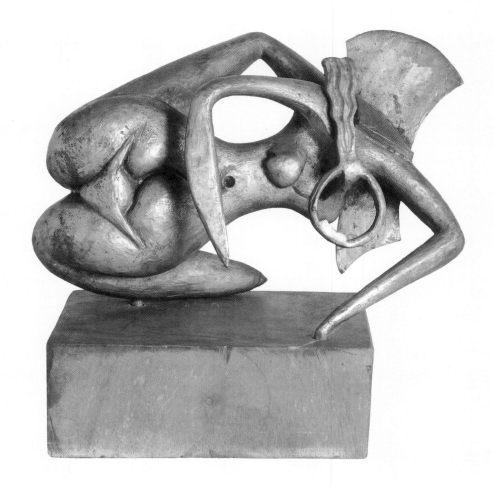

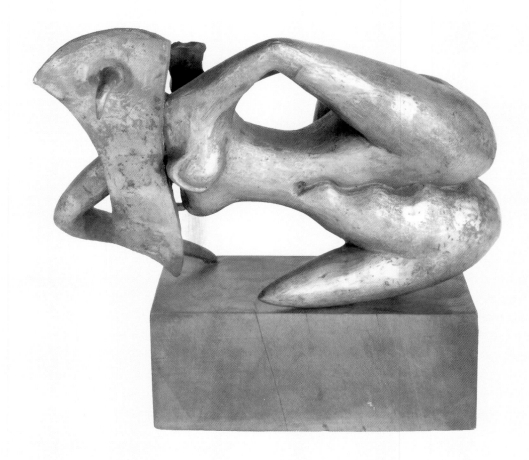

intense feeling through formal means. Abstract Expressionist sculpture stresses aggressive, open, penetrating forms and mythic and metaphysical themes that resonated in the atmosphere of historical crisis brought on by World War II.

The chief technical resource of the Abstract Expressionist sculptors was the process known as direct-metal, whereby the artist creates the sculpture directly by welding together metal pieces. First employed by Julio González and Pablo Picasso in Paris in the late 1920s, the direct-metal technique was adopted in the early 1930s by David Smith, who quickly established himself as the supreme American master of the method. Initially trained as a painter, Smith often painted his metal sculptures with gestural strokes that emulated those of his Abstract Expressionist colleagues, while he gave his later stainless steel works, such as *Superstructure on 4*, burnished surfaces to achieve a similar effect.

Other direct-metal sculptors of the 1940s and 1950s brazed metal alloys onto the exteriors of their works to create a palpably textural—and more purely sculptural—analogue to the thick, roughly handled pigments of the Abstract Expressionist painters. Both Theodore Roszak and Ibram Lassaw, who had previously employed Constructivist techniques of assemblage, took up welding and brazing after the war, as did Seymour Lipton, who before the war had been a direct carver. Lipton's mature style, exemplified in the Sheldon's *Glowworm*, features bent and hammered sheets of Monel metal whose interior and exterior surfaces have been torch-brazed with nickel silver to create a rough texture suggestive of bark or scarred skin. Characteristic of Lipton's work of the period, the dynamic, asymmetrical composition suggests a fusion of both biological and mechanical forms and evokes essential forces of growth and change.

The primal energy of creation itself seems to be the subject of Reuben Nakian's impressive *Birth of Venus*, whose surging abstract volumes, elevated on a scaffolding of thin rods, conjure the nascence of the goddess from the foam of the sea. While resembling Lipton's torch-brazed direct-metal forms, the rough and jagged elements of Nakian's *Venus* were initially modeled in plaster and subsequently cast in bronze—a traditional technique that in Nakian's hands yields fresh and vital results.

The Spaniard Eduardo Chillida, a younger peer of the New York Abstract Expressionists, made his reputation in the 1950s with abstract sculptures in iron—a medium deeply rooted in the blacksmithing traditions of his native Basque country, whose forges have been famous since Roman times. In *Silences*, a small but fine example of Chillida's work, the lower iron segments have been hammered into curving, cufflike shapes, while the upper elements have been filed and sharpened into slender prongs that shoot out aggressively into space.

The lightness and linearity of Chillida's sculpture places it in the tradition of "drawing in space" established by his countryman González and carried on by David Smith. By contrast, the American Tony Smith (no relation to David Smith) emphasized the more traditional sculptural values of heavy mass and closed volumes in his large abstract works in black-painted steel. Though a close friend of several of the Abstract Expressionist painters, Smith did not work in a rough, expressionist vein but instead used smooth, straight-edged geometry, composing the majority of his sculptures from tetrahedral modules that he linked together to form twisting compositions. Smith also differed from his Abstract Expressionist colleagues in not making his works by hand but having them fabricated by an industrial welding company.

Despite their geometric forms and industrial facture, however, Smith's sculptures share with the works of the Abstract Expressionists a sense of having been intuitively composed and a quality of suggested movement: they appear to stretch, turn, and continually change shape as the viewer walks around them. Some, such as the Sheldon's *Willy*—named after a pathetic, crawling character in a Samuel Beckett play—even have an anthropomorphic presence. Such qualities distinguish Smith's sculptures from those of his younger contemporaries, the so-called Minimalists, with whom he has often been superficially

--

OPPOSITE TOP: DAVID HARE, *CATCH*, 1947. UNL, OLGA N. SHELDON ACQUISITION TRUST. COURTESY THERRY FREY-HARE.
OPPOSITE BOTTOM: *CATCH* (BACK VIEW)

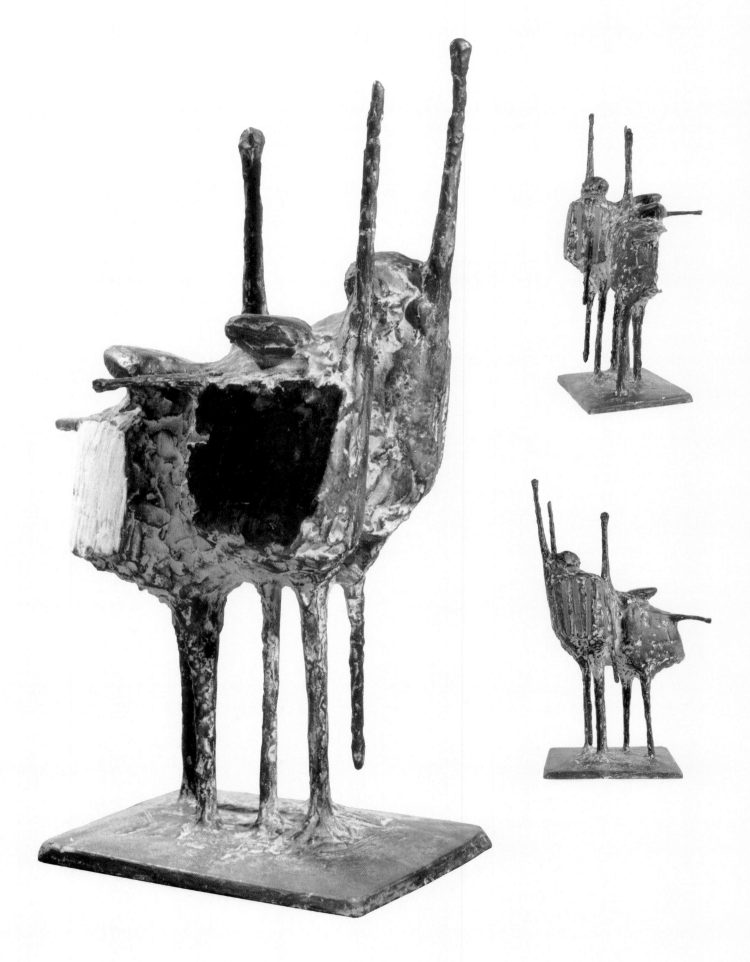

linked. Like Tony Smith, the Minimalists favored simple geometric forms fashioned of industrial materials, but they banished ambiguous, intuitive, and metaphorical qualities of the sort encountered in Smith's *Willy* to concentrate on the artwork's status as a clear, self-contained fact referring to nothing outside itself.

None of the major artists now recognized as Minimalists accepted the label—imposed on them by critics—because it implied that their art was simplistic, whereas they aimed to emphasize directness and immediacy. Donald Judd, one of the tendency's leading spokesmen, preferred to call his and his colleagues' three-dimensional works "Specific Objects" because of the honest, matter-of-fact quality of their shapes, surfaces, and colors, and their rejection of the illusionistic qualities of traditional painting and sculpture. Judd is best known for his anonymous-looking, rectangular units, fabricated out of industrial materials and presented in evenly spaced vertical or horizontal rows, or, as in the case of the Sheldon's *Untitled*, singly. Open on both ends so as to dispel any mystery about what might be inside it, and lined with sheets of brown plexiglass whose color is inherent to the material itself rather than applied, this work is meant to be placed directly on the floor, a situation in which it is most likely to be encountered as a concrete, specific reality, rather than a representation or evocation of something else.

Judd's colleague Carl Andre created an even more radically simplified form of abstract sculpture by eliminating verticality and spatial volume—the latter a defining feature of Judd's open boxes—to concentrate on horizontality and physical mass. In Andre's work these qualities find their characteristic expression in the form of flat, rectangular metal plates set directly on the gallery floor in modular or serial arrangements held in place only by gravity. As in the case of the Sheldon's *Magnesium-Copper Dipole (East/West)*, Andre often uses elemental metals because of their irreducible material simplicity. He conceives of the periodic table of elements as "a kind of palette," the sculptural analogue to "what the color spectrum is for the painter. . . . Copper is more profoundly different from aluminum than

red is from green."[6] And in order to experience the differences in weight, mass, and density among the metals, Andre invites the spectator to walk on his pieces, which become not simply objects but *places*.

Following the example of Duchamp's readymades, Dan Flavin fashioned Minimalist sculptures out of standard fluorescent lighting fixtures. With tubes of differing lengths and colors typically grouped together in simple configurations like that seen in the Sheldon's *Untitled*, Flavin's sculptures consist not just of the light fixtures themselves but also of the light that they cast, which transforms the surrounding room into part of the overall work of art.

One of the few women to be associated with the Minimalist movement, the Washington DC–based Anne Truitt made simple sculptures comprising one or two tall, slender wood boxes placed directly on the floor. While these features connect Truitt's work with that of New York Minimalists such as Judd and Andre, her columnar sculptures are distinguished by their richly painted surfaces—covered by hand with as many as thirty layers of acrylic—and by their evocative titles, such as that of the Sheldon's piece, *Still*.

Sol LeWitt's open, industrially fabricated cubes merge Minimalist form with the concerns of Conceptual art, an important trend that LeWitt helped launch in the mid-1960s through both his art and his writings. Whereas Minimalism stresses the concrete physical reality of the art object, Conceptualism views the idea behind the work of art as ultimately more important than the physical work itself. As LeWitt wrote, "All of the planning and decisions are made beforehand and the execution is a perfunctory affair. The idea becomes a machine that makes the art."[7] LeWitt uses the open cube to explore a variety of mathematical concepts whose logic generates the form of the sculpture. The Sheldon's five-armed *Incomplete Open Cube* belongs to a series that presents all the possible incomplete cubes made up of as few as three and as many as eleven aluminum bars, with twelve constituting a "complete" cube.

OPPOSITE, FAR LEFT: KENNETH ARMITAGE, *THE SEASONS*, 1956. UNL, F. M. HALL COLLECTION. COURTESY KENNETH ARMITAGE FOUNDATION.
OPPOSITE, TOP RIGHT: THE SEASONS (SIDE VIEW)
OPPOSITE, BOTTOM RIGHT: THE SEASONS (BACK VIEW)

Numerous California artists who emerged in the 1960s created work bearing a stylistic resemblance to New York Minimalism but animated by a unique West Coast concern for the insubstantial aesthetics of light and space. Prominent among them was Larry Bell, who gained renown for his six-sided glass boxes banded in chrome and elevated on virtually invisible plexiglass pedestals. Using a vacuum chamber, Bell, who now lives in New Mexico, coats the interior surfaces of his glass cubes with vaporized metallic compounds that, depending on their density, either aid in or interfere with the conduction of light rays. The viewer of a sculpture such as the Sheldon's *Glass Cube Cal #8* both sees through and finds herself mirrored in the glass as the shifting effects of transparency and reflection become the virtual subject of the work.

CALIFORNIA ASSEMBLAGE

With their pristine, gleaming surfaces, Larry Bell's glass cubes exemplify what the critic John Coplans labeled the "Finish Fetish" of Los Angeles art of the 1960s. At odds with that polished and shiny aesthetic is the decidedly rougher and sometimes even raw work of numerous California artists who made assemblages in the postwar decades, some fashioning their work out of joined wood or welded metal, others composing it from cast-off remnants of everyday life.

A pioneer of assemblage in the Bay Area was Jeremy Anderson, whose idiosyncratic early works of carved and assembled redwood reflect the influence of Surrealism as well as that of the medieval weaponry he admired in San Francisco's M. H. de Young Memorial Museum. With its horned head, spindly neck, and pockmarked trunk sprouting a fantastic arsenal of weaponlike instruments, Anderson's *Untitled #85* appears simultaneously menacing and whimsical.

Also composed of wood but more abstract in form and serious in mood is the work of Alvin Light, the major sculptor of the Bay Area school of Abstract Expressionism. To make his sculptures, Light chopped, chiseled, notched, hollowed, mortised, and laminated hardwoods into a variety of shapes, which he then joined together into dynamic compositions that appear to twist and grow upward, as if impelled by a powerful life force. Into each of his sculptures Light incorporated several different woods in order to achieve coloristic variety, which he heightened by adding pigmented epoxies to some of the work's surfaces. While his pieces of the 1950s and 1960s were rugged and expressionistic, Light's works of the 1970s, such as the Sheldon's *Untitled*, combine smooth and jagged forms to create a sophisticated interplay between the raw and the polished.

Unlike Anderson and Light, who composed their sculptures out of carved and cut wood—a traditional artistic material—other California assemblagists worked with cast-off, ready-made materials not normally considered "art supplies." An important innovator in this vein was Bruce Conner, a native Kansan and alumnus of the University of Nebraska who arrived in San Francisco in 1957 and entered the countercultural milieu of the Beat poets and musicians. Conner soon began making what he called "funk" assemblages out of discarded objects and erotically charged materials such as nylon stockings, old lace, doll parts, and pornographic photographs, which gave his art a sinister, sexual charge. Different in character is his *JULY GEORGE/PORTRAIT OF GEORGE HERMS*, a metaphorical portrayal of his friend and fellow assemblagist. The shrinelike structure is built largely of weathered wood—a favorite material of its subject, Herms, represented in the Sheldon collection by an assemblage entitled *Pacific Rim*.

A major practitioner of assemblage in southern California was Edward Kienholz, best known for his environmental tableaux of the 1960s that conveyed social and political criticism through their nightmarish presentation of such subjects as a World War II–era Las Vegas brothel, a cell in a mental hospital, and a 1938 Dodge with a copulating couple in the back seat. The Sheldon's *Opti-can Royale*, a smaller and milder example of Kienholz's work, belongs to a series of "Tin T.V.s" that the artist produced in multiple at Gemini G.E.L. (Graphic Editions Limited) in 1976–77, using manufactured metal cans for the bodies of the television sets. Given television's powerful potential to influence American culture and society, it is hardly surprising that the politically engaged Kienholz chose this medium as a frequent subject of his art. And it is significant that five of the six photographs he selected for viewing through the Tin T.V.'s screen show politically charged subjects such as the extermination of Brazilian Indians, German civilians circa 1940, and the Berlin Wall.

Despite his artistic involvement with the realms of popular and commercial culture, Kienholz rejected being labeled a Pop

artist, insisting that his aim was not simply to reflect the modern world—which is essentially what New York Pop artists like Andy Warhol, Roy Lichtenstein, and James Rosenquist did—but to change it. Closer in spirit to New York Pop is the work of Tony Berlant, who since the early 1960s has made both two-dimensional collages and three-dimensional assemblages out of brightly colored sheets of commercially printed tin nailed onto wooden supports. In Berlant's *Lily After Dark No. 58*, a characteristic work, topsy-turvy snippets of commercial imagery and lettering similar to those seen in Rosenquist's Pop paintings float amid abstract planes of vibrant color. Nailed tin sheets cover all seven sides of the small, house-shaped sculpture, which Berlant intends not just to be looked at but to be physically held and admired from all sides. On the bottom, the viewer will discover the printed slogan from a coffee advertising campaign: "Good to the Last Drop."

THE CLAY REVOLUTION

Concurrent with the rise of assemblage on the West Coast occurred a development known variously as the New Clay movement, the California Clay Rush, and the Clay Revolution, which shattered traditional craft-based definitions of ceramic art and established clay as a major medium of sculptural expression.

The prime mover in this development was the Montana-born Peter Voulkos, who established the ceramics program at the Otis Art Institute in Los Angeles in 1954. Inspired by Picasso's ceramics, traditional Japanese ceramics, and the improvisational aesthetics of jazz, Voulkos urged his students to handle their clay freely and to emphasize self-expression rather than fine craftsmanship. Voulkos himself made ruggedly sculptural ceramic works that resembled traditional pottery only in their retention of the basic form of a hollow container. By the end of the decade he had abandoned the pot form to make large, free-form ceramic sculptures assembled from a variety of wheel-thrown and slab-built elements, their surfaces often brightened with gesturally applied glazes or epoxy paint. In the early 1960s, after moving to the University of California–Berkeley, Voulkos returned to traditional ceramic forms such vases, buckets, and plates—an

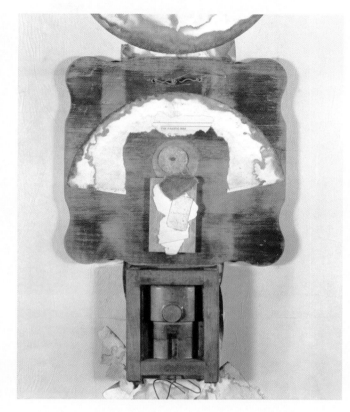

example of the latter is in the Sheldon collection—but deprived them of their usefulness by tearing, gouging, and piercing them in a gestural fashion that has affinities with Abstract Expressionism.

Around the time of Voulkos's arrival at Berkeley, Robert Arneson, then a conventional Bay Area potter, came under his influence and began experimenting with a more innovative approach to the clay medium. In 1961, while demonstrating pottery throwing at the California state fair, Arneson made a quart-sized bottle, sealed it with a clay bottle cap, and wrote on its body "No Deposit." Calling the piece *No Return*, Arneson humorously implied that the history of clay merely as a medium for mass-produced commercial wares was over. The series of playful, impudent, and occasionally shocking ceramic sculptures that followed helped to define the freewheeling and irreverent artistic sensibility known as Bay Area Funk.

ABOVE: GEORGE HERMS, *PACIFIC RIM*, 1985–86. UNL, F. M. HALL COLLECTION. COURTESY OF THE ARTIST.

A recurrent motif in Arneson's work is the brick, which, stamped with his surname (as in the Sheldon's *Brick Multiple*), is transformed into a work of art and becomes a satirical self-portrait of the artist as a worker in the same medium—baked clay—that is used to make this humble building material.

The ceramics program at the University of California–Davis, established by Arneson in 1962, produced a number of distinguished clay sculptors, David Gilhooly and Richard Shaw prominent among them. Arneson's studio assistant from 1963 to 1967, Gilhooly inherited his teacher's sense of humor and applies it to whimsical depictions of frogs and food—often incongruously combined, as in the Sheldon's *Frog Banana-Split Sundae*—fashioned of white earthenware and coated with garish commercial glazes. Shaw exploits porcelain's potential for trompe l'oeil illusionism, using mold casting, transfer printing, and decals to create astonishingly literal replicas of everyday objects. He then combines these elements, in assemblage fashion, into droll, sticklike figures such as the Sheldon's *Mrs. Partch*.

Offering a striking contrast to Shaw's delicate and illusionistic works in porcelain are the massive and powerfully abstract stoneware sculptures of Jun Kaneko. Born in Japan, Kaneko moved to Los Angeles in 1963, taught at several American colleges, and eventually settled in Omaha, Nebraska, where he fires his work in the enormous brick kiln of the Bemis Foundation. Kaneko is best known for his monolithic standing *dangos* (*dango* is Japanese for "dumpling"), which he produces in a variety of shapes and sizes, and whose surfaces he decorates with richly colored stripe patterns that both reinforce and play off against the contours of the form.

RECENT TRENDS IN ABSTRACTION

Kaneko's works participate in modernism's vital and ongoing commitment to abstraction, which rejects imitation of the natural world and seeks to create aesthetic value through purely artistic means such as line, shape, color, and texture, mass, volume, and space. Clement Greenberg, easily the most influential American art critic of the twentieth century, argued that abstraction was in fact an essential feature of modernism, which he defined as the increasing purification of each art form through the elimination of conventions not inherent to the medium itself. In the case of painting, those conventions included figuration, spatial illusionism, and narrative. A successful modernist painting, Greenberg held, should be purely "optical," appealing exclusively to the sense of sight through an emphasis on flat color. In the case of sculpture, Greenberg felt that the medium's traditional concentration on shaped mass and volume inevitably generated figurative connotations, even in a nonrepresentational piece. (Greenberg's point is demonstrated in a work such

ABOVE: ROBERT ARNESON, *BRICK MULTIPLE*, 1976. UNL, F. M. HALL COLLECTION. ART © ESTATE OF ROBERT ARNESON/LICENSED BY VAGA, NEW YORK.
OPPOSITE PAGE: DAVID GILHOOLY, *FROG BANANA-SPLIT SUNDAE*, 1983. UNL, F. M. HALL COLLECTION. COURTESY OF THE ARTIST.

as Kaneko's *Dango*, whose upright, monolithic form evokes a standing person.) Greenberg therefore argued that modernist sculpture should deemphasize mass and closed volumes and, like painting, strive for opticality, which he felt could best be achieved through welded, open-form construction of the kind practiced by David Smith and his English follower Anthony Caro.

Whether consciously responding to Greenberg's ideas or not, numerous American sculptors from the 1960s onward have used open-form construction as their primary artistic means, and the Sheldon's outdoor sculpture collection features several fine examples of such work. Leading figures in this tendency are Mark di Suvero and Charles Ginnever, two friends who in the late 1950s moved from San Francisco to New York, where each began to make huge, sprawling constructions out of cast-off materials such as wooden beams and pieces of steel. These thrusting, asymmetrical compositions extended into three dimensions the gestural energies of the Abstract Expressionist "Action Paintings" of Franz Kline and Willem de Kooning. Described by their creator as "painting in three dimensions with the crane as my paintbrush," di Suvero's later I-beam constructions, such as *Old Glory*, continue to evoke Abstract Expressionism.[8] Ginnever, meanwhile, has since the mid-1960s made many of his sculptures out of flat sheets of raw steel, which he cuts into rectilinear shapes and welds together into complex open configurations that, like the Sheldon's aptly titled *Shift*, change radically in appearance as the viewer moves around them.

More directly influenced by the examples of David Smith and Anthony Caro are the open-form welded constructions of California sculptor Michael Todd, such as *Daimaru XV*, which belongs to a series whose title is Japanese for "big circle." Like many of Smith's and Caro's pieces, Todd's light and airy sculpture is designed, like a picture, to be seen from the front—a quality that has earned for such works the label "pictorial."

Poles apart from the buoyant transparency of Todd's *Daimaru XV* is the heavy physicality of *Ouranos*, by the Anglo-American sculptor William Tucker, a former student and disciple of Caro's who in the early 1980s abruptly rejected his master's—and Greenberg's—ideal of open-form construction in favor of the older sculptural resources of palpably modeled clay and cast bronze, epitomized by the work of Rodin. Without

reverting to overt representation, Tucker also generated figurative connotations by creating in *Ouranos* a rudimentary composition that from different angles suggests a foot, fist, or torso—each of them in a not-yet-fully-formed state appropriate to the myth of genesis evoked by the work's title: *Ouranos* was a male creator god in ancient Greek mythology.

Bryan Hunt is another of the many contemporary sculptors who, like Tucker, have revived the traditional sculptural techniques of modeling and casting to create works that oscillate between the poles of abstraction and representation. Hunt is best known for his bronze waterfalls, such as the Sheldon's *Arch Falls*, which can be appreciated both as images of nature and as autonomous explorations of sculptural form. Working with liquid materials—plaster or plasticine and, subsequently, molten bronze—Hunt translates the amorphous and constantly changing subject of rushing water into highly textured masses of frozen metal, suspended in midair in defiance of gravity, and even, as in the case of the Sheldon piece, assuming the rough shape of an architectural motif.

Rejecting both the modeling and casting methods of Hunt and Tucker, on the one hand, and the welding techniques of Todd, Ginnever, and di Suvero, on the other, Richard Serra works with raw steel, hot-rolled into massive, curved, leaning walls, often set together, as in the Sheldon's *Greenpoint*. Usually classified as a Minimalist, Serra uses simple, impersonal forms that boldly declare their material presence and that refer to nothing outside themselves. Because of their great size, Serra's works also invite bodily participation. *Greenpoint*'s towering walls, for example, define a space meant not just to be seen but to be physically entered. Like many artists of his generation, Serra thus creates works of art that exist somewhere between sculpture and architecture.

Influenced by the stylistic economy of Minimalism but rejecting its impersonal industrial facture and blunt geometric forms, Martin Puryear (a onetime student of Serra's at Yale) emphasizes fine handcraftsmanship and spare, allusive shapes in his distinctive abstract sculptures, often fashioned out of wood. Puryear's expert craftsmanship is rooted in various craft traditions, especially African carving and Scandinavian woodworking, which he studied in the 1960s at their respective sources in Sierra Leone as a Peace Corps volunteer and in Stockholm as an art student.

Though fundamentally nonrepresentational, Puryear's works generate multiple associations, ranging from the organic world of plants, birds, and animals to the man-made realm of tools and machinery. The form of the Sheldon's *The Nightmare* was inspired by a calabash, a hard-shelled gourd used as a drinking vessel by South American Indian peoples, but the sculpture also resembles an outsize head or a giant grenade—a menacing association reinforced by its black-painted surface. As with all of Puryear's works, evidence of the process used to create the sculpture—constructed of thin strips of cedar laid over a ribbed wood armature and stapled together—is evident in its final form, investing the work with a deeply human quality at odds with the impersonality of Minimalism.

RECENT TRENDS IN FIGURATION

The oldest and most enduring of all artistic subjects, the human figure remained a viable sculptural motif even during the heyday of modernist abstraction and has gained increasing prominence in our own postmodern era. In postmodernism, the idea of artistic "progress" toward increasing formal purity, gospel to critics such as Clement Greenberg, has been abandoned and replaced by a much more inclusive attitude that recognizes representation as an equally valid resource for adventuresome artists, many of whom use the figure to explore a wide range of aesthetic problems and possibilities.

In sculpture, the stylistic range of contemporary figuration extends from the nearly abstract to the highly realistic. At the former end of the scale is the work of Joel Shapiro, who realizes extremely simplified human figures out of blocky wooden elements—sawed, glued together into active compositions, and cast into bronze. Like most of Shapiro's figures, the Sheldon's diminutive *Untitled* assumes an unstable, acrobatic pose whose playful quality seems appropriate to the childlike nature of its stick-figure facture. Equally simple in design and lighthearted in mood are the large-scale outdoor sculptures of William King, who uses, as in the Sheldon's *Story*, half-inch thick sheets of aluminum to create silhouetted figures engaged in everyday activities such as reading, playing tennis, or smoking.

In contrast to the cool, impersonal styles of Shapiro and King, the San Francisco Bay Area sculptor Manuel Neri works in a rough and spontaneous manner inspired by Abstract Expressionism.

Neri's central subject is the anonymous female nude, which he depicts in a variety of postures—standing, sitting, squatting—and often in a fragmented state that recalls the broken statues of antiquity as well as the partial figures of Rodin. Since the late 1950s Neri has worked in plaster—a simple, malleable medium that is easy to chisel and mold—and has painted large portions of his sculptures' white surfaces with bright, gesturally handled pigments. In the late 1970s Neri also began using the time-honored media of bronze and marble—the respective materials of his two works in the Sheldon, *Rosa Negra #1* and *Odalisque II*—media that attracted him because of his love of classical antiquity. As he does with his plasters, Neri paints his bronzes and also, occasionally, his marble works. Most of the marbles, however, which originate in the venerable quarries of Carrara, Italy, Neri leaves unpainted in order to preserve the "timeless beauty of the stone."[9] The sensuous appeal of *Odalisque II* owes as much to its opulent material—richly veined gray marble—as it does to its subject, the smooth and curvaceous torso of a reclining female nude.

Two other sculptures of nude female torsos in the Sheldon collection—one by the late George Segal, the other by Robert Graham—exemplify contemporary sculpture in a highly realistic style. Segal gained critical acclaim in the 1960s for the ghostlike figures he cast directly from friends and family members using plaster-soaked bandages; he then placed these figures in settings with real furniture and fixtures to suggest a frozen moment in everyday life. While Segal initially created these figures from plaster shells formed around the exterior of the model, in 1971 he began casting from the interior of the original plaster matrix, which allowed him to capture greater anatomical detail and a more lifelike surface. Segal fully exploited this new method in an extensive series of casts from the female nude, often presented, as in the Sheldon's *Nude Torso*, as a bodily fragment in the format of a bas-relief.

Eschewing Segal's technique of casting directly from living bodies, Robert Graham creates his figures through the most traditional and demanding methods of modeling in clay and casting in bronze. MOCA *Torso*, featuring the headless and limbless torso of a lithe female nude mounted on a textured, cylindrical base, is a characteristic example of Graham's sculpture, which renders the youthful and attractive female body in a fashion that is highly naturalistic yet classically refined, evocative of antiquity yet thoroughly contemporary.

In the 1980s the New York artist Judith Shea developed a unique variation on figurative sculpture in the form of a hollow, sleeveless dress in cast bronze that stands in for the absent woman who usually wears it. In what might be interpreted as a feminist response to the heterosexual male obsession with the female body—an obsession clearly expressed in the Sheldon's works by Graham, Segal, and Neri—Shea not only makes that body disappear but also replaces it with "metal clothing" that she considers a form of protection for the wearer. The artist explicitly describes the Sheldon's *Shield* as "female armor."[10]

THE OBJECT AS SUBJECT

While it evokes a figure, the actual subject of Shea's *Shield*—the sleeveless dress—is not a living being but an object. The object as sculptural subject has been a central interest of modernists from Picasso onward and remains important in today's practice. Many contemporary artists, such as Shea, re-create familiar objects out of unconventional materials, in a stylized form or on an unusual scale, thereby transforming them. Others, following in the tradition of Duchamp and the assemblagists, work with found or ready-made objects, which they combine in unexpected ways to produce new meanings.

A product of the former approach is Joseph Havel's *Silk Drape*, which renders the supple, suspended form of a large sheet in bronze, thereby transforming a soft and mutable material into a hard, permanent one. Although it looks like a simple translation of a hanging curtain into cast metal, *Silk Drape* was, like most of Havel's works, actually the product of considerable manipulation of the original, naturally falling fabric. The sculpture originated in an actual curtain (of heavy muslin, not silk) that Havel hung in his studio and recorded in numerous drawings and photographs. He then stiffened the curtain with wax and reshaped it to achieve an arrangement of folds and wrinkles that he considered suitable for recording in sculptural form. The waxed cloth was next cut into sections—each further manipulated subtly by the artist—which were cast in bronze and welded together to produce the final sculpture. "The results," says the artist, "are various stages of idealizations of the 'natural.'"[11]

Other sculptures that take objects as their subject are two important large-scale outdoor works in the Sheldon collection, *Prismatic Flake Geometric*, by Michael Heizer, and *Torn Notebook*, by Claes Oldenburg and Coosje van Bruggen. Ironically, Heizer is primarily known for his anti-object orientation of the politically turbulent late 1960s. During that period, he made site-specific, environmental artworks in the Nevada desert that protested against the concept of art as a portable luxury object. The most famous of these, *Double Negative* (1969–70), consists simply of two enormous cuts on either side of the top of a mesa. In the 1980s, however, Heizer, originally trained as a painter, returned to the creation of sculptural objects, many of them quite large; *Prismatic Flake Geometric*, for example, is thirty-six feet long and weighs about six tons. Itself a massive object, the sculpture is a streamlined rendition of another, much smaller object: a sharp-edged "prismatic flake" of obsidian that ancient Mesoamerican cultures used for making cutting tools. Though unfamiliar and mysterious to most of us, such objects are well known to Heizer, whose father was a renowned anthropologist and expert on ancient architecture and technology.

While Heizer's *Prismatic Flake Geometric* represents an obscure, though useful, object from an ancient civilization, Oldenburg and van Bruggen's *Torn Notebook* re-creates a familiar article from everyday modern life. The major sculptor of the Pop art movement, Oldenburg since the late 1960s has transformed common objects into whimsical, large-scale public monuments—an enterprise in which he was joined by his wife, van Bruggen, in the mid-1970s. For every one of their commissions, Oldenburg and van Bruggen seek to create a subject appropriate to the particular site. In the case of the Sheldon commission, they decided that a spiral notebook, a symbol of learning and a ubiquitous item on every university campus, was particularly apt. The subject also has personal significance for the artists, both of whom carry and use small notebooks when they visit potential sites. Cut into the pages of the Sheldon sculpture are notes, in Oldenburg's and van Bruggen's handwriting, recording their impressions of Lincoln and the Midwest. The Sheldon notebook is torn and its pages scattered because Oldenburg, after filling a notebook, rips

OPPOSITE PAGE: MANUEL NERI, *ODALISQUE II*, 1989. UNL, GIFT OF MR. AND MRS. GERALD D. KOHS. COURTESY OF THE ARTIST AND HACKETT-FREEDMAN GALLERY.

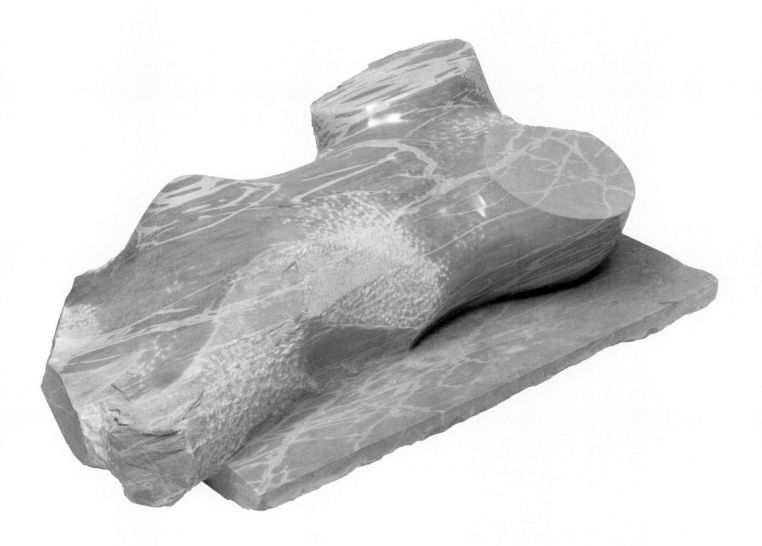

out the pages he wants to save, tears the notebook in half, and throws it away.

Oldenburg and van Bruggen's enlarged objects are recognized as art partly because of where they are placed—typically, on the grounds of a museum, in a public square, or, as in the case of *Torn Notebook*, in an outdoor sculpture collection. But no space has a greater power to confer artistic status on an object than does the museum gallery—a fact the sculptor Haim Steinbach took full advantage of with his works of the 1980s—including the Sheldon's *Untitled (Halco and Tour d'Argent salt and pepper shakers)*—that present a variety of manufactured items on sleek, custom-made shelves. Mimicking the display of merchandise in an upscale boutique or department store, Steinbach's provocative sculptures comment, among other things, on the status of art as a commodity in a capitalist society and on the consumerist mentality that fueled the art-collecting boom of the 1980s.

Childhood memories of a different kind of display—stuffed animals in glass cases—inspired David Ireland's *Box of Angels*. The "box" is a vitrine that Ireland obtained from the Field Museum of Natural History in Chicago, the city in which the Bay Area artist assembled and first displayed the work. The "angels" that fill the box were ordered from a Chicago manufacturer of cast garden statuary. Unlike scientific displays in a natural history museum, which present specimens in an orderly and legible fashion, Ireland jumbles and mixes his angels up with several other figures—Venuses, Atlases, Nikes, and an Eve—as well as with three purely decorative spheres. Originally intended to preserve what is valuable, Ireland's vitrine paradoxically looks more like a garbage bin, filled with dumped and discarded objects. Lost are the high religious ideals signified by the original marble statues of angels, gods, and goddesses, whose forms survive in our culture only in the debased form of kitschy, concrete garden decor.

CONCLUSION

A complex and dynamic artistic practice today, sculpture encompasses a wide variety of media and formats that often depart from the tradition of the static and permanent object, including body and performance art; light, video, and digital projection; and temporary mixed medium installations placed both inside and outside of traditional gallery and museum spaces. Alongside such explorations of new media and new technologies, however,

older ways of making sculpture continue to produce vital results, as the Sheldon collection amply demonstrates. Carved stone, the key medium of mid-nineteenth-century Neoclassicists such as Thomas Crawford, and fundamental to the practice of early modernists such as Constantin Brancusi, Robert Laurent, John Storrs, and Barbara Hepworth, remains a valuable resource for contemporary sculptors such as Manuel Neri. Modeled clay and cast bronze, the chief expressive means of late nineteenth-century Beaux-Arts sculptors such as Augustus Saint-Gaudens and Frederick Mac-Monnies, early modernists such as Elie Nadelman and Gaston Lachaise, and midcentury innovators such as Henry Moore and Marino Marini, continue to produce powerful work ranging in style from the elemental abstraction of William Tucker to the refined naturalism of Robert Graham. The tradition of assemblage incorporating found and manufactured objects and materials, inaugurated before World War I by Pablo Picasso and Marcel Duchamp and continued in later decades by such artists as Joseph Cornell, Bruce Conner, and Edward Kienholz, lives on in the work of David Ireland and countless others. Direct-metal sculpture, introduced by Picasso and Julio González and brought to maturity by midcentury artists such as David Smith, Seymour Lipton, and Eduardo Chillida, continues to produce impressive results in the hands of such artists as Mark di Suvero, Charles Ginnever, and Michael Todd. Finally, industrial fabrication, crucial to the realization of Tony Smith's sculptures as well as those of Minimalists such as Donald Judd and Carl Andre, remains central to the sculptural production of artists as varied in style and intention as Richard Serra, Michael Heizer, and Claes Oldenburg and Coosje van Bruggen. The continuing vitality of all these means of making sculpture, combined with current investigations into the sculptural possibilities of computer technology, robotics, ecology, and even biology, indicates a state of unprecedented and vigorous diversity in this field of artistic endeavor, whose enduring traditions and lasting accomplishments are so excellently exhibited in the collections of the Sheldon Memorial Art Gallery and Sculpture Garden.

DAVID CATEFORIS

NOTES

1. From an unidentified 1892 newspaper article in the files of the Musée
 Rodin, quoted in Albert E. Elsen, *Rodin* (New York: Museum of Mod-
 ern Art, 1963), 125.

2. Interview by Roger Devigne, in *L'ère nouvelle*, January 28, 1920,
 quoted in Eric Shanes, *Constantin Brancusi* (New York: Abbeville
 Press, 1989), 56.

3. Robert Hughes, *The Shock of the New*, rev. ed. (New York: Alfred A.
 Knopf, 1991), 310.

4. Quoted in Claude Marks, *World Artists 1950–1980* (New York: H. W.
 Wilson, 1984), 104.

5. Quoted in Marks, 529.

6. "Carl Andre: A New Structure," press release, Anthony d'Offay Gal-
 lery, London, January 28, 1981, quoted in Irving Sandler, *American
 Art of the 1960s* (New York: Harper & Row, 1988), 267.

7. Sol LeWitt, "Paragraphs on Conceptual Art," *Artforum* 5 (June 1967):
 80.

8. Quoted in Daniel Wheeler, *Art since Mid-Century: 1945 to the Present*
 (New York: Vendome Press, 1991), 217.

9. Quoted in *Contemporary Sculpture: The Figurative Tradition* (Wausau
 WI: Leigh Yawkey Woodson Art Museum, 1997), 9.

10. Judith Shea, conversation with the author, Kansas City, Missouri,
 October 23, 1999.

11. Quoted in Michael Auping, ed., *Modern Art Museum of Fort Worth
 110* (Fort Worth TX: Modern Art Museum of Fort Worth, in association
 with Third Millennium Publishing, 2002), 244.

THE SELECTED SCULPTURES

UNKNOWN ARTIST (American, nineteenth century)

- -

Shop-Sign Horse, nineteenth century

WOOD 27 ¹/₂ X 26 X 6 IN. NEBRASKA ART ASSOCIATION 1957.N-100

This little horse, by an unknown hand, is a prime link between the Sheldon's mainstream collection of sophisticated modern pieces and the time-honored tradition of craft-art. While it dates almost certainly from the nineteenth century, it reflects an activity extending back to American colonial times—to that portion of our folk art that was directed to the fabrication of utilitarian tools and utensils, carved shop signs, weather vanes, ship figure-heads, and the like.

Such objects, like our *Horse*, were commonly worked with a sensitivity to materials and to the plastic three-dimensional character of forms in space. Historically they served to keep alive a feeling for sculpture until such time as a school of professionals appeared.

Our *Horse* was probably a saddler's or harness maker's model. It is fashioned of segments of wood broadly but sensitively carved, carefully fitted together, and coated with gesso. Striking today in its plainness, it initially displayed a short tail of hemp rope and possibly was fitted with harness.

The compact body, erect pose, and clean profile suggest an awareness of Chinese example. Certainly a strand of influence from the Orient is possible given the fact that the art of the East came abundantly into the United States in the China trade of the eighteenth and nineteenth centuries. But stylistic pedigree remains ultimately elusive. Our steed is a type, generic and universal. As befits its commercial purpose, it is best seen broadside in front-plane view, prancing pertly, mouth open, nostrils distended. Withal it remains perfectly under control.

It has long been one of the popular favorites of our collection.

ROBERT SPENCE

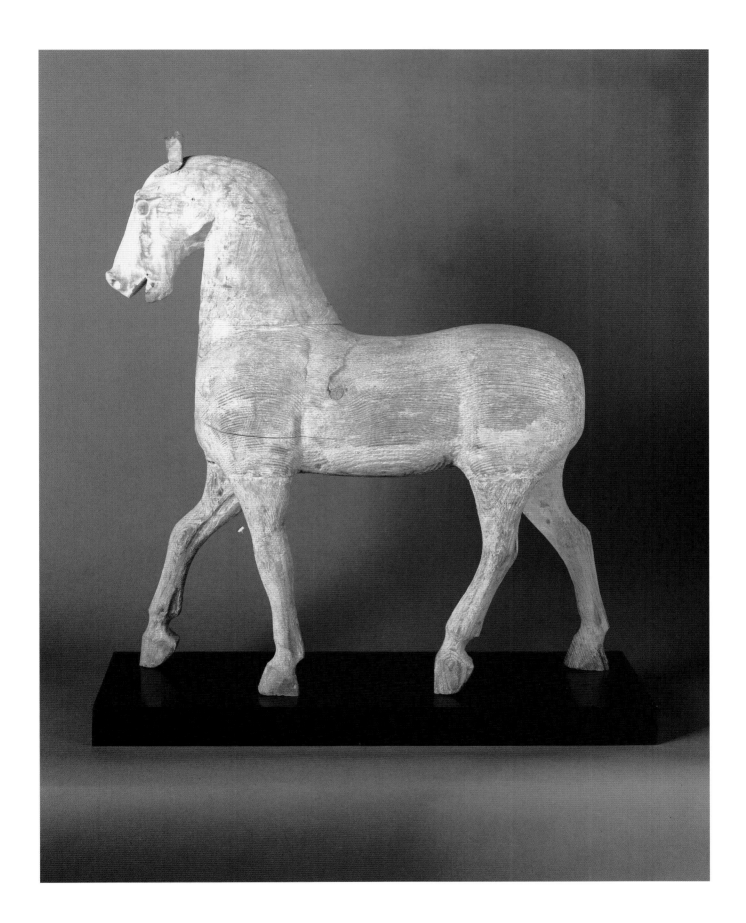

THOMAS CRAWFORD (1813–1857)

Truants (The Bird's Nest), 1856

MARBLE 49 ¹⁄₄ X 34 ¹⁄₄ X 22 ¹⁄₂ IN. NEBRASKA ART ASSOCIATION, GIFT OF MRS. CARL P. ROHMAN 1971.N-233

Thomas Crawford was the most Neoclassical of America's first generation of expatriate sculptors. Unlike his contemporaries Hiram Powers and Horatio Greenough in Florence, he settled in Rome, where sculpture was still dominated by the style of the great neoclassicists Antonio Canova and Bertel Thorvaldsen. Crawford's reputation as their American heir was sealed by the acclaim for his *Orpheus* (1839), for which he inserted that icon of neoclassicism, the Apollo Belvedere, into an emotional narrative. He similarly applied a classical vocabulary to such important public commissions as the allegorical *Armed Liberty* (1860) atop the Capitol building in Washington DC. *Truants,* however, came in the last decade of his career, when he embarked on the critically neglected but equally important (and more popular with private patrons) theme in his work: the American or "domestic" subject.[1]

Like most sculptors of his time, Crawford began as an artisan who carved objects such as marble mantelpieces, including one for the mansion of the wealthy banker and father of Louisa Ward, his future wife. The profession of sculptor, in which sculptors turned over much of the actual marble carving or manual labor to their assistants, promised artisans upward mobility socially as well as economically.[2] By age twenty-two, Crawford had left New York for Italy with a letter of introduction from his employer, Robert Launitz, to Thorvaldsen. Thorvaldsen represented a sterner, more severe neoclassicism than the graceful Canova, and Crawford absorbed his precepts through the master's critiques and assigned practice in modeling after antique sculpture. Before studying nature, the nineteenth-century artist had to train the eye, hand, and taste on the ideal; the forms, proportions, poses, and principles of classical statuary would guide the artist in selecting only the ideal or "best" from nature.

Crawford established his own studio in Rome in 1836 or 1837, when it was already common for sculptors to make inexpensive plaster casts of sculptures for exhibition. Rather than waiting for specific commissions, sculptors could operate like painters, inventing designs that would attract a private patron to pay for their translation into marble. It was just such a model of Orpheus that captivated the Massachusetts senator and abolitionist Charles Sumner, who subsequently promoted Crawford among Boston patrons and secured the marble *Orpheus* for the Boston Athenaeum for $2,500. Sumner was attracted to Crawford's work because it made classical literature (which Crawford himself read only in translation) legible and emotionally appealing rather than erudite, and also demonstrated American success in the most prestigious of styles. Throughout the 1840s, Crawford produced a sequence of works on similar classical, literary, and biblical subjects.

Though Crawford modeled children as early as 1839, it was in the classicized form of his *Genius of Autumn,* depicting a boy with a symbolic sheaf and sickle, a sculpture purchased promptly by New York patron John Paine. An 1843 *Genius of Mirth* (a boy dancing with cymbals), commissioned by the New Yorker Henry Hicks, and a number of other religious or classical infant subjects also sold quickly.[3] But it was not until the 1850s (by which time he had his own four children) that Crawford began to produce "modern" children, as in *Truants,* subjects that continued to sell well in the New York market. His 1850 visit to the United States may have influenced him; his 1853 proposal for the Washington Capitol's pediment, for example, included, in addition to allegorical figures, more recognizably "American" ones such as a white pioneer, an Indian family next to a grave, a merchant, a mechanic, and schoolboys at their studies.

The earliest references to *Truants* are in published letters from visitors to Rome, where sculptors' studios were required stops on the Grand Tour of art in Italy. One letter published in a newspaper describes part of the statue's appeal:

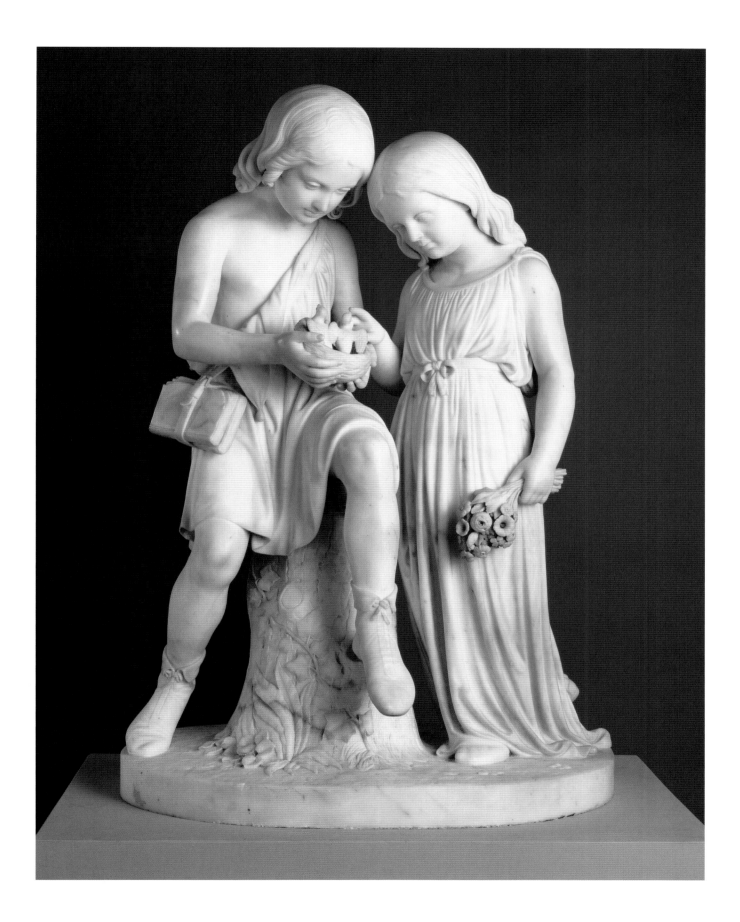

This is one of those tender and graceful compositions, which in contrast with the immense monument, show the prolific and versatile genius of the artist.

Two children, a boy with his books, and a girl with her gathered wild flowers, are the truants. In their rambles, they have found a bird's nest, which the boy is holding, while he and the girl are cautiously peering into the treasure. The look of childlike wonder and curiosity on the countenance of the children is very truthful and sweet. In this composition there is the same delicate poetical thought that characterizes the artist's Children in the Woods.[4]

Children in the Woods, of 1850, was the most famous of Crawford's "infantile" subjects. It was based on a well-known ballad about the deaths of two children observed only by a maternal robin, and was designed to arouse extreme pity in the viewer. Albeit in a different mood, it shares with *Truants* both a degree of familiarity—the latter's subject is readily legible through details like the children's book bag—and an attention to elaborate surface decoration, with incised and carved leaves, ferns, and vines all over the base.

The truants wear classicized garb rather than contemporary dress, but this did not deter viewers from seeing them as modern American children. One writer described Crawford's *Boy Playing Marbles* (1853), in which the child is nude, as "so entirely natural and boyish, that you can almost hear the marbles rattle in his pocket, and the chuckle that follows the well-directed snap."[5] Since the boy had no pockets, it was the child's freedom from constraint that led viewers and patrons to identify him as "dressed" in modern style. A great number of genre painters and sculptors joined Crawford in depicting loosely garbed children at play, and truants in particular, including Lilly Martin Spencer (*Young Students*, 1858), William Sydney Mount (*Truant Gamblers*, 1836), David Blythe (*Boys Playing Marbles*, 1858), and Randolph Rogers (*Truants*, 1854).

While Blythe's street urchins suggested the criminal potential lurking in unsupervised activities, most artists reassured viewers that children's nature and play, even in the absence of authority or the external imposition of controls, predicted their future adoption of ideal gender roles and professions. Thus in *Truants* Crawford's older boy and younger girl study the message in nature of birds building a nest: the boy holds the nest up, but the girl leans forward to touch a baby beak. Such idealized sculptures promised in turn to train children's tastes, as a Crawford eulogist noted: "Little Billy can be trained to delight more in bringing flowers, mosses, leaves, berries and shells from his rambles than in robbing birds' nests, and he and his companions, girls as well as boys, can grow up with a well-spring of original life . . . [that will] in time interpret itself in gardens, halls, pictures, statues, music and all gentle arts."[6]

Crawford's *Truants* originally decorated the Stephen van Rensselaer family home in Albany, New York, until around 1915, when it was bought by Bayard Thayer for his Beacon Hill mansion in Boston. Thomas Kershaw purchased the Boston house, including the statue, in 1970 for a restaurant, and in 1971 the Nebraska Art Association brought *Truants* to Nebraska.

WENDY J. KATZ

NOTES

1. Lauretta Dimmick, "A Catalogue of the Portrait Busts and Ideal Works of Thomas Crawford" (PhD diss., University of Pittsburgh), 1986.

2. On sculptors' careers, see Joy Kasson, *Marble Queens and Captives* (New Haven: Yale University Press, 1990), 5–12.

3. Sylvia Crane, *White Silence: Greenough, Powers and Crawford* (Coral Gables: University of Miami Press, 1972), 312–14.

4. Unidentified newspaper clipping quoted in Dimmick, 701.

5. *Boston Evening Transcript*, quoted in Dimmick, 303.

6. Samuel Osgood, *Thomas Crawford and Art in America: Address before the New York Historical Society, Upon the Reception of Crawford's Statue of the Indian* (New York: John F. Trow & Son, 1875), 25–26.

JOHN QUINCY ADAMS WARD (1830–1910)

The Indian Hunter, 1860

BRONZE 16 X 8 ³/₄ X 15 IN. UNIVERSITY OF NEBRASKA, F. M. HALL COLLECTION 1970.H-1543

John Quincy Adams Ward's *Indian Hunter* established him as a sculptor of American subjects whose combination of realism and vigorous outdoors masculinity in bronze stood in opposition to the marble female nudes of his peers in Italy, who worked in a neoclassical style Ward feared drew "a sculptor's manhood out of him."[1] Indeed, *The Indian Hunter* helped Ward's reputation survive the changes introduced to sculpture after the Civil War by French naturalism. As Augustus Saint-Gaudens, the American leader of that school, said, "His work and career, his virility and sincerity, have been a great incentive to me, from the day when he exhibited his *Indian Hunter* in an art store on the east side of Broadway."[2]

Ward was born in Urbana, Ohio, a town founded by his Virginian grandfather. Antebellum Ohio had nurtured Hiram Powers, Edward Brackett, and Ward's future teacher Henry Kirke Brown, among a host of other sculptors, and it was in Cincinnati that Ward first saw an "ideal" (nonportrait) sculpture, Powers's controversial nude *Greek Slave* (1847). In 1849 Ward's sister showed Brown a statuette by Ward of an old Irish workman "with patches in his trousers," which impressed Brown enough that he invited Ward to create something for him. Instead of another distinctively American "type," this time Ward chose the Medici Venus—the classical prototype for Powers's *Greek Slave*—which convinced Brown to take Ward as a pupil in his Brooklyn studio (1849–56).[3] Ward was clearly going to be able to combine the idealized poses and proportions of antique sculpture with American subject matter, thereby creating what Brown saw as a truly American school of art.

Brown himself did American Indian subjects. In 1849 the American Art Union, which encouraged artists to produce national subjects appealing to a wider market, distributed twenty bronze statuettes of Brown's *Indian Hunter* (*Indian and Panther*).[4] Despite his 1848 trip to the Great Lakes to study American Indians for the statues, the resulting statue was a version of a classical nude,

the Apollo Belvedere. The *New York Home Journal* called Brown's *Indian Hunter* indecent. The "laws of Art" permitted representations of nude women (as in the *Greek Slave*) with no offense to modesty, but since men are less modestly constructed, nudity is improper for them. Perhaps more significant than this discomfort with men as erotic objects was the *Home Journal* writer's concern for color: the cold whiteness of marble suggested a "purity" that excused the nudity of Apollo, but Brown's bronze was too near the color of skin and so did not "modify the complete disgust with which its undisguised nakedness must be looked upon."[5] The neoclassical claim to represent a universal ideal, abstracted from nature into marble, seemed instead to enforce racial difference. Only whites could represent the ideal in art, while other races could merely be vulgar nature.

Ward learned from Brown's experience. He moved to Washington DC in 1858, perhaps hoping to win commissions for the Capitol. In 1855 Brown had proposed a design for the Senate pediment showing a brave white hunter and an American Indian trapper and dog, with the latter expressing the "stillness and wariness peculiar to his race."[6] In 1859 Ward exhibited his own *Indian Hunter* at the Washington Art Association and the Pennsylvania Academy of the Fine Arts, where it was paired with *Simon Kenton,* the depiction of an early Ohio pioneer. Both plasters were probably modeled in 1857. He gave Apollo's contrapposto pose to the white Kenton, who stands upright and at ease in buckskins, with his dog gazing admiringly at his master, while for the American Indian, Ward turned to the Borghese Gladiator, a classical figure frozen in violent action. Ward's *Indian Hunter* crouches—the art magazine *The Crayon,* in advocating representations of American Indian character, preferred them crawling—with his hand resting on but not constraining his dog, who duplicates his master's pose down to the arrangement of limbs.[7] The dog is snarling, while the turned heads and gazes of both man and dog focus on distant prey. Rather than associating the man with Apollo's grace, Ward emphasized the

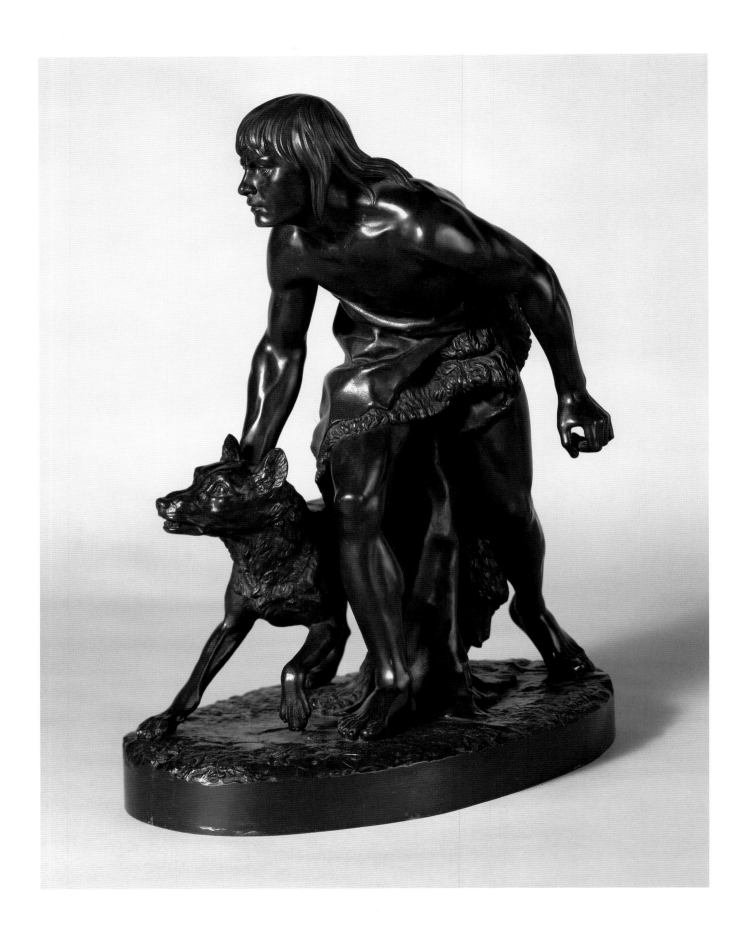

physical and animal. Concerns about nudity were solved by a massive and weighty, if not particularly realistic, fur wrapped around the hunter's waist and trailing around his legs.

While the *Simon Kenton* found some interest in Columbus, Ohio, where the notion of civilized backwoodsmen held appeal, *The Indian Hunter* had a warm reception in New York. *The Crayon* praised Ward's plaster statuette as "complete and masterly" in its rendering of American Indian character, and a bronze version at the National Academy of Design in 1862 helped Ward get elected an associate.[8] Thus encouraged, Ward planned to enlarge the statue, but like Brown, he first traveled to the Dakotas to observe American Indian physiognomy in person. Although he brought back wax portrait studies, the large plaster of 1865 differed only slightly from the original version. Ward strengthened the aboriginal rather than classical cast of the face; supplied coarser, more tousled locks in place of the smooth, beaded hair of the original; raised the bow arm (breaking the absolute symmetry with the dog); showed the other hand now gripping the dog's fur in restraint; and replaced the columnar robe with a bulky loincloth. The plaster was exhibited in Mr. Snednicor's Picture Frame Store on Broadway, and twenty-three private subscribers contributed $10,000 to have it cast in bronze. After the bronze statue toured Paris, the subscribers officially presented it to the City of New York for unveiling in Central Park in 1868, the first work by an American sculptor to be erected there. With the statue safely placed in a natural setting, the kind of fears aroused by the "realism" of Brown's bronze statue were neutralized. A steady stream of commissions for bronze portrait statues of male heroes and statesmen followed the acclaim for *The Indian Hunter* and consumed the rest of Ward's career.

The Sheldon statue is one of at least fifteen bronzes Ward cast on demand from a pin model (now at the American Academy of Arts and Letters in New York City) of the statuette he exhibited in 1859 and which he kept in his possession. The Sheldon's bronze is missing the bow, although the fingers of the hunter's hand are curled as if holding one. Since bronzes were cast in separate pieces, the bow may have been left out during casting. At least four different foundries issued bronze statuettes of *The Indian Hunter* during Ward's lifetime.[9]

Although Ward continued to keep Indian weapons, pipes, and relics in his studio, he did not return to American Indian subjects. However, his *Freedman* (1863) was similarly praised for its fidelity to physiognomic character in showing an African American man "true to his type."[10] During a period when white portraits were still classicized, Ward's representations of American Indians and African Americans were less idealized and so helped buttress his reputation as a realist. In 1872 Ward visited Europe, where he acquired some of the French manner of texturing bronze surfaces. In 1874 he was elected president of the National Academy, and in 1876 he gave a commission for the *Admiral Farragut* monument to Augustus Saint-Gaudens, passing the torch to a new generation of sculptors who would assign the classical ideal to nude women, individualized portraits to clothed white men, and naturalistic stereotypes to American Indians and African Americans.

WENDY J. KATZ

--

NOTES

1. Quoted in Wayne Craven, *Sculpture in America* (Newark: University of Delaware Press, 1984), 249.

2. Quoted in Lewis Sharp, *John Quincy Adams Ward: Dean of American Sculpture* (Newark: University of Delaware Press, 1985), 47.

3. Sharp, 29–30.

4. Michael Shapiro, *Bronze Casting and American Sculpture, 1850–1900* (Newark: University of Delaware Press, 1985), 45–46.

5. "Nudity in Art," *New York Home Journal* 2 (January 5, 1850): 1–2.

6. Brown quoted in Craven, 154.

7. *The Crayon*, excerpted in Sharp, 146.

8. *The Crayon*, excerpted in Sharp, 147.

9. Shapiro, 63–65; Sharp, 147.

10. James Jackson Jarves, quoted in Sharp, 43.

FREDERICK WILLIAM MacMONNIES (1863–1937)

Diana, 1889 (cast 1890)

BRONZE 30 7/8 X 20 1/2 X 17 IN. UNIVERSITY OF NEBRASKA, HOWARD S. WILSON MEMORIAL COLLECTION 1966.U-508

In 1889 Frederick MacMonnies selected the goddess Diana as the subject for his first ideal (nonportrait) sculpture submitted to the French Salon, the arbiter of artistic reputations and future sales. In doing so, he declared his allegiance to the Ecole des Beaux-Arts's reform of sculpture—along with his peers and friends Olin Warner, whose *Diana* (1883) adorned the cover of sculptor Lorado Taft's canonical *American Sculpture* (1903), and Augustus Saint-Gaudens, whose *Diana* (1892) stood atop architect Stanford White's Madison Square Garden in New York. The chaste huntress offered all three artists a chance to display their modernity by treating a classical subject naturalistically while also portraying a nude whose character did not offend American codes of decorum.

By the time he modeled Diana, MacMonnies had had almost ten years of art education and training. Born in New York to a family that traced its lineage to the acclaimed eighteenth-century painter Benjamin West, MacMonnies was hired by Saint-Gaudens in 1880 as an unpaid studio helper, while he also took classes at the National Academy of Design, Cooper Union, and the Art Students League. Saint-Gaudens was committed to the Beaux-Arts principle of unifying the arts, particularly sculpture and architecture, in order to create a great modern public art equal to that of Renaissance Italy or classical antiquity. At Saint-Gaudens's studio, MacMonnies met the men who controlled both the decoration of the mansions of the rich and the commissions for public art in the last quarter of the century: Stanford White (his future collaborator on the *Nathan Hale* [1890] and *James Stranahan* [1891] statues in New York), White's partner Charles McKim, George Post and John La Farge (designer and decorator, respectively, of Cornelius Vanderbilt II's mansion), and other members of an elite group of architects, painters, sculptors, and patrons.[1]

MacMonnies left New York in 1884 to study in Paris with Saint-Gaudens's former instructor Alexandre Falguière, a Neo-Greek whose genre sculptures, though set in antiquity, featured a heightened degree of realism. In Paris's private academies and ateliers, MacMonnies joined a circle of upper-class Anglo-American expatriates who enjoyed the bohemian life offered male art students. He also met his future wife, the painter Mary Fairchild, herself a successful exhibitor in the Salon.

He began work in 1888 on an ideal sculpture for the Salon. *Diana* originally showed the goddess maternally cradling a wounded deer in her arms, a pose Falguière rejected as not in the cruel huntress's character.[2] In an often repeated anecdote, Falguière is supposed to have dropped by the studio to critique MacMonnies's work, and became so enthusiastic that he remodeled MacMonnies's clay model of *Diana* into the form of his own 1887 statue of the goddess. MacMonnies promptly reshaped it, but the story indicates his debt to his teacher, whose *Hunting Nymph* (1884) similarly shows a running woman balanced on one leg. Where Falguière's women are earthy and strong, seen powerfully striding forward, MacMonnies's *Diana* is slender, less energetic, and more restrained in pose.[3]

Marie Caira, from a family of professional models, posed for *Diana* when she was in her mid-teens, when she possessed the svelte proportions desired by Beaux-Arts sculptors.[4] In reminiscences, sculptors emphasized the idealization required to produce their art, since most models were "peasants with poor figures whose large hips had been accentuated by tight corsets . . . dirty and smelly and their ugly feet were so distorted from wearing small shoes that the artists often had to use Greek casts." For that reason, MacMonnies preferred the topless dancers at the Moulin Rouge, who also attended the artists' Beaux-Arts balls "dressed" as the nude characters for whom they posed in the studio.[5]

Diana won an honorable mention in the Salon of 1889, still a rare honor for an American. At home, MacMonnies's success in mastering French naturalism was recognized by his friend Jimmy

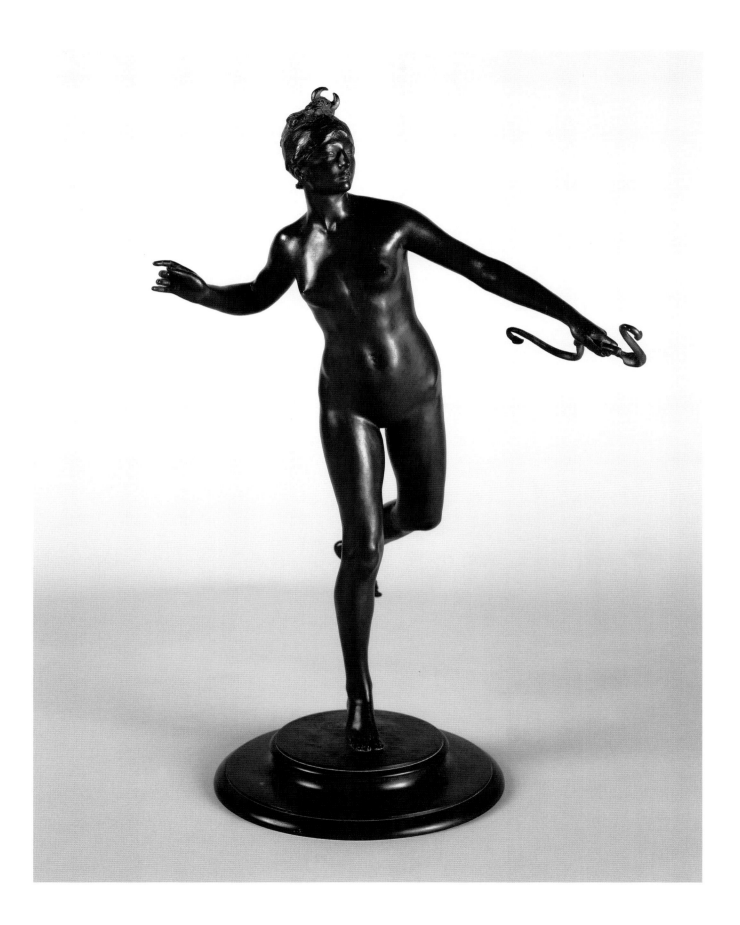

Finn: "It struck me as spontaneous . . . as though you woke up in the middle of the night, or dropped from the moon, saw the fleeting vision, seized, and had a plaster cast made of it on the spot!" Saint-Gaudens instead saw his skill at aestheticizing the nude: "It is extremely elegant & has unusual grace. You have 'achieved style' in it."[6]

Though MacMonnies did numerous public art commissions, *Diana* was part of a profitable if less prestigious sideline in small bronzes for private buyers. Unlike the majority of public monuments, which were devoted to either male heroes or female allegories, such bronzes usually depicted less didactic subjects. Women were especially suitable, since domestic interiors were considered a metaphor for inner ideas, and both inner feeling and the home were feminine realms, marked by symbols of love (Venus), beauty (Diana), and grace (the dance).[7]

In 1890 MacMonnies decided to make some "parlor bronzes" and turned to *Diana* and an adolescent piping *Pan* (1889–90) as most likely to sell. Professional plasterers prepared casts from his clay models for the bronze foundry. After a set of his reductions, including *Diana*, won gold medals on a tour of the United States in 1895, MacMonnies charged between $2,000 and $5,000 for them; they may have cost $30 to $60 to cast.[8] Theodore Starr's 5th Avenue jewelry store and Tiffany's sold his bronzes on consignment, and MacMonnies personally sold small *Diana*s to important patrons like the connoisseur Sara Hallowell, a French collector (his first sale in France), and Edward Adams, whom Stanford White had introduced to MacMonnies. The base of White's statue, now owned by the Sheldon, is inscribed "To Stanford White, from E.D.A.," and photographs of the Italian Renaissance–style drawing room of White's New York mansion show it paired with Saint-Gaudens's *Diana*, a bronze reduction of which is also owned by the Sheldon.[9]

MacMonnies lived all his life in France and occasionally misjudged American public taste. The best-known incident involves the *Bacchante and Infant Faun* (1894), which MacMonnies offered to his benefactor Charles McKim for a memorial to McKim's wife in the courtyard of the Boston Public Library. Without a moralizing narrative to justify the nudity, the sculpture caused a scandal. Even *Diana* fell under suspicion. William Partridge, a fellow Beaux-Arts sculptor, wrote an 1892 essay, "An

American School of Sculpture," in which he argued that good art can only be produced from a healthy moral society. Accordingly, "a modern Frenchman, with his distorted ideas of life and abnormal moral conceptions, could no more produce a statue like the Venus of Melos, than could Phidias, living in the calm, normal, refined atmosphere of Hellas, have produced a figure like a Diana of the French Salon."[10] For Partridge, as for many conservatives, even the stylized realism of MacMonnies promised the degradation of art; or rather, without idealization, the danger was that nature itself would emerge in the sexually suspect, working-class presence of the artist's model. Partridge praised Saint-Gaudens and Warner, but not the unchaste *Diana*s of Falguière and MacMonnies. In reproof he held up to them the entirely "Anglo Saxon" figure of Daniel Chester French's heavily draped female *Death*, who kills a sculptor in the Milmore Memorial (1891). Indeed, the stranglehold of the ideal on American sculpture meant that until the 1920s almost no realism, never mind modernism, touched its goddesses.

WENDY J. KATZ

--

NOTES

1. Mary Smart, *A Flight with Fame: The Life and Art of Frederick MacMonnies* (Madison CT: Sound View Press, 1996), 22–25.

2. Smart, 74.

3. H. H. Greer credits the Falguière anecdote to Frederick Ober, "Frederick MacMonnies, Sculptor," *Brush and Pencil* 10 (1902): 1–15; see also Lorado Taft, *History of American Sculpture* (New York: Macmillan, 1930), 336; and Smart, 74.

4. Smart, 77.

5. Sara Dodge Kimbrough, *Drawn from Life* (Jackson: University Press of Mississippi, 1976), 29–30. The sculptor Bessie Potter Vonnoh, also acclaimed for her spontaneous technique, similarly commented in 1893 that "you have to idealize your model a great deal. . . . The Chicago models are not choice specimens of the race." Quoted in Julie Aronson, "Bessie Potter Vonnoh (1872–1955) and Small Bronze Sculpture in America" (PhD diss., University of Delaware, 1995), 49.

6. Finn and Saint-Gaudens quoted in Smart, 79.

7. Marlene Park, "Sculpture Has Never Been Thought a Medium Particularly Feminine," in Ilene Susan Fort, *The Figure in American Sculpture: A Question of Modernity* (Los Angeles: Los Angeles County Museum of Art, 1995), 59–60.

8. Nor did he limit the number of reproductions made or number editions. Janis Conner and Joel Rosenkranz, *Rediscoveries in American Sculpture* (Austin: University of Texas Press, 1989), 128. For costs, see John Dryfhout, "Augustus Saint-Gaudens," in *Metamorphoses in Nineteenth-Century Sculpture*, ed. Jeanne Wasserman (Cambridge MA: Harvard University Press, 1976), 186.

9. Smart, 98–99.

10. William Partridge, *Art for America* (Boston: Roberts Brothers, 1895), 35–36.

AUGUSTE RODIN (1840–1917)

--

Portrait of Charles Baudelaire, 1892

BRONZE 15 X 7 ½ X 8 IN. UNIVERSITY OF NEBRASKA, F. M. HALL COLLECTION 1955.H-394

"That . . . complex physiognomy of Baudelaire's has me literally riveted; it's as attractive as a problem and painful as reality."[1] So explained Auguste Rodin in 1892 of his interest in producing a sculptural depiction of the deceased French poet. Originally commissioned to produce a funerary sculpture for Baudelaire's grave in the Montparnasse Cemetery, Rodin chose to focus on Baudelaire's head as an appropriate summary or encapsulation of the poet. The artist remarked: "I cannot see a statue of Baudelaire. What is a statue after all; a body, arms, legs, covered with banal clothing. What do these have to do with Baudelaire, who lived only by his brain? With him the head is everything."[2] The result, *Portrait of Charles Baudelaire,* is a captivating bronze sculpture that not only provides the viewer with an insight into the poet but also displays the artistic contributions that account for Rodin's position as one of the most influential of modern sculptors. In his statement, Rodin refers to both complexity and reality, two aspects that set his sculpture apart from much of what was being produced in the late nineteenth and early twentieth centuries.

Late nineteenth-century sculpture was dominated by large-scale, public sculpture, which, because of its function, tended to be monumental, idealistic, and heroic. Rodin chose instead to inject his sculptures with a strong degree of realism. This very direct view was no doubt influenced by the development of French Realism in the mid-nineteenth century, as exemplified by the work of Gustave Courbet and Edouard Manet. Rodin's art thus projects a more intimate, personal, and engaging quality than the prevalent heroic public sculpture.

Rodin's attempt to impart a more realistic sensibility to his sculptures involved an acknowledgment of the complexity of the objects and forms that he was representing. This acknowledgment manifested itself in the rough, active surfaces that are the hallmark of his art. Rodin was extremely sensitive to the qualities of the materials he worked with and as a result was able to produce works that engage the eye and mind of the spectator. He was also acutely aware of the effect that light and shadow have on the viewer's eye—how a heavily textured surface causes the viewer's eye to remain on the sculpture and scrutinize the sculpture all the more. Accordingly, as evident in *Portrait of Charles Baudelaire,* his sculptures have rough, often agitated surfaces.

Although Rodin utilized an artist, Louis Malteste, as the model for this sculpture, and although he completed only a plaster cast (which was cast in bronze years later by the Musée Rodin), *Portrait of Charles Baudelaire* is a wonderful example of Rodin's unique ability to present compelling physical and psychological profiles of his subjects.

CHRISTIN J. MAMIYA

--

NOTES

1. Quoted in Frederic V. Grunfeld, *Rodin: A Biography* (New York: Henry Holt, 1987), 329.

2. Quoted in Albert Elsen, *Rodin* (New York: Museum of Modern Art, 1963), 125.

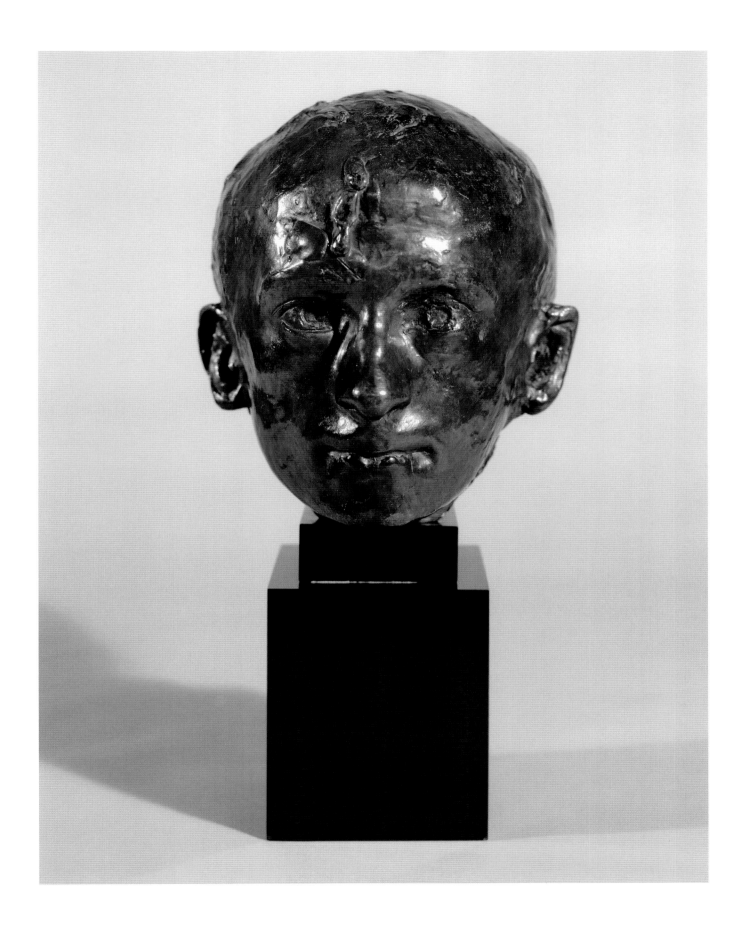

MEDARDO ROSSO (1858–1928)

Bambino Ebreo (Jewish Boy), c. 1892–93

WAX OVER PLASTER CORE 9 X 5 X 7 IN. UNIVERSITY OF NEBRASKA, F. M. HALL COLLECTION 1959.H-586

In the work of Medardo Rosso we have the perfect embodiment of the concept of Impressionism in sculpture. Whereas in Impressionist painting the visible world is dissolved in light and the phenomena of momentary change, in the sculpture of Medardo Rosso the three-dimensional world of human beings and their activity is seen in the glimpse of a moment—an impression, a memory.

The *Jewish Boy* is dedicated to Eli Giordano, the daughter of Rosso's friend Umberto Giordano, the composer of the opera *Andrea Chenier*. The form of the child's head is incomplete, seen in a three-quarter view from the front. Such simplification was part of the creative vocabulary of the time. There are comparable early works by Brancusi in which the form is complete in its three dimensions, and for him this reduction to the simplest abstract equivalent was important. For Rosso a single aspect of that form was sufficient to imply and contain the whole. Over a roughly mounded base of plaster was laid a perilously thin layer of wax, allowing for only the most delicate modeling of the surface, only the suggestion of facial features.

This deliberately partial view of the subject, whether in a portrait or in a composition with figures, is pervasive in Rosso's work. It is as though the observer, the artist, is moving among these people with only the most casual attention to their identity or activity. The figures merge with the ground on which they stand or with the space around them. Frequently the plaster image with its skin of wax becomes an expressionist abstraction.

Rosso's spontaneity was, in itself, considerably in advance of contemporary practice, and he claimed that the stance of Rodin's *Balzac* was derived from the precedence of his figures, boldly angled into their surrounding space.

However abstract, the sculptures of Rosso are not devoid of feeling. There is an intimacy, an intensity of human presence that motivates their activity and expression. They inhabit a world of transient reality that is rare, if not unique, in the history of sculpture. The *Jewish Boy* appears and disappears before our eyes. He is a vision remembered.

NORMAN A. GESKE

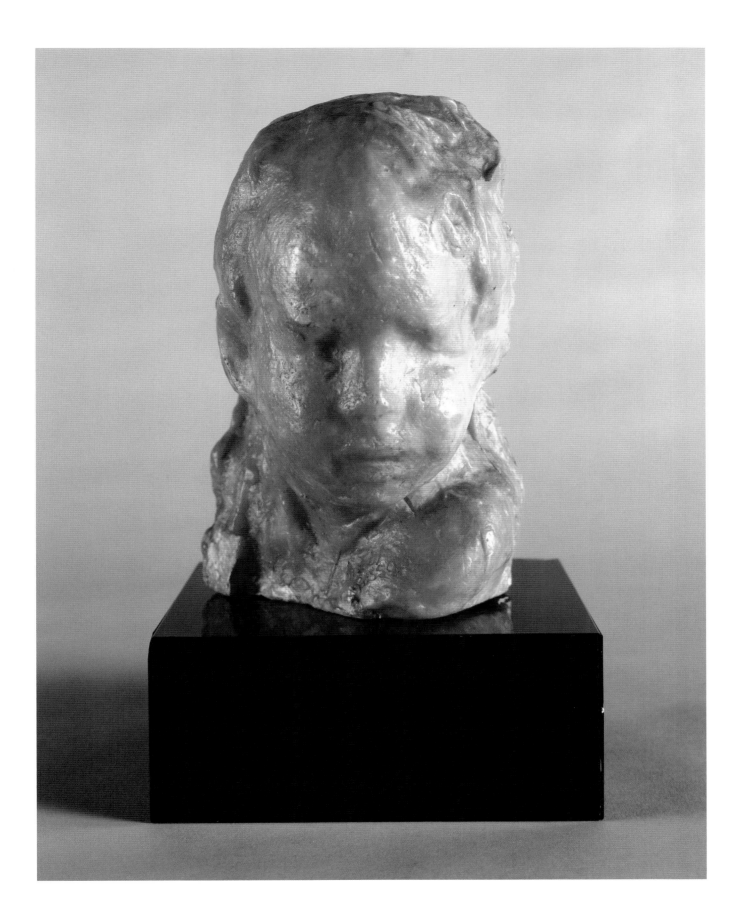

BESSIE POTTER VONNOH (1872–1955)

--

Girl Dancing (Minuet) 1897

BRONZE EDITION 4/45 14 ³/₈ X 12 X 8 ¹/₄ IN. UNIVERSITY OF NEBRASKA, F. M. HALL COLLECTION 1928.H-2925

Girl Dancing epitomizes a number of late nineteenth-century trends: the dominance of genteel social circles, the promotion of sculpture for private rather than public consumption, and the rise of a new generation of successful women sculptors who were nevertheless required to work in what was considered a "feminine" style.

Girl Dancing was important to Bessie Potter Vonnoh's career and reputation. Hailing from St. Louis when it was still a disadvantage to be a westerner among the tight-knit East Coast coterie of sculptors, she studied at the Art Institute in Chicago, where women overwhelmingly outnumbered men and were permitted to study the nude, which was essential for success as a professional sculptor. More than his New York peers, her teacher Lorado Taft supported women as sculptors and obtained work for his students on prestigious large-scale allegorical groups at the 1893 Columbian Exposition in Chicago.

In the year after the fair, with no such public commissions forthcoming, Potter launched her career with a series of colored plaster statuettes of society women in contemporary dress. These were intimate (14–18 inches high) portraits of women, many of whom were active in women's clubs, women's suffrage, and art collecting. Exhibited in Chicago, Philadelphia, and New York, Vonnoh's style was seen as both delicate and, in keeping with the casual poses of the sitters, similar to a photograph. Critics accordingly praised her as both modern and, in her construction of a more lively ideal of femininity, American.[1] The Impressionist painter Theodore Robinson (Potter's husband, Robert Vonnoh, whom she married in 1899, was also an Impressionist) purchased one, and realist writers such as Hamlin Garland and William Dean Howells admired them for what Vonnoh called "the joy and swing of modern American life."[2] Her "Potterines" were relatively inexpensive (beginning at $25), and by 1898 she had done more than a hundred of them, demonstrating that there was both a private market and critical support for small-scale sculptures of elegant, modern women.

Girl Dancing belongs to a group of ideal (nonportrait) sculptures she embarked on in 1896–97, including *Young Mother* (1896) and *Girl Reading* (1897). All three subjects were popular; the Impressionist Mary Cassatt is particularly known for her images of women and children and women reading, but academic artists like George de Forest Brush and Edmund Tarbell took up historicized versions of the same motifs. In her sculptures, Vonnoh also switched from the elaborate detail of women's contemporary fashions to a dressing gown in *Young Mother* and a Federal-style dress in *Girl Dancing*, while retaining the fashionable proportions of modern upper-class women.

Girl Dancing depicts neither a professional performer nor a nymph, but a young woman in costume, curtsying in an old-fashioned court dance—the minuet or cotillion—which was revived in the late nineteenth century because its connotations of formality and grace stood in opposition to the taste for modern sports like football with their tendency toward "coarseness and brutality."[3] Vonnoh depicts the opening "courtesy" in which a lady, facing her partner, slides her right foot toward the center of the set and curtsies with her left hand behind. The sculpture proposes a male partner outside itself, and Vonnoh designed the statue so that a graceful view is available from every viewpoint: the spread of the skirt, the bow of the figure, the length of the arm. Even the polished base suggests a gleaming dance floor.

The modeling and variety of the surfaces of the sculpture, from nearly brittle flakes to deeper depressions, demonstrate Vonnoh's study of contemporary French sculpture, especially that of Auguste Rodin, from whom she learned to leave tool markings on the surface that translate not into details or textures of fabric so much as pools of light and shadow suggesting an "active" or changeable surface. Bronze was the favored material since midcentury for preserving the artist's touch, but in *Girl Dancing* Vonnoh turned to the newly popular lost-wax technique, which preserved more exactly deep undercutting and surface details of the artist's original model. As a result, the use of lost wax,

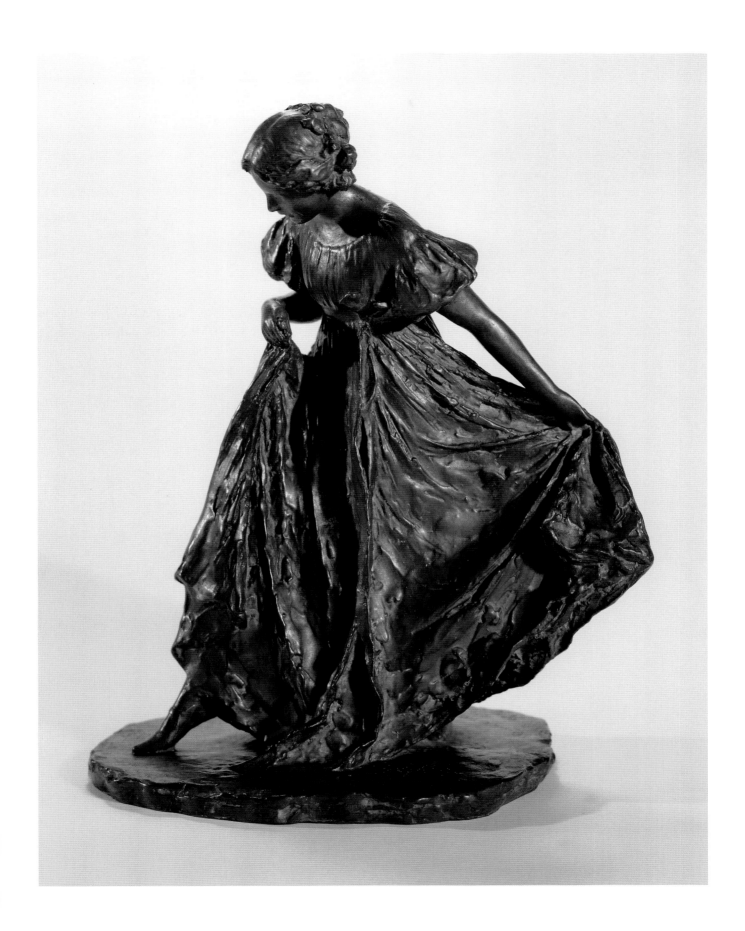

especially in small sculptures, connoted virtuosity, and objects made with this technique were sold through jewelry stores as well as galleries.[4]

The success of *Girl Dancing* and *Girl Reading*, a figure whose repose countered *Girl Dancing*'s movement, confirmed Potter's decision to pursue small-scale works of everyday but upper-class themes, including "a new crop of dancing girls" such as *In Grecian Drapery* (1913).[5] In this she was supported by the recently established (1893) National Sculpture Society, which although believing that sculpture should represent the universal and beautiful, as exemplified by public allegories, sought to popularize less didactic genre pieces for private homes. Vonnoh represented the perfect solution. Her figures were "touched with 'the faint languor of a modern civilization,'" so suited for domestic decoration, and since they were made by a female artist, offered no competition with men and public art: "Her statuettes are purely and obviously the work of a woman. The feeling, the sentiment, and the delicacy are thoroughly feminine."[6] Statuettes like *Girl Dancing*, though reminiscent of classical Tanagra figurines, modernized Hellenistic genre sculptures in technique and subject, giving to representations of upper-class American womanhood the mark of classical refinement.

Vonnoh was embraced by the artistic establishment. With the celebrated sculptor Daniel Chester French advising its board, the Metropolitan Museum in New York purchased and exhibited her bronzes, as did the Art Institute of Chicago, the Carnegie Institute, women's clubs, and international expositions. In 1913 she had her first solo exhibition at the Brooklyn Museum, followed by an exhibit at the Corcoran in 1919; the conservative National Academy of Design elected her its first woman academician in 1921; and her studio on West 67th Street was a social gathering place. In 1920 she was photographed in her studio posing as *Girl Dancing*, accompanied by lines of tuxedoed men and society women.

In 1905–6 Frank and Anna Hall of Lincoln, Nebraska, visited the artist's New York studio and purchased a bronze casting of *Girl Dancing* for $80 for their private collection.[7] As longtime patrons of the arts (Anna was a painter herself) and supporters of the Nebraska Art Association's mission to bring art to the plains, the Halls appreciated the appeal of Vonnoh and her sculpture.

As *The Studio* said: "At a time when the idealisms of our artists and the appreciative capacities of our patrons of art are bounded on the one side by Castle House and on the other by the Persian Garden . . . I find, for example, in [Vonnoh's] home a Steinway parlor grand, in place of the inevitable Victrola, and it is from an atmosphere permeated with a gentleness of demeanor, a breadth of interest, an unobtrusive cultivation, that the work of Mrs. Vonnoh comes to us."[8] After the Halls' deaths, *Girl Dancing* joined the rest of their collection in being donated to the public in the permanent collection of the University of Nebraska.

WENDY J. KATZ

--

NOTES

1. Julie Aronson, "Bessie Potter Vonnoh (1872–1955) and Small
 Bronze Sculpture in America" (PhD diss., University of Delaware,
 1995), 68–103.

2. Quoted in Ilene Susan Fort, "'Mere Beauty No Longer Suffices':
 The Response of Genre Sculpture," in Fort, *The Figure in American
 Sculpture: A Question of Modernity* (Los Angeles: Los Angeles
 County Museum of Art, 1995), 77.

3. Allen Dodworth, *Dancing*, 6th ed. (New York: Harper & Brothers,
 1905), 22.

4. Michael Shapiro, *Bronze Casting and American Sculpture, 1850–
 1900* (Newark: University of Delaware Press, 1985), 108–32.

5. Henry Blake Fuller to Hamlin Garland, January 3, 1898, quoted in
 Aronson, 175.

6. Unnamed critic quoted in J. Walker McSpadden, *Famous Sculptors
 of America* (New York: Dodd, Mead, 1925), 367; 1897 review by
 Century Illustrated Monthly Magazine critic Arthur Hoeber quoted
 in Marlene Park, "Sculpture Has Never Been Thought a Medium
 Particularly Feminine," in *The Figure in American Sculpture*, 56. On
 women's acceptance by professional organizations, see Kirsten
 Swinth, *Painting Professionals: Women Artists and the Develop-
 ment of Modern American Art, 1870–1930* (Chapel Hill: University
 of North Carolina Press, 2001).

7. Vonnoh numbered but did not limit the editions of her bronzes.

8. Quoted in McSpadden, 364.

AUGUSTUS SAINT-GAUDENS (1848–1907)

Diana of the Tower, 1899

BRONZE 39 1/4 X 16 3/4 X 19 5/8 IN. NEBRASKA ART ASSOCIATION, IN HONOR OF LORRAINE LEMAR ROHMAN 1985.N-676

In the judgment of many informed people, Augustus Saint-Gaudens is America's greatest sculptor before the twentieth century. Based in New York, committed to the late nineteenth-century ideal of figurative naturalism, he produced an abundant oeuvre of which the best-known examples are portraits and public monuments of Civil War luminaries such as David Farragut, William Sherman, and Robert Shaw. These works declare irrefutably that he was the quintessential modeler whose visual discriminations were of the most sensitive and subtle sort.

The facts of his personal history have been frequently rehearsed. He was born in Dublin, the son of a French shoemaker and an Irish maid who immigrated to America while Augustus was still an infant. At the age of thirteen he was apprenticed to a cameo cutter, where he learned the nicety of scale, which is one of the hallmarks of his work. After preparation at Cooper Union and the National Academy of Design he went to Paris in 1867 to study with Jouffroy. As a product thereby of the Beaux-Arts regimen, he was to become, upon his return to New York in 1875, a leading player in the so-called American Renaissance in the visual arts.

The Sheldon collection contains four Saint-Gaudens bronzes: the *Diana of the Tower* here pictured, a second *Diana* (bust only, reductive, 1908), *The Puritan* (reduction, 1899), and *Hand of a Child* (1912, presumably modeled by Homer Saint-Gaudens, the artist's son). *The Puritan* merits special mention because it is a striking image that even in reduced size loses none of its inherent power. The original (1887), a great caped figure that stands overlooking the Connecticut River valley at Springfield, Massachusetts, was conceived as a memorial to Deacon Samuel Chapin. But Chapin lived in the seventeenth century, and for the sculptor the challenge was to do not a conventional portrait but a veritable personification of the Puritan proselytizer on historic mission into the wilderness, striding through an evil world in resolute effort to transform it into a New Zion. The success of the piece is a reminder that Saint-Gaudens shares the gift of all the great artists—that of the transfiguring imagination that enables him to begin in the local and particular and to end in the universal.

The *Diana,* of course, is of different character and purpose. Nude, classical in reference (both uncommon in the work of Saint-Gaudens), and generalized in treatment, she was created in 1892 to stand as a weather vane atop New York's Madison Square Garden. The sculptor and the building's principal designer (his close friend Stanford White) agreed that the Greek goddess of the hunt would be an appropriate subject for a facility that was in part athletic arena. The initial version, eighteen feet high and trailing a windblown sash, was fabricated of beaten copper. When elevated into place it was deemed out-of-scale and was pulled down (and no longer exists). It was replaced by a thirteen-foot figure—essentially a cast-bronze finial—which stood atop the building's tower until the structure was razed in 1925.

It is from this version that our full-length *Diana* derives. It is one of a limited edition of so-called large reductions authorized by the artist in 1899. Though lacking bow and arrow, she catches brilliantly the effect of the larger prototype—her lithe, airy grace and slender, virginal figure conscious reminders that the goddess of the chase was also the chaste goddess.

As for the original bronze, it went to the Philadelphia Museum of Art in 1932. In the mid-1960s, when the present Madison Square Garden was being raised over the bones of White's Pennsylvania Railroad Station, Mayor John Lindsay was impelled to write to Mayor James Tate of Philadelphia requesting the return of *Diana.* After all, she belonged to New York: she had stood overlooking Manhattan for many years. Might she not do so again? Mayor Tate, in witty response, reported that "Diana thinks New York is a nice place to visit, but she wouldn't want to live there." And so she remains in Philadelphia.

ROBERT SPENCE

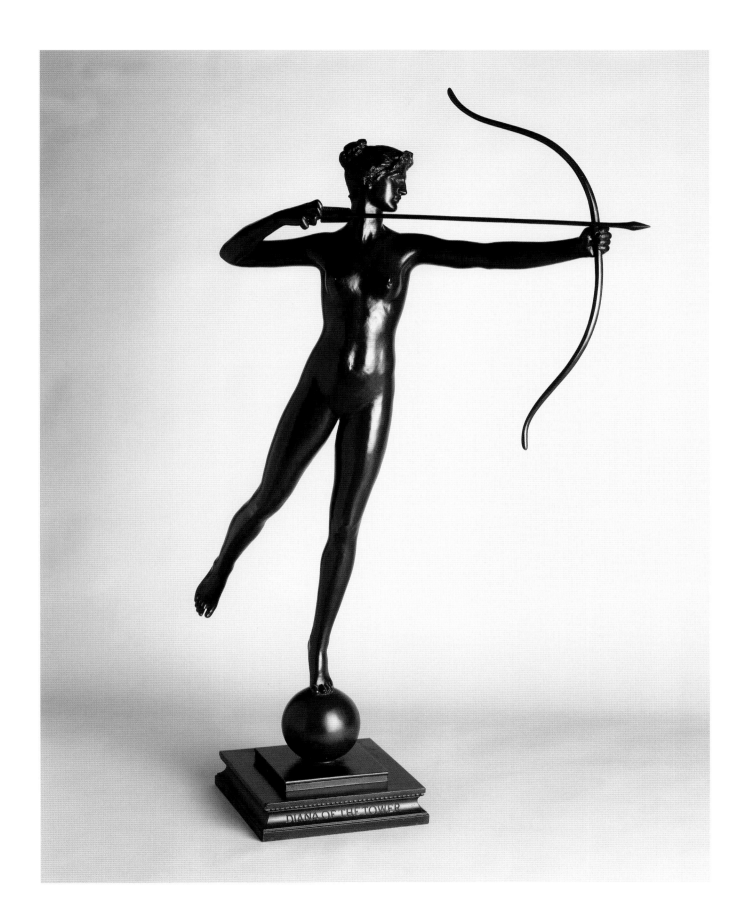

MAHONRI YOUNG (1877–1957)

The Laborer (The Shoveller III), 1908

BRONZE 10 ¼ X 9 X 7 IN. UNIVERSITY OF NEBRASKA, F. M. HALL COLLECTION 1939.H-202

In 1925 Mahonri Young described his famous statues of male workers as showing "the long procession of unskilled labor that has been the means of changing the face of the earth in the first quarter of the twentieth century."[1] *The Laborer*, the first in this series and Young's first original work, shows the toil and strain involved in reshaping the earth, as a powerfully muscled man digs his shovel deep into a load of dirt. While neither Young nor his sculpture was politically radical, in insisting on the value of labor to his art, he helped end American sculpture's dependence on an increasingly conservative and genteel ideal that demanded sculpture represent the spiritual and uplifting.

Born in Salt Lake City, the grandson of Brigham Young, in a period when few among the social and artistic elite were either westerners or Mormons, Young was doubly an outsider.[2] He supported himself as a newspaper illustrator (as did contemporary painters of the working class such as John Sloan and George Luks) while studying with Ecole des Beaux-Arts–trained painters in Utah and, in 1899, at the Art Students League in New York. He traveled to Paris late in 1901, enrolling in the studios that had fostered artists of the previous generation, the Academies Julian and Colarossi. But rather than producing allegories and goddesses, in his second winter in Paris he modeled his first sculptures of workers: *The Laborer* and *Man Tired* (*Tired Out*) (1903).

Worked from memory and sketchbooks rather than a model, the two companion pieces—one working and one resting—were elements in a proposed monument to labor in which classical columns and male nudes framed a centerpiece of contemporary rural workers, giving their exertion and exhaustion mythic dimensions.[3] Although influenced by Jules Dalou's contemporary realism of dress and action, albeit a realism that left little mark on his workers' idealized bodies, Young's theme and style were owed mainly to the Belgian sculptor Constantin Meunier's faithfully depicted miners enduring great hardship and misery with dignified acceptance. Meunier's own monument to labor was crowned not with the overworked but with the triumphant *Sower* (1880–90), who prophesies labor's reward in an eventual harvest. Meunier was exceedingly popular in the United States: George Vanderbilt bought eight of his statues for Biltmore, which was at $5 million the most expensive mansion ever built in the United States and itself a tribute to the benefits of cheap labor for the rich.[4]

Young's *Laborer* grips a modern shovel, with a curved blade and long handle, at the moment of lifting. Young maximized the strain but also created a moment of balance between tool and body. The baggy pants, wider than the waist, give the man's lower body enough mass to match the musculature of his bare shoulders and chest. A jutting elbow extends off the base into the viewer's space, suggesting a body literally pushing its limits, but typically Young hides the worker's face.[5] While he preserves anatomical details like ears and tendons, the features of the bowed head are roughly indicated, and in general the bronze body reveals its origins in a lump of clay: pocked and mottled, with palpable indents of tools and fingers left visible. Young sometimes signed his work with a fingerprint next to his name.

Young twice visited the studio of his idol Auguste Rodin while a student in Paris, and his handling of the clay adapts Rodin's technique. Rather than smooth surfaces, Rodin's bronzes retained traces of gouging and kneading, emphasizing the labor involved.[6] The role of the sculptor as manual worker differed from the gentlemanly ideal of the nineteenth century, whereby sculptors modeled in clay and then hired expert stonecutters to translate the model into marble. Sculptors emphasized the importance of their idea, believing the actual carving was merely mechanical. Rodin's palpable modeling gave new value to that labor, as it became part of the act of creation, essential to expressing the sculptor's idea. In *The Laborer*, despite its small (11-inch) size, Young's strenuous modeling monumentalizes the figure.

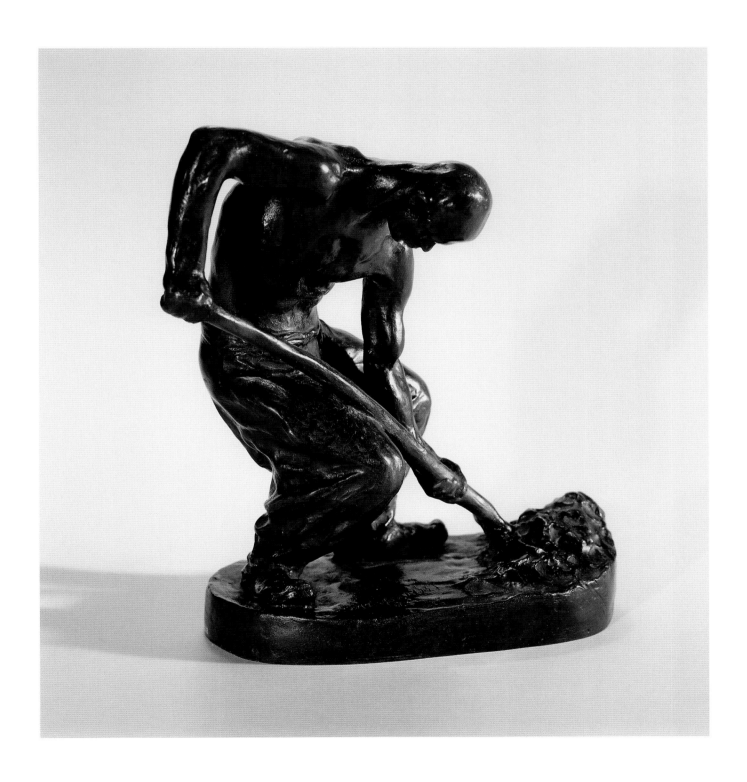

When Young exhibited the plasters of *The Laborer* and *Man Tired* at the American Art Association in Paris in 1903–4, the *Paris Herald Tribune* noticed his work and launched his career as a specialist in labor. These works were not shown in the United States until he moved to New York in 1910, but in 1911 his statue of a tired boatman, *Bovet Arthur—A Laborer* (1904), won an award at the National Academy of Design, and the next year he had his first one-man exhibition, at the Berlin Photographic Gallery. In 1912 he received the first of several commissions for the American Museum of Natural History in New York City to paint Hopi, Apache, and Navajo exhibits. Young's statues of workers sold better to progressives like Gertrude Vanderbilt Whitney (owner of *Man with a Wheelbarrow*, 1915) and museums (the Metropolitan in New York owned three by 1918) than to private patrons, for whom they perhaps remained too unidealized. Later, Young, with other realist artists associated with working-class subjects, helped organize the 1913 Armory Show, which simultaneously introduced European modernism to the United States and made the organizers' own style look old-fashioned. In 1938, when the Sheldon bought a bronze casting of *The Laborer* during a resurgence of interest in American realism, Young wrote a friend that it pleased him very much that people saw his early works as being good.[7]

For the rest of his career, in addition to large public commissions, particularly from the Mormon Church, Young continued to explore themes of male experience, particularly ones emphasizing a rugged masculinity. As he said, "The worker is the essential man," and what his middle- and upper-class patrons seemed to find in his working-class figures, as well as in his later prizefighters, prospectors, and American Indians, was reassurance that masculinity was natural and securely located in a body produced—albeit with considerable strain—by physical labor.[8] Although his sculptures did not present the worker as a threat, and he never depicted contemporary industrial labor—never mind the strikers and unionists of sculptors Charles Haag, Saul Baizerman, and Adolf Wolff—in the early twentieth century the very occupation of space in New York galleries by his laborers made the claims and presence of workers more real. As Young said in 1912, suggesting the increasingly democratic tenor and style of modern American life: "First the dam' Micks, then the guineas, dagos, waps, hunkies, from Ireland, Germany, Italy, Poland, and southern Europe . . . dam' may become for them as

honorable a prefix as the van of the Knickerbocker New Yorker."[9] Young's sculptures helped pave the way for new subjects—and eventually new artists—to enter American art.

WENDY J. KATZ

--

NOTES

1. Quoted in Roberta Tarbell, "Mahonri Young's Sculptures of Laboring Men, Walt Whitman, and Jean-Francois Millet," in *Walt Whitman and the Visual Arts*, ed. Geoffrey Sill and Roberta Tarbell (New Brunswick NJ: Rutgers University Press, 1992), 158.

2. Ilene Susan Fort, "'Mere Beauty No Longer Suffices': The Response of Genre Sculpture," in Fort, *The Figure in American Sculpture: A Question of Modernity* (Los Angeles: Los Angeles County Museum of Art, 1995), 78.

3. Melissa Dabakis, *Visualizing Labor in American Sculpture* (New York: Cambridge University Press, 1999), 141.

4. Dabakis, 125.

5. Dabakis, 137–44.

6. Ilene Susan Fort, "The Cult of Rodin and the Birth of Modernism in America," in *The Figure in American Sculpture*, 44–46. Rodin also did a monumental *Tower of Labor* (1893–99).

7. The Metropolitan owned *Bovet Arthur*, *The Stevedore* (1904), and *Man with a Pick* (1915). Young is cited in Thomas Toone, "Mahonri Young: His Life and Sculpture" (PhD diss., Pennsylvania State University, 1982), 131 n. 12.

8. Young quoted in Dabakis, 141. In 1925 the M. A. Hanna Company commissioned a medal from Young to be given to twenty-five-year employees, and the central figure on the obverse shows *The Laborer* in relief; see Toone, 67–68.

9. Quoted in Toone, 75.

CONSTANTIN BRANCUSI (1876–1957)

--

Princess X, 1909–16

MARBLE 22 X 11 X 9 IN. UNIVERSITY OF NEBRASKA, GIFT OF MRS. OLGA N. SHELDON IN MEMORY OF ADAMS BROMLEY SHELDON 1963.U-418

A masterpiece of simplification, Brancusi's notorious *Princess X* helped to redefine sculpture in the modern era. The work has its origins in an earlier, now lost, sculpture entitled *Woman Looking in a Mirror*, which the Romanian artist carved in 1909. The subject of that work was the notoriously vain Princess Marie Murat Bonaparte, who carried a mirror with her at all times, even to dinner parties, where she would look at herself while eating. Brancusi was enchanted by the graceful way she studied her appearance in the mirror and initially made a portrait of her gazing downward, which in its descriptive realism showed the influence of Rodin. Brancusi worked briefly in Rodin's studio following his move to Paris in 1904, but in the years leading up to World War I he began to move away from the French artist's heroic and often melodramatic renditions of the human body (which Brancusi humorously dismissed as "beefsteak") in favor of an increasingly abstract style.

As Brancusi reworked the theme of the narcissistic princess over the next seven years, he dramatically reduced her complex anatomical structure into a series of upwardly soaring curvaceous forms. The featureless face, elongated neck, and rounded breasts have an almost industrial, streamlined precision, even though the piece was carved by hand. Indeed, the velvety smooth surface of the marble highlights the artist's emphasis on the integrity and innate beauty of his materials, as well as his admiration for the pristine quality of machine design. It should also be noted that the sculpture is much taller than it is wide, and this, combined with the bulbous forms of its lower edge and the slightly twisted body, adds a note of precarious tension to an otherwise balanced and refined expression.

The attenuated grace of the piece reflects Brancusi's friendship during the intervening years with the Italian painter Amedeo Modigliani, whose *Caryatid* drawings of this time bear a remarkable formal similarity to the finished version of *Princess X.*

Although ostensibly a stylized portrait of a princess (whose identity Brancusi had to keep a secret, since Marie Bonaparte was a descendant of Napoleon and a prominent member of Parisian society at the time), the piece also can be seen as a fusion of male and female elements. The sculpture has an inescapably phallic shape, especially when viewed from the side and back, where the forward bending ovoid head and long neck, which terminates in the full breasts at the base, are transformed into male genitalia. The sculpture thus becomes a modern fertility symbol, an interpretation in line with Brancusi's interest in non-Western, ancient, and folk art precedents that bypassed the classical tradition of sculpture. The end result is a breathtaking combination of elegant sophistication and daring eroticism that has made the work an enduring icon of modern art.

When Brancusi sent a bronze version of *Princess X* to the 1920 Salon des Indépendants exhibition in Paris, it caused a sensational scandal. It was probably Matisse (although some accounts credit Picasso) who first noticed the overt sexuality of the piece, exclaiming "Voilà le phallus," when looking at the work with friends at a private viewing of the exhibition. This remark, and others like it, ultimately led to the censure of Brancusi's sensuous sculpture. The work was denounced as an outrage to public morality and was removed by orders of the head of police on the morning of the presidential opening of the Salon, shortly before the exhibition was to open to the public. The artist protested his innocence on the charge of "phallic obscenity," explaining that the marble sculpture represented a feminine ideal: "It is 'Woman,' the very synthesis of Woman. It is the eternal female of Goethe, reduced to her essence."[1] Although the work was later restored to the exhibition, Brancusi was so disgusted by the incident that he refused to show his work in Paris for the next six years, and thereafter he preferred to show his work privately in his studio or in exhibitions abroad, especially in the United States.

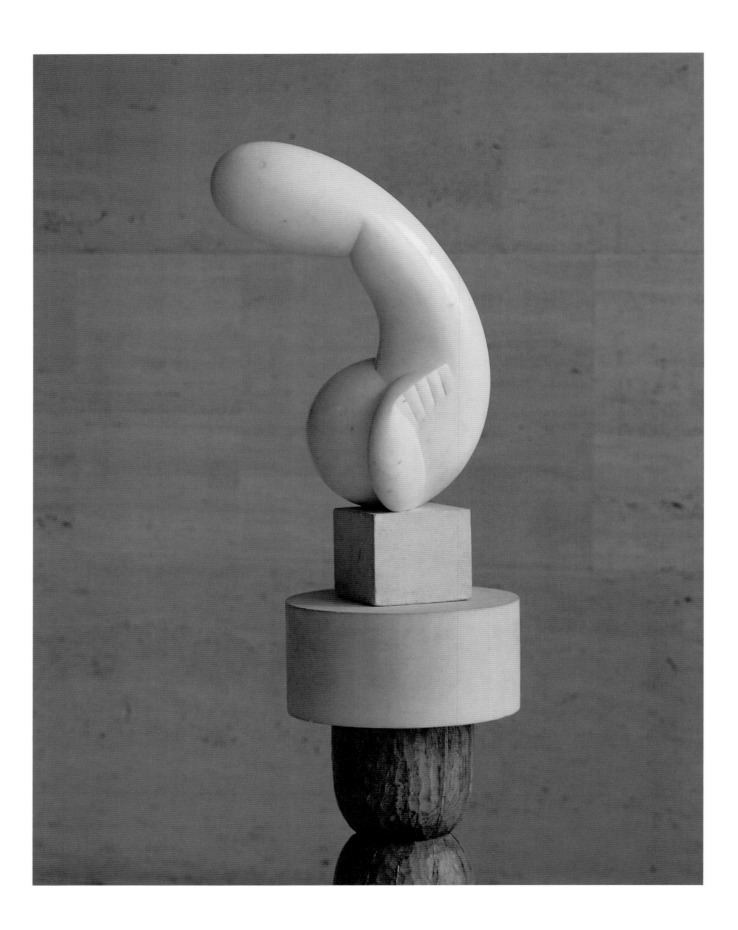

The sculpture was first shown in America at the Modern Gallery in New York in the fall of 1916, where it was purchased by the New York lawyer and collector John Quinn, who was at that time one of the leading American supporters of European avant-garde art. After his death in 1924, the Quinn collection was dispersed, and this celebrated marble sculpture was eventually purchased by Mrs. Sheldon in 1962. The work was donated to the Museum in the following year, where it remains as one of the great treasures of the collection.

MICHAEL R. TAYLOR

For additional information on Princess X, *see also the foreword by Norman A. Geske*

- -

NOTE

1. Quoted in Roger Devigne, "L'homme qui rabote les femmes," *L'ère nouvelle*, January 28, 1920, 6.

DANIEL CHESTER FRENCH (1850–1931)

Abraham Lincoln, 1912

BRONZE 38 X 10 X 12 IN. UNIVERSITY OF NEBRASKA, F. M. HALL COLLECTION 1928.H-2918

The centenary of Abraham Lincoln's birth in 1909 inspired monuments throughout the United States in an effort to revamp his legend into a national rather than a Northern or partisan hero.[1] In Lincoln, which was chosen as Nebraska's state capital precisely because of a sectional compromise, the proposal for a statue originated at a Republican Party banquet whose promoters described their purpose as "patriotic and free from all factional differences . . . non-partisan."[2] A committee drawn from the most distinguished leaders in finance, politics, and religion, and guided by attorney Frank Hall and his wife, Anna, chose sculptor Daniel Chester French to create an image of Lincoln as a man of the people who had nevertheless risen above them. French's larger-than-life-size bronze statue was dedicated in Lincoln on September 2, 1912, with Nebraskan William Jennings Bryan, hero of the Populist and Democratic parties, giving the keynote address to an estimated ten thousand people. The three-foot bronze statue at the Sheldon was cast from a plaster model (also owned by the Sheldon) for the larger statue and was bought by the Halls for their own collection. Unlike the statue at the Capitol, which is literally framed and magnified by Henry Bacon's architectural setting, the small Lincoln suggests a more personal, perhaps because literally more possessable, symbol than the public monument.

Born to an old New England family, French had already designed the *Minute Man* (1874) for Concord, Massachusetts, when he departed in 1875 for the American sculptors' mecca of Florence, where in Thomas Ball's studio he acquired the Neoclassical tradition of ideal sculpture. Only in 1886 did French travel to Paris "to try and learn what I ought to have learned years ago" —a more modern style that emphasized greater naturalism, particularly for the increasingly popular medium of bronze. In bronze casting, every mark of the tool on the clay model is reproduced, unlike marble, which in any case was cut by expert craftsmen rather than the sculptor.[3] Indeed, the first sculptor to attempt a statue of Lincoln for Nebraska, John Currie,

was known as a stonecutter rather than an artist, which proved a major stumbling block to his ambition to complete a monumental marble statue of Lincoln, to be depicted holding the Emancipation Proclamation on a rustic stump suggestive of his humble origins.[4] By the time the Halls visited French in the summer of 1908, however, French had considerable skill at bronzes as well as the Ecole des Beaux-Arts practice of combining sculpture with architecture in order to control how the sculpture would be viewed. As French wrote to Hall about the importance of Bacon's stone marker inscribed with the Gettysburg Address, "If people should make up their minds that the monument looked meagre or incomplete when first shown, it would never recover its prestige. . . . Let a joke or two be cracked about a statue at the start and it will queer it for all time."[5] In 1909 French traveled to Lincoln to see the site to the west of the second State Capitol (not the present-day one) and then began work on clay sketches. From his clay model, one-third the size of the finished statue, a plaster cast was taken; this was approved by Hall and the committee in 1911. It is this working model that was the source for the Sheldon's Lincoln; for the Capitol, a full-size plaster, made by assistants from the working model, was sent to the foundry.

Lincoln was the first time French actively promoted a bronze edition of a statue. Most sculptors did only a limited number (if any) of full-size replicas of a statue, but sometimes produced small plaster, marble, or bronze reductions of very successful statues, on demand or for stores and without limits on their numbers. Once the sculptor completed the clay model for the original statue, however, he or she had little involvement with its reproduction or reduction, which was delegated to assistants and foundries. The danger remained, though, that an artist known as a specialist in statuettes would be perceived as operating on a more commercial and domestic level, and so might be excluded from prestigious and grand-scale public monument commissions.[6] This may explain why French earlier showed relatively little interest in doing bronze multiples of his working models,

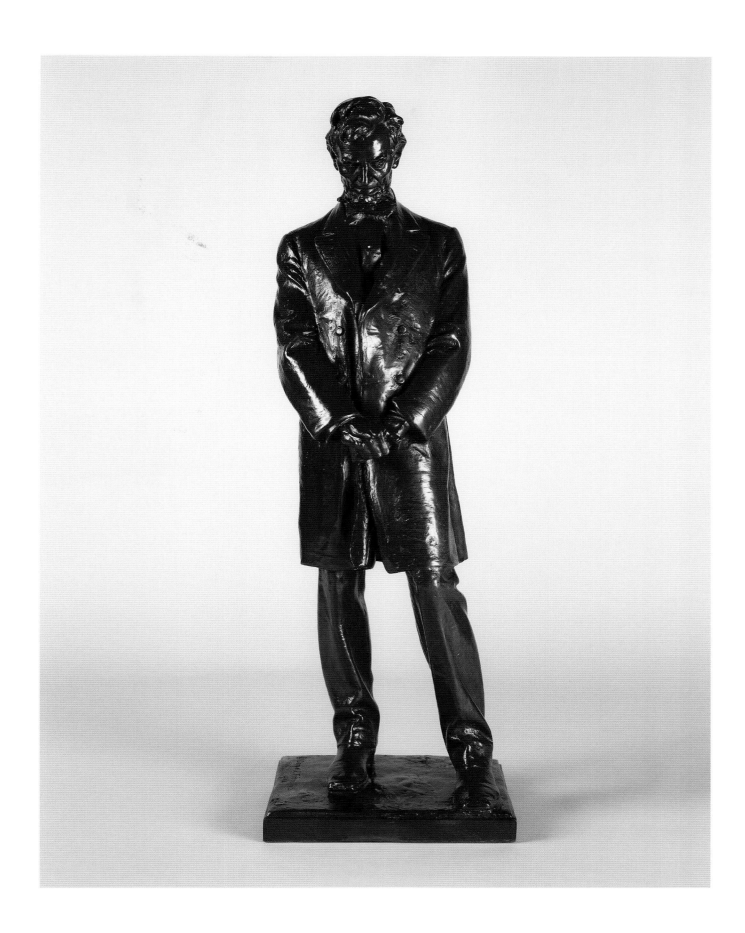

although he did sell less expensive plaster casts of finished works, including three to the Halls. The cash-strapped Lincoln Memorial Association forbade French from doing replicas of the full-sized statue, as he first proposed, but agreed that in lieu of the remainder of his contract ($2,890), he could have sole right and privilege of making and selling copies in miniature of the statue. From 1912 to 1917 he did ten of the three-foot bronzes, selling them for $180, or $165 for two.[7]

French wrote to one purchaser that the bronze miniature "has more vigor and character than a mechanical reduction of the statue would have, if not so much finish."[8] Indeed, the smaller size permits observation of the contrasts between the broadly handled hair, the raised veins on the hands, and the delicately hatched surfaces of the clothes. The surface of the statuette seems particularly lively, with the wrinkled sleeves, rumpled tie and lapels, and tousled hair reflecting light and casting sharp shadows, reinforced by variations in the brown patina. As with the full-size statue, the overall mood—conveyed by the line of the bowed head, repeated in the angle of the arms and knee, as well as by the contrapposto stance—is one of repose, meant to convey sorrow and solemnity. French said he tried to represent Lincoln, bearing the burdens of the war, collecting his thoughts before the speech at the battlefield at Gettysburg.[9] His portrait differs both from Augustus Saint-Gaudens's standing *Lincoln* (1887) in Chicago, whose massive chair and firm grip on his coat suggest more confidence and decisive action, and from a later *Lincoln* (1917) by George Gray Barnard, which shows Lincoln without the fatherly beard and classical proportions French gave him, resulting in a more diffident and ungainly, if more human, sculpture.[10] However, French's more "finished" monument, on its raised pedestal and with its explicit reminders of memorials to the dead and a specific historical moment, more forcefully keeps viewers at a physical and temporal distance. The small bronze has less with which to counter the impact and approachability of Lincoln's unpretentious dress, modestly clasped hands, and unrefined exterior, permitting a closer approach.

WENDY J. KATZ

NOTES

1. Albert Boime, *The Unveiling of the National Icons: A Plea for Patriotic Iconoclasm in a Nationalist Era* (Cambridge: Cambridge University Press, 1998), 253–306.

2. *State Journal*, October 2, 1908, reproduced in the Lincoln Journal Star, August 4, 1995.

3. French quoted in Michael Richman, *Daniel Chester French: An American Sculptor* (Washington DC: Preservation Press, 1976), 21.

4. Typed summaries and transcripts of newspaper clippings from the *Lincoln Courier*, 1895–97, Lincoln Monument vertical file, Nebraska State Historical Society.

5. Quoted in Richman, 125.

6. Jacques de Caso, "Serial Sculpture in Nineteenth-Century France," in *Metamorphoses in Nineteenth-Century Sculpture*, ed. Jeanne Wasserman (Cambridge MA: Fogg Art Museum, 1975), 1–13.

7. Michael Richman, "Daniel Chester French," in Metamorphoses in Nineteenth-Century Sculpture, 223. Eventually twelve were recorded. Several plasters of the full-scale statue also were made.

8. Quoted in Richman, *Daniel Chester French*, 127.

9. Mary French, *Memories of a Sculptor's Wife* (Boston: Houghton Mifflin, 1928), 222–24.

10. Wayne Craven, *Sculpture in America* (Newark: University of Delaware Press, 1984), 402.

PAUL MANSHIP (1885–1966)

Salome, 1915

BRONZE 18 1/4 X 12 X 6 7/8 IN. UNIVERSITY OF NEBRASKA, GIFT OF MARY RIEPMA ROSS, EX-32 1969.U-436

Paul Manship's most important tutelage came at the American Academy in Rome, to which he won a coveted three-year scholarship in 1909. He credited his Roman years with "form[ing] the technical approach to the problems of my art," a virtuoso technique that was the hard-won result of studying sculpture from various civilizations.[1] His choice of bronze, the medium of the ancients, as his preferred material honors artistic tradition even as it revitalizes it. With exquisite skill, Manship chased the metal castings, refining his figures with gleaming, highly polished surfaces that he often contrasted to linear patterns or detailed ornament. In their finish, his works differed from Rodin's expressive bronzes and offered a modern generation an alternative to the mannerisms of late nineteenth-century sculpture. As e. e. cummings noted, Manship was "no slave to the Rodin tradition, nor the Saint-Gaudens tradition, nor whatever may have produced those fattish girls helplessly seated on either hand as you enter the Boston Public Library."[2]

Manship's skills with material and technique were combined initially in a group of small bronzes begun in Rome and continued in New York after 1912, works that were acclaimed for their inventive adaptation of archaic Greek precedent. He wrote of the decorative value of Greek sculpture, admiring particularly its "power of design, the feeling for structure in line, the harmony in the division of spaces and masses," traits that are reflected in his own creations. He responded especially to the manner in which the ancient artist "subordinated everything to his formal composition," yielding "a decorative form upon which all the detail is drawn rather than modelled."[3]

These aesthetic priorities are well exemplified in *Salome,* one of the works featured in the immensely popular one-man show that introduced Manship's new work to New York in 1916. The statue's richly ornamented surface, which "might be an excess of fine detail on another work is entirely suitable to the barbaric opulence of his theme," wrote Edwin Murtha.[4] One early critic noted that "in Manship the silhouette is triumphant," a judgment reinforced by *Salome*'s theatrical pose and the planar arrangement of the drapery's sweeping lines.[5] Susan Rather has noted the parallels between the historicized detail of Manship's dancer and the aesthetic of Léon Bakst, an influential designer for the Ballets Russes. Both men participated in—and by their examples helped to shape—the vogue for archaicism that reigned in the 1910s. The preoccupation with stylized form and exotic sources united the two inventors in disparate realms, both "masters of absorption, adaptation, and transformation."[6]

In his quest for themes and forms, Manship turned to the precursors of the classical work that had influenced nineteenth-century sculptors. He thought each generation regarded cultural precedent anew, "each decade goes further back into the primitive . . . now it is gone practically as far as it can . . . we have gained and gone the full turn to the beginning."[7] At that point of aesthetic origins, Manship discovered the genesis of his modern amalgamation. It provided the basis for a career of exceptional note: from the acclaim for small bronzes of *Salome*'s vintage; to large architectural monuments (most famously, the gilded *Prometheus* at Rockefeller Center), which defined Art Deco in the 1930s; to critical neglect in his final years, as abstract imagery eclipsed his historicized motifs; and finally to posthumous reacclamation.

CHARLES C. ELDREDGE

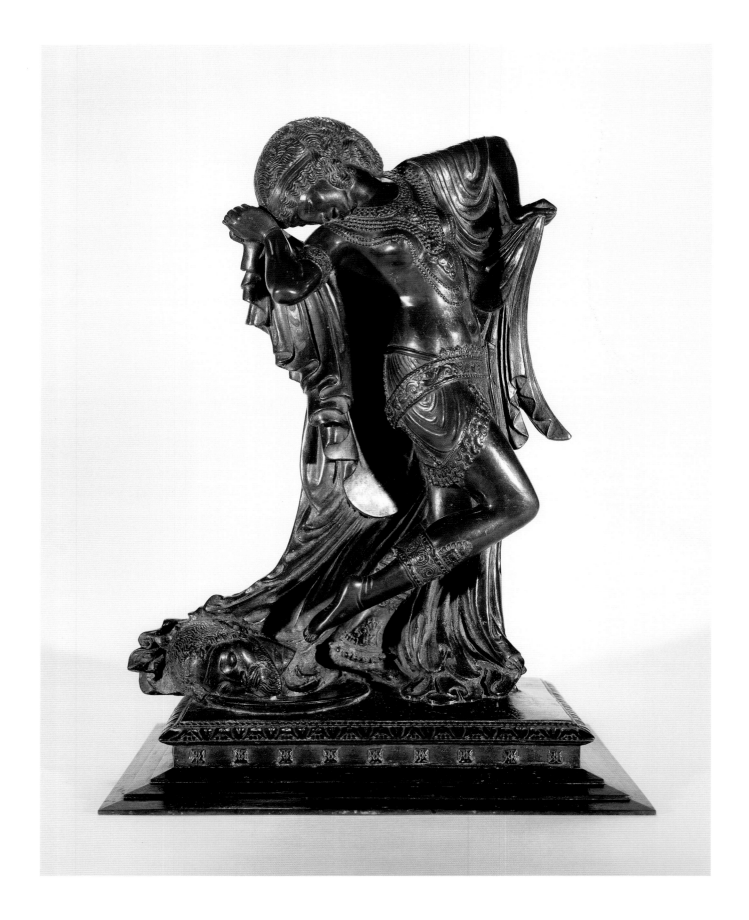

NOTES

1. Paul Manship, "Credo," in *Paul Manship*, American Sculptors Series, no. 2 (New York: W. W. Norton, 1947), 5.

2. e. e. cummings, "Gaston Lachaise," *The Dial* 68 (February 1920): 195. The "fattish girls"—allegorical representations of Art and Science— were created by Bela Pratt in 1911.

3. Paul Manship, address to the American Academy in Rome, May 1912; quoted in Edwin Murtha, *Paul Manship* (New York: Macmillan, 1957), 11–12.

4. Murtha, 157. The grisly tale of Salome and the severed head of John the Baptist is told in the Gospels (Matt. 14:1–12; Mark 6:14–29) and was often repeated; in the late nineteenth century it became a favorite theme of the playwright Oscar Wilde, the composer Richard Strauss, the painter Gustave Moreau, and a host of similarly imaginative artists in Europe and the United States.

5. Royal Cortissoz quoted in Murtha, 14.

6. Susan Rather, "The Origins of Archaism and the Early Sculpture of Paul Manship" (PhD diss., University of Delaware, 1986), 328.

7. Quoted in *Paul Howard Manship: An Intimate View*, exhibition catalogue (St. Paul: Minnesota Museum of American Art, 1972), 3.

ELIE NADELMAN (1882–1946)

Man in the Open Air, c. 1915

BRONZE 53 X 22 ½ X 11 ¼ IN. UNIVERSITY OF NEBRASKA, F. M. HALL COLLECTION 1952.H-323

© ESTATE OF ELIE NADELMAN/COURTESY SALANDER-O'REILLY GALLERIES

A pioneering modernist in Paris before World War I and a celebrated participant in the American avant-garde from 1914 onward, Elie Nadelman was one of the first modern sculptors to experiment with the abstraction of the human figure into simplified, geometrically regular forms. Born and educated in Warsaw, Poland, Nadelman studied briefly at the Warsaw Art Academy in about 1899 and again for a year in 1901. During a six-month stay in Munich in 1904 he discovered classical Greek sculpture in the Glyptothek and folk art dolls in the Bayerisches Museum, both of which would influence his own art. In late 1904 Nadelman moved to Paris and in early 1905 decided to devote himself to sculpture.

Nadelman sought to understand the fundamentals of plastic form through a dispassionate analysis of the volumes, curves, and contours of the human body. In a statement published in 1910, he declared: "I employ no other line but the curve, which has freshness and force. I compose these curves so as to bring them in accord or in opposition to one another. In that way I obtain the life of the form, i.e., harmony."[1] The harmonious proportions and serene expressions that Nadelman gave to his female nudes and marble heads often approached the idealized norms of classical Greek art. He also experimented with other semiabstract figurative styles, including a fluid, tubular mode and a segmented, proto-Cubist one.

By the time of his first solo exhibition in Paris at the Galerie Druet in 1909, Nadelman was recognized as a leading modernist sculptor. His supporters included Leo and Gertrude Stein, André Gide, Guillaume Apollinaire, and the Natanson brothers, and his art won the admiration of Pablo Picasso, Alexander Archipenko, and Constantin Brancusi. Nadelman's entire 1911 exhibition at Patterson's Gallery in London was purchased by Madame Helena Rubinstein, who displayed his pieces in her famous salons as "her trademark for the quasi-scientific beautification of modern womanhood."[2] Madame Rubinstein also provided for Nadelman's passage to New York in 1914 following the outbreak of World War I, and gave him the use of a studio on her estate. There, Nadelman prepared for his first American exhibition, which opened in December 1915 at Alfred Stieglitz's 291 Gallery. At 291, Nadelman exhibited a plaster version of the sculpture destined to become his most famous work, the *Man in the Open Air*.

Standing at ease with a serene smile on his face, legs crossed and left arm tucked behind his back, this graceful, bowler-hatted man leans against a whimsically stylized tree that passes smoothly through his right arm as he daintily fingers its slim upper branch. The gentleman's lissome, tubular body, devoid of firm skeletal structure or muscular articulation, seems to be enclosed in a skin-tight leotard. The only signs that he wears modern clothing are the faintly indicated sleeve lines at his wrists, the string bow tie that decorates his swelling chest, and, of course, his bowler hat.

Subtly playing off these features of modern, dandyish elegance are numerous sly references to classical art. The man's bowler, for example, resembles the round-brimmed hat worn by Hermes in a Pheidian bust formerly at Broadlands, England, and depicted by Nadelman in a marble head of *Mercury Petassos* (c. 1911).[3] The man himself adopts the cross-legged, hand-behind-the-back pose of the Lansdowne Paris, formerly attributed to the fourth-century BC sculptor Euphranor.[4] And the presence of the supporting tree creates an allusion to the Praxitilean Apollo Sauroktonos (c. 340 BC), a languorous youth who prepares to toss a pebble at a lizard crawling up the trunk against which he leans.[5]

With its witty transformation of a classical posture of repose into a modern gesture of nonchalance, the *Man in the Open Air* marks the beginning of Nadelman's playful engagement with subjects from the world of contemporary high society. For the remainder of the 1910s, he made small wooden figures of society hosts and

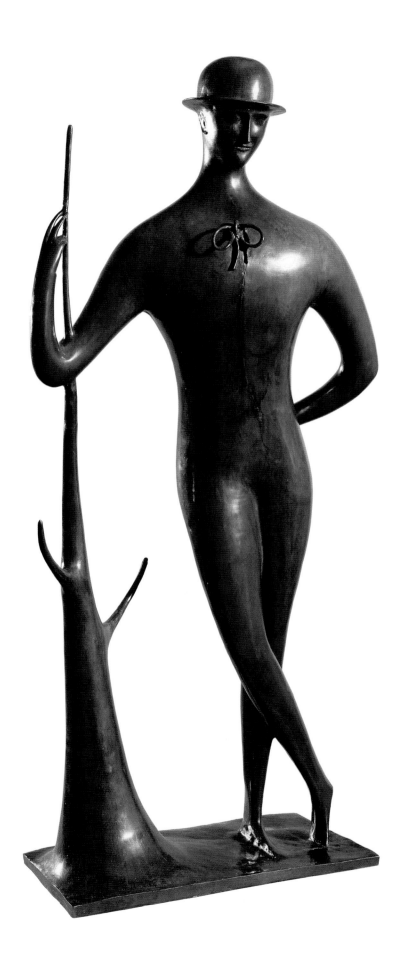

hostesses, orchestra conductors, singers, dancers, and circus per-
formers, strongly influenced by the simplified forms of American
folk art, which Nadelman and his American wife began to collect
avidly in 1919. While these later figures are stylish and charm-
ing, none approach the iconic power of the *Man in the Open Air*.
Memorably described by Albert Elsen as "a bowler-hatted, bow-
tied modern Apollo, a paragon of poise,"[6] the *Man in the Open Air*
epitomizes urbane twentieth-century man, taking his ease in the
out-of-doors with the grace and confidence of a Greek god.

DAVID CATEFORIS

NOTES

1. Elie Nadelman, "Notes for a Catalogue," *Camera Work* 32 (October
 1910), reprinted in Lincoln Kirstein, *Elie Nadelman* (New York: Eakins
 Press, 1973), 265.

2. Kirstein, 193.

3. Kirstein, 201. The bust of Hermes is reproduced in Adolf Furtwangler,
 *Masterpieces of Greek Sculpture: A Series of Essays on the History of
 Art*, rev. ed. (Chicago: Argonaut Publishers, 1964), 58, fig. 13.

4. Kirstein, 201. The Lansdowne Paris is reproduced in Furtwangler, 358,
 fig. 154.

5. Kirstein, 201. A later antique copy of the Praxitilean original is in the
 Louvre, and reproduced in Furtwangler, plate 5, fig. 6.

6. Albert E. Elsen, *Origins of Modern Sculpture: Pioneers and Premises*
 (New York: George Braziller, 1974), 30.

JOHN STORRS (1885–1956)

Figurative Abstraction, c. 1919

MARBLE 20 X 13 X 6 IN. UNIVERSITY OF NEBRASKA, OLGA N. SHELDON ACQUISITION TRUST 1984.U-3590

© VALERIE CARBERRY GALLERY, AGENT FOR THE ESTATE OF JOHN STORRS

In 1919 John Storrs created sculptures honoring two very different heroes, Joan of Arc and Walt Whitman. The simultaneous interest in iconic figures embodying the Gallic and American spirits suggests the emotional and inspirational poles of the Chicago-born sculptor, resident in Paris. Ultimately France became his expatriate home, and as a result, Storrs's radical abstractions of the late 1910s and later exerted little influence on his contemporaries in the United States, where they remained largely unknown until introduced in posthumous exhibitions in the 1960s.

Storrs first visited Paris in 1906, at the beginning of his art studies. In 1912 he returned to continue those pursuits, which in the interim had taken him to various schools in the United States and Germany; the following year he began studying with the influential Auguste Rodin. In June 1913, while on a visit to Paris, Storrs's mother died unexpectedly; in his sorrow, the artist turned to the theme of mother and child, a subject that continued to inspire him for much of the decade. The motif gained added significance five years later when Storrs's French wife bore their first and only child, an event that prompted new developments in Storrs's maternal themes. The sculptures had begun with conventional relief carvings but quickly moved, around 1918, to more-stylized reliefs and freestanding works. The "modern Madonnas," as Storrs called them, represented his effort to apply Cubist principles to three-dimensional form, a quest in which he and his friend Jacques Lipchitz had been joined since meeting in Paris in the fall of 1911. The faceted planes of the modern Madonnas were variously tinted with green, white, and black, adding to the decorative effect of the figures. The blocky vertical of the standing figure anticipated his "Forms in Space" series, columnar "architectural" abstractions developed in the 1920s. Its human subject was echoed as well in sculptures of the stylized figure that periodically occupied him over his career.

Figurative Abstraction combines the maternal theme with inventive Cubist form. On one side, the mother moves into the block, her faceless form and simplified angular back reminiscent of Matisse's major series of "Back" reliefs, begun circa 1909; more traditionally, the figure merging with the stone recalls funerary monuments from the turn of the century, such as Daniel Chester French's acclaimed Melvin Memorial (1906–8). On the other side of Storrs's block, the child similarly moves into the stone. The gesture of the mother's reach, around and through the block, links the two faceless figures and effectively constitutes the sculpture. As Noel Frackman noted, "The viewer is as aware of the solid geometry as of the figures themselves. A recognition of this dual perception may have been the beginning of Storrs' eventual separation of his architectural sculpture from his figurative ones."[1]

The schism became more apparent in the 1920s, when Storrs invented geometric "architectural" designs—initially carved of stone, later made of metal—forms that looked like "a fragment of architectural ornament that had been pried off a building."[2] These culminated in simplified, streamlined "skyscrapers" of the late 1920s and metal reliefs and "figures" of the 1930s. Concurrently, Storrs explored figurative subjects in various architectural commissions, most notably a monumental aluminum *Ceres* atop the Board of Trade Building and the stylized decorations for the 1933 "Century of Progress" exposition, both in his Chicago hometown.

CHARLES C. ELDREDGE

NOTES

1. Noel Frackman, *John Storrs*, exhibition catalogue (New York: Whitney Museum of American Art, 1986), 22–23.

2. Jeffrey Wechsler, "Machine Aesthetics and Art Deco," in Joan M. Marter, Roberta K. Tarbell, and Jeffrey Wechsler, *Vanguard American Sculpture, 1913–1939*, exhibition catalogue (New Brunswick NJ: Rutgers University Art Gallery, 1979), 96.

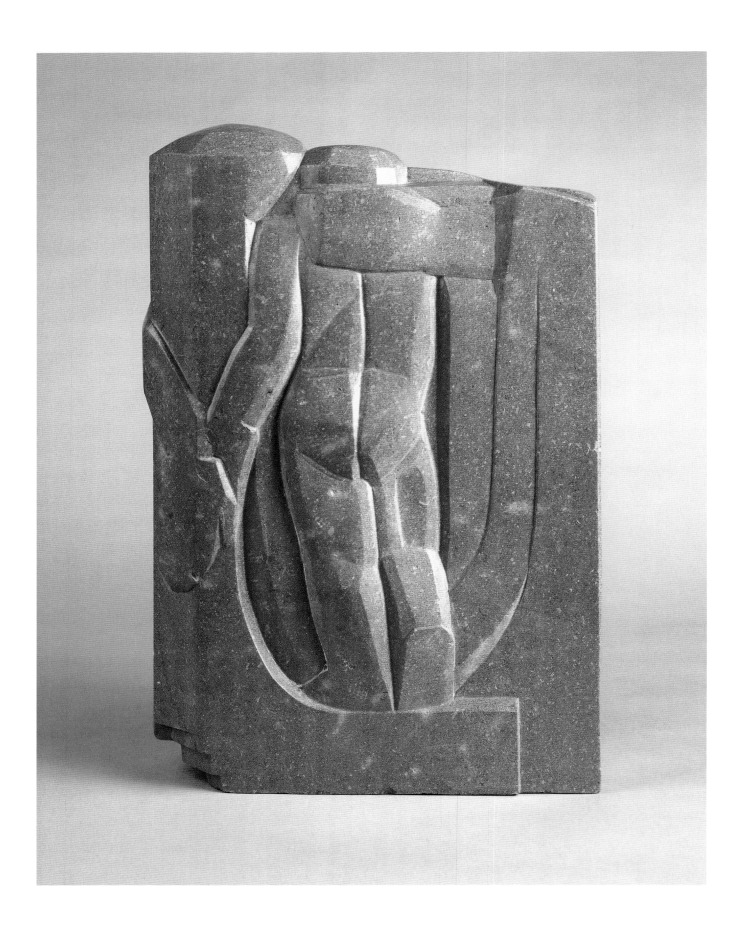

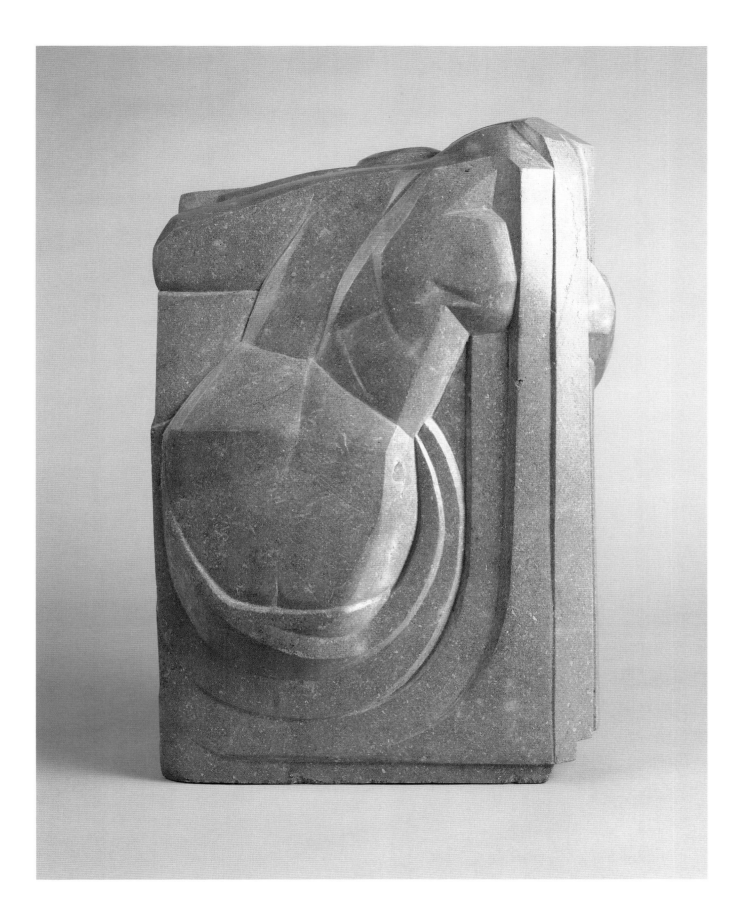

MAN RAY (1890–1976)

Cadeau, 1921 (fabricated 1974)

CAST IRON, TACKS 6 ½ X 3 ⅞ X 4 ⅛ IN. UNIVERSITY OF NEBRASKA, F. M. HALL COLLECTION 1987.H-2860

© ZABRISKIE GALLERY, NEW YORK NY

Born Emmanuel Radnitsky in Philadelphia in 1890, Man Ray grew up in Brooklyn, studying art at the National Academy of Design and the Art Students League while supporting himself as a commercial artist and draftsman. Like Arthur B. Davies and Alfred Stieglitz, Man Ray's importance for the development of modern art in the United States transcended his own art-making activities. The success of European modernism in the United States lay in a number of complex interactions, but none were as important as the ability of a few American artists to interact socially and aesthetically with important European modernists both on American soil and in Paris, Vienna, and Milan. They played, as Man Ray did, an important social role in the acceptance of modern art in the United States, primarily through the translation of a European modernist ideology into an American vernacular.

Through his close friendship with the French modernist Marcel Duchamp, whom he met in 1915, and through his association with the avant-garde community in Paris, Man Ray was privy to a perspective on modernism rarely seen and experienced by American artists. In 1920, together with Katherine Dreier, Duchamp and Ray founded the Société Anonyme and in 1927 organized the highly influential "Société Anonyme's International Exhibition of Modern Art" in Brooklyn.

However, Ray's success in advancing the cause of modern art in the United States was not limited to public relations. His talent as a photographer and his ability to assimilate European modernism into his own art-making activities in creative ways did much to put him into the vortex of modernism, both in New York and in Paris. Duchamp's notorious *Nude Descending a Staircase* made a powerful impact on Ray when he saw it at the Armory Show in New York in 1913. And when he was introduced to Duchamp in 1915, a close aesthetic and conceptual collaboration was initiated that extended well over fifty years and included

Ray's photo documentation of Duchamp's "Dada" activities and his coediting *New York Dada* in 1921, a single-issue journal that established Dada on American soil. Significantly, most of the photographic images of Duchamp and his various "personas" and "events" were produced by Man Ray.

In 1921 Ray left for Paris, where he became an important member of the Surrealist community, exhibiting with them in the first Surrealist exhibition in 1925 and in the first Surrealist exhibition in New York, at the Julien Levy Gallery in 1932. Ray's work was also included in the landmark exhibition "Fantastic Art, Dada, Surrealism," curated by Alfred H. Barr Jr. at the Museum of Modern Art in New York in 1936, an exhibition that served to bring European modernism, especially Dada and Surrealism, into the fold of the American art world.

It was in Paris that Ray conceived of and executed *Cadeau,* or "gift." In December 1921 he was given his first solo exhibition as a Dadaist, a show of thirty-five works dating from 1914 to 1921 at La Librairie Six, a small bookstore and art gallery owned by the Dadaist Philippe Soupault.[1] At the opening Man Ray met the composer Erik Satie, and together they purchased an iron, tacks, and glue at a hardware store. The piece was intended to be included in his show and then raffled off among the Dadaists in thanks for their support of his work, thus the significance of the title. However, as the story goes, *Cadeau* disappeared soon after it was exhibited. Since 1921, however, several editions of replicas have been fabricated and are housed in important museums throughout the world.

Perhaps because of the spontaneous inception of the original piece, *Cadeau* remains one of Man Ray's significant works, combining the anti-art perspective of the Dada "act" with the Surrealists' obsession with exploring the various manifestations of the unconscious and dream (or nightmare) state.

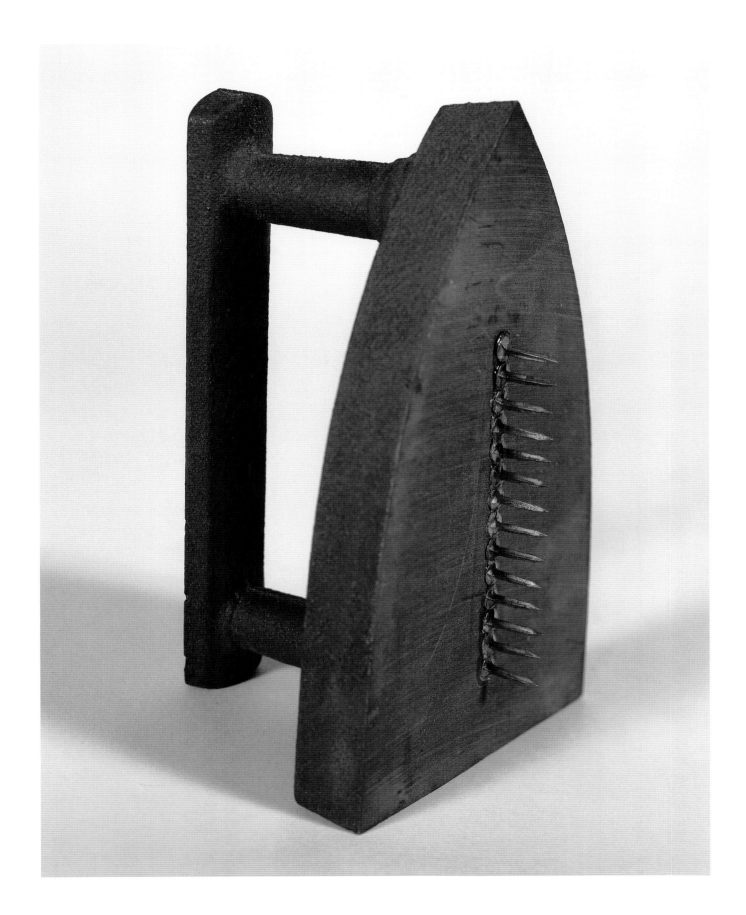

While in Paris, Ray explored new techniques in photography, developing what he called "Rayographs," which consisted of placing objects on light-sensitive paper and exposing the "composition" to light; he claimed that through this process he had been "freed from the sticky medium of paint."[2] He also made Surrealistic paintings, Dadaist assemblages, and extended his interest in photography to include filmmaking. His first film, a three-minute piece entitled *Le retour à la raison* (The return to reason), was billed as the last Dada spectacle in Paris, according to Tristan Tzara.[3]

In 1940 Man Ray returned to the United States. He settled in Hollywood, which had served as an inspiration for his own filmmaking activities, until 1951, when he returned to Paris, where he died in 1976.

DANIEL A. SIEDELL

NOTES

1. Irene Gordon, comp., "Chronology," in William S. Rubin, *Dada, Surrealism, and Their Heritage* (New York: Museum of Modern Art, 1968), 202. See also Elizabeth Hutton Turner, "Paris: 'Capital of America,'" in *Americans in Paris: 1921–1931* (Washington DC: Counterpoint, in association with the Phillips Collection, 1996), 15–24.

2. Quoted in Turner, 20.

3. Turner, 21.

ERNST BARLACH (1870–1938)

The Young Wife (Standing Woman with Folded Arms), 1922

LINDEN WOOD 38 ³/₄ X 10 X 8 ³/₄ IN. UNIVERSITY OF NEBRASKA, F. M. HALL COLLECTION 1953.H-336

According to the art historian George Heard Hamilton, Ernst Barlach's art is a "mystical interpretation of life as man's lonely search for himself, for others, and for his lost God, a search beset by invisible presences which emerge, as visible artistic forms, from an 'unknown darkness' within the artist's consciousness."[1] Barlach's artistic forms, however, did not simply come out of his own "unknown darkness," as Hamilton argues, but emerged from his attempt to find suitable aesthetic forms to communicate values he believed to be universal. Like many European modernists, Barlach found these forms in two powerful myths: the existential purity of the peasants and the directness of their art, which seemed to communicate the human condition more directly than "high art." For Barlach these values, in both life and art, were epitomized by the Russian peasants he encountered in 1906: "I found in Russia this amazing unity of inward and outward being, this symbolic quality. This is what we human beings are, at bottom all beggars and problem characters."[2] Barlach's art must be understood as a desire, in form and content, to approach the potency and directness of an art ("folk" art) that emerges directly out of lived experience.

Like many modern artists burdened with a desire for full aesthetic expression, Barlach's artistic production included more than sculpture. He spent much of his early life writing plays and is still regarded as an influential figure in German Expressionist literature. For such plays as *The Dead Day* (1912) and *The Foundling* (1922), Barlach executed a set of lithographs "to illuminate" the content. Although he ultimately directed most of his energy toward the visual arts (sculpture and the graphic arts), Barlach continued to write. It is likely, as several scholars have suggested, that his literary, graphic, and sculptural work are all inextricably interrelated and that in many instances his sculptures are elaborations on his literary "sketches."

Trained as a decorative ceramicist, Barlach made a living during the early decades of the twentieth century by making war memorials commissioned by the Weimar Republic. (Most were subsequently dismantled by the National Socialist Party because of their failure to conform to what the party regarded as a more "uplifting" and ultimately less challenging and more deeply ideological view of humanity.) Throughout his life Barlach sought to escape the entanglements of twentieth-century sculpture by resisting the urge to move to Berlin, where most serious "high" artists lived, instead remaining in the small town of Gustrow. For Barlach, it was in such a town where art, refusing to answer to any utopian calls, truly fulfilled its symbolic function by serving the emotional needs of the community.

The Young Wife, made in 1922, is an excellent example of the strong impact of the myths of Russian peasant life and art on Barlach's poetics. Like most folk artists, Barlach found the human body to be the most suitable vehicle for communicating spiritual as well as physical experience. Rather than represent humanity as heroic—even godlike—Barlach saw the simple, plain form of the lowly Russian peasant as expressing better than any other form the glorious achievements as well as the tragic fate of human existence.

The influence of the myth of folk art and his belief that it could communicate more directly the serious concerns of humanity is also symbolically expressed in Barlach's preference for direct wood carving, which harkened back to pre-Renaissance art (the "golden" age of northern folk art), in which human values were communicated through simple wood crucifixes and devotional objects made throughout European villages. In *The Young Wife* this simple, direct sculptural process is the perfect correlation to the plain peasant woman and italicizes the heroic stature of simple peasant life: the woman's dedication to her spouse and to the family that will soon follow.

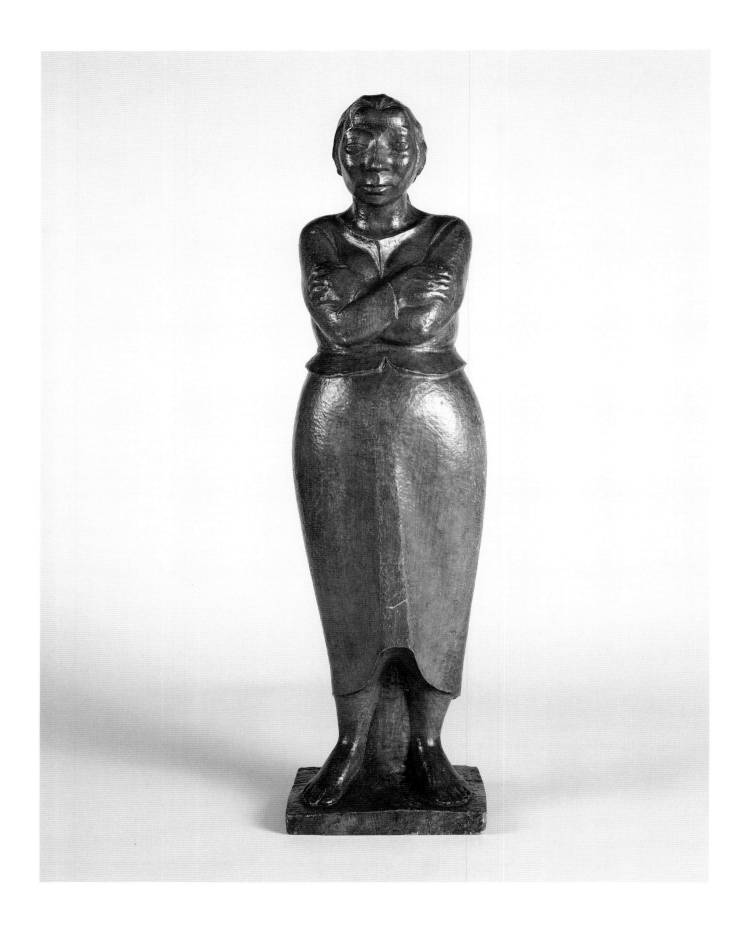

The success of Barlach's art, as expressed in *The Young Wife*, is due to his creation of an art form that could communicate the tragic beauty of human existence without relying on representations of raising the dead, ruling nations, or even making great works of art, but in the heroic simplicity of everyday life. And Barlach's greatest accomplishment is thus his ability to comprehend and then express the universal nature of human existence—both its heroic and its tragic character—through the very unexceptional people with whom he shared his life.

DANIEL A. SIEDELL

NOTES

1. George Heard Hamilton, *Painting and Sculpture in Europe: 1880–1940* (Middlesex, England: Penguin Books, 1986), 188.

2. Quoted in Alfred Werner, *Ernst Barlach* (New York: McGraw-Hill, 1966), 13.

JACQUES LIPCHITZ (1891–1973)

Bather (Baigneuse), 1923–25

BRONZE EDITION 2/7 79 X 32 X 27 IN. UNIVERSITY OF NEBRASKA, BEQUESTS OF FRANCES SHELDON AND ADAMS BROMLEY SHELDON 1961.U-344

One of the major sculptors of the twentieth century, Jacques Lipchitz played a central role in the development of Cubist sculpture in France during the 1910s and 1920s. In the 1930s he turned to a highly expressive representational style and began to execute symbolic public monuments in France and later in the United States, where he settled in 1941. Born in the town of Druskieniki, Lithuania, Lipchitz attended schools in Bialystok and Vilna and then left for Paris in 1909 to study sculpture. He enrolled briefly at the Ecole des Beaux-Arts before switching to the Académie Julian, and attended evening sketch classes at the Académie Colarossi. Under the influence of this academic training, Lipchitz worked in a style of idealized naturalism until 1912.

Moving to Montparnasse in that year, Lipchitz became friendly with a group of young avant-garde painters including Amedeo Modigliani, Chaim Soutine, and Diego Rivera. Through Rivera, Lipchitz met Picasso in 1913. Picasso's paintings, along with the Cubist-inspired sculptures of Raymond Duchamp-Villon and Umberto Boccioni, inspired Lipchitz to investigate Cubism in his own work. He made his first Cubist sculptures in 1914 by simplifying figural forms into geometric elements defined by arcing and angular contours. By 1915–16 he was rendering his figures as slender, architectonic shafts of interpenetrating vertical and horizontal planes, derived from the cutout planes of Synthetic Cubism. The curving lines that suggested shoulders or eyebrows and the small circles representing eyes were all that prevented these works from being seen as complete abstractions.

After 1916 Lipchitz abandoned planar, architectural structure and returned to more recognizably human proportions and volumes, interpreted through the Analytic Cubist devices of angular fragmentation and multiple viewpoints. From 1917 to 1919 Lipchitz created standing bathers, musicians, Harlequins, and Pierrots whose bodies were broken down into complex assemblies of interlocking geometric masses, with flat, convex, and concave surfaces and curved and angular edges. He also typically incorporated into their compositions diagonal thrusts defining imaginary rotation around a twisting axis and encouraging the viewer to move around them. In the early 1920s Lipchitz once again simplified his forms and produced more-massive figures, now frontally oriented like the ancient Egyptian, archaic Greek, and African statues he greatly admired.

Lipchitz originally designed his *Bather* of 1923–25 to occupy a niche in the new museum building being constructed in Merion, Pennsylvania, by his patron, Dr. Albert C. Barnes. The monumental figure, seventy-nine inches high, far exceeds the modest, tabletop scale of Lipchitz's earlier sculptures and was conceived by the artist as a "large scale summary" of his "previous findings" in the realm of Cubism.[1] With the *Bather,* Lipchitz said:

> *I was returning to the problem of creating a cubist figure, free-standing in surrounding space, creating that space by its axial pivot. The legs are placed firmly at right angles to each other, and the circular movement is suggested by the curvilinear forms of the drapery enclosing the arm, actually enclosing space. In its final form, I think it is a successful work, despite and perhaps because of the long period of struggle that went into its making; but, at the same time, it was in a sense my farewell to literal cubism, the record of the moment when it was no longer necessary for me to concentrate on the vocabulary of forms, when I could move on to a sculpture of themes and ideas.[2]*

Beginning in the late 1920s Lipchitz did indeed depart from "literal cubism" and concern himself more with "themes and ideas," rendering mythological and biblical subjects in a boldly expressive style of swelling, curvilinear volumes. But Lipchitz's

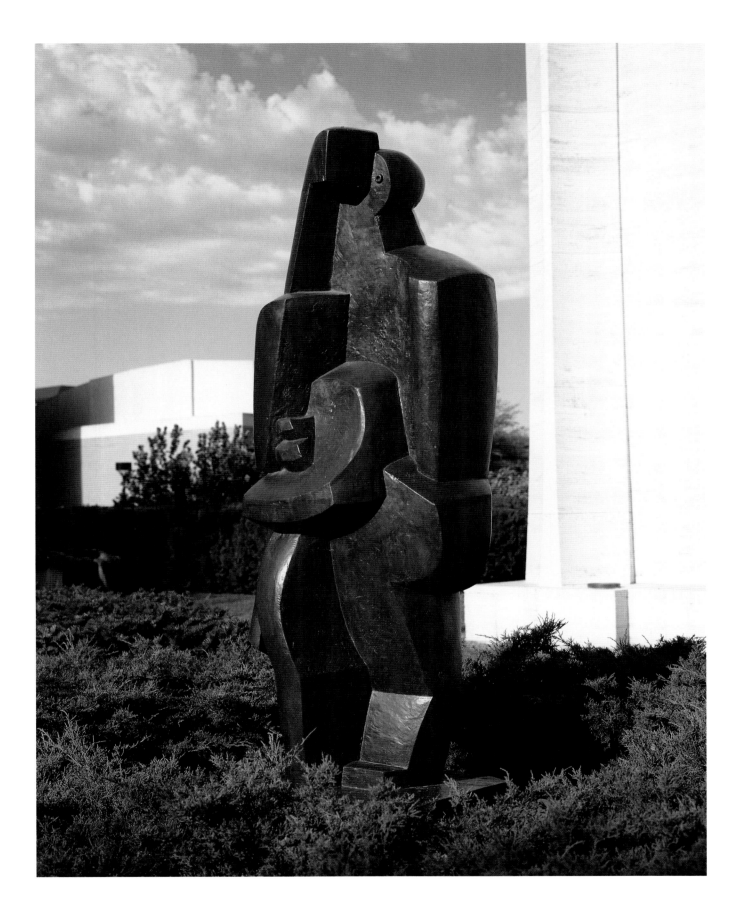

49

original Cubist discipline continued to inform his balancing of solids and voids, and inspire his exploration of multiple viewpoints. Near the end of his life, Lipchitz affirmed, "I have continued to use the cubist point of view, continued to refresh myself at the springs of this fundamental grammar."[3]

DAVID CATEFORIS

NOTES

1. Jacques Lipchitz, with H. H. Arnason, *My Life in Sculpture* (New York: Viking Press, 1972), 74.
2. Lipchitz, 74.
3. Lipchitz, 74.

ALEXANDER ARCHIPENKO (1887–1964)

Sarcophagus of Angelica (Angelica: Variation 8), 1925

An energetic contributor to the development of Cubist sculpture in France during the 1910s, Alexander Archipenko enjoyed a long and prolific career in the United States after 1923. He was born in Kiev, Ukraine, and studied art there from 1902 to 1905. From 1906 to 1908 he worked and exhibited in Moscow, before moving to Paris. Archipenko attended the Ecole des Beaux-Arts for a mere two weeks before rejecting academic instruction and studying independently in the Louvre. There he found Egyptian, Assyrian, archaic Greek, and early Gothic art that inspired his own experiments in the simplification and abstraction of the figure. In 1910 Archipenko began exhibiting with the Cubists in the Salon des Artistes Indépendants, and the next year began showing with them in the Salon d'Automne. In 1912 he joined the Cubist group Section d'Or, with which he would exhibit for several years. In the same year he opened his own art school in Paris and had a one-man exhibition in Hagen, Germany. Archipenko spent the war years, 1914–18, in Nice, and in 1921 moved to Berlin, where he opened another art school. In 1923 Archipenko immigrated to the United States and founded yet another art school, in New York City. He became an American citizen in 1929 and spent the rest of his career working and teaching at schools and colleges throughout North America.

Archipenko made his most important contributions to the development of modern sculpture during his first decade in France, from 1908 to 1918. Particularly influential was his incorporation of a void or "negative space" into the mass of a figure, which served to reverse the traditional conception of sculpture as a solid surrounded by space. He also adapted the new technique of collage to sculpture by assembling figures out of various materials such as painted wood, glass, and metal; in some cases, he also incorporated mirrors and found objects into his compositions. Finally, Archipenko created a new medium, the "sculpto-painting," a form of brightly polychromed relief combining actual three-dimensional volumes with painted, illusionistic ones.

In the 1920s Archipenko largely abandoned these bold formal experiments to work in a style of mannered naturalism, exemplified by the *Sarcophagus of Angelica.* Set on a black marble block, this small bronze rendition of a sleek, reclining female nude is coated in a shiny gold patina that reflects surrounding light and serves to dematerialize its streamlined forms. To enhance the fluency of the figure's contour, Archipenko has edited the woman's anatomy, omitting her left arm below the shoulder and her legs below the upper thighs.

The sculpture is designed to be viewed from the frontal plane of reference, with the woman's head seen in profile. Her carefully modeled and incised features rise from a narrow chin and petite mouth to a slender, straight nose, and a large, almond-shaped eye, surmounted by a pencil-thin brow. A smooth, helmetlike coiffure frames her face, while three horizontal rows of tiny incised circles along her neck suggest strings of pearls. The woman's torso is twisted toward the frontal plane to display her firm, round breasts and svelte abdomen. Her surprisingly powerful right arm, which arches over the graceful torso, is almost Michelangelesque in its swelling muscularity, providing a fascinating physical contrast to the slim waist, small head, and delicately tapered right hand.

The subject of this sculpture is Archipenko's German wife, Angelica Schmitz (1893–1957), whom he married in 1921 and portrayed numerous times in the 1920s. Granddaughter of the Berlin painter Bonaventura Genelli (1789–1868) and daughter of the Berlin architect Bruno Schmitz (1858–1916), Angelica Schmitz was herself an expressionist sculptor. She exhibited under the name of Gela Forster and was a founding member of the Sezession Gruppe 1919 in Dresden. Tall, blonde, and strikingly beautiful, Angelica Schmitz has been described as "an overpowering Brunhilde type . . . cold, composed, and sophisticated."[1] Her marriage to Alexander Archipenko was a stormy one, yet by all accounts he remained in love with her until her death.

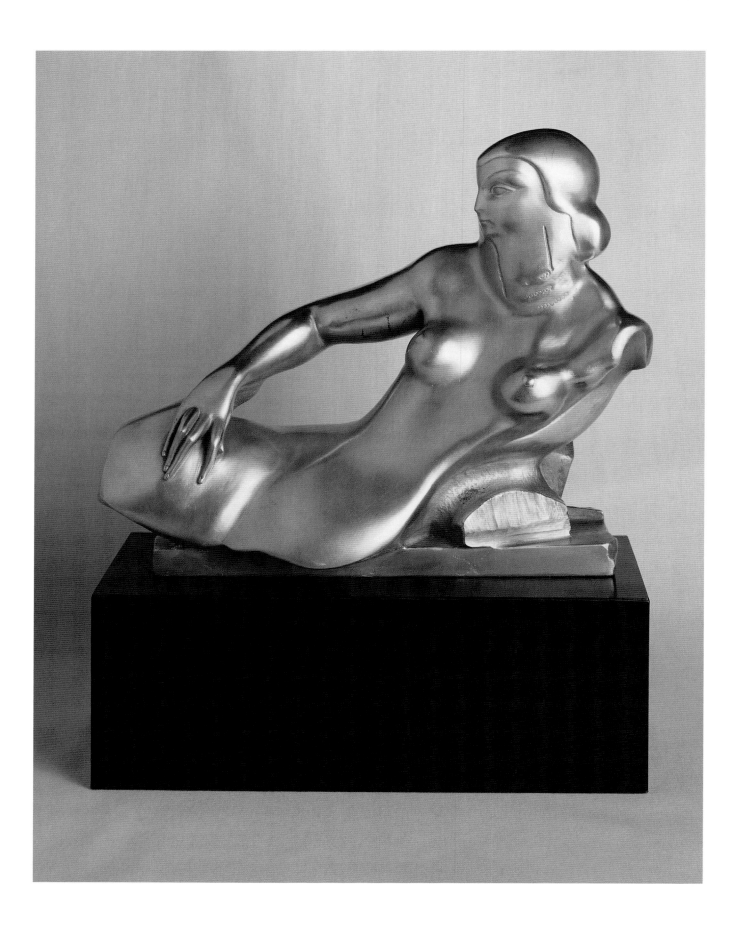

Surely it was love that motivated him to create the *Sarcophagus of Angelica* as a fancifully premature memorial to his bride, who was then still in the prime of life. In designing the work, Archipenko doubtless drew inspiration from ancient Etruscan sarcophagi, which feature smiling effigies of the dead as they appeared in life, reclining happily on the lids of their own stone coffins. Angelica's twisting pose and powerful arm also suggest the influence of Michelangelo's famous recumbent figures on the tombs of Giuliano and Lorenzo de' Medici. Through the incorporation of such references, Archipenko's *Sarcophagus of Angelica* succeeds in both memorializing and immortalizing its subject.

DAVID CATEFORIS

- -

NOTE

1. Katherine Janszky Michaelsen, "Alexander Archipenko 1887–1964," in *Alexander Archipenko: A Centennial Tribute*, exhibition catalogue (Washington DC: National Gallery of Art, 1986), 55.

GASTON LACHAISE (1882–1935)

Floating Figure, 1927

BRONZE EDITION 3/7 50 ½ X 90 ¾ X 25 IN. UNIVERSITY OF NEBRASKA, BEQUESTS OF FRANCES SHELDON AND ADAMS BROMLEY SHELDON 1969.U-701

© THE LACHAISE FOUNDATION

In vivid detail Hilton Kramer portrayed Gaston Lachaise as the young Frenchman debarked in Boston, in January 1906: "a sculptor by ambition, a craftsman by trade, a passionate and romantic foreigner, unable to speak a word of English, his mind filled with the poetry of Baudelaire, Verlaine, and Rimbaud, and in feverish pursuit of a mistress (herself a married woman with a child) ten years his senior."[1] About 1902 Lachaise had met Isabel Nagle, "a young American person who immediately became the primary inspiration which awakened my vision."[2] Over the decade and a half of his amorous quest in France and the United States, and in the years after their marriage in 1917, her imposing presence prompted Lachaise's repeated treatments of the female for which he is best remembered.

His obsession with a unique feminine ideal prompted Marsden Hartley's observation that Lachaise "saw the entire universe in the form of a woman."[3] The sculptor claimed that his figures, characterized by large hips and weighty breasts, expressed "the glorification of the human being, of the human body, of the human spirit, with all that there is of daring, of magnificence, of significance."[4] By exaggerating some physical attributes and diminishing others, he developed an erotic expressionism in a series of female figures "radiating sex and soul."[5]

In 1928, a decade after his first one-man show in New York, Lachaise presented his most important dealer show, at the Brummer Gallery in New York. Included in that exhibition were the products of a recent and remarkable creative burst: his familiar modern women, as well as portrait busts and "masks," and new work based on fragments of figures. Of particular note was the debut of two monumental sculptures: a newly cast bronze of *Standing Woman* (also titled *Elevation,* 1912–27), and the plaster for his equally imposing *Floating Figure.* The former represented the weighty earth-bound dignity of his Isabel—an ideal, reminding one admirer of "a priestess from another planet."[6] The latter was its opposite—"Woman of the sky, Woman of the earth"[7]— equally grand in proportion, yet loosed from gravity's strictures and the laws that govern lesser figures.

Airborne women were a favorite Lachaise motif, their ascension marking the triumph over mundane life and the elevation to a spiritual plane. None was more triumphant than the grand *Floating Figure.* It was preceded by studies in pencil and clay.[8] The preliminary model (1924) was cast in two states: in the earlier, the feet and right arm below the elbow were abruptly cut, leaving the long left arm to rhyme with the paired legs; in the second, the left arm was amputated at the shoulder, increasing the figure's sense of lightness and slight imbalance. In the final, enlarged version of *Floating Figure,* Lachaise restored her feet and limb, but the reattached arms were not articulated in conventional Western fashion; rather, they flow in a single curve from shoulder to fingertip, echoing the gestures of Indian sculpture admired by Lachaise. The smooth dome of the head suggests a move beyond the fashionably severe coiffures of the 1920s to timeless baldness; the head, which echoes the spheres of the breasts, is oddly diminished in scale to the rest of the figure, implying the subservience of intellectual powers to sexual. The triad of head and breasts is balanced by the massive buttocks and thighs in what e. e. cummings, Lachaise's early friend and champion, described as "one gradual collocation of breasts and thighs, one single effortless glide of volume."[9] In amplifying the loci of life force and sexual distinction, Lachaise created what Gerald Nordland aptly summarized as "a fantasy of sexually laden forms."[10]

For such a fantasy, the airborne position was especially apt. On the one hand, it suggested Woman's qualities as "celestial, perhaps divine," the "embodiment of cosmic concepts."[11] On the other, it suggested concepts more carnal than cosmic. In Freud's scheme—which was broadly popularized (and vulgarized) in the 1920s—the experience of flight and ascension were analogous to sexual arousal. Hence, Lachaise's monument of the *Floating Figure* simultaneously celebrates both spirit and flesh, an apotheosis of Woman.

CHARLES C. ELDREDGE

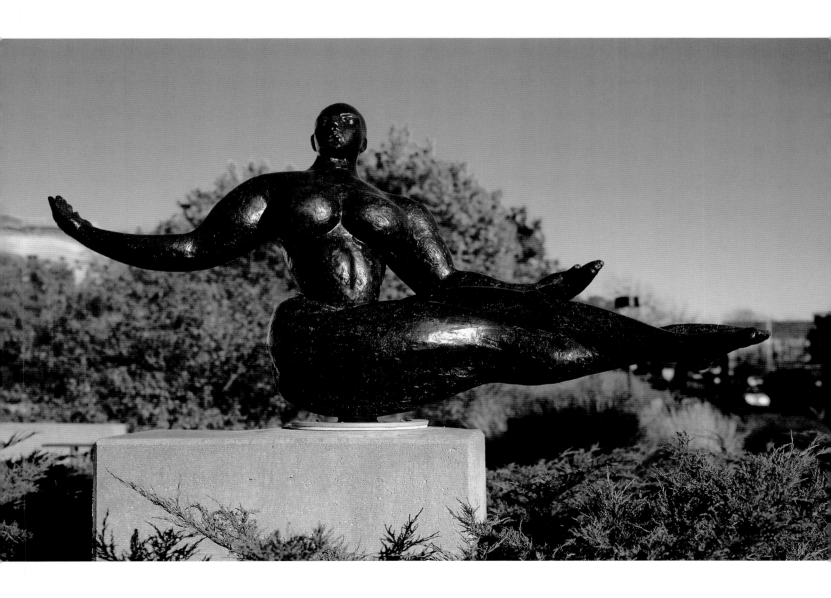

NOTES

1. Hilton Kramer, "Gaston Lachaise," in *The Sculpture of Gaston Lachaise* (New York: Eakins Press, 1967), 10–11.

2. Gaston Lachaise, "A Comment on My Sculpture," *Creative Art* 3 (August 1928): xxiii.

3. Marsden Hartley quoted in Patterson Sims, *Gaston Lachaise: A Concentration of Works from the Permanent Collection of the Whitney Museum of American Art*, exhibition catalogue (New York: Whitney Museum, 1980), 8.

4. Quoted in "Yankee Wife Is Model for Lachaise's Women," *Art Digest*, February 1, 1933, 15.

5. Quoted in "Radiating Sex and Soul," *Time*, January 17, 1964, 66.

6. Henry McBride, "Here's to Lachaise," in *Lachaise*, exhibition catalogue (New York: Brummer Gallery, 1928), n.p.

7. Herschel B. Chipp, *Gaston Lachaise*, exhibition catalogue (Palm Springs CA: Desert Museum, 1982), 21.

8. Lachaise's pencil drawings, describing figures with dramatically simplified contour lines, were generally explorations of form and pose independent of specific sculpture projects. His development of a specific study for *Floating Figure* suggests something of the work's exceptional importance in the artist's mind and practice.

9. e. e. cummings, "Gaston Lachaise," *Creative Art* 3 (August 1928): xxxvii.

10. Gerald Nordland, "Gaston Lachaise: An Introduction," in *Gaston Lachaise, 1882–1935: Sculpture and Drawings*, exhibition catalogue (Los Angeles: Los Angeles County Museum of Art, 1964), n.p.

11. Gerald Nordland, *Gaston Lachaise, The Man and His Work* (New York: G. Braziller, 1974), 130; Lincoln Kirstein, *Gaston Lachaise, Retrospective Exhibition* (New York: Museum of Modern Art, 1935), 16.

BORIS LOVET-LORSKI (1899–1973)

On Parade (Stallions), c. 1929–31

BRONZE 18 ¼ X 36 ⅞ X 5 ¼ IN. NEBRASKA ART ASSOCIATION, GIFT OF CARL ROHMAN IN MEMORY OF LORRAINE LEMAR ROHMAN 1988.N-687

When Boris Lovet-Lorski's sculptures were shown at Washington's Corcoran Gallery in 1939, critics praised their "emphasis on rhythm and . . . flowing line," evidence of "the sense of decoration bred in the bone of Russians of his day."[1] For the Lithuanian-born graduate of St. Petersburg's Imperial Academy of Art, the decorative traditions of his native region were echoed in his love of sumptuous materials and elegant form, aesthetic traits that distinguished his work in the United States, where he arrived in 1920.

In the 1920s and '30s, he was known for his carvings of exotic materials from around the world: black Belgian marble, rare blue Egyptian marble, lava from the isle of Stromboli, ancient Assyrian lemon wood, onyxes from Brazil, Morocco, and Mexico. He sought to suit the medium to his theme, hence a *Winged Sphinx* of Egyptian granite. Portrait subjects also could evoke different materials; for instance, he claimed that "the classical features of Greta Garbo cry for pure ivory Carrara marble," whereas lava best suited the Latin actress Dolores Del Rio, and child star Shirley Temple would be perfect in pewter, because it was a naive metal.[2]

Lovet-Lorski was an accomplished modeler as well as a carver. His first major exhibition, in New York in 1925, featured "great fairylike Tanagras," plaster models of imaginative musical compositions that would be cast in bronze for purchasers.[3] Their success enabled his move the following year to Paris, where he thought even stonecutters and foundrymen "have the souls of artists."[4] During his Parisian years (1926–32), he enjoyed great vogue, especially for his portrait commissions; by 1929 Lovet-Lorski was maintaining studios in New York, Paris, and Rome, where he completed bronze busts of the Italian royal family.

Throughout this period, Lovet-Lorski continued his personal, formal experiments. Beginning in 1929, these included decorative compositions of cast metal, whose flattened forms emphasized the stylized silhouettes of animals or dancers. These subjects were inspired by ancient Minoan murals from Crete, which, for the Slavic sculptor, represented the lure of classical Mediterranean culture, what one of his admirers termed "the ancient power of the South."[5] It was this southern legacy that led to his interest in legendary subjects (e.g., *Diana and Hounds*) and idealized form of the human body; it even may have prompted his own experiment with nudism.[6]

The slim-limbed, barrel-chested pair of horses called *On Parade* was crafted in various metals. In addition to the Sheldon's bronze, another bronze casting was finished with a patina of polished gold; a slightly smaller version was cast in brass.[7] In their elegant proportions and athletic grace, Lovet-Lorski's prancing equines are similar to other decorative creatures from the period, such as Paul Manship's airborne bulls or the wrought-iron animals that decorate Wilhelm Hunt Diederich's fire screens and chandeliers, and with them helped define the Art Deco style that reigned for a decade from the mid-1920s.

By 1940 crippling arthritis had forced Lovet-Lorski to stop carving and led to changes in his modeling style; his later portrait bronzes have rougher, expressive textures different from the silken surfaces of his prime. In his final years he abandoned sculpture altogether and turned to painting, creating abstractions that he could still describe as "drawn from Mediterranean memories."[8]

CHARLES C. ELDREDGE

--

NOTES

1. *Washington Star*, February 5, 1939; unidentified clipping in American Art/Portrait Gallery Library, Smithsonian Institution, Washington DC (hereafter cited as AA/PG Library).

2. Martin H. Bush, *Boris Lovet-Lorski: The Language of Time*, exhibition catalogue (Syracuse NY: Syracuse University, 1967), 58–60.

3. Jules Bois, *Boris Lovet-Lorski*, exhibition catalogue (New York: Reinhardt Galleries, 1925), n.p.

4. Bush, 56.

5. Salvatore Quasimodo, introduction to Bush, *Lovet-Lorski*, 12.

6. "Lovet-Lorski Seeks Nudity on Bali Isle," *Chicago Evening Post*, March 20, 1928; clipping in AA/PG Library. This account of the sculptor's plan to travel to Bali, "island of nudity and beautiful stone," noted, "Clothes do not appeal to Lovet-Lorski, even for himself. Last summer he tried going without raiment while in Connecticut, but was annoyed and distracted by the presence of others who wore it."

7. For other examples, see auction catalogue, Parke-Bernet Galleries, New York, May 11, 1967, lot 76. Such animals appeared as well in other media with which Lovet-Lorski occasionally worked, such as ceramics and drawings.

8. *Paintings by Boris Lovet-Lorski*, exhibition catalogue (New York: World House Galleries, 1963), n.p.

SAUL BAIZERMAN (1889–1957)

Serenity, 1932–39

HAMMERED COPPER 39 X 27 X 15 IN. UNIVERSITY OF NEBRASKA, F. M. HALL COLLECTION 1954.H-348

Saul Baizerman worked as a professional sculptor in New York City at a time when modernism, with an emphasis on abstract style and innovative technique, was the dominant influence on American artists. Although Baizerman's pursuance of nontraditional sculpting methods aligned him with his contemporaries, he divorced himself thematically from the prevailing focus on social realism. Transcending immediate concerns of human welfare, Baizerman explored lofty, heroic themes, as in *Serenity.*

Because of the work's inspirational effect, *Serenity* was chosen as an entry for the U.S. Sculpture Pavilion of the Brussels International and Universal Exhibition. Held in 1957, this was the first World's Fair since 1939 and had the overall theme of "a broader, deeper humanism in this atomic age."[1]

During his lifetime and posthumously, Saul Baizerman has been respected for energetic workmanship whereby dramatic, evocative human shapes were created by hammering sheets of copper. His completed work—mostly heads and torsos—ranges from three inches to ten feet in dimension. As a sculptor, he initially worked with bronze on a statuette series depicting life in New York City, but he switched to copper because of its light weight and portability for traveling exhibitions.

In 1954, in a letter to Norman Geske, then director of the Sheldon Memorial Art Gallery, Baizerman described the process by which he had executed *Serenity,* recently purchased for the Sheldon collection: "I conceive my work as though done in the round. . . . Hammering the metal without the aid of fire produces a steel-like strength. Heat can only be harmful. . . . The form-harmony of *Serenity* was planned as an arrangement of endlessly moving lines, with the simplicity of effect executed by a concentration of its many modulations of planes rather than of their elimination."[2]

Challenging to viewers is Baizerman's ability to manipulate thin metal so that hollow, lightweight figures appear stolid and formidable, as though they are cast bronze. The process of converting ideas from his sculptural imagination to physical reality did not come easily for Baizerman. He said, "How do I know when a piece is finished? When it has taken away from me everything I have to give. When it has become stronger than myself. I become the empty one, and it becomes the full one. When I am weak and it is strong, the work is finished."[3]

LONNIE PIERSON DUNBIER

NOTES

1. George W. Staempfli to Norman A. Geske, March 26, 1957, Sheldon Memorial Art Gallery Archives.

2. Saul Baizerman to Norman A. Geske, April 11, 1954, Sheldon Memorial Art Gallery Archives.

3. Quoted in Robert Goodnough, "Baizerman Makes a Sculpture," *ARTnews* 51 (March 1952): 66.

MALVINA CORNELL HOFFMAN (1885–1966)

Egyptian Dancer, Nyota Inyoka (Exotic Dancer), 1932

GILT BRONZE 12 X 14 ¹/₂ X 5 ³/₈ IN. UNIVERSITY OF NEBRASKA, GIFT OF MR. AND MRS. CARL H. ROHMAN 1990.U-4439

Malvina Hoffman titled her personal history, published the year before her death, *Yesterday Is Tomorrow.* The title aptly conveys her view of her life and work—a life respectful of order and tradition, mindful of the contribution of predecessors and of the ways in which past accomplishment informs future endeavor, and sensitive to the role that a gifted individual may play in that grand humanistic continuum we call civilization. Put simply (and she would have preferred it that way), she was a conservative. In private life patrician in taste and with a strong sense of noblesse oblige, she was in her career as a sculptor totally committed to nurturing and enriching the centuries-old tradition of figurative art.

Born in New York of fortunate parentage (her father was a concert pianist), she studied at the Art Students League and profited additionally from the guidance of Herbert Adams, Gutzon Borglum, and Daniel Chester French. In 1910 she went to Paris to study with Auguste Rodin, whom she regarded as the most gifted contemporary legatee of the classical-Renaissance tradition. She seems not to have been awed by the great man, but she did acknowledge the indelible impress of his "power and scope." His influence is perhaps most apparent in the seriousness with which she approached her art, the vigor of her modeling, and her constant striving to imbue her work with emotional and symbolic content.

In Paris (where she encountered Anna Pavlova, subsequently a good friend) she first explored the theme of dance. It was a theme that was to interest her for the rest of her life. Our piece dates from midcareer and is a spinoff from an intimidating assignment undertaken for Chicago's Field Museum. This was a commission to do a hundred heads, busts, and figures for the museum's Hall of Man, a task that occupied her from 1927 to 1932 and required a trip around the world.

The Sheldon's *Egyptian Dancer* reflects this anthropological thrust, confirming what she called her "natural interest in far-off countries and peoples" and her fascination with "primitive and religious ceremonial dancing." Traversing Southeast Asia and India afforded her abundant opportunity to study and draw dancers, and she was especially concerned, she said, to capture the grace and movement that springs from the "muscular coordination of perfectly balanced, evenly developed young bodies." Our bronze exemplifies the success of this effort.

Probably Malvina Hoffman would have regarded the Hall of Man collection and related heroic or ideal pieces as her most consequential work. However, most critics today prefer her sensitive portrait studies of famous contemporaries such as Henry Clay Frick, Ignace Paderewski, and Wendell Willkie, which locate her in a tradition descending from Augustus Saint-Gaudens, Daniel Chester French, and other masters of the American Renaissance. Her fidelity to a refined and traditional naturalism—in the face of twentieth-century innovation and experiment—has guaranteed her a reputation of modest dimensions. But it is a reputation that will not diminish.

ROBERT SPENCE

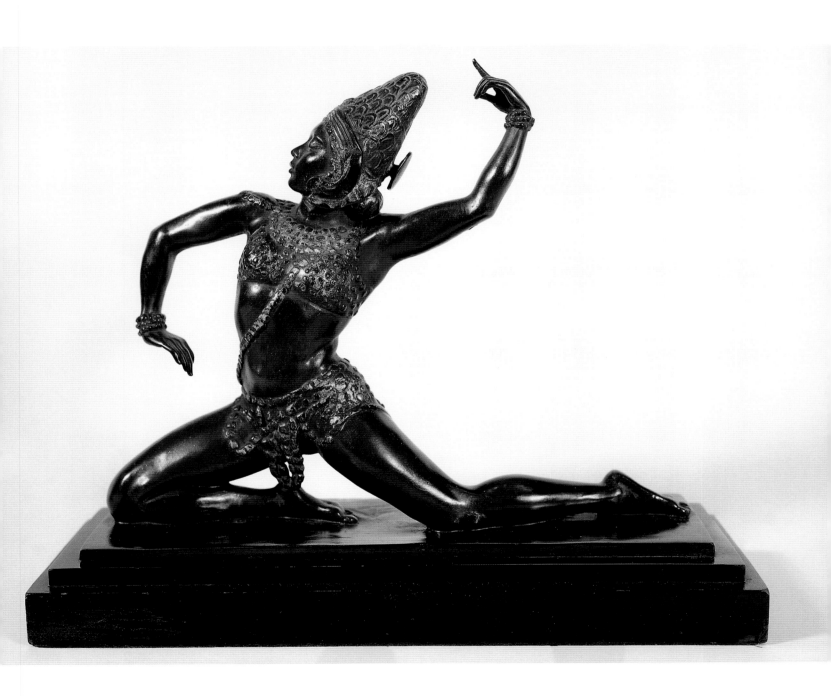

MAURICE STERNE (1878–1957)

Seated Figure, 1932

BRONZE 22 ½ X 12 ½ X 16 IN. UNIVERSITY OF NEBRASKA, F. M. HALL COLLECTION 1942.H-229

In 1933 the Museum of Modern Art in New York held a retrospective exhibition of Maurice Sterne's painting and sculpture, the first one-man show the museum had given to an American artist. Sterne once admitted, "I am intellectually incapable of appreciating abstract art," and he appears to be a conservative choice as standard-bearer for the museum.[1] Yet his career recapitulated the typical experimentation and searchings of American modernists for an authentic personal and cultural source for abstraction. Sterne's Seated Figure in marble appeared in the retrospective as an example of the latest phase of his career, the archaizing realism of the 1920s and 1930s. A subsequent bronze version is the one owned by the Sheldon.

Like other early American modernists such as Jacob Epstein and Max Weber, Sterne was a Russian Jew from a well-to-do and well-educated family who immigrated to America after the expulsion of the Jews from Moscow in 1889. Before leaving Moscow, Sterne won a scholarship to the Kommisarsky Art Academy but could not enroll; in New York, while working in a factory, he took classes at the National Academy of Design. He later wrote that he found the instruction stultifying, but at graduation in 1899 he won four first prizes and in 1904 the academy's Mooney Award for travel to Paris.[2]

In Paris he was both attracted to and repelled by the Impressionists and Postimpressionists. His "most strenuous struggle was against preconceived, deeply rooted traditional art standards," Sterne declared, but he never really wavered in his conviction that art must remain connected to nature and the object outside the artist. Although befriended by modernists Leo and Gertrude Stein, he never admired Pablo Picasso, and he only came to appreciate Paul Cezanne when he realized that he was a realist, albeit "a realist who observed reality not only with his eyes." Sterne lived briefly with Auguste Rodin in Rome, and cited Rodin's comment that Henri Matisse was a "murderer" of the female nude in support of his own bias for less expressively distorted nature.[3]

From 1904 to 1910 Sterne traveled and studied in France, Germany, and Italy. In 1908 a patron funded a trip to Greece, where he saw in archaic sculpture a version of the "primitive" very different from the Hellenistic sculptures that had dominated Western taste in the eighteenth and nineteenth centuries. He spent six weeks studying the Delphi Charioteer and its "perfect, stark reality," produced, he believed, by artists untroubled by modern existential angst. Upon returning to Italy, he began his first sculptures in wax on a plaster base. In 1911, at age thirty-four, when another patron offered to pay his expenses to a "Garden of Eden where life would be simple, where beauty might exist as part of daily living," Sterne left for Egypt, India, Burma, Java, and finally Bali, returning to Europe only in 1914.[4]

Like many of his fellow artists in Paris, Sterne believed that artists in nonindustrialized, small-scale societies produced abstract art naturally and unself-consciously as an expression of their culture, unlike the modern European artist, who was alienated from any "natural" style or tradition. However, the poverty, disease, and colonialism he observed in his travels prevented him from finding such a "living vital tradition," particularly one where he could study the nude human body among people who were unself-consciously accustomed to it in daily life. In Bali, he finally found men and women who he thought looked like ancient Greeks and possessed a group consciousness rather than "modern" individualism.[5]

Sterne's Balinese paintings founded his reputation as a "barbarian" modernist in New York and remain his best-known work. They depict Balinese religious rituals, dances, and nudes in landscapes in a style based on Cezanne's building up of form and space with blocks of color. Sterne had returned to New York once World War I began, and in 1917 he married Mabel Dodge, host of an important Greenwich Village intellectual and artistic salon. He encouraged her to travel with him to Taos, New Mexico, where he hoped the Pueblo Indians would provide him with the

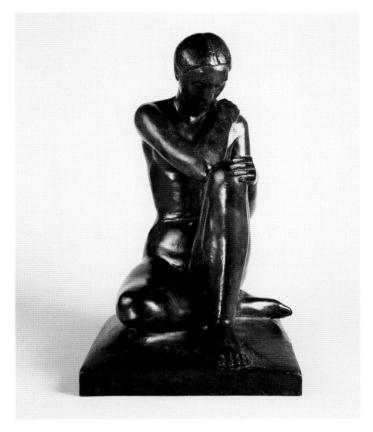

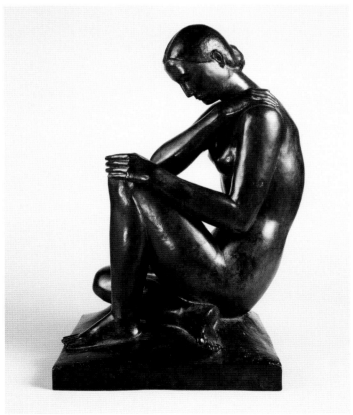

same experience of an authentic art and culture that he'd known in Bali. Dodge, along with other leading patrons and dealers of modern art, supported Sterne throughout his career. Gertrude Vanderbilt Whitney bought a painting from him in 1907, the Steins encouraged him, Paul Cassirer in Berlin showed his work, Albert Barnes bought his drawings, and in 1926 Duncan Phillips bought a painting resulting from his most recent absorption with the human figure.

Sterne had spent three years in the early 1920s posing the nude female model in "every imaginable position" among the "peasants" of Anticoli-Corrado, Italy, but the resulting paintings and sculptures were a rejection of his earlier primitivism. As he wrote to the critic Henry McBride while sitting in front of a drawing by Michelangelo, the "unconscious 'naive' inventions of self-consciously unconscious 'masters' are no longer taken seriously" and instead art must be learned, and learned thoroughly.[6]

This new classicism sold quite well.[7] It also brought new institutional recognition. In 1926 Sterne won his first commission for a public sculptural monument, for the Rogers-Kennedy War Memorial in Worcester, Massachusetts. He was elected president of the Society of American Painters, Sculptors and Gravers in 1929 and received a gold medal in 1930 from the Corcoran. *Seated Figure* belongs to this period, and in 1932 a critic for the *New Republic* suggested how Sterne's style could be interpreted as abstract: "It is a lovely statue, full of this sculptor's power to isolate a space, for example the triangle between and below the rib-cage . . . into a unit resting in volume, so to speak, as well as on the surrounding anatomy."[8] The seated woman is contained, with bent limbs forming a series of right angles from almost every point of view. The care with which the motif is repeated throughout the sculpture caused critics like Lewis Mumford at the *New Yorker* to accuse him of overintellectualized and labored forms and to complain about his retreat from the "primitive vitality" Mumford admired in the Bali paintings.[9]

To some extent, Sterne was caught in the debate over what modern American art should be. Whether it ought to be vitally rooted in the soil of a particular place—in Sterne's words, whether only another onion can paint an onion—or whether, as Sterne believed, significant art must aim for the universal.[10] For him, the study of the female nude provided essential contact

with universal nature, on which he could develop a personal—and so national too—formalist idiom. In 1942 the Milch Gallery, which handled his work, sent a bronze *Seated Figure* (from a mold taken from the 1932 marble) to a Nebraska Art Association exhibition, where it was purchased for the Sheldon's collection.

WENDY J. KATZ

--

NOTES

1. Sterne quoted in Charlotte Leon Mayerson, ed., *Shadow and Light: The Life, Friends and Opinions of Maurice Sterne* (New York: Harcourt, Brace & World, 1965), xxix.

2. Mayerson, 35–37.

3. Sterne quoted in Mayerson, 42, 44; his account of Rodin's comments, 107.

4. Sterne quoted in Mayerson, 66–67, 83.

5. Sterne, "A Note by the Artist," in *Maurice Sterne: Retrospective Exhibition 1902–1932* (New York: Museum of Modern Art, 1933), 13. On his travels, see Mayerson, 86–100.

6. Sterne's letter excerpted in Mayerson, 187–88.

7. In addition to Phillips, a "collector of Italian Renaissance art" bought twelve paintings and drawings at the same 1926 exhibition, while Ralph Pulitzer bought a seated nude woman in marble, *The Awakening*, with bronze versions going to Adolph Lewisohn and Galen Stone. See Mayerson, 197.

8. Stark Young quoted in Mayerson, 215.

9. Lewis Mumford excerpted in Mayerson, 217–18.

10. See Sterne's comments in Mayerson, 186; and from the 1932 Whitney debate "Nationalism in Art—Is It an Advantage," quoted in Mayerson, 210–12.

WILLIAM ZORACH (1889–1966)

Torso, 1932

BRONZE EDITION 4/6 31 ½ X 16 X 11 IN. UNIVERSITY OF NEBRASKA, GIFT OF DR. AND MRS. FRANK STANTON 1962.U-386

© ZORACH COLLECTION LLC

Trained as a painter before World War I, William Zorach emerged in the 1920s as a leading modern American sculptor and an influential advocate of direct carving. Zorach typically portrayed human and animal subjects, individually or in pairs, in a solid, powerfully simplified manner. He taught at numerous schools, including the Art Students League from 1920 to 1960, and from the 1930s onward received numerous commissions for monumental public sculpture.

Born in the town of Eurburg, Lithuania, Zorach immigrated with his family to Port Clinton, Ohio, in 1891. The family moved to Cleveland in 1894. In 1902 Zorach began to work for a commercial lithography firm in Cleveland, and from 1903 to 1907 he studied nights at the Cleveland School of Art. Zorach went to New York City in 1907 and studied painting at the National Academy of Design from 1908 to 1910. In 1910 he traveled to Paris, where he discovered the work of the Fauves and Cubists and exhibited his own Fauve-inspired paintings at the 1911 Salon d'Automne. Returning to Cleveland in 1911, Zorach again worked for a year as a lithographer. In December 1912 he moved to New York City and married Marguerite Thompson, an American painter he had met in Paris. Both Zorachs participated thereafter in major modernist exhibitions in New York, including the 1913 Armory Show and the 1916 "Forum Exhibition of Modern American Painters."

William Zorach's turn to sculpture began in 1917, when he carved a wooden bas-relief. By 1919 he was making freestanding wooden figures, and in 1922 he abandoned oil painting to concentrate on carving. He developed a keen sensitivity to the distinctive qualities of the different types of wood and stone he employed, and came to believe that the shape of each sculpture should express the inherent nature of the material from which it had been carved. Rejecting Renaissance naturalism, Zorach drew inspiration from African, Chinese, Mesopotamian, Egyptian, and archaic Greek sculpture. In his own mature sculpture he suppressed surface detail and created massive, generalized forms and compact volumes. "Real sculpture," he wrote in 1925, "is something monumental, something hewn from a solid mass, something with repose, with inner and outer form; with strength and power."[1]

The Sheldon *Torso* was cast in bronze from a stone version Zorach carved in 1932 out of gray Labrador granite.[2] Labrador granite is an extremely hard material that resists easy cutting; Zorach responded to the stone's obdurate nature by rendering the torso in a broad and simple manner, with a frontal orientation and symmetrical pose that seem to echo the outlines of the original granite block. Zorach also played with the anatomical proportions of the torso to create an intriguing tension between naturalism and idealism, dynamism and stasis. The lower portion of the figure appears more naturalistic and motile; the swelling hips and sensuously rounded buttocks connote a specific female body, while the gently advancing right thigh and corresponding weight shift convincingly suggest incipient movement. In contrast, the upper torso appears rigid and abstract; the narrow waist, elongated abdomen, high-set breasts, and perfectly squared shoulders are strongly idealized.

Though it is a partial figure, devoid of limbs and head, Zorach's *Torso* is aesthetically complete. Eliminating rhetorical gesture and facial expression liberated the sculptor from the demands of storytelling and psychological communication, and allowed him to concentrate on creating a calm, self-sufficient artistic unity. The result successfully demonstrates Zorach's belief that "a human body . . . or any part of the human body . . . can be reduced to simple elementary forms and become a thing of sheer beauty."[3]

DAVID CATEFORIS

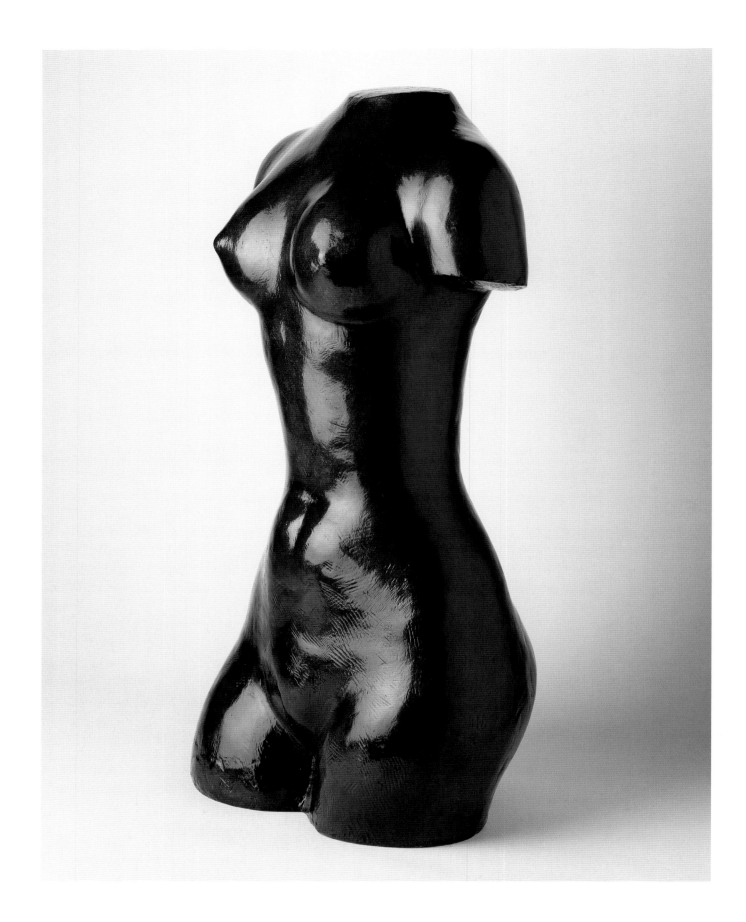

--

NOTES

1. William Zorach, "The Sculpture of Edgar Degas," *Arts* 8 (November 1925): 264.

2. On the granite *Torso*, see Roberta Kupfrian Tarbell, "Catalogue Raisonné of William Zorach's Carved Sculpture," vol. 2 (PhD diss., University of Delaware, 1976), 442–46.

3. William Zorach, *Zorach Explains Sculpture: What It Means and How It Is Made* (New York: American Artists Group, 1947), 7.

JOHN B. FLANNAGAN (1895–1942)

Elephant, 1937–38

BLUESTONE 8 X 5 X 9 ½ IN. UNIVERSITY OF NEBRASKA, F. M. HALL COLLECTION 1939.H-201

Nothing in his training at the conventional Minneapolis School of Art pointed to John Flannagan's creative assault on a tree in Woodstock, New York, from which in 1924 he hacked an eighteen-foot-tall sculpture of a horse.[1] He had turned to wood-carving only a year or so earlier, while working as a farm-hand for the artist Arthur B. Davies, the guiding spirit of the landmark Armory Show, who had encouraged his employee's new work in three dimensions.

More than painting, or even photography and the graphic arts, sculpture was dominated by principles of academic tradition well into the 1920s; innovation was slow and difficult. The critic Thomas Craven cautioned would-be Michelangelos, "If there is any one less necessary in America than a painter, it is a sculptor. The lot of the sculptor has always been hard; it is far from easy in Europe; in the United States it is hellish."[2] His somber prognosis came in 1925, the same year that Flannagan received his first large exhibition, when twenty-one of his carvings were shown at the Whitney Studio Club in New York. For innovative American sculptors between the world wars, direct carving offered a modern alternative to virtuoso modeling, the academic legacy of an earlier era; it was in that manner that Flannagan shaped his wood works, including the Maverick signpost horse and his Whitney exhibits.

About 1925 Flannagan began working in stone, using the same direct-carving technique to free the image from the mass. Stone quickly replaced wood as his favored medium, and by 1929 he had come "to hate the sight of the woodblock." The blockiness of quarried stone in time also fell from favor; in lieu of it, Flannagan gathered fieldstones in the countryside, natural materials that were freely available in abundant variety, an important consideration during hard economic times. More important, they conformed to Flannagan's evolving objective, which he described as "a sculpture with such ease, freedom and simplicity that it hardly feels carved, but rather to have always been that way." He explained that "the shape of the stone does not determine the design. More often the design dictates the choice of the stone because I like to have them appear as rocks left quite untouched—and natural."[3] From the late 1920s, animals figured increasingly in his carvings. The "eternal nature of the stone," he wrote, suggested a "deep pantheistic urge of kinship with all living things and fundamental unity of all life," an "occult attraction" conveyed more readily through "the humbler life forms . . . than the narcissistic human figure."[4]

The Sheldon's *Elephant* is part of a small herd that Flannagan included in his carved menagerie.[5] The earliest example (1926, The Detroit Institute of Arts) was carved in plaster, an unusual material for the artist. Two stone beasts followed in 1929–30, the carvings retaining the strong sense of rounded mass from which the concentric forms of animal were liberated with minimal cutting. Like the Sheldon *Elephant,* that in the Whitney Museum of American Art is carved of a bluestone unique to the Woodstock region that became a favorite material for Flannagan; its natural color was appropriate to the grayish beast, a matching of stone and subject that he often sought. Another pachyderm, smaller in size, was carved from stone in Ireland, where Flannagan worked in 1930–31. The Sheldon's is the fifth and final treatment of the subject.

CHARLES C. ELDREDGE

70

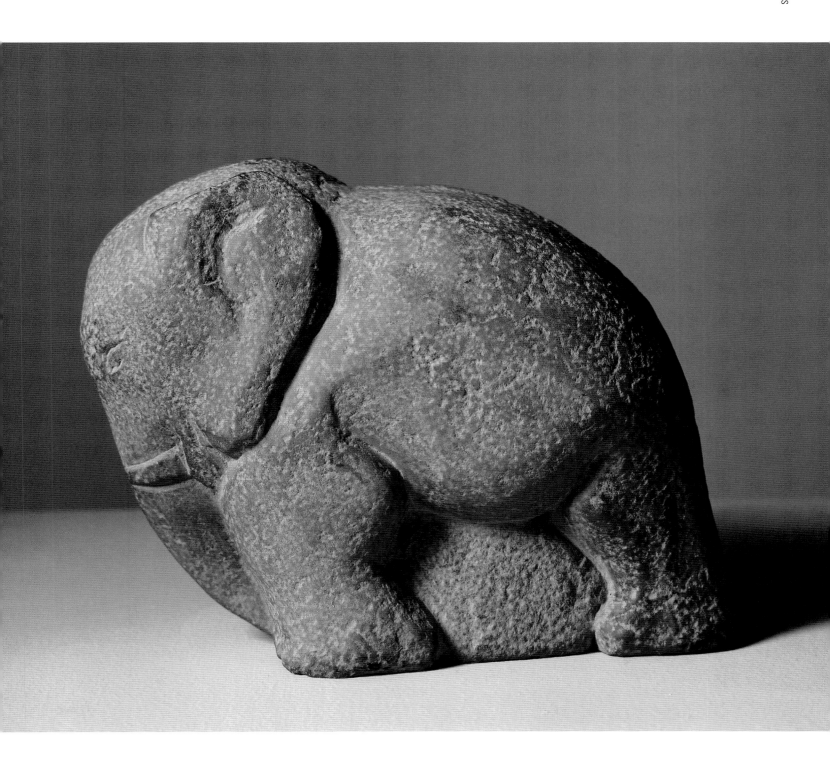

--

NOTES

1. The horse was intended as a signpost to the site of a summer festival on a farm known as Maverick, which was an annual feature of the Woodstock artist colony. According to historians' accounts, the Woodstock festivals of that era were makeshift affairs that featured "open-air entertainment . . . unmanageable crowds and well-founded rumors of nude midnight orgies." Karal Ann Marling, introduction to *Woodstock: An American Art Colony, 1902–1977*, exhibition catalogue (Poughkeepsie NY: Vassar College Art Gallery, 1977), n.p. Revelers were guided by Flannagan's landmark to the boisterous proceedings in the pastoral Catskills countryside. The horse was an early instance of the direct-carving technique by Flannagan, who was a recent arrival at the prominent Woodstock art colony.

2. Thomas Craven, "Men of Art: American Style," *American Mercury* 6 (December 1925): 430.

3. John B. Flannagan to Carl Zigrosser, Woodstock, New York, May 1929, *Letters of John B. Flannagan*, ed. Margherita Flannagan (New York: Curt Valentin, 1942), 21, 20.

4. John B. Flannagan, "The Image in the Rock," *Magazine of Art* 35 (March 1942): 90.

5. Information on Flannagan's elephant motifs is from "Catalogue for Sculpture by John B. Flannagan," in Robert Joseph Forsyth, "John B. Flannagan: His Life and Works" (PhD diss., University of Minnesota–Minneapolis, 1965), 307–15.

IBRAM LASSAW (1913–2003)

Intersecting Rectangles (Intersecting Angles: The Mondrian), 1940

STEEL, LUCITE 27 ³/₈ X 19 ¹/₂ X 19 ¹/₄ IN. UNIVERSITY OF NEBRASKA, OLGA N. SHELDON ACQUISITION TRUST 1986.U-3883

© ZABRISKIE GALLERY, NEW YORK NY

Born in Alexandria, Egypt, Ibram Lassaw moved with his family in 1921 to New York, where at an early age he became interested in art. Recalling that he had seen and was influenced by the "International Exhibition of Modern Art" organized by the Société Anonyme in 1929 at the Brooklyn Museum, Lassaw was one of the first U.S. sculptors to engage the European modernist tradition. By 1933 he was making sculpture that resembled the biomorphic forms of Joan Miró and Constantin Brancusi. Lassaw was especially affected by Alexander Calder's kinetic art exhibited in the highly influential "Cubism and Abstract Art" show curated by Alfred H. Barr Jr. at MOMA in 1936. In a revealing 1955 review, the art critic Martica Sawin wrote that "even without the benefit of direct contact with the European sculptors or their work, [Lassaw] was one of the first American sculptors to work in an abstract style, abandoning the solid mass for the incorporation of space."[1]

Perhaps even more significant is the extraordinary breadth of Lassaw's work. "I am constantly absorbed . . . by things that are going on around me, the motion of people in the streets, the movement of clouds, the patterns of branches. There is no duality, everything is nature."[2] And this "constant absorption" allowed him to be influenced by and to assimilate nearly every major aesthetic and philosophical innovation from the late thirties through the fifties. His work of the late thirties consists most importantly of an American translation of biomorphic surrealism, an aesthetic that was highly influential not only for fellow sculptors David Smith and Theodore Roszak but also for painters, such as Arshile Gorky and Jackson Pollock. Lassaw also adeptly assimilated the Cubist-Constructivist aesthetic, represented in the United States by László Moholy-Nagy and Piet Mondrian.

Moreover, as the art historian Stephen Polcari has observed, artists at midcentury were obsessed with universal values that were revealed not only in an emphasis on direct art making that made little or no use of preliminary studies but also in a philosophical preoccupation with nonrational perspectives, from Jungian psychology to Eastern mysticism, which provided the interpretive framework for much of the art. Lassaw's work demonstrates both the aesthetic and philosophical depth of what the critic Sam Hunter called "the collective impulse of abstract expressionism."[3] Intimately associated with the most progressive avant-gardists in the United States at midcentury, Lassaw was one of the founding members of the influential American Abstract Artists Group and served as its president from 1946 to 1949. In addition, he was instrumental in starting the Club on Eighth Street, which included among its frequent visitors Franz Kline and Willem de Kooning.

Lassaw's creative power was recognized early on, and his work was included in several major exhibitions of the 1950s, including the important "Abstract Painting and Sculpture" exhibition curated by Andrew Ritchie at MOMA in 1951, "The New Decade" at the Whitney Museum of American Art in 1955 curated by John I. H. Baur, and Dorothy Miller's "12 Americans" at MOMA in 1957.

Intersecting Rectangles (*Intersecting Angles: The Mondrian*) is a major example of Lassaw's assimilation and retranslation of the Cubist-Constructivist aesthetic. Wayne Andersen wrote that "Lassaw's *Intersecting Rectangles* of that year [1940] is the most severely geometrical of his works and predicts his continued involvement with cage constructions during the forties—an interest shared by Isamu Noguchi, Seymour Lipton, Herbert Farber, and other American sculptors."[4] But this work also reveals Lassaw's translation of this aesthetic language into a unique expression of spontaneity, directness, and dynamic movement that characterizes the American interpretation of Constructivism. As Sawin argued, Lassaw "emphasized a reference to organic forms even in his most abstract compositions."[5]

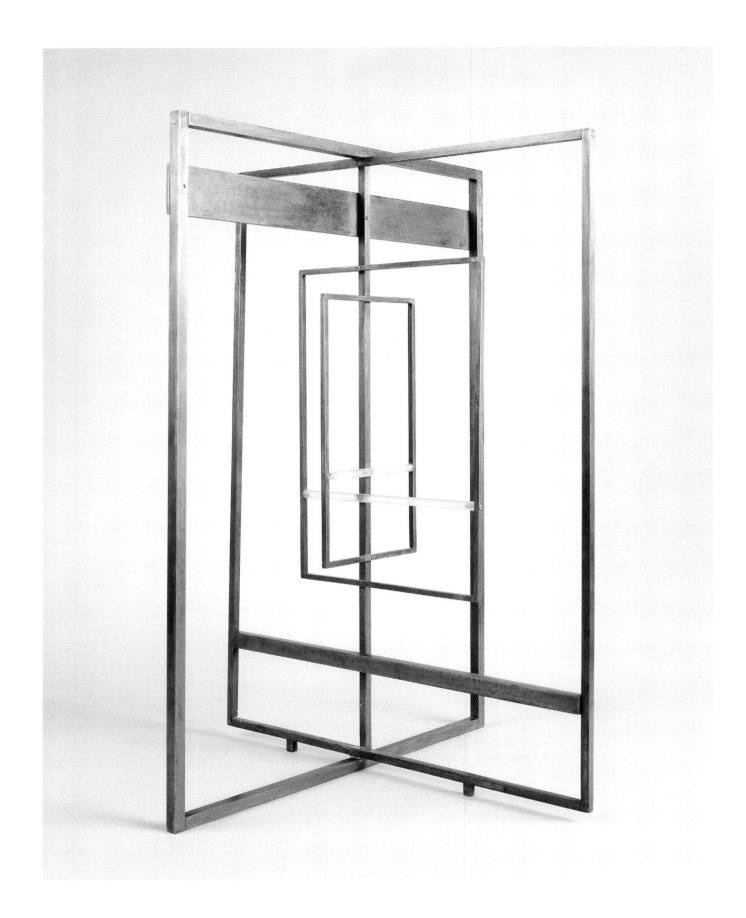

In the last analysis, it is Lassaw's desire to translate and assimilate all influences (whether aesthetic, philosophical, or banal) through the lens of the organic unity of form and content that accounts not only for his unique oeuvre but also for his inextricable ties to the needs and desires of the midcentury art world.

DANIEL A. SIEDELL

NOTES

1. Martica Sawin, "Ibram Lassaw," *Arts Magazine* 30 (December 1955): 25.

2. Quoted in Sawin, 24.

3. Sam Hunter, *The Sculpture of Ibram Lassaw* (Detroit: Gertrude Kasle Gallery, 1968), n.p.

4. Wayne Anderson, *American Sculpture in Process, 1930–1970* (Boston: New York Graphic Society, 1975), 56.

5. Sawin, 25.

THEODORE ROSZAK (1907–1981)

Transverse Polar, 1942

WOOD, FERROUS AND ALUMINUM METAL, PAINT 22 ¹/₂ X 3 ¹/₂ IN. (DIAMETER) UNIVERSITY OF NEBRASKA, GIFT OF CARL H. AND JANE ROHMAN IN HONOR OF GEORGE W. NEUBERT THROUGH THE UNIVERSITY OF NEBRASKA FOUNDATION 2000.U-5076

© ESTATE OF THEODORE ROSZAK/LICENSED BY VAGA, NEW YORK NY

Theodore Roszak was the first American sculptor to assimilate the machine aesthetics of the Bauhaus and create a coherent body of work based on the principles of European Constructivism.[1] Born in Pozna, Poland, Roszak grew up in Chicago, where his family moved when he was two years old. While still in high school he attended classes at the School of the Art Institute of Chicago, and after graduating he enrolled there full-time in 1925. The next year he moved to New York City, where he attended the National Academy of Design, took private painting lessons from George Luks, and studied philosophy at Columbia University. He returned to Chicago in 1927 for further study at the School of the Art Institute, and was also appointed an instructor of drawing and lithography at the school.

In 1929 Roszak won a fellowship that allowed him to travel and study in Europe for two years. He spent the majority of his time in Czechoslovakia, but also traveled to Austria, Italy, Germany, and France. In these countries Roszak encountered a variety of modernist movements, including Cubism, Purism, Surrealism, and the Scuola Metafisica, various aspects of which would influence his painting for the next several years. Most decisive for his subsequent development, however, was his discovery of Constructivism and the Bauhaus, which both advocated the artistic use of modern industrial materials and techniques and envisioned a utopian unity between art, science, and technology.

Following his return to the United States in 1931, Roszak continued to paint, but he also began to experiment with abstract sculpture. From modeling in clay and plaster he quickly turned to construction. In 1932 he made his first machined-metal sculptures, applying the knowledge he had recently gained through courses in toolmaking and industrial design. In 1934 he settled in New York City and set up his own shop with industrial equipment such as lathes and drill presses. In 1938 Roszak was appointed an instructor at the Laboratory School of Design (formerly the Design Laboratory) in New York, an experimental school modeled on the educational philosophy of the Bauhaus. The experience of teaching at the Laboratory School strengthened his interest in making abstract constructions that embodied the technological optimism of the machine age.

Between 1932 and 1945 Roszak fabricated about forty-five constructions, in a wide variety of materials and formats and in styles ranging from geometric to biomorphic abstraction—and occasionally combining aspects of both. Distinctive among these works are numerous "bi-polar" constructions, each composed principally of two slender, teardrop-shaped volumes, symmetrically disposed along a vertical axis, with the two opposing apexes joining to form a central point of balance. Typically, the teardrop, or "polar," elements are made of lathe-turned wood that has been brightly painted in a single color (white, red, or blue), while the joint between them is fabricated of shiny metal. Often appended to the main polar forms are additional geometric elements such as rings, disks, and orbs. The bi-polar structure typically rises from a cylindrical or conical base with a flattened top, the base itself being an integral part of the sculpture.

Roszak likely enjoyed the bi-polar composition for its ability to generate numerous associations—to a figure eight, an infinity symbol, an airplane propeller, or even a human figure, the most traditional of all sculptural subjects. In philosophical terms, he understood the bi-polar sculptures as metaphors for the reconciliation of opposites. Of one example, he wrote that "as *content* [it] relates to the same natural phenomenon as north vs. south pole, heat vs. cold, male vs. female, as well as any polar opposite constituting a basic and fundamental force of opposite. Without the bipolarity of magnetic fields in space, the solar system could not exist. In short, the entire physical and emotional apparatus is dependent on the unique quality of opposing forces."[2]

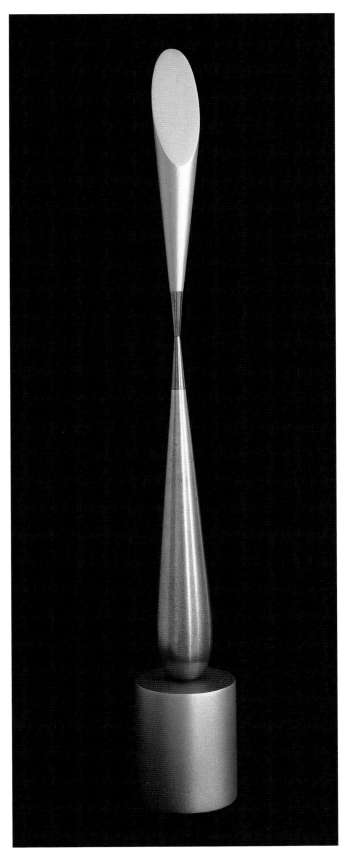
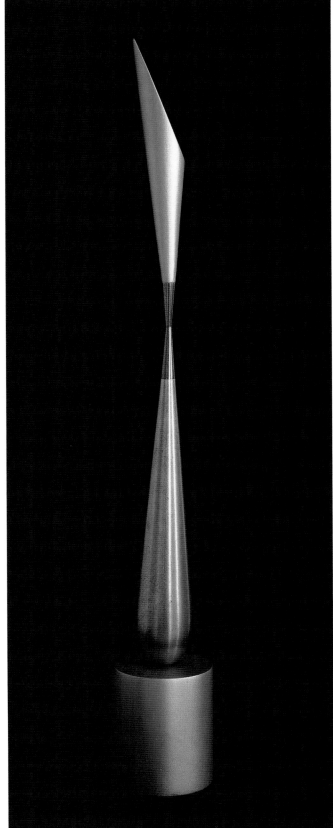

The Sheldon's *Transverse Polar* offers an interesting variation on the bi-polar theme. Seen from the front or the rear, the vertical body of the sculpture presents the figure-eight silhouette characteristic of the bi-polar constructions. However, the top polar segment—made of wood coated with aluminum paint—is not the same shape as the lower one, which is made of aluminum. Rather, the top polar has been neatly sliced crosswise at a sharp angle to give it a flat, elliptical face and, in profile, a pointed apex. Unlike the perfectly symmetrical bi-polar constructions, which, except for their appendages, look the same from all directions, *Transverse Polar* appears to change as the viewer walks around it, with the elliptical face of the top element seeming to expand or contract according to the angle from which it is viewed.

Roszak's decision to give the top segment of *Transverse Polar* a slanted, elliptical face may well have been inspired by Constantin Brancusi's similar treatment of the top of his famous *Bird in Space* (first carved in 1924 and repeated in several later variations), a work that Roszak greatly admired.[3] And Roszak's sculpture, while less aerodynamic than Brancusi's, shares with it a quality of aspiration that may be associated with the idea of flight—an idea that fascinated both artists.

More explicitly expressed in at least four earlier constructions— *Airport Structure* (1932, Newark Museum, New Jersey), *Ascension (Monument for La Guardia Airport)* (1939), and two versions of the *Monument to Lost Dirigibles* (1939–40)—Roszak's devotion to flight connoted enthusiasm for the penetration into the unknown and the constant advance of knowledge through science and technology—an optimistic view of the mechanized future that *Transverse Polar* also evokes. However, by the end of the period in which he made the Sheldon sculpture—the World War II years, which saw Roszak helping to build airplanes for the Brewster Aircraft Corporation and teaching aircraft mechanics—his attitude toward technology had changed. The war brought Roszak to the anguished realization of technology's capacity for incredible destruction, and led him to abandon the machine aesthetic for a more spontaneous form of welded, direct-metal sculpture on mythic and expressionistic themes, which resonated with the anxious mood of the postwar era. While the "constructivist's position . . . has been and is an important one," explained Roszak in 1946, "the world is fundamentally and seriously disquieted and it is difficult to remain unmoved and complacent in its midst."[4]

DAVID CATEFORIS

NOTES

1. Joan Marter, "Theodore Roszak," in *Abstract Painting and Sculpture in America 1927–1944*, ed. John R. Lane and Susan C. Larsen, exhibition catalogue (Pittsburgh: Museum of Art, Carnegie Institute, in association with Harry N. Abrams, 1984), 213.

2. Theodore Roszak, "Statement on *Bi-Polar in Red* for the Whitney Museum of American Art, New York," 1979, quoted in Douglas S. Dreishpoon, "Theodore J. Roszak (1908–1981): Painting and Sculpture" (PhD diss., City University of New York, 1993), 56. Dreishpoon suggests that Roszak's interest in the reconciliation of opposites may have been informed by Marxist political theory—attractive to numerous intellectuals in the 1930s—with its emphasis on "dialectical materialism."

3. So great was Roszak's interest in Brancusi's *Bird in Space* that he made, with what he called "devastating precision," a five-foot-high replica of it. Joan French Seeman, "The Sculpture of Theodore Roszak: 1932–1952" (PhD diss., Stanford University, 1979), 37.

4. Theodore J. Roszak, statement in Dorothy Miller, ed., *Fourteen Americans*, exhibition catalogue (New York: Museum of Modern Art, 1946), 59.

ALEXANDER CALDER (1898–1976)

Snake on Arch, 1943–44

BRONZE 44 X 28 X 18 IN. UNIVERSITY OF NEBRASKA, F. M. HALL COLLECTION 1945.H-258

© 2002 ESTATE OF ALEXANDER CALDER/ARTISTS RIGHTS SOCIETY (ARS), NEW YORK

For any artist, a retrospective exhibition can be a most revealing but daunting experience, and so it was with Calder's show at the Museum of Modern Art, from September 1943 to January 1944. The gathering of works in metal, wood, and wire from nearly two decades charted the development of an abstract sculptural language in his creative inventions of mobiles and stabiles. At the same time, the review of his career contributed to what H. H. Arnason diagnosed as Calder's "fear that he might become enslaved to his materials."[1] As a possible consequence, the artist turned to less familiar media and techniques, among them modeling plaster forms for casting in bronze.

A series of such bronzes constituted his November 1944 show at the Buchholz Gallery in New York. That show met a tepid reception, however, and the artist thereafter abandoned modeling. Calder remembered the collaborative nature of foundry casting as "disagreeable" and dismissed the undertaking as "an expensive venture . . . [which] did not sell very well."[2] (Something of his distaste might be glimpsed in a comical drawing of the sculptures, made at the time, in which a dog lifts his leg to relieve himself against *Snake on Arch.*) Nevertheless, he admitted years later that "I play with the idea, from time to time, of going back to the [bronze] medium."[3] In 1968, when surviving plasters from the original group were rediscovered, Calder authorized the casting of a new edition, limited to six numbered casts of each of eighteen pieces. These later casts, which were featured in a show at the Perls Galleries in New York in 1969, included other two-part sculptures of bronze snakes balanced on supports, but the *Snake on Arch* was not among the survivals and apparently exists only in the small edition of 1944.[4]

The bronzes were exceptional in several respects, including their technique. Calder spoke disparagingly of the modeler's art and materials: "The important thing for me is to avoid an impression of mud piled up on the ground."[5] Hence, his concern for airy mobiles and graceful stabiles. Generally, he was faithful to his favored commonplace materials, eschewing those with cultural associations, such as precious metals or the hallowed bronze of the ancients.[6] Calder attributed his turn to plaster to a remark by a friend, the architect Wallace K. Harrison, who suggested that he try some outdoor pieces in cement.

Following the validation of his work at the Museum of Modern Art, Calder's momentary reversion to, then rejection of, modeling and casting might have ramifications beyond an artist's coming of age. As the son and grandson of master sculptors, both of whom created prominent civic monuments in bronze, Calder's flirtation with the stuff of his fathers might have overtones of filiation as well as aesthetics. The death of his father, Alexander Stirling Calder, in January 1945, within weeks of the Buchholz Gallery exhibition's closing, apparently rendered moot the son's need to continue with bronze casting.

While Arnason remained uncertain whether the bronze experiments "served any useful purpose as a catharsis," he acknowledged that they immediately preceded Calder's entry on "the most fertile and imaginative period of his creative life."[7] The large and simple forms of the bronzes, as well as the public nature of the outdoor setting suggested by Harrison, were prophetic for Calder's future career, which culminated in commissions for civic monuments of a type and scale unimaginable to his forebears. The acrobatic snake balanced precariously on a tripodal arch—a stabile mobile—anticipates Calder's late gigantic architectural stabiles, as Roy Neuberger noted.[8] Many of those monuments, such as *Teodelapio* (1962), in Spoleto, Italy, are composed of multiple arches with dark "arrows" rising to the sky, like a gigantic enlargement of the dark tripod holding an upwardly stretched tail. In the anomalous bronze of 1944 might be found the seed of one of the great civic monuments of the modern era.

CHARLES C. ELDREDGE

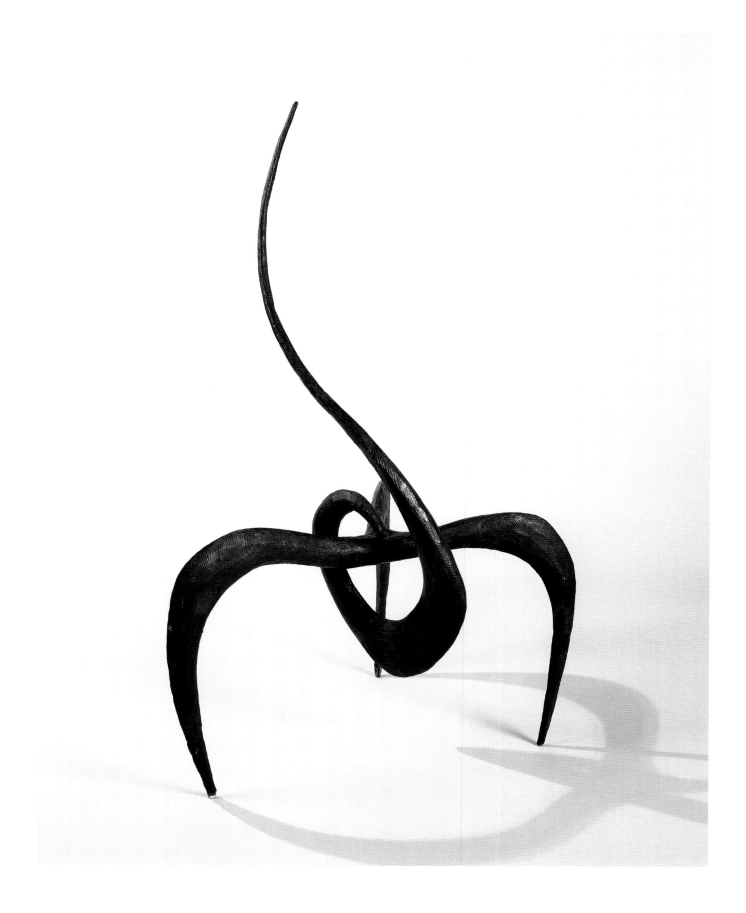

NOTES

1. H. H. Arnason, *Calder* (New York: Von Nostrand, 1966), 69.

2. Alexander Calder, *Calder: An Autobiography with Pictures* (New York: Pantheon, 1966), 196.

3. Calder, 196.

4. *Alexander Calder: Bronze Sculptures of 1944*, exhibition catalogue (New York: Perls Galleries, 1969). *Snake on the Post* (#9) and *Snake on Table* (#10) are both included in the fully illustrated catalogue. Following the Perls Galleries exhibition, Calder donated the surviving plasters to the Smithsonian American Art Museum, Washington DC.

5. Alexander Calder, interview by Yvon Taillandier in *XXe Siècle Review* 20 (March 1959). Reprinted as "No One Thinks of Me When They Have to Make a Horse," in *Homage to Alexander Calder* (special issue of *XXe Siècle Review*), ed. G. di San Lazzaro (New York: Tudor Publishing, 1972), 948. Although Calder had produced a small group of bronzes in Paris in 1930—whimsical animal and circus figures—they seem to have been inspired as much by the proximity of the Valsuani foundry as by any commitment to the medium.

6. When Frank Lloyd Wright requested that Calder's design for a large mobile for the Guggenheim Museum be executed in gold, the artist responded obligingly, "All right, I'll make it of gold, but I'll paint it black." Robert Osborn, "Calder's International Monuments," *Art in America* 57 (March–April 1969): 48.

7. Arnason, 69, 76.

8. *An American Collection: The Neuberger Collection, Paintings, Drawings, and Sculpture*, exhibition catalogue (Providence: Museum of Art, Rhode Island School of Design, 1968), 101.

ALEXANDER CALDER (1898–1976)

Red Disk, Black Lace, 1948

PAINTED STEEL 29 X 65 X 46 IN. NEBRASKA ART ASSOCIATION, GIFT OF MRS. CARL ROHMAN, MR. AND MRS. CARL H. ROHMAN, MRS. OLGA N. SHELDON, MR. AND MRS. PAUL SCHORR JR., MR. AND MRS. ART WEAVER, MR. AND MRS. THOMAS C. WOODS JR., MR. AND MRS. THOMAS C. WOODS SR., AND FIRST NATIONAL BANK OF LINCOLN 1970.N-226

Red Disk, Black Lace is painted steel and exemplifies the delicately balanced mobiles for which Alexander Calder is best known. His sculptures are careful studies in equilibrium and movement, and when wind currents catch these mobiles, they entice the viewer with the fluidity of their movement.

Calder became interested in exploring the kinetic possibilities of sculpture during the 1930s, when he produced wire sculptures and motorized abstractions. During this period sculpture was undergoing a reevaluation, and many artists such as Pablo Picasso, Henri Matisse, and Constantin Brancusi were moving away from traditional approaches to the art form. Calder participated in this reassessment, concluding that "art was too static to reflect our world of movement."[1] This belief led him to experiment with activating his sculptures, resulting in his kinetic works. In this manner Calder was able to capture more accurately the sensibility of a fast-paced world and, at the same time, emphasize sculpture's engagement with space and mass, volume and void.

Calder developed a format that was simple yet visually descriptive. His shorthand vocabulary included abstract flat metal shapes, often with rounded edges, which imbue his sculptures with an organic feel that contributes to the fluidity of his works. He often limited the chromatic range of his mobiles to basic high-intensity hues—red, yellow, and blue, along with black and white.

His sculptures are delicately balanced. Calder explained his method of designing his mobiles: "I begin with the smallest and work up. Once I know the balance point for this first pair of disks, I anchor it by a hook to another arm, where it acts as one end of another pair of scales, and so on up. It's a kind of ascending scale of weights and counterweights."[2]

This meticulous balance is evident in *Red Disk, Black Lace*. It is composed of simple abstract steel plates balanced at the ends of thin wire rods. The steel plates are painted basic black and red and hang suspended, awaiting a current of air to set the mobile in motion.

The result of this careful design and construction is sculptures that are suggestive of various objects in the world around us. Yet they are also unique, presenting us with amusing and whimsical visually engaging works.

CHRISTIN J. MAMIYA

NOTES

1. Quoted in Jean Lipman, *Calder's Universe* (New York: Viking Press, 1976), 263.

2. Quoted in Curtis Cate, "Calder Made Easy," *Horizon* 14 (Winter 1972): 57.

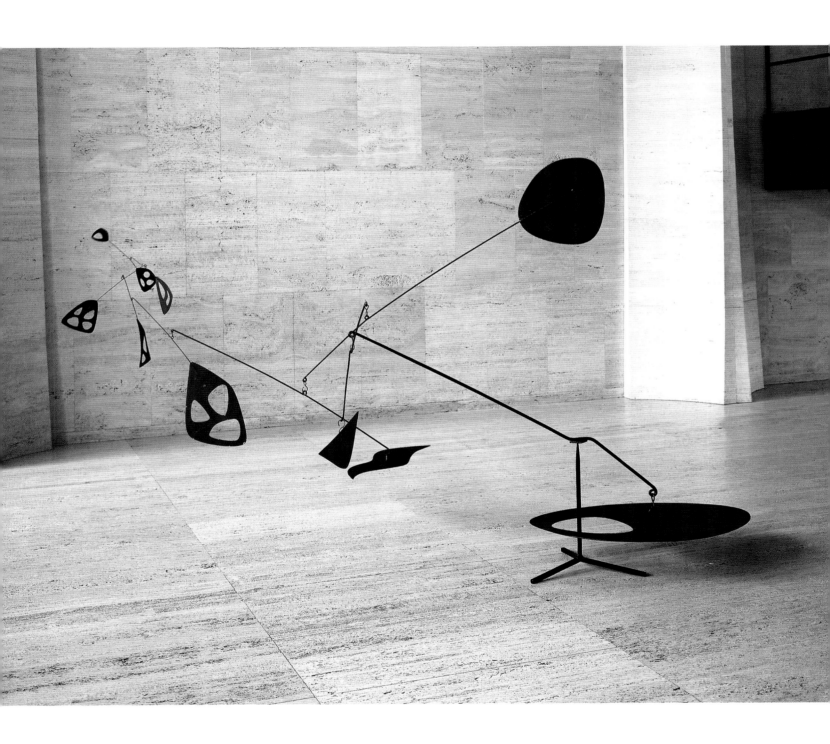

BARBARA HEPWORTH (1903–1975)

Small Form Resting, 1945

MARBLE 9 X 12 ¼ X 10 ½ IN. NEBRASKA ART ASSOCIATION, THOMAS C. WOODS MEMORIAL COLLECTION 1959.N-112

© BOWNESS, HEPWORTH ESTATE

Unlike most sculptors during the 1950s and 1960s, who were committed to the belief that art belonged to the autonomous realm of formal innovation, Barbara Hepworth regarded form as a direct outgrowth of lived experience and thus invested with significant emotive powers. "The work of the artist today springs from innate impulses towards life, towards growth—impulses whose rhythms and structures have to do with the power and insistence of life."[1] For Hepworth, her seemingly "pure" forms, which on the surface seem so detached from a lived experience of the world, are in actuality attempts to communicate both her own personal experience and an experience she feels to be common to all humanity.

According to Hepworth, her forms were strongly influenced by her awareness of the natural environment. Born in Yorkshire, a town consumed by industrialism, Hepworth took trips with her family to the coasts, where, as she stated, "every hill and valley became a sculpture to my eyes."[2] These experiences with the geological mysteries of the northern shore were so great that in 1939 she moved her family (she and the sculptor Ben Nicholson had triplets) to St. Ives in Cornwall to take advantage of an environment ripe with the dynamic rhythms of nature that she recalled from childhood. The key to grasping the full depth of Hepworth's art is to understand its roots in her experience of and sensitivity to organic forms. "I think of the works as objects which rise out of the land or the sea, mysteriously. You can't make a sculpture without it being a thing—a creature, a figure, a fetish."[3] Hepworth's conception of her objects as "fetishes" or "creatures" manifests itself in the care and sensitivity with which she regards their creation. In contrast to sculptural trends since the sixties, whereby artists have often farmed out the actual execution of their pieces to fabricating plants, Hepworth stressed—to the point of obsession—her personal contact with the medium, whether wood or stone. And it is this process of creation, involving a close contact with the medium as she brings the work into being, that gives them this "magical" aura.

Although Hepworth's early work in the twenties was figurative and strongly influenced by Henry Moore's figure abstractions, her intention was never to represent the external "realities" of nature but the internal rhythms that structure this reality. "The consciousness and understanding of volume and mass, laws of gravity, contour of the earth under our feet, thrusts and stresses of internal structure, space displacement and space volume. . . . These are surely the very essence of life, the principles and laws which are the vitalization of our experience, and sculpture a vehicle for projecting our sensibility to the whole of existence."[4]

Small Form Resting is an example of Hepworth's belief in the "consciousness and understanding of volume and mass" as the "very essence of life." To interpret this work as simply an exploration in pure formal composition is to miss the point of Hepworth's art. On the contrary, understood in the context of her symbolic vocabulary, these forms become metaphors for the essential—"internal"—structures of the lifeworld. *Small Form Resting* is thus charged with meaning beyond its formal appearance. The impeccably crafted marble suggests Hepworth's belief in the timelessness of "craft" and human effort, as well as evoking the mysterious, ancient rock formations she experienced on the shores of the British Isles. Moreover, the two forms whose relationship makes up the composition metaphorically express the primal relationships that precariously balance the lifeworld. It is not insignificant that her forms are ovoids, which harken back to ancient philosophies that celebrated circular forms as symbolic manifestations of continuity, fecundity, and eternity.

Hepworth's representational sculptures earlier in her career are significantly related to her completely abstract work by her intention, which remained constant throughout her life, to penetrate through the appearances of the natural world in order to reveal the hidden structures of the lifeworld.

DANIEL A. SIEDELL

NOTES

1. Quoted in J. P. Hodin, *Barbara Hepworth* (New York: David McKay, 1961), 23.

2. Quoted in Michael Shepherd, *Barbara Hepworth* (London: Methuen, 1963), n.p.

3. Quoted in A. M. Hammacher, *Barbara Hepworth: The Family of Man—Nine Bronzes and Recent Carvings* (London: Marlborough Fine Art, 1972), 7.

4. Quoted in Hammacher, 7.

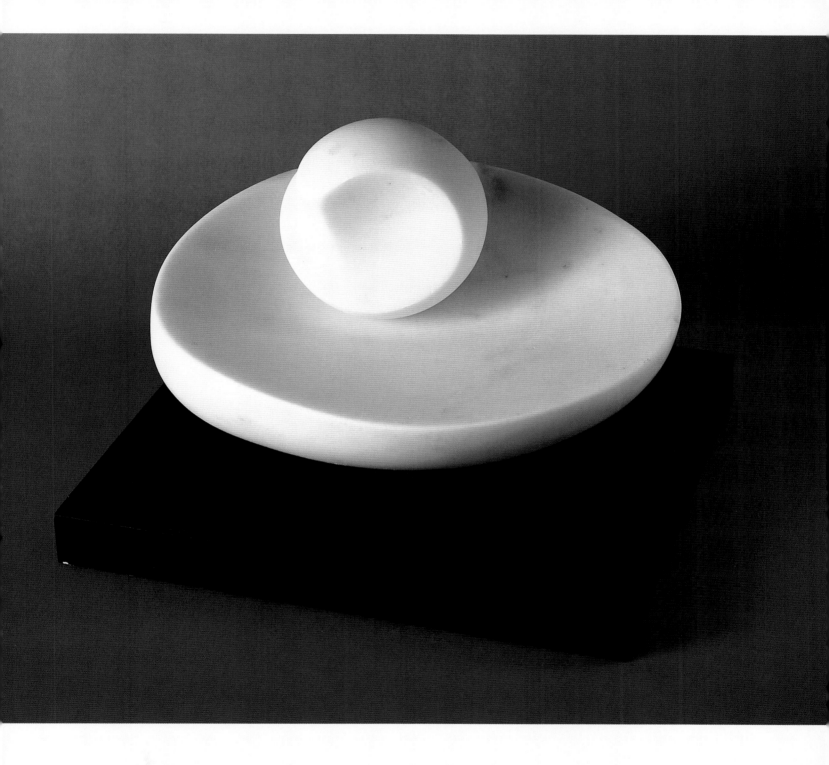

ROBERT LAURENT (1890–1970)

- -

Seated Nude, 1946

ALABASTER 12 ½ X 13 X 8 ¼ IN. UNIVERSITY OF NEBRASKA, F. M. HALL COLLECTION 1947.H-275

© KRAUSHAAR GALLERIES FOR THE ESTATE OF ROBERT LAURENT

It was the sort of military career every draftee dreams of: sculptor and navy airman Robert Laurent spent much of World War I under the command of an appreciative officer who, after discovering his talents, "excused him from most duties, and set the rookie to work carving nudes for the good of his country."[1] Subsequently, the newly naturalized American serviceman was stationed in his native Brittany, where he met his future wife. For Laurent, it was a very satisfying hitch!

Today Laurent is remembered not for his military career but for his artistic one, and particularly the technique of direct carving by which he crafted his nudes for the nation. He pioneered this technique around 1910, upon his return to New York from study in Rome and Paris, where he encountered various influences at a crucial moment in his development. The precocious student visited Pablo Picasso's studio in 1907 and there discovered the Spaniard's innovative sculptures as well as African carvings. Laurent had always been lucky in such encounters, but none was more important than his childhood meeting with the American painter, publisher, and critic Hamilton Easter Field, who recognized the promise of the Breton art prodigy and convinced Laurent's parents to bring him to the United States. From 1901 to 1904 the family stayed with Field in Brooklyn while Laurent studied art with his sponsor before leaving to continue his training in Europe. There, Laurent was impressed by sources as different as Assyrian reliefs, Paul Gauguin's wood carvings, traditional African carvings, and contemporary sculptures by Constantin Brancusi, Aristide Maillol, and Wilhelm Lehmbruck, influences he incorporated into his own maturing style.

Back in the United States in 1910, Laurent was early in his choice of medium (initially wood) and technique (carving, at first in relief, later in the round). For modernists, the engagement of the artist with tools and materials would make carving an attractive alternative to the traditional academic practice of modeling and casting. Instead of the latter's additive process (constructing the image from daubs of clay or plaster) and often collaborative nature (involving artist and foundry workers), carving allowed the sculptor's direct involvement with the subtractive process of freeing the three-dimensional image from a block of wood or stone. The importance of Laurent's choices became apparent after the war, when his example inspired other artists, especially in the circle around Field at his summer school and art colony in Ogunquit, Maine. In 1919, at the Art Students League in New York and at the Ogunquit School of Painting and Sculpture, Laurent began a lengthy teaching career that furthered his influence. About that time he also started carving in stone, eventually developing a particular finesse with alabaster. Between 1920 and his death, Laurent created approximately fifty sculptures in the soft, translucent material, making him this country's alabaster master.

Seated Nude is characteristic of the type: a figurative subject of broad and simple masses, without narrative or allegorical intent; polished forms contrasting with the naturally chalky stone; chiseled evidence of the carving process, suggesting the primacy of materials and technique. Such was the basis of Laurent's strongest work, which in 1940 was acclaimed as "vigorous and forceful, and impressive" while being simultaneously, and perhaps paradoxically, "savage . . . rooted in the primitive and setting aside civilization."[2]

CHARLES C. ELDREDGE

- -

NOTES

1. "Art Takes Laurent from Brittany to Brooklyn," *Life*, June 2, 1941, 64.

2. "Robert Laurent Exhibition: Sculpture Is on View in Corcoran Gallery," *Washington Star*, February 25, 1940, clipping in American Art/Portrait Gallery Library, Smithsonian Institution, Washington DC.

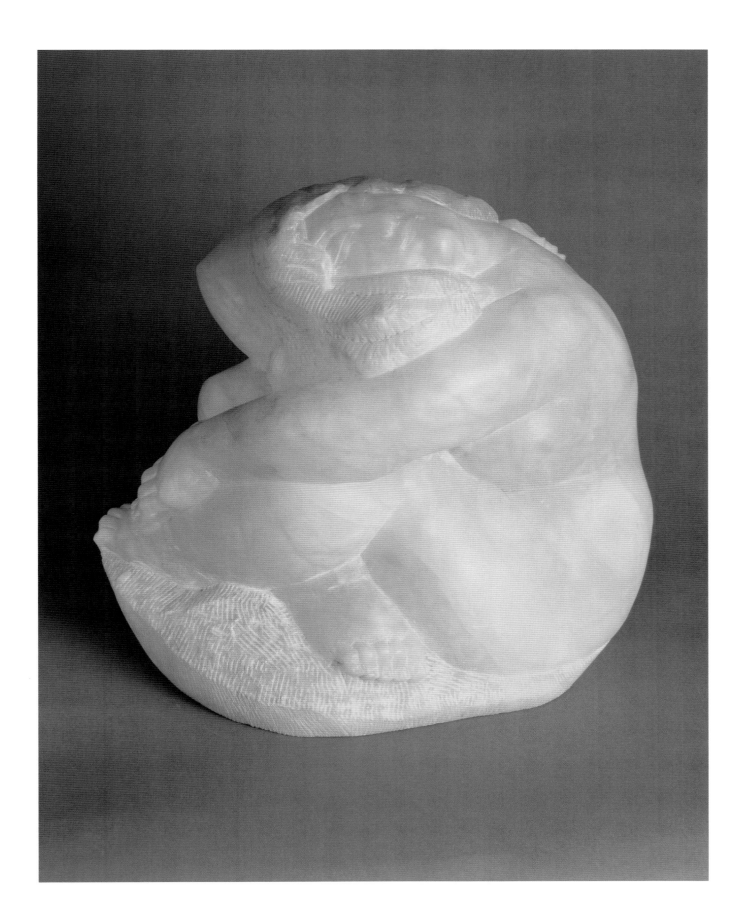

LOUISE NEVELSON (1899–1988)

Mountain Figure, 1946–48

TERRA-COTTA WITH BLACK WAX SURFACE 25 X 8 ³/₄ X 5 IN. UNIVERSITY OF NEBRASKA, GIFT OF MISS ANITA BERLIAWSKY 1958.U-255

Like many artists who began working during the 1930s and 1940s, Louise Nevelson was concerned primarily to rehabilitate the notion that art expresses timeless values common to all humanity. For Nevelson, and for such artists as Barnett Newman, Mark Rothko, Jackson Pollock, and Adolph Gottlieb, it was not art's preoccupation with aesthetic form that made it important, but its mysterious ability to bring to the surface the deep, dark truths of humankind.

During those years, Nevelson studied at the Art Students League in New York and with Hans Hofmann in Munich, in addition to working in Diego Rivera's workshop. Significantly, she also continued her study of modern dance, which she had begun as a child and which remained a serious and important interest throughout her life. Nevelson's experience in dance is not irrelevant to her sculpture; in fact, it can be argued that it informs it. As the art historian Stephen Polcari has noted, the developments of modern dance in the thirties and forties helped shape the belief that the arts could tap into primal energies.[1] Nevelson saw dance as "a link with ancient mysteries and ritual and, ultimately, to the very roots of art itself, while freeing her very earthbound spirit."[2]

The fact that she felt dance played an important role in her art is significant. As exemplified by the dynamic performances of Martha Graham, dance was believed to access experience untapped by the other arts by mysteriously linking the dancer and audience through the joyous affirmation of physical existence. Like dance, Nevelson's sculpture is an attempt to transgress the magical boundary that separates art and life. In the fifties this led her to construct sculptural "environments"—large wood relief structures that create a situation in which the viewer is actively a participant and not a distanced observer. This active, participatory role on the part of the viewer was assumed to be the "natural" function of the work of art in tribal societies, which aestheticized communal *experience* rather than objects.

Nevelson's *Mountain Figure* is intended to tap into primal experience. The "primitive" medium of cast stone and the "archaic" subject matter, which seems to function more as a totem for ritual activity than as an objet d'art, suggest her concern for retrieving the magical power of art long suppressed by civilization. In her later work—which is an extension of her sculpture in the thirties—this interest in the primal and magical is communicated through her environments.

In order to appreciate the expressive depth of her later work in other than the purely aesthetic terms it is often perceived, it is seminal to understand the symbolic intention of her earlier work of the thirties, of which *Mountain Figure* is an important example. It is an excellent manifestation of the powerful symbolic burden borne by the visual arts during the thirties and forties.

DANIEL A. SIEDELL

NOTES

1. Stephen Polcari, *Abstract Expressionism and the Modern Experience* (Cambridge: Cambridge University Press, 1991), 49.

2. Jan E. Adlmann, *Louise Nevelson,* exhibition catalogue (Rockland ME: William A. Farnsworth Library and Art Museum, 1979), 29.

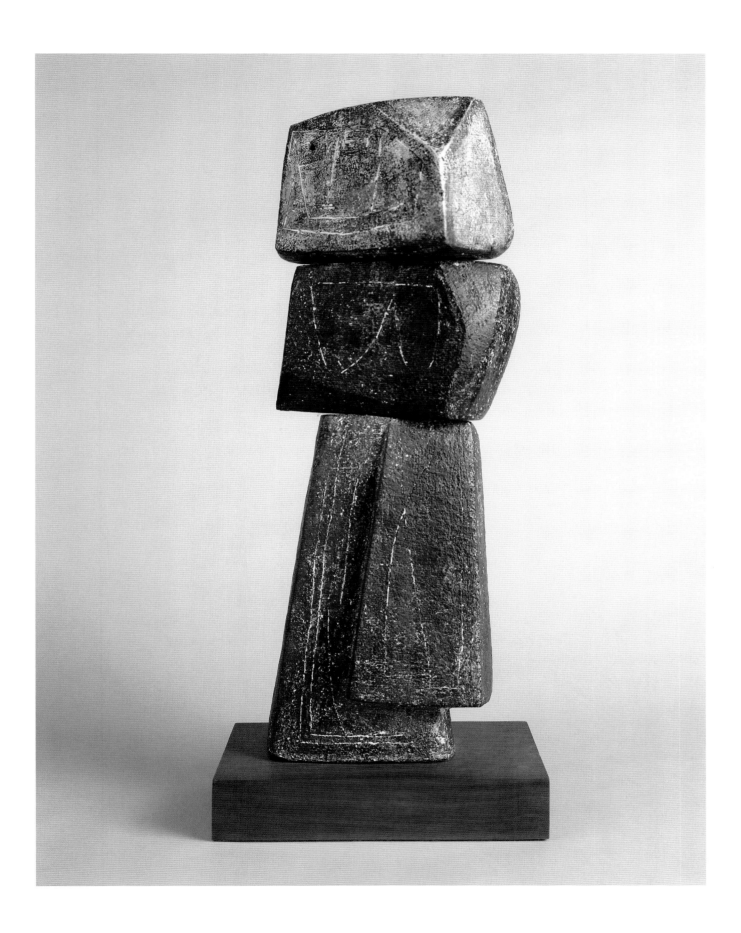

LOUISE BOURGEOIS (b. 1911)

Observer, 1947–49 (cast 1987)

BRONZE WITH WHITE PAINT EDITION 1/6 76 ¼ X 29 X 10 ⅛ IN. UNIVERSITY OF NEBRASKA, OLGA N. SHELDON ACQUISITION TRUST 1988.U-4087

COURTESY CHEIM AND READ, NEW YORK

No doubt Louise Bourgeois's early exclusion from academic art history was complicated by her lack of signature style, by her defiance of simple categorization. The linear historical logic of critic Clement Greenberg's formalist doctrine, which had become accepted dogma since the late 1930s, allowed historians to ascribe artistic invention to preestablished positions in a preordained progression of styles: pigeonholes in which Bourgeois did not neatly fit. But there are many reasons why Bourgeois has only recently come into vogue. That she is a woman is not the least of them, certainly. For years the art apparatus allowed very few women into its front ranks. That her work forces the viewer to confront the uncomfortable physical manifestations of feelings such as grief, humiliation, betrayal, frustration, and that her sculptures have dealt unapologetically with sexual identity may also have contributed to her omission.

It was only with the pluralism (and feminism) of the seventies that Louise Bourgeois began her slow infiltration into a revised art canon. But it was not until the early nineties that she truly arrived. In 1982, when the Museum of Modern Art organized a retrospective of her work, she was still relatively unknown. Finally, in 1992 at the age of eighty, after more than fifty years of work, she was included as the only woman alongside Wassily Kandinsky, Constantin Brancusi, and Joseph Beuys in the inaugural exhibition of the Guggenheim Soho. In 1993 Bourgeois was chosen to represent the United States at the Venice Biennale. Since then, she has been rewritten into nearly every art survey.

Born in Paris in 1911, Louise Bourgeois was a student of mathematics at the Sorbonne before entering the art academies of Paris in the 1930s where she worked with Fernand Léger. She arrived in New York City with her new husband, the art historian Robert Goldwater, in 1938. It became her permanent home.

The timing of her move could not have been more advantageous. The emigration of artists from the European vanguard, fleeing the Nazi occupation in 1940, shifted the center of the international art scene from Paris to New York. The Surrealists Yves Tanguy, Salvador Dalí, Max Ernst, André Masson, Joan Miró, and the Surrealist "pope" himself, André Breton, all landed in New York. Their impact on Bourgeois's art was profound, as they encouraged her to probe into the depths of her psychological urgings. Later she learned with the Abstract Expressionists of the New York School to use her art as episodes of cathartic creation. There have been, of course, both Surrealist and Abstract Expressionist qualities in her work throughout her prolific career, but the keys to the formal and psychological dynamics embodied in Louise Bourgeois's oeuvre lie elsewhere.

Bourgeois rejected current trends throughout her life. Just as the New York artists were shedding the subjectivity of figuration for the abstract universal, Bourgeois began exploring the figure as means of exorcising her impassioned subconscious. She regards her work as extremely autobiographical and talks about her sculptures as if they were "fragments of her psyche."[1] Self-revelation, however, does not wholly account for the diversity of her style.

Bourgeois insists that her exploration of materials does not express an interest in material for its own sake. She has even stated that she does not believe in "the romantic notion of truth to materials."[2] She nonetheless switches easily from marble to latex, plaster to glass, wood to metal, and rubber to bronze, so that the materiality of her work, through its diversity, becomes important to its meaning. In both form and content, her work has been forged between those familiar binarisms of gender. She builds bridges between the polarities of fierceness and fragility, tenacity and vulnerability, tenderness and violence, figuration and abstraction, attraction and revulsion, often within a single work. Charlotta Kotik, a curator of contemporary art at the Brooklyn Museum, has said that Bourgeois has the "ability to deal directly with issues of gender, to address universal themes of sex, anxiety, death, loneliness, in a way which is not didactic but captures our imagination."[3]

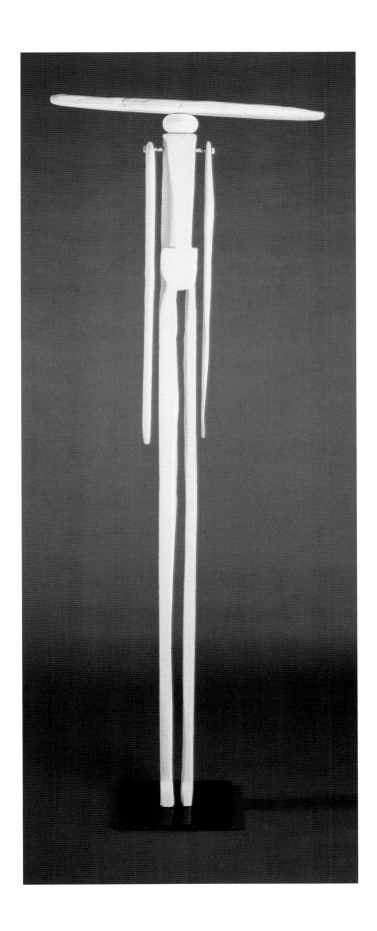

Bourgeois's early work is still often touted as among her best. The *Observer*, 1947–49, a bronze cast painted with a white patina, was originally conceived in found wood. First shown as part of a 1949 exhibition at the Peridot Gallery in New York, it was a precedent for Bourgeois's theatrical proclivity. It was an installation of sorts—long before installation art—on which she later expanded and which influenced a whole generation of younger artists. The *Observer*, like most of her works, is filled with metaphor. As it was, placed in an installation of "friends," the *Observer* conveys through its severity of treatment the tragedy of isolation. "The terror is in the stiffness," Bourgeois has said.[4] The rigid totemlike figure stands precariously on almost no feet. A weighty hat is firmly balanced on its head. Its clearly defined arms hang stiffly at its sides with no hint of movement. Bourgeois has stated that "the fragility of the verticality [of the sculpture] . . . represents a superhuman effort to hold oneself up."[5] In light of her struggle as an artist and her rather newly achieved position in the art world, perhaps *Observer* can then also be seen as an animate incarnate of the artist herself, who has persevered and prevailed after all.

INGRID A. SEPAHPUR

NOTES

1. Michael Kimmelman, "After Many a Summer, a Sculptor Comes of Age," *New York Times*, August 30, 1992, sec. H, p. 27.

2. Robert Storr, "The Matter at Hand," in *View, a Supplement to Journal of Art* 3 (December 1990): 10.

3. Quoted in Kimmelman.

4. Louise Bourgeois, interview by Donald Kuspit, *Bourgeois* (New York: Vintage Books, 1988), 64.

5. Quoted in Alain Kirili, "The Passion for Sculpture: A Conversation with Louise Bourgeois," *Arts Magazine* 63 (March 1989): 70–71.

DAVID HARE (1917–1992)

Catch, 1947

BRONZE 9 13/16 X 14 3/4 X 9 IN. UNIVERSITY OF NEBRASKA, OLGA N. SHELDON ACQUISITION TRUST 1985.U-3781

© THERRY FREY-HARE

Closely involved with the French Surrealists in exile in New York during World War II, David Hare gained recognition as an important American Surrealist in the 1940s.[1] Hare was born in New York City into an artistic family; his mother, Elizabeth Sage Goodwin, was an art collector and backer of the 1913 Armory Show; his uncle, Philip Goodwin, was the original architect of the Museum of Modern Art. Although Hare made small sculptures in high school, he never formally studied art but instead trained for a career in medicine, studying biology and chemistry at several schools, including the University of Colorado and Bard College.[2] In the late 1930s he worked as a professional photographer, documenting surgical operations and making portraits. In 1939 he began to exhibit his photographs in commercial galleries in New York City, and in 1940 he collaborated with Clark Whistler of the American Museum of Natural History on a portfolio of color photographs of the Native Americans of Arizona and New Mexico.

Through his cousin the painter Kay Sage, who had married Yves Tanguy, Hare met the Surrealist émigrés who had fled to the United States with the outbreak of World War II. He was attracted to the Surrealist practice of "psychic automatism"—a form of free association meant to liberate the creative powers of the unconscious—and developed an abstract photographic technique in which an unfixed negative from an 8 x 10 inch plate was heated to produce a molten and fluid image. Hare exhibited his automatist photographs, which the dealer Sidney Janis dubbed "heatages," in "The First Papers of Surrealism" exhibition in New York in 1942. That same year Hare became editor of Breton's newly founded Surrealist periodical *VVV*, published from June 1942 to February 1944. Hare also began in 1942 to make Surrealist sculpture, inspired by the work of Pablo Picasso, Julio González, Alberto Giacometti, and Max Ernst. Working in wax, plaster, bronze, and stone, Hare combined human, animal, and mechanical forms to produce bizarre hybrid figures, often disturbing in their suggestions of violence and eroticism.

In a 1946 statement, Hare explained his attitude toward artistic creation:

I believe that in order to avoid copying nature and at the same time keep the strongest connection with reality it is necessary to break up reality and recombine it, creating different relations which will take the place of relations destroyed. These should be relations of memory and association. . . . Reality exists not in the individual object but somewhere in the mind as it moves from one object to another. And so I feel that sculptors should present reality not as an object which might exist by itself in the closet, but as the relations between that object and the observer.[3]

In *Catch,* those relations take on a nightmarish quality as we are confronted with a human female figure that has been transformed through the sculptor's imagination into a kind of sexual monster. This awkward yet oddly sensual creature appears to be undergoing metamorphosis or mutation before our very eyes. Her head has been reduced to an empty ring and her hair to a wavy band, her tool-like arms end in sharp points, one leg is truncated and terminates in a nub, and the other stretches over her torso to fuse with her right shoulder. From behind her shoulders grows a curious flat form reminiscent of an ax head, its back sprouting a menacing thorn or talon. The creature's torso is graphically sexualized, offering abstracted breasts, a narrow waist, enlarged navel, and, most prominently, a swollen pelvic area that simultaneously suggests buttocks and vulva. From a split in this region another small creature appears to emerge, as if being born or egested. Or perhaps this little creature is being swallowed up, as the sexual "catch" of the ravenous female. The latter reading evokes the female praying mantis, who devours her mate during copulation—an act that stimulated the morbid sexual fantasies of many male Surrealists.

Of course, *Catch* does not ultimately symbolize this or any other

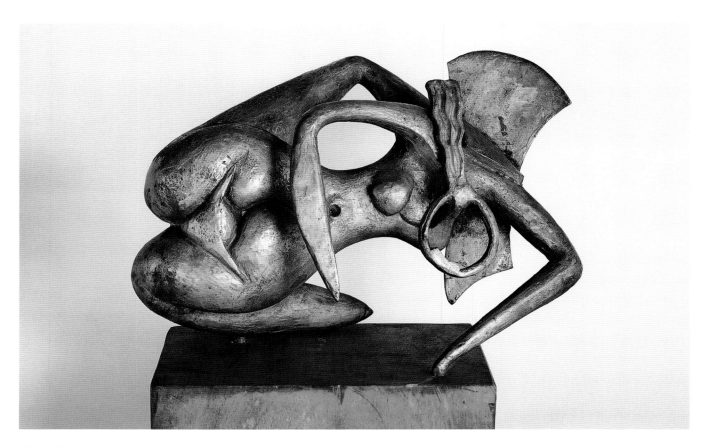

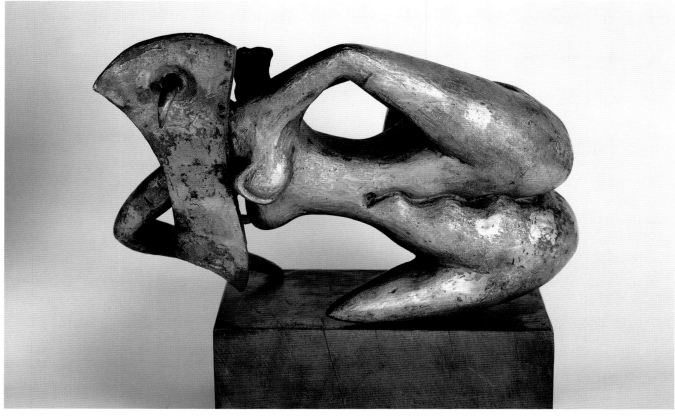

fixed concept but remains highly ambiguous, resisting definitive analysis and continually generating new and unexpected associations. "The ambiguity of [Hare's] art," observed Jean-Paul Sartre in 1947, "consists in that it always and simultaneously 'offers to show' what is and, beyond what is, creates what is not."[4] In a similar vein, Hare himself later wrote: "From the imagination must be formed an object whose oneness is seen through its ambiguity, whose truth centers on the fact that it has a presence and is not a symbol. It must be transfigured, not distorted. Perhaps above all it should frighten its creator, since it should hold more than he expected. Once born, it walks by itself."[5]

DAVID CATEFORIS

NOTES

1. The influential critic Clement Greenberg, for example, characterized Hare's work as "the most intensely surrealist art I have ever seen." Greenberg, "Art," *The Nation* 162 (February 9, 1946): 176.

2. Most biographical accounts state that Hare graduated from the University of Colorado in 1936. However, his name does not appear in the university's graduation records. Carol Mash, Office of the Registrar, University of Colorado–Boulder, letter to author, December 19, 1996. According to one writer, Hare majored in chemistry at Bard College. See Sarah Clark-Langager, "The Early Work of David Hare," *Arts Magazine* 57 (October 1982): 105.

3. David Hare, statement in Dorothy C. Miller, ed., *Fourteen Americans*, exhibition catalogue (New York: Museum of Modern Art, 1949), 24.

4. Jean-Paul Sartre, "N-Dimensional Sculpture," in *Women: A Collaboration of Artists and Writers* (New York: Samuel M. Kootz Editions, 1948), n.p. Sartre's essay on Hare first appeared in French under the title "Sculptures à n dimensions," in a four-page, unnumbered insert for *Derrière le miroir* 5 (October 1947).

5. David Hare, "The Spaces of the Mind," *Magazine of Art* 43 (February 1950): 50.

HENRY MOORE (1898–1986)

Family Group, 1947

BRONZE 15 ¹/₂ X 10 ¹/₂ X 7 IN. UNIVERSITY OF NEBRASKA, F. M. HALL COLLECTION 1951.H-314

REPRODUCED BY PERMISSION OF THE HENRY MOORE FOUNDATION

"For me sculpture is based on and remains close to the human figure."[1] So declared British artist Henry Moore in 1962. This statement reveals one of Moore's deeply held beliefs and explains his enduring interest in producing figurative sculptures such as *Family Group.* His imagery often focused on the human form—either singly or in groups—and he developed a signature style that suggested the organic origin of the forms through fluid, interwoven, curvilinear shapes.

Moore's sculptures also reveal an extraordinary sensitivity to the materials with which he worked. Moore believed that sculpture, rather than deny the inherent qualities of materials, should focus on them and exploit those qualities. Materials should not be disguised or made to look like something else. In his sculptures, Moore adapted his images to most effectively showcase the material, whether it was wood, lead, or bronze.

Family Group evinces Moore's fundamental beliefs about sculpture. The mother, father, and two children appear interconnected, and the forms flow seamlessly into one another. As the artist himself described it: "In the sculpture the child is shown in the arms of his parents, as though the two arms come together and a knot is tied by the child. It is as though they are pulling with their arms and the knot that connects both parents is the child."[2] This reinforces the unity of the family construct and visualizes the coherence of familial relationships. The smoothness of the surface suggests natural life processes—for example, those of growth and erosion—thereby further emphasizing the naturalness of the family.

The Sheldon's work is one of a number of family group sculptures that Moore produced between 1945 and 1949 while working on a commission for a large bronze sculpture for an elementary school in Impington, England (the sculpture was later placed at the Barclay School in Stevenage, England). The philosophy of the school was based on the principle that parents were integral to the educational experience and therefore should be encouraged to participate in the school's environment. Moore's choice of a family group is thus very appropriate.

The sculpture of Henry Moore is not only visually striking but conceptually rich. Contemplating his sculptures leads the viewer to understand Moore's attitude toward his art. Claimed Moore: "Sculpture, for me, must have life in it, vitality. It must have a feeling for organic form, a certain pathos and warmth If a work of sculpture has its own life and form, it will be alive and expansive."[3]

CHRISTIN J. MAMIYA

NOTES

1. Henry Moore, *Henry Moore on Sculpture* (New York: Viking Press, 1967), 115.

2. Quoted in David Mitchinson, ed., *Henry Moore Sculpture* (London: Macmillan, 1981), 102.

3. Moore, 58.

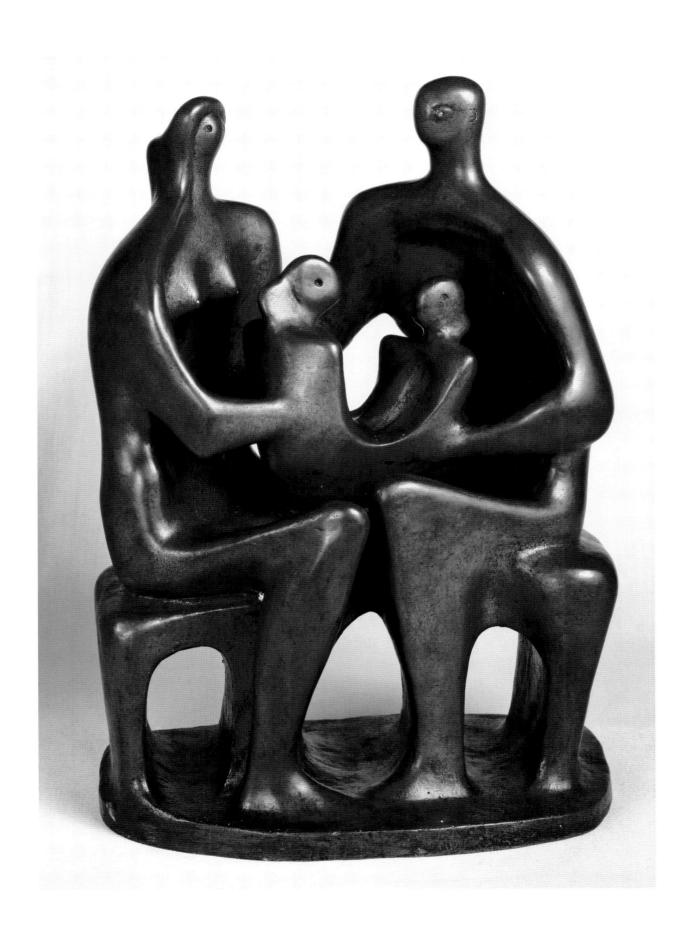

MARINO MARINI (1901–1980)

--

Horseman, 1949

BRONZE 16 X 11 ½ X 5 ½ IN. UNIVERSITY OF NEBRASKA, F. M. HALL COLLECTION 1950.H-305

© 2002 ARTISTS RIGHTS SOCIETY (ARS), NEW YORK/SIAE, ROME

Born in Tuscany and educated at the art academy in Florence, where he absorbed the atmosphere of Italian aesthetic culture, Marino Marini achieved a highly original art by confronting and creatively engaging with this omnipresent art historical past. Unlike the Italian Futurists a generation before him, who attempted to liberate themselves from this past by denouncing and dismissing it, Marini liberated himself from its dominance by forcing it to serve his own emotional needs. As a result, Marini's art offers a unique interpretation of the Italian past precisely because it is "worked through" rather than avoided.

This joust with his artistic ancestors is clearly evident in *Horseman,* which recalls the ancient equestrian portrait theme that had played such a vital role in the creation of Italian cultural identity for centuries. Marini must have been powerfully affected by Donatello's *Gattamelata* (1445–50) in Florence and the ancient Marcus Aurelius in Rome. Their messages are clear: both embody the noble and heroic warrior as the defender of the masses. In both monuments, the powerful steed is reined in, and the natural forces it symbolizes are subdued by the "authority" of the rider.

Marini's *Horseman,* however, reveals an unusual interpretation of the equestrian theme's symbolic meaning. Rather than glorifying a specific individual (i.e., political demagogue), Marini makes his rider anonymous. In fact, by refusing to particularize—even personalize—him, Marini has turned the meaning of the equestrian topos on its head, in effect, glorifying the anonymity of the private citizen rather than the charismatic personality of the *Ubermensch.* Marini accomplishes this aesthetic sleight of hand by loosening the hierarchy explicit in the equestrian topos; the triumph of human culture, metaphorically realized by the rider's ability to control the powerful forces of the world symbolized by his imposing mount, is blatantly absent in Marini's version. Rather, his *Horseman* presents us with a rider struggling to stay atop his equally unbalanced steed. Marini has transformed the power and strength traditionally communicated in the equestrian theme into a symbolic image expressing the desire to stay atop one's own awkward life in the face of a world that must be adapted to and worked through rather than simply conquered or subdued.

Marini's interest in the equestrian theme stems not simply from a keen awareness of art history but from his own life—his first art studio was located near a riding school. For the Italians, the relationship between rider and steed was symbolic of human existence, the ability of humankind "to rein" the environment (whether physical or psychic).

The pathos of *Horseman* is increased given the serious political unrest in Italy and the rest of Europe at this time, which imbues the work with an added charge and topical urgency. Marini's equestrian themes represent a defiant refusal to succumb to an ideology (ironically, one resurrected by Mussolini from Italy's storied past) that sought to undermine rather than celebrate human individuality.

Marini has thus reinterpreted this ancient theme by giving it a twentieth-century existential meaning his ancestors certainly had not intended. Marini's *Horseman,* through its timidity and awkwardness, is an aesthetic glorification of the integrity and ethical necessity of each person's own awkward journey into the world.

DANIEL A. SIEDELL

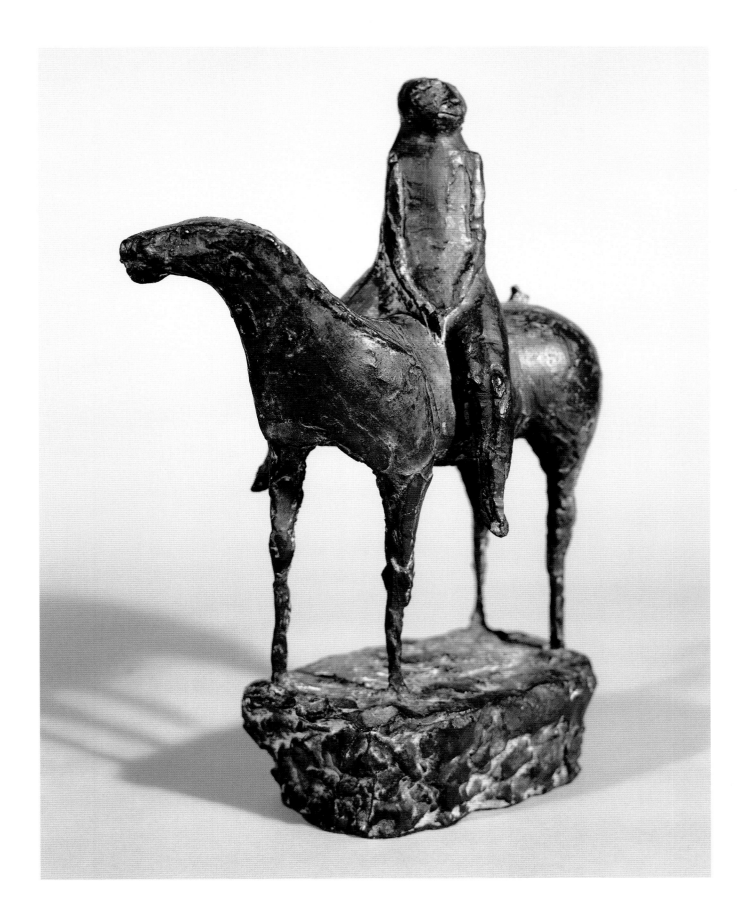

JEREMY ANDERSON (1921–1981)

Untitled #85, 1954

REDWOOD 41 ³/₄ X 13 X 17 IN. UNIVERSITY OF NEBRASKA, F. M. HALL COLLECTION 1989.H-2892

© BRAUNSTEIN/QUAY GALLERY

Jeremy Anderson was an enormously influential figure in the San Francisco art world of the 1950s, a time when the Bay Area trailed only New York in importance as an art center. His sculpture—bristling with implications of sexuality, organic growth, and latent aggression—provides a direct link between European Surrealism of the 1930s and '40s and Bay Area Funk art of the 1960s.

Anderson was among the many returning veterans who took advantage of the G.I. Bill to attend art school after the close of World War II. He attended the California School of Fine Arts in San Francisco, then a hotbed of Abstract Expressionism thanks to the presence of such teachers and students as Clyfford Still, Mark Rothko, and Richard Diebenkorn. Through the influence of his teacher Robert Howard, at that time the area's most influential sculptor, and readings in such Surrealist-based publications as *View, VVV,* and *Tiger's Eye,* Anderson became familiar with the work of Giacometti, Noguchi, and especially David Hare, whose spiky, violence-laden plasters inspired Anderson's early work in the same medium. Another important source of inspiration proved to be the weapons collection at San Francisco's M. H. de Young Museum, whose assortment of clubs, maces, and guns is often reflected in Anderson's work of the 1950s.

While on a travel fellowship in 1950, Anderson visited New York and then France, where he was profoundly affected by the neolithic stone fields at Carnac. Soon after that, he abandoned plaster as a sculptural medium and began carving and assembling wooden sculptures, usually out of redwood but occasionally using other woods such as mahogany and teak.[1] Anderson's sculptures from this period tend to be of two types: tall columnar forms or long horizontal "shelves" or tabletops. The latter clearly show the influence of sculptures by Giacometti and Noguchi from the 1930s, with their hallucinatory confusion of anatomical and landscape forms. The vertical totemic forms, including *Untitled* #85, also recall Noguchi's bonelike sculptures of

the 1940s—which were often carved out of balsa wood—though generally on a more modest scale.

Untitled #85 is typical of Anderson's work in its conflating of unrelated elements. "Art is perhaps the only instance where seemingly unrelated ideas are completely related and accepted without the slightest feeling that they have been pounded into an ideology," he wrote in 1952. "A fondness for croquet and an interest in ancient Egypt side by side but adding up to more than the sum of these two interests."[2] Particularly evident in this work are his interests in both weapons and sites of ritual and ceremonial significance. With its dimpled main trunk surmounted by a smaller hemispherical form, the work has clear figural allusions. The phallic trunk is highly organic, resembling a pickle or cactus. Sprouting from shoulder level of this form are a series of bristling appendages resembling shields, maces, and battle-axes, giving the whole work a sense of menacing hostility. At the same time, both the base and the hemispherical top form sprout a series of tall thin poles, one curlicued like a unicorn's tusk, that imbue the work with a sense of landscape and ritual site, not unlike Carnac. This coexistence of two vastly different scales in a single work is a hallmark of Anderson's work, and his ability to evoke the monumental through the intimate has been remarked. Alfred Frankenstein, critic for the *San Francisco Chronicle* throughout Anderson's heyday in the 1950s and 1960s, wrote, "Anderson plays Giacometti's favorite paradoxical game: the smaller the scale, the larger the implication. Anderson's smallest redwood pieces are immense monuments."[3]

By virtue of his appointment as instructor at the San Francisco Art Institute (formerly the California School of Fine Arts), Anderson became an influential figure to many young artists of the region. Along with several of these artists, including Robert Hudson and William Wiley, Anderson in the 1960s began painting his sculptures, establishing the so-called polychrome sculpture

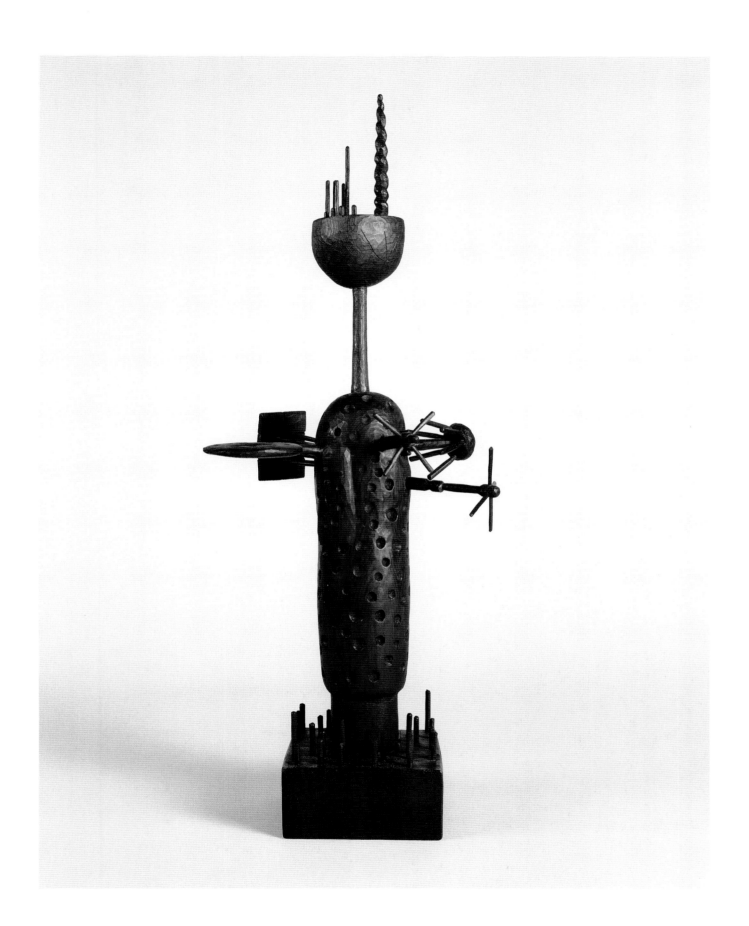

movement that eventually developed into the Funk Art of the late 1960s, characterized by an eccentric organicism; slick, shiny, brightly colored surfaces; and such modern materials as fiberglass or plastic.

PETER BOSWELL

--

NOTES

1. It is interesting to note that in 1952 Anderson had a joint show with Louise Bourgeois, another Surrealist-inspired artist who worked primarily in wood, at Chicago's Frumkin Gallery. H. C. Westermann— with whose work Anderson's is often compared—also showed at the Frumkin Gallery and later at San Francisco's Dilexi Gallery, where Anderson also showed. It appears that Anderson took up wood as a medium before Westermann did, but it is tempting to speculate that his exposure to Bourgeois's work may have provided the impetus for his switch from plaster to wood.

2. Jeremy Anderson, *The Artist's View* 2 (September 1952): n.p.

3. Alfred Frankenstein, "A Major Show by Local Artist," *San Francisco Chronicle*, December 8, 1966, 45.

REGINALD BUTLER (1913–1981)

Study for Girl with Chemise, 1954

BRONZE EDITION 6/8 19 ³/₈ X 7 ¹/₄ X 5 ¹/₄ IN. NEBRASKA ART ASSOCIATION, THOMAS C. WOODS MEMORIAL COLLECTION 1959.N-113

© ROSEMARY BUTLER

According to accepted wisdom, an artist's encounter with abstraction is supposed to begin with the artist gradually disbanding a "common" representational form and developing an ever more "abstract" and thus more individual style. The case of Reg Butler has frustrated and confused art historians and critics precisely because his oeuvre cannot be submitted to this "developmental" model. Butler began his artistic career with an abstract style and gradually "regressed" to a representational one at a time when art writers were interested only in modern sculpture's "significant" and "innovative" form and structure as manifested in abstraction.

Forced to confront representations of women whose "main communication now is an eroticism which is not in the least sunny,"[1] art critics lamented Butler's focus on "content" at the expense of his "form." The artist and critic Patrick Heron wrote that "what worries me is that not enough is happening in Butler's form."[2] Butler's "development," or "regression," is a clear and explicit testimony to art history's naive desire to create a tight, linearly progressive narrative of the history of art that ignores the ruptures, the regressions, the jumps and skips that make its history incapable of being emplotted and its development "predicted."

Ironically, Butler's reputation was achieved with his abstract work, derivative of Henry Moore and the so-called British school sculptors, in the early 1950s. For most critics, painting and sculpture was about its own materials (art about art) and any reference to "subject matter" outside this was considered unnecessary and just cause for being condemned as "literary." Clearly, for Butler abstraction could not fulfill his expressive needs, and his gradual "fleshing" out of the cold scaffolding of sculptural "structure" is a fascinating development. Butler's more-representational sculptures, exhibited in the late fifties, demanded that the critic account for more than simply form. One perceptive critic wrote

that "they seem to play on the morbidity of flesh—flesh at its liveliest—not as inherent but as victimized; as though an idea had attacked like a disease."[3] One could argue that this "idea" was the messy, morbid, and unclean female figure, which gradually "infected" and destroyed his pure and sterile abstract forms of the early fifties.

Study for Girl with Chemise is a remarkable example of Butler's plummet from the ivory towers of abstraction to the murky, muddy waters of figuration. It is this stage in Butler's career (mid-fifties) that the struggle between abstraction and figuration manifests itself most clearly. Influenced by the truncated "tragic" figures of Marino Marini, Butler melds the female figure in an abstract composition, which she seems to be attempting to shed along with her clothing. However, as Butler's work became more figurative and less "abstract," it drew increasing criticism from the critics who craved form and seemed to resent having to be forced to write about their uncomfortable feelings in front of women who, as Heron put it, "are being tormented."

The critic Sidney Tillim, however, found in these figurative works a profound statement of the times. "While these monolithic bronzes are a step 'backward' from the open, constructive style which prevails today, the standing, tumbling and suspended female figures are marked with the imprint of anxiety that is thoroughly contemporary."[4] And as one might add, something that the new "cool" formalist aesthetic refused to acknowledge as an important element in art.

In many ways, Butler's melancholic women, in various stages of undress, are similar to Edgar Degas's paintings and sketches of prostitutes bathing and dressing in their boudoirs. For generations, art historians have wanted to ignore Degas's powerful statements of femininity in order to focus on the artist's "formal" innovations. But it is clear, as Butler's sculpture attests, that

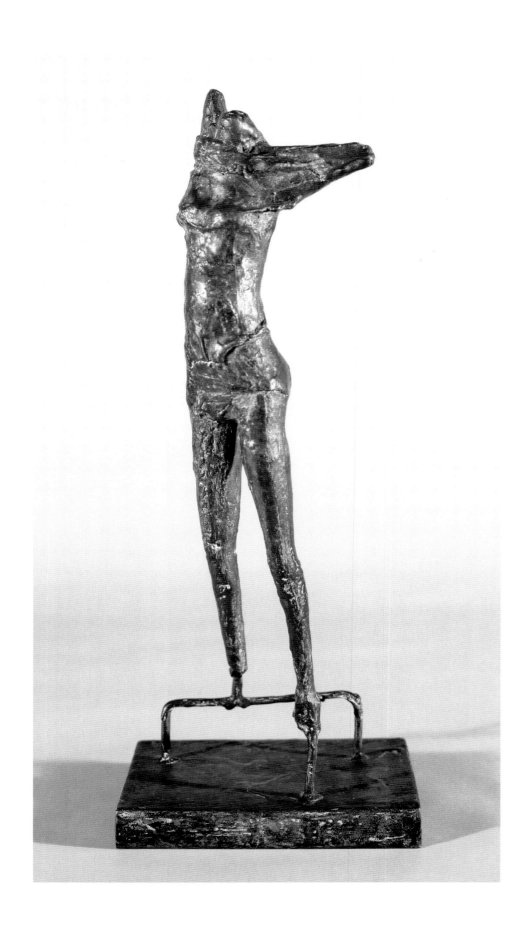

art has more to say than simply to declare its formal properties. For Butler, as for most authentic artists, "modern" or otherwise, humanity is at stake in art, not formal innovation.

DANIEL A. SIEDELL

--

NOTES

1. Patrick Heron, "London," *Arts* 31 (September 1957): 64.

2. Heron, 64.

3. J.S., "Reviews and Previews," *ARTnews* 58 (March 1959): 16.

4. S[idney] T[illim], "In the Galleries: Reg Butler," *Arts* 33 (April 1959): 51.

EDUARDO CHILLIDA (1924–2002)

Silences (Silencios), 1955

WELDED IRON 19 ³/₄ X 18 ¹/₂ X 15 ¹/₂ IN. UNIVERSITY OF NEBRASKA, BEQUEST OF BERTHA SCHAEFER 1971.U-955

© 2002 ARTISTS RIGHTS SOCIETY (ARS), NEW YORK/VEGAP, MADRID

Born in San Sebastian, Spain, in 1924, Eduardo Chillida studied architecture in Madrid from 1943 to 1947, but because of a growing dissatisfaction with conventional architectural problems and the methods for solving them, he began to experiment with sculpture. From 1948 to 1951 he moved to Paris in order to devote himself entirely to drawing and sculpture. Chillida had his first solo show in Madrid in 1954. Although in Paris he had first worked in clay and plaster, Chillida gradually made the move to iron, which became the medium through which he has made a vital and original contribution to the tradition of twentieth-century sculpture. Furthermore, it is this medium, welded iron and steel, which brought him closer to the culture of his own heritage, the Basques, who were known throughout Spain as great iron welders. It is his creative use of iron that has seduced many critics. As the critic and curator J. J. Sweeney wrote in 1966, "The struggle with the material and the energy which Chillida puts into his direct handling of materials with hammer, fire and chisel gives the vital quality that is characteristic of his work."[1]

Although he early on abandoned the formal study of architecture, Chillida understands his sculpture as intimately related to it. "My work is a critique of architecture, but it also seeks to develop in sculpture those possibilities that architecture hasn't developed."[2] This architectural sense, as it were, is also manifest in what he calls the "stress on relationships rather than the things related."[3] Chillida's focus on relationships rather than things per se coincides quite closely with his use of welded iron and steel. As he says, these materials "are particularly attractive to me because they are appropriate to the dialectics of space."[4]

Although his iron structures are reminiscent of the work of such Spanish sculptors as Picasso and Julio González, who explored the formal implications of post-Rodin sculptural form, Chillida views his work in a much more personal and even idiosyncratic way that figures importantly in his understanding of the world

and his position in it. "My work is a process of becoming that attempts to approach knowledge."[5]

Silences is a strong example of the highly personal charge with which Chillida imbues his work. Although wrought from cast iron, it suggests an intimacy that is rivaled only by its universality. Chillida's ability to communicate on both a personal and a universal level brings him onto the same stage as Brancusi, whom Chillida has called "a special master of mine," not only because of Brancusi's sensitivity to his materials, but because of his desire to draw creative sustenance from the folk traditions of his native homeland—in Brancusi's case, rural Romania.

Although *Silences* also makes manifest Chillida's architectonic sense, his feel for spatial relationships, and his ability to make welded iron and steel "speak" aesthetically, it is perhaps the intimacy and personality of his work—true even of his much larger outdoor pieces—which are revealed most clearly in *Silences*.

DANIEL A. SIEDELL

NOTES

1. James Johnson Sweeney, *Eduardo Chillida*, exhibition catalogue (Houston: Museum of Fine Arts, 1966), 14.

2. Ellen Schwartz, "Eduardo Chillida," *ARTnews* 79 (March 1980): 71.

3. Quoted in Sweeney, 18.

4. Quoted in Schwartz, 71.

5. Quoted in Schwartz, 71.

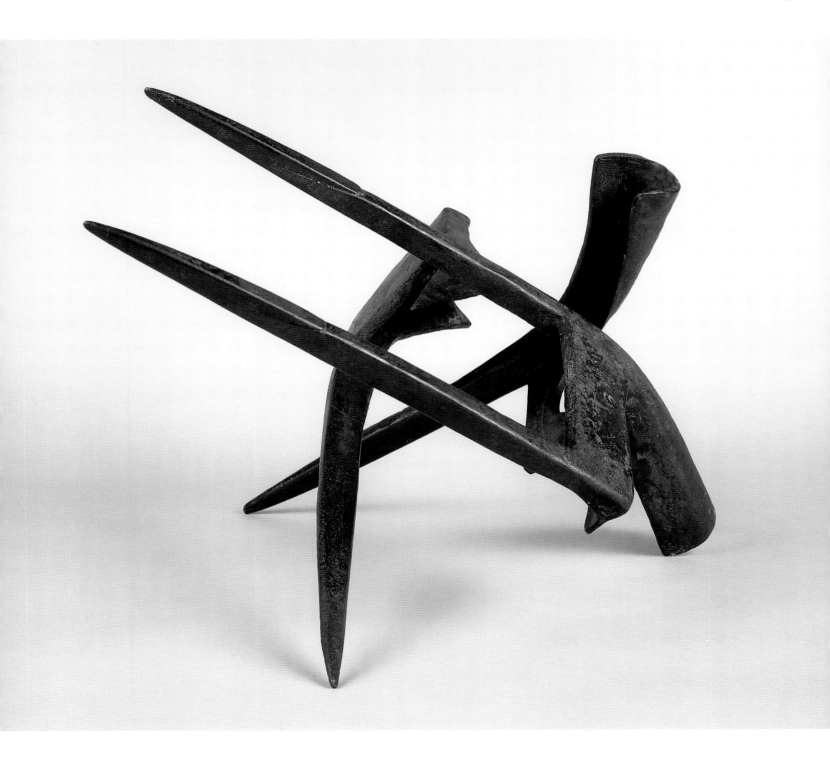

KENNETH ARMITAGE (1916–2002)

The Seasons (Three Seasons), 1956

BRONZE EDITION 3/6 30 X 16 X 14 IN. UNIVERSITY OF NEBRASKA, F. M. HALL COLLECTION 1959.H-585

© KENNETH ARMITAGE FOUNDATION

The history of modern painting from Edouard Manet to Willem de Kooning has often been written as the history of a unique and utterly subjective view of the world. On the other hand, histories of modern sculpture have often tended to focus on the artist's ability to express a *shared* or collective experience of the world. Sculptors such as Barbara Hepworth, Constantin Brancusi, Louise Nevelson, Alberto Giacometti, Reg Butler, and Henry Moore have all, to varying degrees, been concerned to create sculptural forms that aestheticize the *common* state of humanity.

Kenneth Armitage's sculpture is no exception, and he perhaps goes further than any other modern sculptor toward expressing this collectivity. For Armitage, "art is something shared among all of us and [I] feel almost apologetic for the effort and specialization involved in its production."[1] It is this belief in shared experience and art's ability to make us aware of it—even at the expense of dissolving artistic identity—that his art is most concerned to express.

Like many of his British contemporaries who have been profoundly influenced by the work of Henry Moore, Armitage has been committed to the "rethinking of the problem of the human figure."[2] But unlike most modern sculptors, who use one figure or a small group to evoke metonymically a common emotion or experience, Armitage employs what could only be called figure "crowds," which dissolve individuality and isolation and express the communal experience of humanity. Armitage's small bronze entitled *The Seasons* is a fine example of such figurative groups in which individuality is dissolved into community. Armitage gives physical expression to the group; the figures are not individually conceived but exist solely as a group of heads, arms, and legs in which their being seems completely reliant on their identity as a community.

Although his desire to express collective experience through the human figure is not unique to modern sculpture, his quirky,

witty approach to the figure is. According to him, art is "rather like looking at night at a very faint star. If one looks, directly, very hard, at it, one cannot see it. And so I treat myself rather politely in this way, and don't ask myself too many questions."[3] Armitage's sculptural figures are products of this "oblique" look at what it means to be human by revealing the inherent wit, humor, and nobility that lie embedded within it. As one critic wrote, "Though his expression is modern, the thing that he is expressing is quite rare in art today. It is the daily humanities of human life, the small things like sitting in the sun, listening to music, stretching, sprawling on the floor and rolling over, going for a walk, being buffeted by the wind."[4] With *The Seasons*, Armitage's wit can be seen in the ironic title. Armitage often gives "very simple and frivolous titles to works that have meant rather more . . . than their titles suggest."[5] Apparently titled to allude to the cyclical nature and continuity of the four seasons, the work seems to give us only three figures. It seems to poke fun at the overly self-consciously serious artists who have paid lip service to "universality" by invoking in their titles such advocates of universal experience as Jung, James Frazer, and Joseph Campbell. For Armitage, authentic universality and collective experience are represented in the "daily humanities," in which—as demonstrated in *The Seasons*—being human is revealed to be a truly collective enterprise.

DANIEL A. SIEDELL

NOTES

1. Quoted in Norbert Lynton, *Kenneth Armitage* (London: Methuen, 1962), n.p.

2. Peter Stone, "Kenneth Armitage," *Studio* 161 (April 1961): 129.

3. Quoted in Lynton.

4. Stone, 131.

5. Lynton.

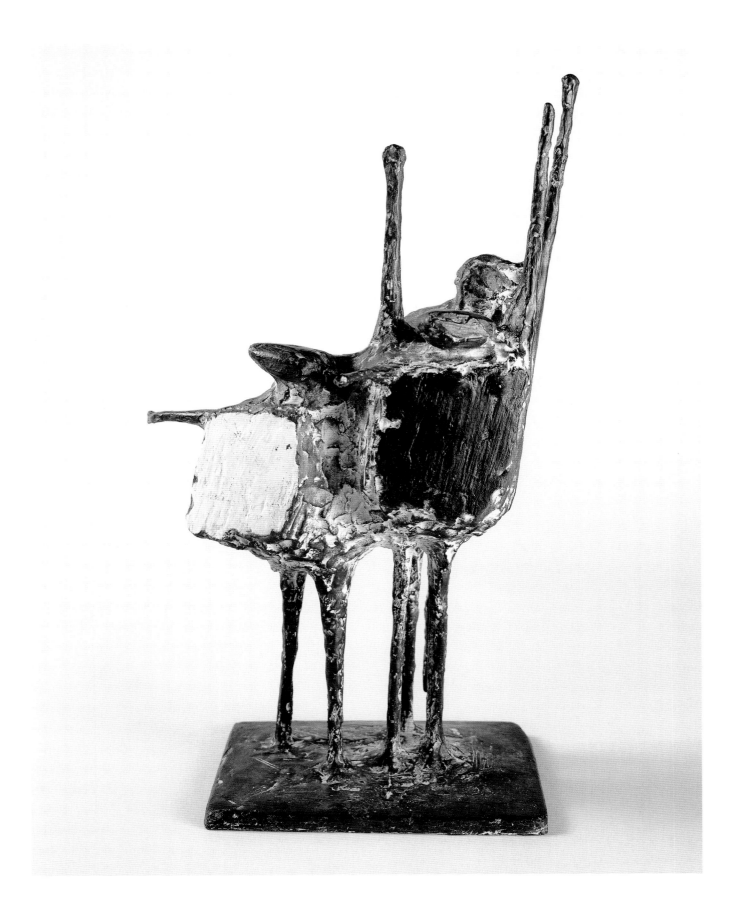

HUGO ROBUS (1885–1964)

Water Carrier, 1956

BRONZE 36 X 6 ¾ X 10 ⅝ IN. NEBRASKA ART ASSOCIATION 1972.N-300

© HUGO ROBUS, COURTESY FORUM GALLERY, NEW YORK

After studying painting at the Cleveland School of Art and at the Art Students League in New York, Hugo Robus embarked on a European sojourn, common for aspiring artists of his generation. In his time there (1912–14) he became acquainted with Stanton Macdonald-Wright, Frantisek Kupka, and other innovators, suggesting his modernist inclinations; in Paris he also, somewhat surprisingly, studied sculpture with Emile Antoine Bourdelle, master of heroic bronzes. Upon returning to New York, Robus pursued his work as a painter for the balance of the decade, during which time he produced a group of sophisticated Futurist designs. In 1920, however, he abruptly quit this promising career after finding himself "so fascinated by form that I was building paint upon my canvases a quarter of an inch thick. It became expensive, so I decided to find a medium I could afford."[1]

From the outset, Robus the sculptor worked not as a carver but as a modeler of malleable clay and plaster, creating figures for casting "because I have considered ours an age of metal and new alloys rather than of stone."[2] Memories of Bourdelle's classes may have directed his technique, although Robus handled his materials very differently from his teacher; instead of expressive surfaces and rhetorical poses, Robus's forms are typically compact and his surfaces polished, traits closer to Constantin Brancusi than to Bourdelle. His aim was a sculptural art "timeless and spaceless," one of "universal value."[3]

Robus's sculptures, often of lithe, pubescent females, early showed a witty approach that was rare among modern artists of the period. Since his interest was "in what our sensitivities feel" rather than empirical vision, Robus worked "to eliminate and exaggerate," with sometimes comic results.[4] Some critics thought his "instinct for simplification" propelled Robus in an "antic direction, toward a Brueghelesque mood"; others likened his unexpected but winning combination of "humor, beauty, and despair" to Jean Arp or Paul Klee, resulting in a similarly artful balance of humor and pathos.[5]

The sculptor William Zorach, who with Robus had begun as a painting student in Cleveland, noted that his friend's work "turned inward and deals with the weird, the strange," conveying a mood of "fantasy" and ambiguity.[6] The *Water Carrier,* whose head becomes a jug, or vice versa, fits Zorach's description. The decapitated figure, which had been a favorite artistic motif during Robus's formative years, appeared several times in his work, for instance in the figurative *Vase* (1928), with detachable head to hang from the woman's hand, which early won acclaim for Robus; in a trio of headless torsos appearing as *Three Caryatids without a Portico* (1953–54); and in the faceless figures of *Girl with Pretty Face* (1945) and *Vanity* (1963–64), women looking down on detached visages that stare upward at them.

Various precedents have been suggested for Robus's curious combination in *Water Carrier,* from the sculpture of his friend Milton Hebald to the painting of Attilio Sallemme, both of whom had earlier created jug-headed women.[7] More generally, the open-necked figure literally turns the women into vessels, playing with an equation that had been inspirational from the ancient Greeks to nineteenth-century Neoclassicists to Picasso, who made ceramic vessels decorated with female nudes. The work that Robus laughingly described as "just a jughead" resonates of Jung's archetypal female.[8]

CHARLES C. ELDREDGE

NOTES

1. Quoted in "True to Life," *Time* 75 (May 1960): 78.

2. Hugo Robus, "The Sculptor as Self Critic," *Magazine of Art* 36 (March 1943): 96.

3. Quoted in Leslie Judd Portner, "Art Survey Adds a New Dimension," *Washington Post and Times Herald,* February 16, 1958, sec. E, p. 7.

4. Robus, "Self Critic," 96.

5. Robert M. Coates, "Two Sculptors: Manzu and Robus," *The New*

Yorker, January 1966, 29, 103; Joshua C. Taylor, foreword to Roberta K. Tarbell, *Hugo Robus (1885–1964)* (Washington DC: National Collection of Fine Arts, 1980), 10.

6. Quoted in Tarbell, 93.

7. Tarbell, 109, 214–15.

8. Quoted in "True to Life," 78.

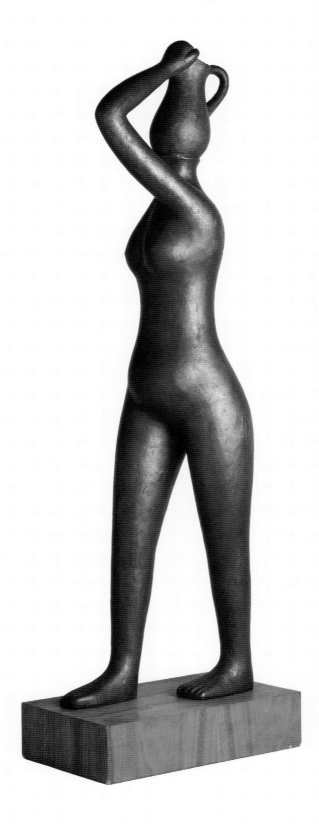

SEYMOUR LIPTON (1903–1986)

Glowworm, 1957

NICKEL SILVER ON MONEL METAL 32 X 22 X 22 ½ IN. UNIVERSITY OF NEBRASKA, F. M. HALL COLLECTION 1998.H-3075

© ARTIST'S ESTATE (MICHAEL AND ALAN LIPTON)

Through their organic style and the interplay of internal and external forms, Seymour Lipton's metal sculptures evoke primary biological forces and the cyclical drama of birth, growth, death, and regeneration. A native of New York City, Lipton attended the Brooklyn Polytechnical Institute, City College of New York, and Columbia University, earning a DDS in 1927. While supporting himself as a dentist, Lipton developed an interest in sculpture and, without the benefit of formal artistic training, began carving in wood and stone. By the mid-1930s he was exhibiting in New York, and in the following decade he started teaching sculpture. Lipton taught at the New School for Social Research (1940–65), Cooper Union (1943), New Jersey State Teachers College (1944–46), and Yale University (1957–59).

Lipton's early carvings of stylized human figures, strongly influenced by German Expressionist sculpture, dealt with themes of social and political concern common in New York art of the 1930s and early 1940s. By the mid-1940s Lipton had turned from carving to casting in bronze and constructing in sheet lead, and from figurative and anecdotal subject matter to more generalized, mythic themes. He now worked in a jagged, biomorphic style influenced by Surrealism, and his imagery, forged in response to the violence of World War II, was often brutal and aggressive.

In 1949 Lipton arrived at his characteristic direct-metal technique of torch-brazing bronze and nickel silver rods onto shaped sheet-metal armatures. At first these armatures were made from sheet steel and then, after 1955, Monel metal, a rustproof white bronze alloy. Typically, Lipton would make one or more working drawings for each sculpture, then realize its composition in a small sheet-metal maquette before proceeding to the final, full-scale version.[1] The ductility of the sheet metal allowed Lipton to create a wide variety of forms, both open and closed, while the brazing technique enabled him to work with subtly sensuous surface colors and textures.

Lipton's sculptures of the 1950s combine shapes suggestive of plant, animal, and mechanical forms into strikingly original configurations that evoke fantastic living entities pulsating with vital energies of growth and movement. The sculptures typically combine both smooth and jagged elements and explore what Lipton termed "a concern with internal and external anatomy."[2] Bud- or larvalike structures are encased within curving, shell-like planes, creating a dialectical interplay between internal spaces and external surfaces, centripetal and centrifugal forces. "Gradually," wrote the sculptor, "the sense of the dark inside, the evil of things, hidden areas of struggle became for me a part of the cyclic story of living things. The inside and outside became one in the struggle of growth, death and rebirth in the cyclic renewal process. I sought to make a thing, a sculpture as an evolving entity; to make a thing suggesting a process."[3]

Glowworm epitomizes Lipton's ability to evoke, through static sculptural shapes and volumes, energetic forces of growth and transformation. The central element of the dynamic, asymmetrical composition is a leaning, hollow cylinder composed of twenty irregular, ringlike segments. A spiky, weaponlike implement extends from the bottom of this cylinder, while from its top emerges a rounded cluster suggestive of a blossoming flower. Revolving around the cylinder are a number of curved, sharp-edged shells that meet and fuse at various junctures. From the front of the sculpture, these shells cut across the diagonal of the cylinder at various angles to create a sense of vectors expanding in different directions. As the viewer walks around the sculpture, the shells seem to rotate about the cylinder, enfold it, and unfold into the surrounding space, producing an illusion of centripetal and centrifugal movements.

Lipton almost certainly gave *Glowworm* its title only after the sculpture itself was completed.[4] Lipton intended his titles to communicate something of his personal experience of each work

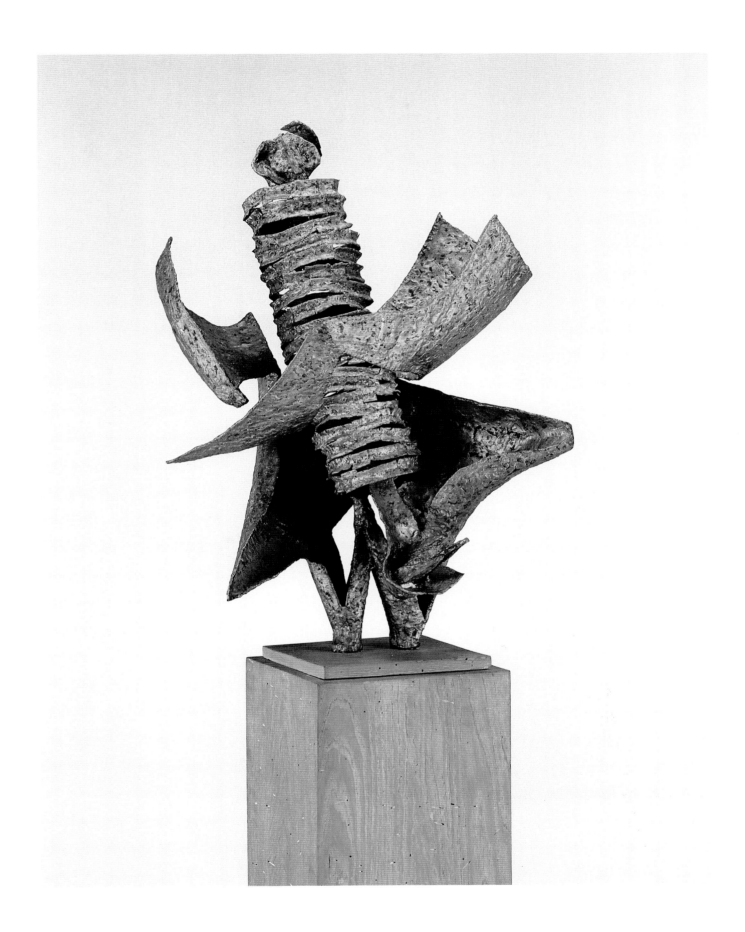

113

as well as to "provoke . . . a challenging involvement for the observer" in the work's interpretation.[5] In the case of *Glowworm*, the title invites us to imagine the sculpture's central element as the segmented body of a bioluminescent insect or larva, and the shells surrounding it as wings, the husks of a chrysalis, or even pulsations of light. At the same time, the title in no way invalidates the many other associations that the sculpture is capable of generating. The central cylinder might suggest, for example, a spinal column or the barrel of a science-fiction ray gun; the surrounding metal planes, broken seashells or dried and curling leaves.

Among these associations is *Glowworm*'s evocation of a human or humanoid figure, standing upright on a pair of stalklike legs, extending its arms, and raising its head. This anthropomorphism, more frankly pronounced in other examples of Lipton's work of the period, is an expression of the artist's fundamentally humanistic attitude. "Basically, 'man' concerns me in all the things I make," Lipton observed. "I find 'inner spaces' of man in things outside himself; in the sea, under the earth, in animals, machines, etc. . . . Whether or not I use the gesture of man, of forms other than man, all the works in a fundamental way concern human life—are an expression of what I feel about myself and others. This can happen because of the interrelatedness of all biological nature and broad laws applicable to all life."[6]

DAVID CATEFORIS

--

NOTES

1. A study drawing for *Glowworm*, dated 1956, from the collection of Mr. and Mrs. Alvin Lane, Riverdale, New York, is illustrated in *Seymour Lipton: The Creative Process*, exhibition catalogue (Milwaukee: University of Wisconsin–Milwaukee, 1969), n.p.

2. Quoted in Andrew Carnduff Ritchie, "Seymour Lipton," *Art in America* 44 (Winter 1956): 15.

3. Quoted in Ritchie, 15.

4. "I always name a work after I finish it, not before." Quoted in Tal Streeter, "The Sculptor's Role: An Interview with Seymour Lipton," *The Register of the Museum of Art, The University of Kansas* 2 (April 1962): 32.

5. Quoted in Streeter, 32.

6. Quoted in Albert Elsen, *Seymour Lipton* (New York: Harry N. Abrams, n.d.), 37.

ISAMU NOGUCHI (1904–1988)

- -

Song of the Bird (Bird Song), **1958**

IMPERIAL RED SWEDISH GRANITE AND GREEK MARBLE BIRD: 47 3/4 X 18 1/2 X 13 1/4 IN.; SONG: 116 3/4 X 15 1/2 X 16 IN.; BASE: 84 X 120 X 216 IN. UNIVERSITY OF
NEBRASKA, BEQUESTS OF FRANCES SHELDON AND ADAMS BROMLEY SHELDON 1961.U-345

© ISAMU NOGUCHI FOUNDATION

Born in Los Angeles, the son of an American mother and a Japanese father, Isamu Noguchi was taken to Japan at age two and spent his childhood there. He was educated in both Japanese and Western schools until 1918, when his mother, concerned about the position of an adolescent of mixed race in Japanese society, decided that he "had better become completely American" and dispatched Noguchi to the progressive Interlaken School in Indiana.[1] When the school abruptly ceased operations that fall, Noguchi was stranded, reliant on the kindness of strangers.

Through a serendipitous series of encounters, he was in 1922 apprenticed to Gutzon Borglum when the sculptor was conceiving his grand schemes for Mount Rushmore. Noguchi did not figure in that carving campaign, however—Borglum told him he "would never be a sculptor"—and he quit the master's employ. Following his Indiana patron's advice, Noguchi enrolled at Columbia University Medical School, where his mentor explained that "only certain persons were gifted to become doctors" and "urged me to become an artist." Noguchi returned to art and, three months after enrolling in art school, presented his first one-man show.

His renewed commitment was deepened by exposure to modern art in New York, especially a 1926 exhibition of Constantin Brancusi's sculpture that "completely crystallized my uncertainties. I was transfixed by his vision." By the following year, Noguchi was installed in Paris on a Guggenheim Fellowship, pursuing his studies and working as studio assistant to Brancusi; from him Noguchi learned respect for tools and materials, and especially a reverence for pure form that served him well throughout his career. With other young innovators in Paris (Alexander Calder, Stuart Davis, and Morris Kantor were among his close friends), Noguchi was melding his American nature—"completely acclimatized . . . [with] no hint of Japan about me"—to European standards of craft and design.

Upon returning to New York in 1928, Noguchi supported himself by making stylish portrait heads of an impressive roster of sitters, many of whom became close friends. In 1931 he returned to Asia for the first time since his youth, first to Beijing, to "learn the art of the brush, learn how to be with nature, how to live," then to Japan, to study pottery. His pursuits suggest his facility and eventual mastery in various media, as well as his reliance on natural inspiration, even for abstract forms. The sojourn suggests other priorities as well: reunited with his estranged father, Noguchi "abandoned myself to conflicting emotions" before ultimately isolating himself with his ceramic work, "seeking after identity with some primal matter beyond personalities and possessions. In my work I wanted something irreducible, an absence of the gimmicky and clever."

Back in New York in 1932, Noguchi continued his inventive work, which eventually embraced many and diverse fields: planning playgrounds, gardens, and other public spaces as "sculptural landscapes," designing ballet sets for his friend Martha Graham, executing relief murals for Rockefeller Center skyscrapers and Mexico City marketplaces, designing furniture and Akari (paper light sculptures), and all the while continuing his studio sculptures in varied materials.

Song of the Bird reflects Noguchi's love of carving and of stone, affections developed in Brancusi's studio and reinforced over the years by encounters with Japanese traditions. The twisting, knobbed pylon and the abstract columnar "birds" were souvenirs of designs for the plaza of the Lever House in New York City (1952–53). This collaborative project with the architect Gordon Bunshaft was the first such venture for Noguchi, and although his plan was never realized, he continued to regard it as one of his most important designs. In 1958 Noguchi returned to the Lever House concept, its two principal elements reappearing, carved to half-scale, in *Song of the Bird.*

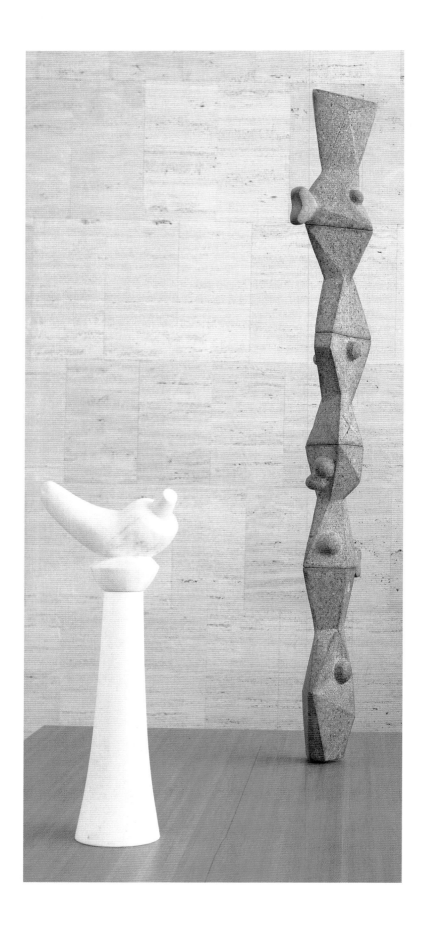

Sam Hunter related the lofty post of the Lever design both to the animistic imagery of Noguchi's experiments with traditional Japanese ceramics and to Brancusi's *Endless Column*, one of the icons of European modernism.[2] The stacked units of the dark column illustrate the artist's fascination with "the idea of sculpture made of parts, replaceable and extensible." The modularity of the stack recalls Brancusi's influential prototype, but now turned on its axis. Noguchi explained, "I wanted to give a torque to [it]. I had always felt its lack."[3] The twisting pylon, which reappeared in studio sculptures, civic monuments, and domestic designs, became one of the essential elements in Noguchi's formal vocabulary.[4]

The white marble of the shorter column "provides a memory of my love for Greece, which I have held since childhood."[5] In the 1950s marble became a favorite carving material and figured prominently in Noguchi's important 1959 exhibition at the Stable Gallery, where *Song of the Bird* was first shown. The pure white Greek marble was used for several works on the bird theme, a subject that paralleled Brancusi's symbols of human imagination—"poetic evocations," in Hunter's words, "which most vividly recall Brancusi's classical spirit."[6] However, the simple, Brancusian spread-winged form also echoes Japanese precedent; it appeared in Noguchi's *Mu*—the title alludes to the Zen state of blissful nothingness—designed for Keio University in 1952, and it was repeated in the smaller avian marbles. Evolving from such disparate sources, *Song of the Bird* illustrates the complex and sophisticated merger of cultural forms and meaning that Noguchi uniquely represented among his generation.

CHARLES C. ELDREDGE

NOTES

1. Isamu Noguchi, *A Sculptor's World* (New York: Harper & Row, 1968), 13. Unless otherwise noted, all quotations of the artist are taken from this autobiography.

2. Sam Hunter, *Isamu Noguchi* (New York: Abbeville, 1978), 103.

3. Isamu Noguchi, *The Isamu Noguchi Garden Museum* (New York: Abrams, 1987), 48.

4. Martin L. Friedman, *Noguchi's Imaginary Landscapes*, exhibition catalogue (Minneapolis: Walker Art Center, 1978), 91ff.

5. Noguchi, *Garden Museum*, 78.

6. Hunter, 117.

JOSEPH CORNELL (1903–1972)

Pipe Box, c. 1960

BOX CONSTRUCTION, MIXED MEDIA: CLAY PIPE, CORK BALL, METAL RODS, WOOD, TREE BARK, PAPER 7 ¹/₈ X 13 ¹/₈ X 3 ⁵/₈ IN. UNIVERSITY OF NEBRASKA, OLGA N. SHELDON ACQUISITION TRUST 1997.U-4968

Few American artists in the twentieth century have exerted as powerful an influence on the history and development of modern art in the United States as did Joseph Cornell. Best known for his Surrealistic shadow boxes, which he began assembling in the early 1930s, Cornell was highly influential for generations of American sculptors, painters, collage artists, photographers, and filmmakers.

Cornell was born in Nyack, New York, in 1903 to a close-knit and highly religious middle-class family to whom he would remain devoted throughout his life. In 1929 his family moved to Flushing, where he cared for his brother, Robert, who suffered from cerebral palsy, until Robert's death in 1965. Cornell received no formal training in art, although he possessed a nearly insatiable passion for French Symbolist poetry from Baudelaire to Mallarmé, theater, opera, nineteenth-century Romantic ballet, and films. These passions, combined with his love for collecting "Americana" such as old books and engravings as well as other forms of ephemera, provided the foundation on which Cornell's aesthetic achievement was built. Cornell gradually became involved in the lively New York art milieu during his frequent trips to Manhattan, where, in addition to exploring the museums, theaters, and opera houses, he also scoured the downtown bookstores, antique stores, and junk shops for obscure ephemeral objects that affirmed his romantic yearnings for distant places and eras.

In the early thirties Cornell's love of Symbolist poetry, film, and collage gradually put him in the orbit of the exiled French Surrealists at the Julien Levy Gallery in New York; the Surrealists shared his passion for the unexpected juxtaposition of seemingly unrelated objects and texts to create new meanings. Cornell made his first work of art in 1931 after seeing Max Ernst's "collage-novel" *La femme 100 têtes,* and exhibited a glass bell containing a mannequin's hand holding a collage of roses in the very

important group exhibition entitled "Surréalisme," at the gallery from January 9 to 29, 1932, which also included collages by Max Ernst; paintings by Salvador Dalí, Pablo Picasso, and Man Ray; and photographs by Eugene Atget, László Moholy-Nagy, and Man Ray. In the fall of 1932 Cornell's minutiae, glass bells, and other so-called *jouets surréalistes* that consisted of various objects, cut-up engravings, and other ephemera, including some small shadow boxes in which these objects were displayed, were shown at the gallery. Throughout the forties and fifties, these shadow boxes gradually developed into more-complex and elaborate compositions in which Cornell used rugged frames to function as a display box for the cuttings and fragile objects that he found on frequent sojourns to Manhattan bookstores and antique stores and on his frequent walks along the beaches of Long Island.

Cornell exhibited at the Julien Levy Gallery throughout the thirties and knew most of the Surrealist artists and writers. His *Untitled (Soap Bubble Set)* was even included in the 1936–37 "Fantastic Art, Dada, and Surrealism" exhibition at the Museum of Modern Art, a highly influential exhibition curated by Alfred H. Barr Jr. Cornell was very much influenced by Dalí, whose meticulously painted compositions he saw at the Spanish Surrealist's first American solo exhibition, at the Levy Gallery in 1933. In addition to the Surrealists whom he met at the Levy Gallery, Cornell was deeply affected by Marcel Duchamp, whom he met in the early thirties and with whom he developed a close relationship throughout the forties and fifties. From Duchamp, Cornell reaffirmed his interest in the found object as a legitimate means for aesthetic expression. Cornell paid homage to Duchamp with a series of assemblage box constructions entitled "Pharmacy," which he began in the early 1940s.

Pipe Box (c. 1960) is from Cornell's final series of box constructions, called "Celestial Navigations," which he began in the mid-fifties. As he did in the other series, such as "Bird Habitats,"

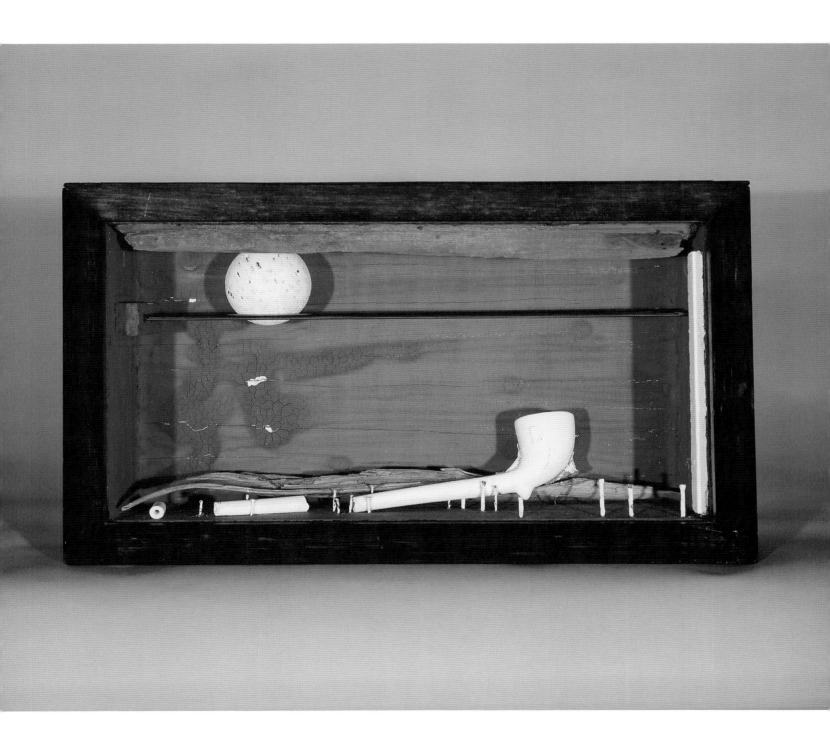

"Medici Constructions," "Hotels," "Palaces," and "Sand Fountain Boxes," Cornell explores one primary theme with a common set of objects and imagery through a variety of different but related variations. *Pipe Box* communicates Cornell's Romantic interest in astrology, astronomy, and the power of the stars as a symbolic vehicle to communicate the spiritual, the wonders of creation, and the infinite. Themes that Cornell's lifelong belief in Christian Science, through his study of and devotion to Mary Baker Eddy's *Science and Health* and the Holy Bible, led him to pursue with particular zeal.

In *Pipe Box*, a cork ball precariously balanced on two horizontal rods suggests not only the movements and orbits of planets but also the cyclical ebb and flow of all creation—a meaning further underscored by the dark bluish-green painted background that emphasizes the expanse of the heavens and painted constellations on the top frame of the box. A fragment of a scholarly Italian text pasted to the back of the box lends further mystery not only to the ultimate meaning of the box construction but to the ultimate meaning of life itself. Cornell's use of a broken white clay pipe, a common theme throughout his "Celestial Navigations," harkens back not only to the Surrealists' use of the pipe, from Man Ray to Magritte, but also to Cornell's own previous use of it in his first full-scale box construction, *Soap Bubble Set* of 1936. Despite the pipe's symbolic presence in the Freudian-laden Surrealist community, Cornell's use of the pipe—a child's toy soap-bubble pipe—was much less ideologically charged, harkening back to the innocence and wonder of childhood, an innocence and wonder apparently lost and never fully recovered with the broken pipe delicately reassembled in the box. In addition, the inclusion of a piece of driftwood, a souvenir from his many walks, intensely personalizes the meaning of the piece.

Although his affinities with the Surrealists were obvious, especially in their eager use of nonart objects, Cornell had little interest in the kind of sociopolitical radicalism and ideological agenda that characterized them. "I never had any real sympathy for the movement and what it stood for."[1] Diane Waldman observes, "But, while utilizing the Surrealist technique of disorientation through seemingly random juxtapositions, Cornell's collages of the 1930s also reveal a disarming innocence and naiveté quite different from the black humor and disturbing, often grotesque imagery deliberately cultivated in Surrealist painting and poetry."[2] Ironically, it is precisely because of his lack of interest in the sociopolitical

radicalism of European modernism and his unwillingness to adhere to modernism's "movements" that Cornell exerted such a massive influence on the development of modern art in the United States. Cornell's aesthetic interest in but ideological distance from European modernism allowed artists at midcentury, primarily those who would make up the New York school of the 1940s and 1950s and whom he met when he exhibited his work at the Charles Egan Gallery in the early fifties, to be influenced by the European avant-garde in purely aesthetic and idiosyncratic ways. In short, Cornell translated European modernism into a language that was understandable to American artists.

In fact, Cornell's work succeeded in wrapping the ideological radicality of Dada and Surrealism in the comforting aesthetic cloak of the American folk tradition, which emphasized craftsmanship and the material beauty of objects. In a monograph on the artist, Diane Waldman draws a comparison between Cornell and the nineteenth-century American trompe l'oeil still-life painter William Harnett. "The artist's workmanship and technique were as impeccable and meticulous as that of an early American craftsman."[3]

The art critic Carter Ratcliff observed that "Joseph Cornell is a virtuoso of fragments, a maestro of absences. Each of his objects—a wine glass, a cork ball—is the emblem of a presence too elusive or too vast to be enclosed in a box."[4] Therein lies Cornell's greatness, and greatness for any artist: the ability to communicate the universal through the individual, the spiritual through the material, the sacred through the common.

DANIEL A. SIEDELL

--

NOTES

1. Quoted in Deborah Solomon, *Utopia Parkway: The Life and Work of Joseph Cornell* (New York: Farrar, Straus and Giroux, 1997), 56.

2. Diane Waldman, *Collage, Assemblage, and the Found Object* (New York: Abrams, 1992), 205.

3. Diane Waldman, *Joseph Cornell* (New York: George Braziller, 1977), 29.

4. Carter Ratcliff, "Joseph Cornell: Mechanic of the Ineffable," in *Joseph Cornell*, ed. Kynaston McShine, exhibition catalogue (New York: Museum of Modern Art, 1980), 43.

DAVID SMITH (1906–1965)

--

Superstructure on 4, 1960

STAINLESS STEEL 139 3/4 X 79 3/4 X 22 IN. (WITHOUT BASE) UNIVERSITY OF NEBRASKA, BEQUESTS OF FRANCES SHELDON AND ADAMS BROMLEY SHELDON
1969.U-656

© ESTATE OF DAVID SMITH/LICENSED BY VAGA, NEW YORK NY

An artist of prodigious talent, ambition, and originality, David Smith pioneered welded metal sculpture in the United States and won recognition as the leading American sculptor of his generation. Born in Decatur, Indiana, Smith moved with his family to Paulding, Ohio, in 1921, and in 1924–25 attended Ohio University, where he took art classes. In the summer of 1925 he worked as a welder and riveter at the Studebaker plant in South Bend, Indiana, gaining experience in metalworking that would inform his later approach to sculpture. In 1926 Smith moved to Washington DC and then to New York City, where he enrolled in painting classes at the Art Students League. His most important teacher was the Czech Cubist Jan Matulka, who encouraged his interest in abstraction. Also influential was the Russian émigré painter John Graham, who around 1930 showed Smith reproductions in *Cahiers d'art* of the welded metal sculptures of Pablo Picasso and Julio González.

By 1931 Smith was making constructions, and in 1933 he made his first group of welded metal "Heads." The next year, he established a studio in the Terminal Iron Works factory in Brooklyn. Smith and his first wife, Dorothy Dehner, herself a painter and sculptor, moved to a farm at Bolton Landing in Upstate New York in 1940. From 1942 to 1944, Smith worked at a defense plant in Schenectady, welding tanks and locomotives. After the war, he built at Bolton Landing a new house and a machine shop–style studio that he called the Terminal Iron Works. He worked there for the rest of his life.

Smith applied the lessons of Cubism, Surrealism, and Constructivism to his sculpture of the 1930s, combining elements of biomorphic figuration and geometric abstraction. The "Medals for Dishonor" (1937–40), a series of bronze reliefs explicitly protesting the social and political ills of the day, brought Smith his first wide public recognition. Following World War II, he defied the traditional values of vertical, monolithic sculpture by welding horizontally formated, open-form pieces whose fluent metal calligraphy represented a kind of "drawing in space." In their emphatic linearity, shallow spatial depth, and frontal orientation, these works were strongly pictorial. Indeed, Smith, whose formal training was in painting rather than sculpture, acknowledged no real separation between the two media and often applied paint to his metal pieces in order to make "painting and sculpture both."[1]

Guggenheim Fellowships in 1950–51 provided Smith the wherewithal to begin making large-scale iron and steel works. He commenced a number of remarkably powerful sculptural series, including the "Agricolas" (1951–59), incorporating metal parts scavenged from abandoned farm machinery; the "Tanktotems" (1952–60), assembled from steel beams and boiler-tank heads; and the "Sentinels" (1956–61), which ranged from stacked towers of painted steel to frontal arrangements of overlapping stainless steel planes. Many of the works in these series were powerfully anthropomorphic, standing upright like primitive totems recast in industrial materials.

The Sheldon's *Superstructure on 4* also strongly suggests a totemistic personage, whose boxy stainless steel torso, bristling with planar appendages, lofts into the air on a quartet of stiltlike legs. Though seemingly arrived at spontaneously during the process of assembly, as were most of Smith's sculptural compositions of the 1950s and 1960s, *Superstructure on 4* was in fact planned out in advance in a spray drawing made nine months before the sculpture's execution.[2] In the drawing, the frontal view of the sculpture is powerfully silhouetted and monumentalized by the spray paint, which creates an illusion of deep space around it.

Superstructure on 4 occupies a transitional place in Smith's oeuvre. Its stainless steel planes and anthropomorphism relate it to the contemporaneous "Sentinels," while its salient compositional

element, the burnished stainless steel box, looks ahead to the "Cubis" (1963–65), a series of monumental, eccentrically balanced compositions of polished stainless steel boxes and cylinders, widely regarded as Smith's crowning achievement. He was still actively working on them at the time of his tragically premature death in an automobile accident.

Like all of Smith's large-scale stainless steel pieces, *Superstructure on 4* was meant to be situated in the out-of-doors, where sunlight reflects off the animated, swirling patterns on its burnished surfaces and optically dematerializes its masses. Smith himself originally placed *Superstructure on 4* in his sculpture field at Bolton Landing, along with dozens of his other creations, where he could contemplate it year-round against the majestic backdrop of the forest-covered mountain ranges that surrounded his property.

DAVID CATEFORIS

--

NOTES

1. David Smith, interview by Thomas B. Hess, New York, June 1964, published as "The Secret Letter," in *David Smith*, ed. Garnett McCoy (New York: Praeger, 1973), 182.

2. The drawing, *Untitled (study for Superstructure on 4)*, dated 5/59, is reproduced in Edward F. Fry and Miranda McCintic, *David Smith: Painter, Sculptor, Draftsman*, exhibition catalogue (New York: George Braziller, in association with the Hirshhorn Museum and Sculpture Garden, Smithsonian Institution, 1982), cat. no. 103, pl. 90.

BRUCE CONNER (b. 1933)

JULY GEORGE/PORTRAIT OF GEORGE HERMS, 1962/1991

WOOD, PAPER, CARDBOARD, METAL, LEATHER, STRING, CLOTH, STONE, CORK, LUCITE 29 ¹/₄ X 27 ¹/₂ X 7 IN. UNIVERSITY OF NEBRASKA, OLGA N. SHELDON
ACQUISITION TRUST 1992.U-4442

© BRUCE CONNER

Bruce Conner is among the most versatile artists to have emerged in American art in the second half of this century. Amid his prolific output, he is best known for his often macabre assemblages produced in the period 1957 to 1965 and for his groundbreaking experimental films edited together from scraps of preexisting footage. However, Conner eludes easy pigeonholing, having also produced work in painting, drawing, collage, photography, printmaking, performance, and conceptual art.

Born in Wichita, Kansas, Conner attended the University of Nebraska—where he married his wife, Jean—before moving to San Francisco and becoming one of the most widely acknowledged practitioners of California assemblage art, along with Wallace Berman, George Herms, and Ed Kienholz. Conner's assemblages were for the most part wall-hung works fabricated from material ransacked from secondhand stores and crumbling Victorian houses being demolished to make way for housing projects. Conner's assemblages often had a sinister quality. Among his favorite materials was torn and shredded nylon, which, combined with his frequent use of women's clothing, costume jewelry, and photos from period stag magazines, made some of his works look like mementos of sexual violence. Other works took on a slightly decrepit, nostalgic elegance.

In 1961 Conner left California for a one-year sojourn in Mexico, where he hoped to take advantage of the low cost of living and to escape the threat of nuclear holocaust that loomed as a possibility in cold war America. It is to this period that *JULY GEORGE/PORTRAIT OF GEORGE HERMS* belongs.[1] Most of Conner's Mexican assemblages differ dramatically from their San Francisco predecessors. Mexico did not share the kind of consumer culture and fascination with the new that typified fifties America, consequently the cast-off materials that Conner had used previously were in scarce supply. Instead he had to rely more on inexpensive colored papers and mass-produced items, often created for the tourist trade. The

work became more brightly colored, flatter, and often reflective of an ardent Catholic spirituality that Conner found and admired among the lower classes of Mexico.

In July 1962, while living in Mexico City, Conner created *JULY GEORGE* as a means of conjuring up the distant spirit of fellow assemblage artist George Herms. As such it is one of several "portrait" homages of fellow artists Conner created over the years, including *PORTRAIT OF ALLEN GINSBURG* (1958), *HOMAGE TO JAY DE FEO* (1958), and *HOMAGE TO JOAN BROWN* (1958). For this work, Conner in essence sought to create a sculpture in the manner of George Herms, using materials of the type Herms favored, particularly rough pieces of weathered wood.

Shrinelike in composition, the piece has a distinct front and back, the "front" being relatively blank, while the "back" features a boxlike cavity housing miscellaneous items, including a page of poetry by George Herms. "The front is more of an enigma. If you want to know what is happening inside of George, you have to get inside of his mind," Conner explains.[2] The boxlike "head" is mounted on a stack of crude wooden boards whose diminishing lengths create a steplike progression reminiscent of Mexico's pre-Columbian pyramids.

The current work is much altered from its original appearance, having been damaged during a long period in storage as part of a private collection. Many loose or loosely attached objects disappeared, including a "mushroom" at the top of the sculpture (a clear allusion to hallucinogenic mushrooms used by many in the so-called Beat subculture as a means of entering an alternative reality), which in reality was a broken maraca gourd onto whose concave interior Conner had pasted two eyes clipped out of a magazine. Also missing is a folded bottle cap placed in the center of the front side of the sculpture, which was meant to represent Herms's smile. Among the original pieces that remain are

the mop "hair" and a printing plate consisting of a wooden board faced with metal. Attached to the back of this plate is a turned wood element given to Conner by Wallace Berman, another key figure in the assemblage underground and one of Herms's acknowledged mentors. Conner is uncertain about the origin of this wooden piece, but believes it is either one of a number of pieces Berman acquired from the set of Charlie Chaplin's film *Modern Times* or a remnant from Berman's days as a producer of imitation antique furniture.

Conner reworked JULY GEORGE in 1991, adding new objects to replace those that were missing. Among the new elements are the empty photo album placed in the back of the "head." The album features translucent separating pages embossed with a spider web design "that may capture random thoughts now and again, but they're liable just to rush out the window anyway." Conner also added a key chain with a small plastic heart, an allusion to the Tin Woodman from *The Wizard of Oz* (Conner was originally from Kansas). Other elements he added include a cork sphere, a Lucite cylinder, and a crushed metal can. None of these items are affixed (just as many of the original objects had not been attached), and it is the artist's intention that they can be placed in different areas of the sculpture, allowing it to change. "You can take the cylinder and place it inside of the box in the back or put it on another of the steps of the base, or you can take the book out, put it in front of the piece and JULY GEORGE can attempt to read his own mind."

PETER BOSWELL

- -

NOTES

1. Conner always uses capital letters in the titles of his works.
2. All quotations from Bruce Conner, conversation with the author, January 28, 1993, San Francisco.

MARCEL DUCHAMP (1887–1968)

Boîte-en-valise (Series E), 1962–63

MIXED MEDIA ASSEMBLAGE: IMITATION LEATHER BOX CONTAINING MINIATURE REPLICAS, PHOTOGRAPHS, AND COLOR REPRODUCTIONS OF WORKS BY DUCHAMP
16 $^{1}/_{16}$ X 14 $^{15}/_{16}$ X 3 $^{15}/_{16}$ IN. (CLOSED) UNIVERSITY OF NEBRASKA, OLGA N. SHELDON ACQUISITION TRUST 1987.U-4061

Marcel Duchamp described his *Boîte-en-valise* as a "portable museum" that would allow him to carry around his life's work in a traveling box. The artist spent five years (1935–40) re-creating his oeuvre in miniature through photographs, hand-colored reproductions, and diminutive models. These facsimiles of the artist's major paintings, drawings, and sculpture provided the source material for an edition of 320 boxes, which he would spend the rest of his life assembling. The title is derived from the first edition of the work, which was issued in a series of twenty deluxe boxes. The works in this series consisted of a wooden box fitted inside a leather-covered suitcase—or valise—with a carrying handle. Each box contained an "original" work of art, usually mounted on the inside of the lid, in addition to the 69 standard reproductions of Duchamp's works.

In a television interview with James Johnson Sweeney that aired on NBC in 1956, Duchamp explained his reasons for making a comprehensive anthology of his own works: "It was a new form of expression for me. Instead of painting something the idea was to reproduce the paintings that I loved so much in miniature. I didn't know how to do it. I thought of a book, but I didn't like that idea. Then I thought of the idea of the box in which all my works would be mounted like in a small museum . . . and here it is in this valise."[1] At a time when no museum would honor Duchamp with a retrospective, the artist decided in effect to be his own curator, organizing a self-contained traveling exhibition of his life's work that could be changed at will, simply by rearranging the contents of the box.

Duchamp's most significant works are cleverly arranged inside the box like a traveling salesman's wares. Open the lid and you find a treasure trove of art objects all reproduced on a Lilliputian scale. The centerpiece of the display, once the lid is opened, is the artist's magnum opus *The Bride Stripped Bare by Her Bachelors, Even*, otherwise known as *The Large Glass*. Duchamp used transparent celluloid to re-create this huge painting on glass, which is flanked to the left by three tiny replicas of his readymades, which hang one above the other in a narrow vertical space. These items—the notorious urinal he christened *Fountain*, an Underwood typewriter cover, and a chemist's glass ampoule filled with Paris air—were bought by Duchamp as "readymade" works of art, in a gesture that would redefine art in the twentieth century. Below them, mounted on the lid, is an early painting entitled *Sonata*, which depicted his mother and three sisters playing music.

Why the artist should want to faithfully reproduce the highlights of his artistic career in miniature and pack them into a small suitcase has been the subject of great discussion since the first *Boîte-en-valise* appeared in 1941. Duchamp may have been humorously commenting on his meager artistic output. Unlike many of his contemporaries, such as Pablo Picasso, Fernand Léger, and Henri Matisse, who by this time had created a prodigious number of paintings, Duchamp had deliberately limited his artistic production to a handful of key works. In doing so, the artist thought that he could avoid repeating himself, which he believed had been the sad fate of many successful painters in the modern era. The *Boîtes-en-valise* can thus be seen as a self-deprecating joke, with an undertone of criticism for the excesses of his fellow artists, which allowed Duchamp to proudly claim that his life's work was so small that he could fit all his art objects in a little suitcase. The obsessive attention to detail that one finds in the production of the boxes also suggests a concern to preserve the past, while simultaneously keeping his ideas alive for a new generation.

The *Boîtes-en-valise* can be divided into seven distinct series, each slightly different, including the deluxe, leather-bound edition of twenty and the standard edition of three hundred, which the artist periodically distributed in small batches during the last three decades of his life. The Sheldon's version comes from

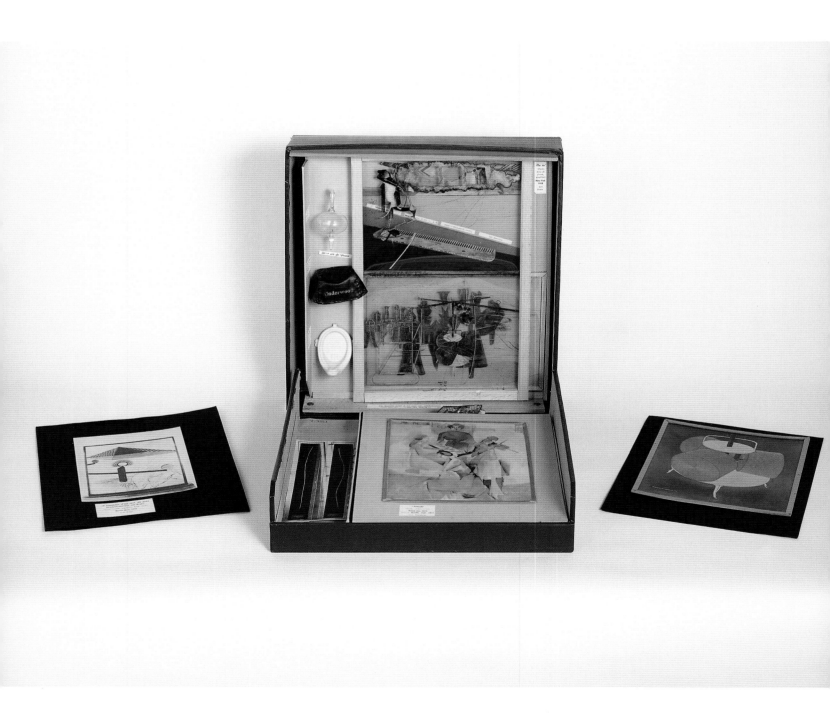

Series E, which was released in an edition of thirty copies in 1963. The works in this series contained sixty-eight items kept in a dark green imitation-leather box, the size of a large attaché case, with a light green lining inside. Eventually Duchamp grew tired of the repetitive and time-consuming nature of the project and hired assistants to help him complete the set. Among them was the young American artist Joseph Cornell, who would later become famous for his own box constructions. This version of the *Boîte-en-valise* was made with the loving care of Duchamp's stepdaughter, Jacqueline Matisse-Monnier, who took over production of the series in the 1960s. It was given by Duchamp to the filmmaker Arnold Eagle, who had been the cameraman on a number of films that Duchamp had appeared in during the 1940s and 1950s, including the famous Surrealist film *Dreams That Money Can Buy*. It was subsequently acquired by the Sheldon Memorial Art Gallery in 1987, exactly one hundred years after the artist was born, and was the first work by Duchamp to enter the collection.

MICHAEL R. TAYLOR

--

NOTE

1. James Johnson Sweeney, "A Conversation with Marcel Duchamp," in *Salt Seller: The Writings of Marcel Duchamp (Marchand du Sel)*, ed. Michel Sanouillet and Elmer Peterson (New York: Oxford University Press, 1973), 136.

ELISABETH FRINK (1930–1993)

Small Bird, c. 1962

BRONZE 8 9/16 X 3 1/4 X 6 1/4 IN. UNIVERSITY OF NEBRASKA, BEQUEST OF BERTHA SCHAEFER 1971.U-886

© FRINK ESTATE

Elisabeth Frink's corpus of sculptural works is a complex admixture of colossal male nudes, dogs, wild boars, rabbits, baboons, and other animals. Of these subjects, however, the most interesting are her birds. In a review of her solo exhibition at the Bertha Schaefer Gallery in 1961, Sidney Tillim lamented, "She is trying—perhaps she does not know it—to conceive heroic figures in a technique that humiliates the human form."[1] The association of humanity and the bird implied by Frink was too much for the staunch humanist critic to take. Tillim further argued that her bird figures had even become passé in the art world, with such artists as Reginald Butler, César, Germaine Richier, and Leonard Baskin adopting the bird-man theme in various ways: "But the time has run out on these predators. They are too popular to be convincing images of anxiety; they belong to a folk idiom where sentiment can house-break them."[2] Tillim's mistake was to assume Frink's bird forms are simply reworkings of a fashionable modernist innovation. Quite the contrary, the bird figure has an important history in folk and classical mythology, from Icarus and his wax wings to Papageno, the birdcatcher in *The Magic Flute,* and Tillim fails to do justice to this theme, which has been employed by cultures throughout history to express both humanity's tragic and comic state.

It is evident that Frink sees her preoccupation with the bird figure in a similar way. "The birds I did in the early 1950s were really expressionist in feeling—in their emphasis on beak, claws and wings—and they were really vehicles for strong feelings of panic, tension, aggression and predatoriness. They were not, however, symbolic of anything else; they certainly were not surrogates for human beings or 'states of being.'"[3] Although she refuses to acknowledge the symbolic value of her birds, it is ironic that the most powerful expressions of "tension," "aggression," and other human emotions in her work are found, not in her classically stoic male nudes, but in her representations of crows and ravens. Frink does see the birds as significantly meaningful, however: "But the birds at that time [the 1950s] were indeed implying more than the generalized physical body of a bird. They were specifically based on the forms of ravens and crows, and the war and violence around me must have been the reasons for my interest, at the time, in violence and aggression."[4] These ominous birds, with their powerful and prominent legs, are human metaphors. Perhaps this is why the animal form—especially the bird or winged beast—has been an important figure in art and literature throughout history; it enables the artist to step outside the obvious communicative baggage of the human form, as it were, and observe humanity from other coigns of vantage. Frink's bird sculptures, like Leonard Baskin's bird men, are important modern manifestations of this ancient theme. *Small Bird* is a good example of Frink's ability to embed human meaning within these bird forms. Unlike her other animal forms, the bird is most explicitly "human," perhaps because her bird figures seem to be "in costume"; in other words, they look, as *Small Bird* does, as if they are "acting out" parts scripted for them by Frink.

Most critics and historians—hostile or otherwise—have almost completely ignored this "theatrical" aspect of her sculpture. Critics such as Sidney Tillim trivialize the "folk" aspect of this theme, but it is exactly this "folksiness" that makes these forms so powerful. The theater, with its popular appeal, has been an important forum for the interpretation of human action since the Greek tragedies of Aeschylus and comedies of Aristophanes, the medieval morality plays, and the works of Shakespeare. For many critics, sculpture is only about significant form. For Frink, and such artists who plumb the depths of the "folk" psyche, art is theatrical in a profound way; it attempts to communicate human concerns through fictional characters. Therefore, Frink's birds and bird men, far from doing violence to or embarrassing humanity, imbue it with all the tragic and comic dimensions it has acquired in the most authentic and penetrating art, literature, and theater throughout history.

DANIEL A. SIEDELL

NOTES

1. S[idney] T[illim], "In the Galleries," *Arts* 36 (December 1961): 49.

2. Tillim, 49.

3. Quoted in Bryan Robertson, *Elisabeth Frink: Sculpture and Drawings* *1950–1990*, exhibition catalogue (Washington DC: National Museum of Women in the Arts, 1990), 42.

4. Quoted in Robertson, 42.

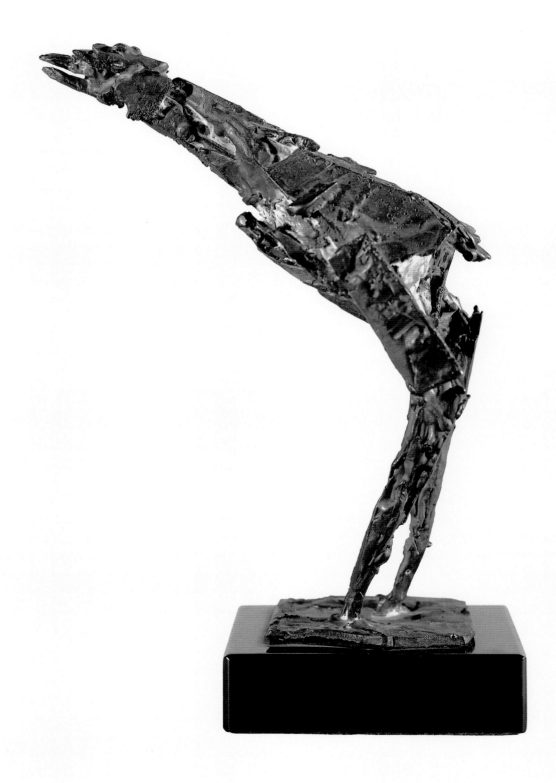

TONY SMITH (1912–1980)

Willy, 1962

WELDED STEEL EDITION 1/3 92 X 216 X 144 IN. UNIVERSITY OF NEBRASKA, BEQUESTS OF FRANCES SHELDON AND ADAMS BROMLEY SHELDON 1969.U-657

The significance of Tony Smith's sculpture lies in its ability to wriggle free from the restrictive confines of Minimalist poetics. When most sculptors working in the 1960s were using basic forms to exploit art's inherent objecthood, Smith was using this limited formal language to expand rather than restrict the expressive range of his sculpture.

The critic Michael Fried picked up on Smith's refusal to throw out the baby of expressivity with the bathwater of form when he criticized Smith's work for possessing an "inner, even secret, life."[1] It was precisely this inner life that Minimalism sought to eliminate from the work of art. That Smith's work refused to do so makes problematic the oversimplified classification of him as a Minimalist and draws attention to his strong ties with Abstract Expressionism.

Smith was forty-eight years old when he first exhibited his work in 1960. Before then he had worked for Frank Lloyd Wright and taught design at New York University, Cooper Union, Pratt Institute, and Bennington College. Although he had been trained as an architect (he had entered the New Bauhaus in Chicago to study architecture), it was his relationships with Jackson Pollock, Barnett Newman, and Mark Rothko and his participation in their heady conversations at that artists' meeting space the Club that truly inform his work. For although he did not exhibit seriously until 1960, Smith had painted and sculpted as a "hobby" in this creative atmosphere for many years. And what he gleaned from that association was a radical view of artistic creation. This is precisely what prompted Harold Rosenberg, the movement's great critical champion, to claim that the significance of Smith's work is found in his ability to express the "openness of the creative act."[2]

Smith's relationship to Abstract Expressionism thus provides a counterpoint to the intellectually cool and architecturally rigorous forms he uses. The residue of his contact with Abstract Expressionism remains in his work: titles with symbolic innuendo, the strong "gestures" of his geometric shapes, and the powerfully physical presence they communicate. Unlike much Minimalist sculpture, Smith's forms are not ready-made formulas systematically applied but seem to be spontaneously achieved and reachieved anew in each composition.

The dialectic between Abstract Expressionist content and Minimalist form is perhaps most poignant in *Willy.* Described by Smith as "rather Surrealist" and "as close to a chance piece as I could get," *Willy* is one of his most ambitious attempts to stretch the expressive limits of the Minimalist vocabulary.[3] Named for the character who spends his days crawling around a stage set designed as a bed in Samuel Beckett's play *Happy Days,* Smith's piece seems to unfold awkwardly with the same agonizing desperation. Smith underscored the tragic nature of the piece when he suggested that it "resembled a crawling thing that hadn't been designed for crawling."[4] It is perhaps fitting that the work was inspired by Beckett, who, like Smith, was capable of such expressive power with what seemed to be the barest of forms.

DANIEL A. SIEDELL

NOTES

1. Michael Fried, "Art and Objecthood," in *Minimalist Art: A Critical Anthology,* ed. Gregory Battcock (New York: E. P. Dutton, 1968), 129.

2. Harold Rosenberg, "Defining Art," in *Artworks and Packages* (Chicago: University of Chicago Press, 1982), 40.

3. Quoted in Lucy Lippard, *Tony Smith* (New York: Abrams, 1972), 11.

4. Quoted in Sam Hunter, "The Sculpture of Tony Smith," in *Tony Smith: Ten Elements and Throwback,* exhibition catalogue (New York: Pace Gallery, 1979), 7.

REUBEN NAKIAN (1897–1986)

Birth of Venus, 1963–66 (cast 1969)

BRONZE 96 X 131 X 72 IN. UNIVERSITY OF NEBRASKA, BEQUESTS OF FRANCES SHELDON AND ADAMS BROMLEY SHELDON 1970.U-655

COURTESY PAUL S. NAKIAN, SON AND EXECUTOR OF THE ESTATE OF REUBEN NAKIAN

Reuben Nakian once lamented, "I hate this age. We have no people knocking at our doors and asking to come in and see what we're doing."[1] Nakian's oeuvre can perhaps best be summarized as a creative attempt to make a heroic statement for an age that seemed to make every effort to frustrate such heroism.

Nakian began his artistic career as a studio assistant, along with Gaston Lachaise, to Paul Manship. Until the mid-1930s his reputation was achieved as a portrait sculptor in Manship's Neoclassical style. The heroic was never far from Nakian's mind, as demonstrated in his gigantic eight-foot full-length portrait of Babe Ruth (1934) and his portrait busts of Franklin Delano Roosevelt and his cabinet members.

It was during this period that Nakian's style shifted from the more refined style inspired by Manship to a bolder, more raw expressionism, which strongly resembled the painted gestures of Abstract Expressionism.

Although his desire to search out and express the heroism of the age remained, Nakian's style and subject matter changed drastically in the late forties. He moved away from representing contemporary American heroes and began to focus instead, like many of the Abstract Expressionists, on classical Greco-Roman myth. Moreover, with his Ledas, Venuses, Europas, and nymphs, Nakian seemed to make the deep-seated sexual impulses of humanity the content of his art. In these themes he found the suitable subject to express what he saw as the nobility and tragic drama of contemporary life.

Nakian's *Birth of Venus* can be regarded as one of the fullest symbolic manifestations of his entire creative endeavor. Born directly out of Poseidon's sea foam, Venus becomes symbolic not only of sexual energy but of the energy of creation itself.

Although it is rarely noted in the literature, there is a strong affinity between Nakian's work and Abstract Expressionism. Not only were many Abstract Expressionists interested, as Nakian was, in mythical subject matter, but they also shared his awareness of the importance of the art-making process. The poet and museum curator Frank O'Hara believed that Nakian had "the energy of a young man and a confidence more sure for having been hard won, more certain for having included defeat, rejection, and triumph."[2] The notion of "winning," and more often "losing," a work of art implied by O'Hara resembled the views of several Abstract Expressionists, most notably Willem de Kooning, Franz Kline, and Jackson Pollock.

Perhaps de Kooning may be the most beneficial coign of vantage from which to appreciate Nakian's sculptural achievement. Not only do they share a fundamental preoccupation with expressing sexual imagery (recall de Kooning's "Woman" series of the fifties), but both seem to understand the "luck" needed "to win" a work of art. (There are, perhaps, no two artists in American art more willing to risk artistic defeat.) And as Barbara Rose claimed, Nakian's heroic desire "to capture and make permanent fugitive qualities such as energy and movement" often got the best of his art.[3] However, it is precisely in these "defeats" that Nakian's own tragic heroism, manifested in *Birth of Venus,* is most fully revealed.

DANIEL A. SIEDELL

NOTES

1. Quoted in Frank O'Hara, *Reuben Nakian,* exhibition catalogue (New York: Museum of Modern Art, 1966), 7.

2. O'Hara, 19.

3. Barbara Rose, "Nakian at the Modern," *Artforum* 5 (October 1966): 19.

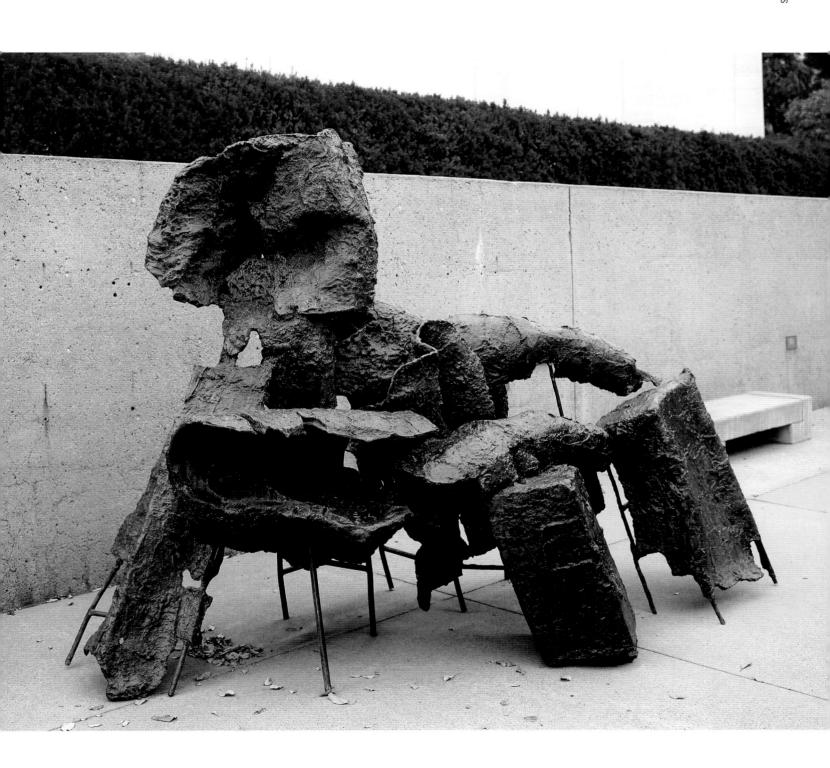

DAN FLAVIN (1933–1996)

- -

Untitled, 1964

FLUORESCENT LIGHT TUBES, FIXTURES EDITION 2/5 7 X 96 X 4 AND 7 X 25 X 4 IN. UNIVERSITY OF NEBRASKA, F. M. HALL COLLECTION 1985.H-2738

© 2002 ESTATE OF DAN FLAVIN/ARTISTS RIGHTS SOCIETY (ARS), NEW YORK

Dan Flavin's light sculptures are prominent manifestations of the purist principles advanced by the Minimalist artists of the 1960s. These artists sought to arrive at a three-dimensional art form that was simplified and straightforward and that provided a direct and unmediated aesthetic experience. Even further, Flavin's art represents an ongoing exploration of the basic sculptural dialogue between mass and space.

Using commercially available fluorescent light tubes as his sculptural material, Flavin combines them in unique configurations that, when lighted, alter the space in which they appear. At times, walls seem to dissolve or corners become skewed. In this manner, the space surrounding the lights becomes as important to the sculpture as the tangible object itself. Indeed, the glow that emanates from the lights when turned on seems to dematerialize the fluorescent tubes.

Dan Flavin's *Untitled* work is a typical example of his light art, executed on a smaller scale. It is composed of two sealed tubes, one red and the other yellow, placed next to each other, but differing in length. The light from each tube alternately competes with the other and combines with it to project a luminous aura—one that calls attention to the space in which the work resides.

By making the spectator keenly aware of the space these glowing sculptures occupy, Flavin has succeeded in solving a problem that has challenged many sculptors over the years— creating an understanding of sculpture that extends beyond the three-dimensional, volumetric object. Flavin's work is significant because it represents the intersection of Minimalist interests and philosophy, the use of high technology in art, and a reevaluation of the basic principles of sculpture—in particular, the relationship between object and space.

CHRISTIN J. MAMIYA

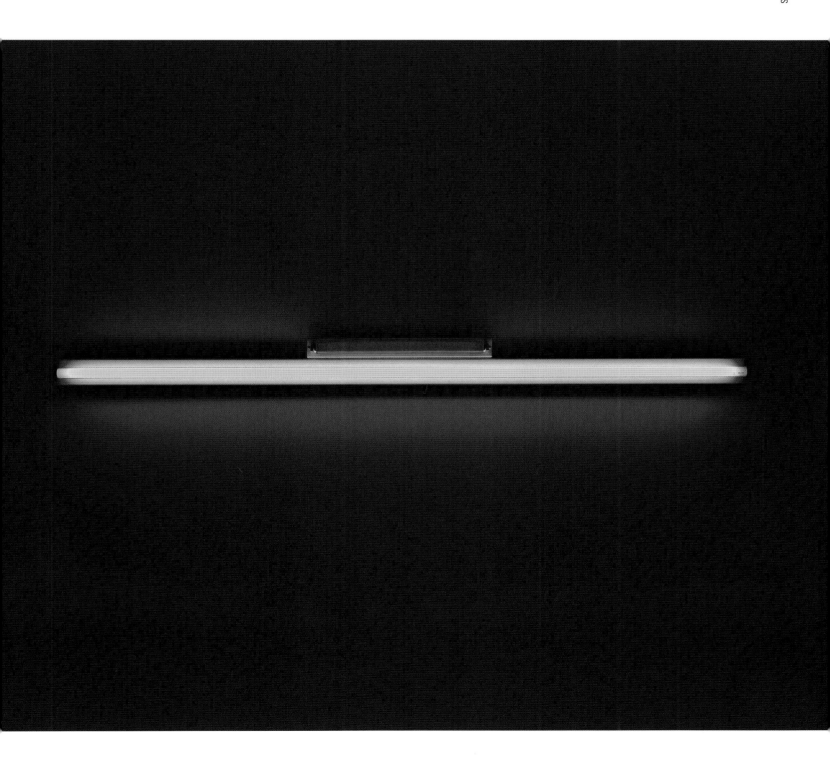

GEORGE RICKEY (1907–2002)

Six Lines in a Column, 1967

STAINLESS STEEL 84 ¼ X 14 X 14 IN. UNIVERSITY OF NEBRASKA, GIFT OF DR. AND MRS. HAROLD GIFFORD 1991.U-4394

© PHILIP RICKEY, EXECUTOR OF THE ESTATE OF GEORGE RICKEY

The laws of gravity, the powers of uncertainty, the passage of time, the direction of the wind—not simply ethereal muses, these intangibles, chance, light, instability, are both the tools and materials of sculptor-inventor George Rickey. His precise kinetic creations emulate the very spirit of nature, its animation, its discourse with the passage of time. His process of making art is as much like choreography as it is sculpting.

"My artistic ideas, like the motions of my sculptures, have unfolded in a casual unexpected manner," Rickey has stated.[1] The same could be said of the many and winding paths his artistic career has taken. Although Rickey was born in South Bend, Indiana (1907), he grew up in Scotland, where he lived until 1930. He was educated at Trinity College, Glenalmond, and at Balliol College, Oxford, where he received an MA in European history. He also studied drawing at the Ruskin School, Oxford; painting at the Académie Lhote, Paris; art history at the Institute of Fine Arts, New York University; etching at the University of Iowa; and design at Chicago's Bauhaus-indoctrinated Institute of Design.

Rickey has been described as patient craftsman, mechanical engineer, creative theorist, research scientist, conceptual designer, rational organizer, poetic observer. He painted for twenty years before he began making sculpture in 1949. Yet his delicately engineered kinetic sculpture seems to have evolved naturally out of his childhood interest in things technical. His father, a mechanical engineer at Singer, and his grandfather, a clock maker, were the role models whose tinkering minds inspired curiosity. It wasn't until World War II, however, that Rickey truly discovered his own mechanical impulse. He taught the use and maintenance of remote-controlled gun turrets in B-29 bombers for the U.S. Army Air Corps. "In the course of working with industrial tools and military hardware, I started toying with the notion of dynamic constructions that were neither static sculptures nor mobiles in the traditional sense."[2]

The formal vocabulary of Rickey's sculpture must also be examined, albeit briefly, through a series of artists who pioneered the modern art of motion. There is a long history in the Western tradition of depicting action, but one of the first to use it not only as a stylistic device but as the very content of a work were the Italian Futurists, led by Filippo Marinetti, in the early 1900s. They used the "dynamism" of fast-paced modern life as subject matter for their art. Their static expression of the illusion of movement nonetheless only exploited the Cubist method of depicting pictorial changes in objects passing through time and space.[3] Marcel Duchamp was one of the first to experiment with actual motion. His *Revolving Glass* (*Rotorelief,* 1920) pushed the possibilities of motion in art further than they had ever gone.

In 1920 the Russian Constructivists Naum Gabo and Antoine Pevsner published their *Realistic Manifesto.*[4] In it they called for "a new element in pictorial art, kinetic rhythms, as the basic forms of our feeling for real time."[5] Gabo's experiments in actual motion were few, however, and he soon abandoned kinetics altogether, discouraged by the crude technology available for supplying constructions with dynamic temporality.[6]

Alexander Calder finally made the most important strides, when in 1932 he gave up motive power, with which he too had been experimenting, for the "chance operations of wind and atmosphere."[7] He invented the mobile. Calder has been called the true father of kinetic sculpture, and if that is true, Rickey, who codified motion art, can be called its most authoritative spokesman. His 1967 book *Constructivism: Origins and Evolution* became the definitive history of kinetic sculpture.

Six Lines in a Column (1967) is exemplary of what became Rickey's signature style. It belongs to a family of like-minded works with names such as *Eight Lines* (1963–64), *Six Lines in a T* (1965–66), *Five Lines in Parallel Planes* (1965), and so on. *Six Lines in a Column* is composed of six stainless steel needles set vertically in

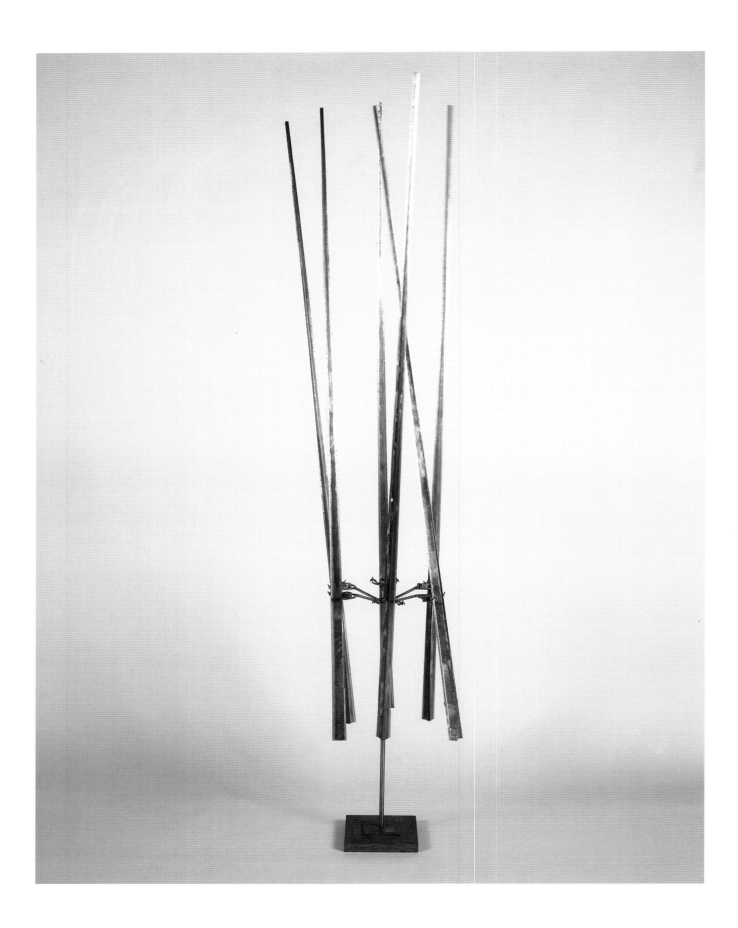

a circle on finely wrought knife-edge bearings. The delicately engineered bearings allow the blades of steel enough sensitivity so that the gentlest breeze can set them in motion. Ironically, the complex interplay of weights and balances as well as the simplicity of design are both highly calculated. About these works Rickey has stated, "I realized that if I was going to compose with movement, I must dispose of shape and reduce my forms to the minimum. . . . So I very soon reduced the components to lines."[8] The sculpture, therefore, becomes as vast as movement itself. Clearly there is a stark contrast between the slight sculptural (actual, literal) material and the virtual, implied mass so that the observer is made aware of both. George Rickey has bridged the fine line between art and science and somewhere in the middle, his sculpture dances.

INGRID A. SEPAHPUR

NOTES

1. George Rickey, "Science in Pictures: A Technology of Kinetic Art," *Scientific American* 268 (February 1993): 75.

2. Rickey, 75.

3. Daniel Wheeler, *Art since Mid-Century: 1945 to the Present* (New York: Vendome Press, 1991), 236.

4. In 1948–49 Rickey attended Gabo's lectures at the Institute of Design, Chicago.

5. Quoted in Wheeler, 236.

6. Wheeler, 236.

7. Wheeler, 236.

8. Quoted in *George Rickey Retrospective Exhibition, 1951–71*, exhibition catalogue (Los Angeles: The UCLA Art Council and UCLA Art Galleries, 1969), 21.

WILLIAM KING (b. 1925)

Story, 1970

ALUMINUM 144 X 112 X 45 ¼ IN. NEBRASKA ART ASSOCIATION, GIFT OF BLAKE KING IN HONOR OF NORMAN A. GESKE 1983.N-632

© WILLIAM KING

A lanky Floridian who began as a student of engineering, William King followed the artist's lodestar to New York. (Florida, he decided later, was "a fine place until you're 15.") At New York he turned seriously to art, studying at Cooper Union (1945–48) and earning a Fulbright to Italy. Upon his return to Manhattan he began in the 1950s the long climb to his current elevated position in the profession.

Such an ascent is seldom easy, and it was not so for King. He struggled with his métier and fumbled for his form language, supporting himself as he could—mainly by teaching. As a teacher he was good, and he taught for many years, particularly at the Brooklyn Museum School and the Art Students League.

In his teaching he was characteristically open to variant styles and modes of expression, but in his own work he has been committed to the figure. This he has investigated with progressive self-assurance, utilizing a wide variety of materials including clay, plaster, wood, metal, fabric, paper, and vinyl. Usually he has selected generally accessible subject references taken from his own visual experience. Always he has spoken in a personal idiom. His art as it has matured owes little to that of other sculptors, although one may be reminded, in this piece or that, of the folk tradition, of Elie Nadelman, of Alberto Giacometti, of Alexander Calder.

One may even be reminded, in spirit, of Honoré Daumier—he of the great heart, sharp eye, and deft hand. King's people, like Daumier's, tend to be rather ordinary, doing ordinary things—sitting, standing, walking, waiting. Each, as it is isolated out of time, is caught in characteristic attitude or mood or gesture, the gesture being preeminently important (and in the best work inherent in the total figure) because it directs us to the interpretive point. And as in Daumier there is always a point—insightful, commonly amusing, satiric if need be, and ultimately affirmative.

The Sheldon's King, titled simply *Story,* is one of a series of large-scale outdoor works initiated in the late 1960s. All are cut from half-inch aluminum plate and consist of rigid sections fitted together paper-doll fashion to describe the subject in three dimensions. Our example is built of three pieces. One comprises the torso, head, left arm, and the block on which the man sits. It is drawn and sawn in frontal silhouette. The other two are the right arm holding the cigarette, and the single leg. These are cut in profile and set at right angles to the torso, so that the piece is both tridimensional and self-supporting. In ingenious simplicity, fabrication, and impact it is as witty as a Steinberg drawing.

Admittedly, it does not press us urgently into new areas of awareness. King's art does not do that. He has not seen that as his role. Perhaps one could say with justice that in style and content his good-humored sculpture establishes its own parameters. Within them, in the late twentieth century, it has been unique.

ROBERT SPENCE

CHARLES BIEDERMAN (1906–2004)

#35, Ornans, 1971–73

PAINTED ALUMINUM 43 1/16 X 34 X 9 1/2 IN. NEBRASKA ART ASSOCIATION, THOMAS C. WOODS MEMORIAL COLLECTION 1978.N-485

Although he is seldom mentioned in the same breath as such modern masters as Pablo Picasso, Piet Mondrian, and Kasimir Malevich, Charles Biederman has perhaps taken the expressive possibilities of abstract form further than any American artist. Biederman's absence from the annals of art history is due in part to his irascible personality and his own high-handed and idiosyncratic stance toward art and its making.

Biederman's artistic life has been spent distancing himself from the aesthetic concerns of his contemporaries. For example, in the 1930s, when American artists began to turn their collective back on the abstract art of the Paris school and embrace figuration, Biederman intensified his exploration into abstraction. (His refusal to abandon abstraction is even more striking considering his midwestern roots and exposure to the Regionalist school of Thomas Hart Benton, Grant Wood, and John Steuart Curry.)

However, Biederman did not simply swallow the European models whole. He ultimately dismissed Mondrian, Russian Constructivism, and Cubism because of what he saw as a decadent *art for art's sake* attitude. This self-imposed isolationism allowed him to devote full attention to the exploitation of abstract form for his own personal sensibility—without the residue of Regionalist politics or modernist historical determinism.

Biederman's idiosyncratic approach to art stems from his effort to redefine it according to his own needs. A prolific writer, his colossal *Art as the Evolution of Visual Knowledge* (1946), followed by several other books and treatises, communicates an extremely personal interpretation of the visual arts. In fact, his reliefs, which he calls "New Art," should be seen as attempts to transcend the limitations of both painting and sculpture. This New Art, called "structurism" by Biederman, resulted from a return to the observation of nature and "the structural process level of reality."[1] As Donald Kuspit suggests, Biederman is "convinced that abstract art refers to nature in spite of itself."[2]

Biederman thus attempts, through his abstract reliefs, to represent the inherent structural rhythms of nature. He expresses this intent in the play of color, light, and line exploited in the horizontal and vertical juxtaposition of aluminum planes. Although he emphasizes "structure," it is a structure won from an aesthetic struggle with the constant flux of perception. For Biederman, nature—like art—is "a dynamic, ever changing process."[3] And this dynamism is expressed in the recognition that his images emerge only gradually. Only after the viewer has taken in each angle of perception, and the colors of the brightly painted planes have shifted hue and intensity, does the composition make itself fully manifest.

Biederman's success in transcending the traditional limitations of painting and sculpture is strongly felt in *Ornans*. With its dynamic play of shifting planes played out on a bright ground, their visual harmony seems to evoke the expressive immediacy of music.

Because he self-consciously sought to distance his art from institutional contexts, Biederman's "structurist" works will remain outside the pale of modern art history. However, the intensity and integrity with which he explored the expressive language of abstract forms have demonstrably opened up the communicative capabilities of the visual arts for scores of artists, revealing the degree to which abstract form can express the artist's psychic and physical experience of his environment.

DANIEL A. SIEDELL

NOTES

1. Donald Kuspit, "Charles Biederman's Abstract Analogues for Nature," *Art in America* 65 (May 1977): 80.

2. Kuspit, 83.

3. Jan van der Marck, "Biederman and the Structurist Direction in Art," in *Charles Biederman*, exhibition catalogue (London: Arts Council of Great Britain, 1969), 12.

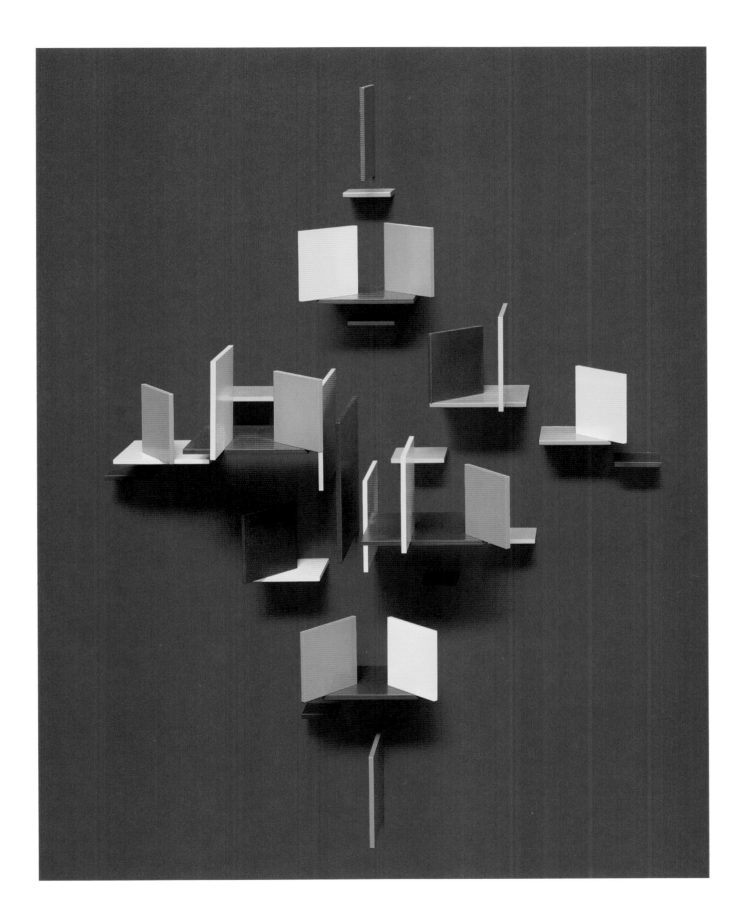

DONALD JUDD (1928–1994)

--

Untitled, 1971

STAINLESS STEEL, BROWN ACRYLIC SHEET 4 X 23 X 27 IN. UNIVERSITY OF NEBRASKA, F. M. HALL COLLECTION 1990.H-2942

ART © DONALD JUDD FOUNDATION/LICENSED BY VAGA, NEW YORK NY

Like the other Minimal artists with whom he is often associated, Donald Judd's work challenges cherished notions about the nature of art. His sculptures are simple metal units, often rectangular in shape. These reductive, geometric units are so simplified that the viewer is not allowed to bring any emotional or intellectual preconceptions to the work, but rather is forced to engage directly with the object, and to see art in general from a fresh perspective. Judd further encourages viewers to arrive at their own conclusions by not titling his works, as is the case here, thereby not dictating a response to the art object.

Much has been written about the Minimalist trend toward simplification and about the fact that what is absent from the sculpture (e.g., subject matter) is as significant as what is resolutely there. While Judd acknowledges this, his goal was not necessarily just reduction. His art is admittedly reductive and simplistic, yet he does more than ignore traditional elements. By deleting certain conventional sculptural components, Judd forces the viewer to focus on other elements. In so doing, he opens up new perspectives on sculpture.

Untitled exemplifies these characteristics. Constructed of stainless steel and sheets of brown acrylic, *Untitled* betrays no emotional tone and reveals no deep intellectual engagement. The absence of facile associations pushes the viewer to reflect on the nature of sculpture and to arrive at a conclusion that may range from visual fascination with the materials to confusion about the meaning of such a work—all of which are acceptable responses.

CHRISTIN J. MAMIYA

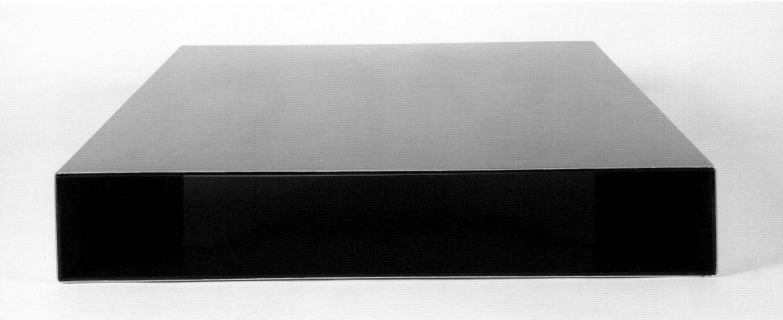

LYMAN KIPP (b. 1929)

Ulysses, 1972

PAINTED ALUMINUM 132 X 36 X 24 IN. UNIVERSITY OF NEBRASKA, F. M. HALL COLLECTION 1979.H-2298

COURTESY LYMAN KIPP, SCULPTOR

Lyman Kipp's sculpture is an elegant expression of the aesthetic concerns of the 1960s, a period when both painting and sculpture were caught up in the attempt to reduce aesthetic form to its barest compositional necessities.

Kipp's sculpture underscores Michael Fried's belief that painting's compositional purity had become the model for all the modern arts.[1] In effect, Kipp articulates his three-dimensional sculptural forms in two-dimensional pictorial terms. One critic commented that "Kipp's pieces lack mass, let alone a sense of monumentality, and refer most cogently to painting."[2] The fact that his work resists the temptation to intrude into the viewer's space with an emotionally charged and dynamic composition has often encouraged critics to call his sculpture "graceful," "elegant," and even "distant." By deemphasizing the physicality and emotionally charged kineticism that has characterized much American sculpture from Reuben Nakian and Alexander Calder to Tony Smith and Mark di Suvero, Kipp has imbued his work with an emotional distance and "purity" that characterized painting, sculpture, music, and dance during the 1960s.

Ulysses is an excellent example of Kipp's exploitation of concern for the "pictorial" aspect of sculpture. In this work, the aluminum planes create a flat, two-dimensional effect, with bright color reminiscent of Frank Stella's and Ellsworth Kelly's paintings.

However much his work seems to defy the traditional spatial concerns of sculpture, Kipp is far from forsaking all its compositional problems. Following the lead of Constantin Brancusi's innovations exhibited in his remarkable *Endless Column* (1937), *Ulysses* suggests a concern with what William Tucker has called "the inescapable problem of part-whole, whole-part relation" made explicit in Brancusi's *Column*.[3] Although it is conceived on a much smaller scale than the *Column* (11 compared to 96 feet), *Ulysses* is a unified form constructed from clearly articulated units (like Brancusi's work), which gives it a rhythm and cadence that underscore Kipp's deep understanding of the structural problems inherent in twentieth-century sculpture.

Although one critic suggested that "it is a gamble to concede so much to the province of painting,"[4] Kipp retains enough concern for sculptural form to exploit the tension between the two- and three-dimensional, which results in a cunning recognition and expression of the fundamental problems that confronted both painting and sculpture throughout the sixties and seventies.

DANIEL A. SIEDELL

NOTES

1. Michael Fried, "Art and Objecthood," in *Minimal Art: A Critical Anthology*, ed. Gregory Battcock (New York: E. P. Dutton, 1968), 146.

2. S[idney] Z[immerman], "In the Galleries: Lyman Kipp," *Arts* 40 (January 1966): 62.

3. William Tucker, *The Language of Sculpture* (London: Thames and Hudson, 1974), 138–42.

4. William Zimmer, "Art Reviews: Lyman Kipp/Peter Forakis," *Arts* 52 (May 1978): 35.

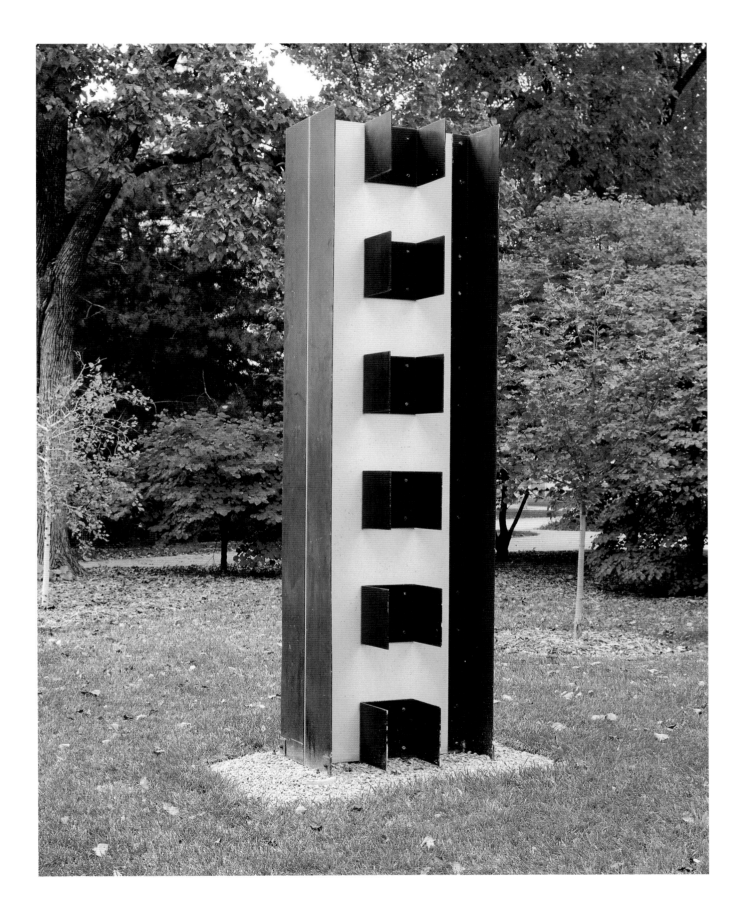

JOHN McCRACKEN (b. 1934)

Gray Plank, 1973

POLYESTER RESIN, FIBERGLASS, PLYWOOD 120 X 22 X 2 ½ IN. UNIVERSITY OF NEBRASKA, F. M. HALL COLLECTION 1994.H-3032 © JOHN MCCRACKEN

Born in Berkeley, California, in 1934, John McCracken received his BFA from the California College of Arts and Crafts in 1962, and remained there for graduate work until 1965. Teaching has been an important part of McCracken's artistic development, and he has taught in the art departments of the University of California–Irvine and UCLA (1965–68), the School of Visual Arts, New York (1968–69), and Hunter College, New York (1971–82).

In 1964 McCracken abandoned painting as a primary concern and began exploring the possibilities inherent in sculpture. Claiming "I want realness in my art,"[1] he began constructing monochromatic planks of wood or polished fiberglass and polyester resin in various widths, heights, colors, and thicknesses that were leaned up against the wall rather than being mounted on bases. For McCracken, this "realness," as he once put it, consisted in making art objects that referred to nothing outside their literal material presence, including the great aesthetic traditions of high art. The plank, then, "requires no pedestal, hooks, or nails; it is simply leaned against a wall."[2] Moreover, these planks frustrate attempts to categorize them as "painting" or "sculpture." The critic Eugene Goossen wrote, "As for John McCracken's slabs of sheer color, it is hard to tell whether one is confronting a painting or a sculpture."[3] And for McCracken, what interests him primarily is color, not sculpture or painting per se. "I think of color as being the structural material I use to build the forms I am interested in." These planks, then, are understood as "objectifications of color."[4]

Although these planks are McCracken's attempts to create "realness," their status as objects recedes in favor of their status as pure color. As one critic wrote, "Solidity seems to dissolve into a haze of deeply saturated hues, like the mind drifting from rational to poetic thought."[5]

McCracken's *Gray Plank* offers an excellent example of the complexities that bubble just under the surface of what appears at first blush to be a simplistic construction. Although its sleek slate-gray fiberglass surface suggests a superficial attractiveness incapable of communicating any deeper meaning or significance,

Gray Plank engages the issues of environment and interaction that McCracken has sought to address with his planks. "I want a sculpture to have a definite presence or individuality of its own, but at the same time function interactively with things around it."[6] The ten-foot *Gray Plank* not only incorporates the viewer into the theatrical dynamic of the art situation but also activates the entire gallery context as well. Alongside other important manifestations of postwar American modernism, the fact that it is leaned casually, almost haphazardly, against a gallery wall without the customary pomp and circumstance required for other modern sculptures gently pokes fun at many of the overly serious paintings and sculptures that keep McCracken's plank company in the environment of the gallery or museum space. Its simple beauty, imposing size, and casual display stress the viewer's assumptions concerning modern art and its function within the traditional exhibition space. Unlike most works of art, which appear to gain strength and sustenance when they are exhibited together in the context of a solo exhibition, McCracken's planks, as demonstrated quite well by the Sheldon's *Gray Plank*, appear to have the most direct effect when placed within a gallery space of more traditionally modern sculptures and paintings that concern themselves to be "about" something rather than to simply "be," as do McCracken's works.

DANIEL A. SIEDELL

NOTES

1. Quoted in Art Gallery of Toronto, *John McCracken*, exhibition catalogue (Toronto: Art Gallery of Toronto, 1969), n.p.

2. I. Michael Danoff, *John McCracken*, exhibition catalogue (Milwaukee: Milwaukee Art Museum, 1968), n.p.

3. Eugene Goossen, *Art of the Real*, exhibition catalogue (New York: Museum of Modern Art, 1968), 9.

4. Quoted in Art Gallery of Toronto, n.p.

5. Pamela Hammond, "John McCracken," *ARTnews* 92 (January 1993): 147.

6. Quoted in Barbara Rose, *A New Aesthetic*, exhibition catalogue (Washington DC: Washington Gallery of Modern Art, 1967), 57.

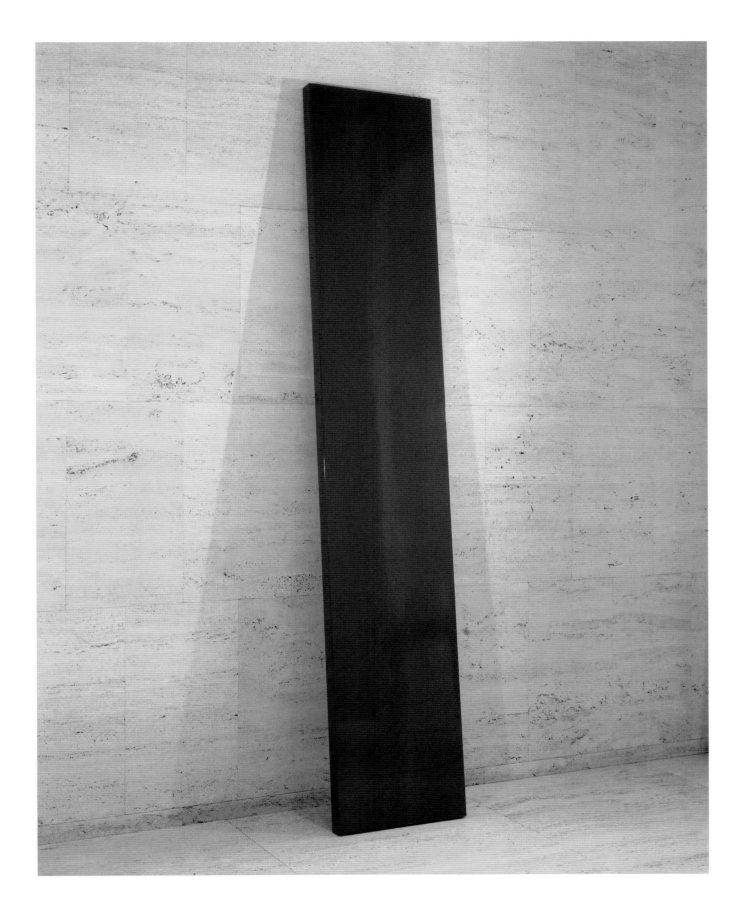

PETER VOULKOS (1924–2002)

Plate, 1973

STONEWARE WITH GLAZE, GAS-FIRED 3 ³/₈ X 18 ⁷/₁₆ IN. UNIVERSITY OF NEBRASKA, F. M. HALL COLLECTION 1984.H-2726

COURTESY OF THE VOULKOS FAMILY TRUST

Peter Voulkos is credited with revolutionizing contemporary American ceramics in the latter half of this century. He was born in Bozeman, Montana, in 1924. Following World War II he enrolled at Montana State University on the G.I. Bill with the intention of studying painting, then switched to ceramics at the California College of Arts and Crafts, where he received an MFA. Achieving almost immediate success, Voulkos became an award-winning ceramist skilled in the traditional techniques and forms of his medium. An early 1950s visit to New York, where he met the Action Painters of that period—Jackson Pollock, Franz Kline, Willem de Kooning, and Mark Rothko—inspired Voulkos to begin to use clay as an expressive sculptural medium. He later recalled, "I really got turned on to what the painters were doing. It was a special kind of time, a necessary kind of time . . . all the energies came together."[1]

In 1954, as head of the new ceramics department at the Los Angeles County Art Institute (renamed the Otis Art Institute in 1960), the energetic and charismatic Voulkos began to experiment with wheel-thrown, assembled forms, combining slabs and strips of clay and departing from earlier concepts of perfection and fine craftsmanship. The ceramics of Picasso; the Jomon, Shigaraki, and Bizen pottery of Japan; and the painting of the Abstract Expressionist movement provided inspiration during this period of prodigious activity for Voulkos and his students. A new standard for American ceramics was developed at this time as the emphasis shifted from craft to art. Ultimately, Voulkos's creations negated the function of vessels, as he incised, gouged, and added surface additions to large bowls and plates, frequently making sculptural elements of containers.

Voulkos's work in the Sheldon collection is the visually assertive footed stoneware *Plate.* Part of a series begun by Voulkos in 1973 and now considered among his most important works, the oversized plate is wheel-thrown and altered with eruptions from wads of porcelain. A thin, clear, low-fire commercial glaze was used, in deliberate rejection of a century of glaze research.[2] V O U L K O S 73 is brushed on the bottom.

NANCY H. DAWSON

NOTES

1. Peter Voulkos, interview by Elaine Levin, Berkeley, California, 1971, in Elaine Levin, *The History of American Ceramics* (New York: Harry N. Abrams, 1988), 201.

2. Levin, 212.

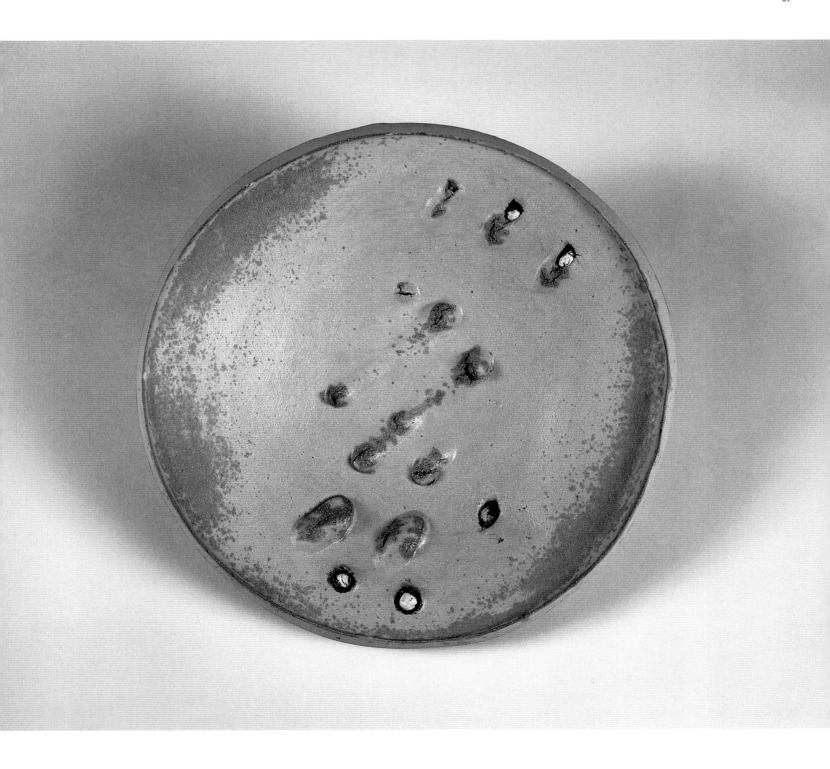

SOL LEWITT (b. 1928)

Incomplete Open Cube (5/14) (Incomplete Cube), 1974

ARCHITECTURAL ALUMINUM TUBING WITH SILICONE PAINT 41 ¹/₂ X 41 ¹/₂ X 41 ¹/₃ IN. UNIVERSITY OF NEBRASKA, OLGA N. SHELDON ACQUISITION TRUST 1985.U-3744

Born in Hartford, Connecticut, in 1928, Sol LeWitt received a BFA from Syracuse University in 1949. In 1953, after serving in the United States Army in Korea and Japan for two years, LeWitt enrolled in the Cartoonists and Illustrators School in New York City, which later came to be known as the School of Visual Arts. LeWitt was hired by I. M. Pei's architectural firm as a graphic artist and continued to work as a graphic designer through 1960. His interest in the fine arts was facilitated by his employment at the Museum of Modern Art, where he met such important modernists as Lucy Lippard, Robert Ryman, and Dan Flavin. By 1962 LeWitt's work had begun to move from two-dimensional to three-dimensional objects. These works, which consisted of "a sequence of squares which project from a square background plane,"[1] revealed LeWitt's sensitivity to the graphic sensibilities of the Bauhaus, de Stijl, and Constructivist movements.

By the mid-sixties LeWitt had increasingly begun to work within the context of Conceptual art, which claimed that "all of the planning and decisions are made beforehand and the execution is a perfunctory affair."[2] Stating that "it is difficult to bungle a good idea," LeWitt began to work with the idea of what he called the "modular grid," which became manifest ultimately in the cube. "The most interesting characteristic of the cube is that it is relatively uninteresting. . . . Therefore, it is the best form to use as a basic unit for any more elaborate function, the grammatical device from which the work may proceed."[3] The cube, then, became LeWitt's basic unit with which he explored various "ideas," such as seriality, repetition, and various ratio-based constructions. *Incomplete Open Cube (5/14)* is a fine example of LeWitt's provocative sculptural work conceived of within the context of his "Incomplete Open Cubes" series of 1974 in which he offered various presentations of "incomplete" cubes by using between three and eleven bars of aluminum tubing (twelve bars would "complete" a cube). Through the series, LeWitt was provided the opportunity to carry out his "idea" as completely and as far as the formal limitations of his modular unit would take him.

In addition to his cube series, LeWitt's wall drawings, which, as the critic Kenneth Baker put it, express the "right quotient of meaningless energy—for the right amount of nonsense,"[4] and his book art seem to put into question the relevance of applying a modernist critical vocabulary to the work. As Baker suggests, "Perhaps the ultimate question to raise about LeWitt's work is whether we really need the concept of art to respond to it."[5] And the tension between the fine arts and the graphic arts, which has sustained his oeuvre, is not only ambiguous but even exploited in various projects, of which the "Incomplete Open Cube" series is one. For although in isolation *Incomplete Open Cube (5/14)*, with its aesthetically pristine surface and its Minimalist-inspired formal vocabulary, assumes the role of modernist sculpture, in the context of LeWitt's series—with its "idea" of the cube and all the various geometrical combinations that could be employed "to incomplete" the cube, as it were—such high art modernist aesthetics give way to the vocabulary of the graphic arts and architectural planning.

DANIEL A. SIEDELL

NOTES

1. Jennifer C. Toher, "Sol LeWitt," in *Beyond the Plane: American Constructions, 1930–1965*, exhibition catalogue (Trenton: New Jersey State Museum, 1983), 74.

2. Sol LeWitt, "Paragraphs on Conceptual Art," *Artforum* 5 (Summer 1967): 80.

3. LeWitt quoted in Alicia Legg, ed., *Sol LeWitt*, exhibition catalogue (New York: Museum of Modern Art, 1978), 172.

4. Kenneth Baker, "Sol LeWitt: Energy as Form," *Art in America* 66 (May–June 1978): 74.

5. Baker, 80.

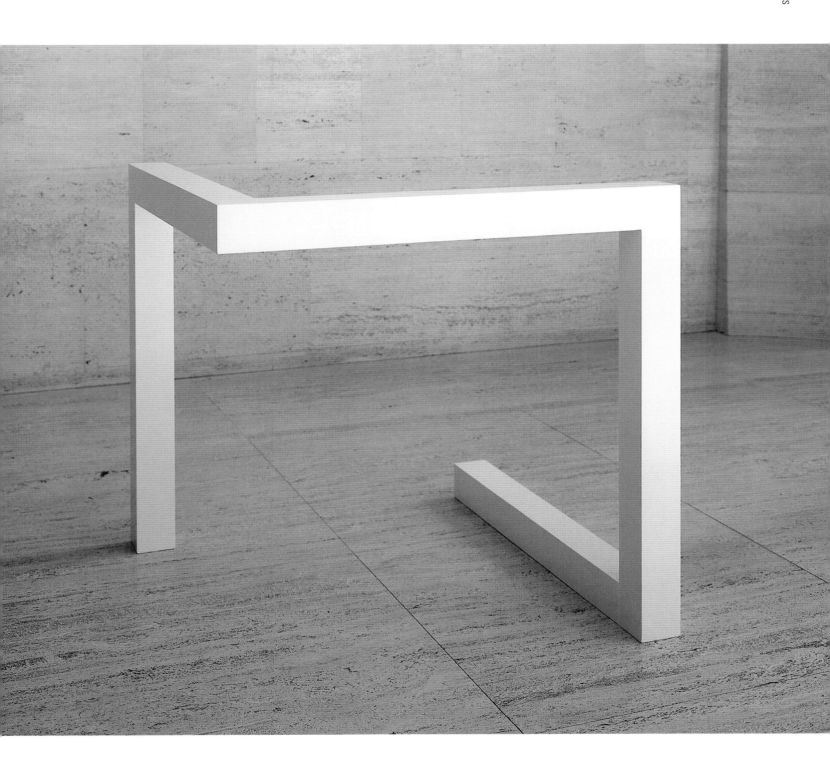

ALVIN LIGHT (1931–1980)

Untitled, 1975

HARDWOODS, EPOXY 96 X 27 X 18 IN. NEBRASKA ART ASSOCIATION, GIFT OF JINX ROWAN 1983.N-652 © JEREMY LIGHT

Alvin Light established a reputation in the 1950s as an artist who gave three-dimensional form to the Abstract Expressionist aesthetic that dominated San Francisco painting in that period. He attended the San Francisco Art Institute, the foremost training ground for artists in the region, receiving both a BFA and MFA. He subsequently taught at the school from 1962 to 1972. One of his teachers and closest friends was the painter Frank Lobdell, whose gnarled and tortured forms clearly influenced Light and are reflected in his earliest sculptures.

In his work Light seems to have united the two prominent aesthetic movements found in the Bay Area: Abstract Expressionism and assemblage, or found-object, sculpture. He worked almost exclusively in wood and primarily with pieces that he found on frequent scavenging forays to area beaches and parks. Later he also would make use of manufactured wood—beams, veneers, and boards. His works are as much assembled as carved. Using clamps, epoxy, nails, and dowels, he would join variegated pieces of wood together, then have at them with an array of handtools—chisels, axes, saws, rasps—some of them of his own design. For Light, as for an Abstract Expressionist painter, the process of creating was as integral to his aesthetic as the finished artwork. He would often hack off elements that were not to his liking and begin again. "What Al picked up from painting was adding imagery, then cutting it off," Lobdell has said. "The evidence of what had been there still remains, the memory. So when you get involved in it, it's not just what was there, it's also what isn't there but used to be there. So [you can see] the dowels that had been glued in there and cut off as evidence of recognizing error."[1]

Although Light was certainly attracted to wood for its facility of shaping, the fact that it was an organic ingredient—that it retained the visible memory of its own growth—was certainly an essential factor as well. The shaping of the work by the artist thus complemented or continued a process begun by nature. Because of Light's additive (and subtractive) method, his sculptures have a distinct sense of growth and accumulation. Eschewing the necessity of a base, they writhe upward from the floor like plants or tormented beings.

Untitled is typical of Light's later work, which displays a formal and technical sophistication not found in his rawer, more brutally expressionistic pieces from the 1950s and '60s. The wood is handled in a variety of ways ranging from undulating fields carefully laminated and finished, to sinuously cut boards, to roughly chiseled pieces of found wood. He achieves an illusion of weightlessness by assembling "sheets" of wood at the top and bottom of the sculpture that evoke sails or billowing banners. Though still reflective of natural forces, particularly in the evocation of wind, this piece is less overtly organic than his earlier work (though it still seems to grow up from the ground). Consistent with the majority of his work, there is an emphasis on silhouette and the interplay of positive and negative form, much in the manner of the welded iron sculptures of that other great translator of Abstract Expressionist ethos into three-dimensional form, David Smith.

Despite this emphasis on silhouette, *Untitled* also reflects Light's concern with color. As in the majority of his works, Light has employed a variety of woods, playing their grains and tonalities off each other to emphasize the additive rather than the monolithic nature of the work. In addition, he used pigmented epoxies both in the joints and daubed onto the surfaces of different elements to highlight individual passages, much as his onetime studio mate, figurative sculptor Manuel Neri, painted portions of his plaster figures.

Untitled is among Light's last works. Paradoxically, his work became more sophisticated and carefully crafted as his own physical capabilities were declining. In 1972 a stiffening of the joints in his hands and arms was diagnosed as resulting from the genetic disease lupus. This was followed by a bout of meningitis and the debilitating effects of prolonged alcoholism. He died of a heart attack in January 1980.

PETER BOSWELL

NOTE

1. Quoted in Abby Wasserman, "Impressions of Light," *The Museum of California* (Oakland Museum) 5 (Summer 1991): 25.

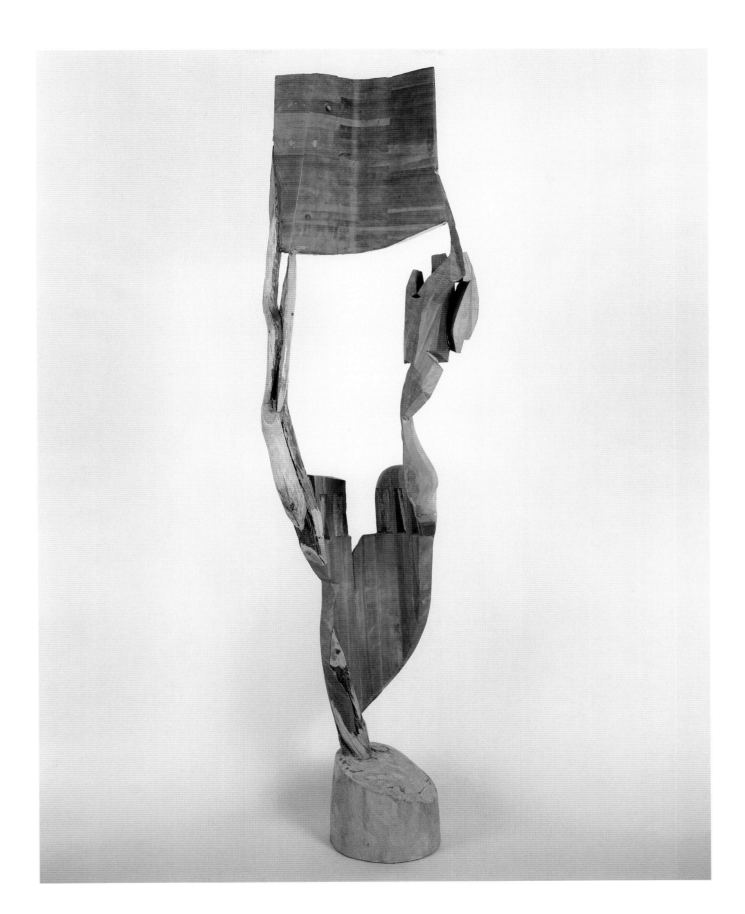

EDWARD KIENHOLZ (1927–1994)

The Opti-Can Royale, 1977

METAL, FRESNEL LENS SYSTEM WITH CAST ALUMINUM RIM, LIGHTBULB, AND SET OF SIX PHOTOGRAPHS 12 ¹/₄ X 8 ⁷/₈ X 9 IN. UNIVERSITY OF NEBRASKA, F. M. HALL
COLLECTION 1985.H-2740

Edward Kienholz emerged on the West Coast art scene in the 1960s, during a period characterized by great social upheaval in the United States. From the civil rights and women's liberation movements to the sexual revolution and the changing character of the American family unit, the lifestyle of the average American citizen was undergoing a dramatic revision. Kienholz's art is significant for his incisive ability to comment on these social transformations. His early art has been compared to the work of the Beat writers in its critical, disillusioned, and often sarcastic tone. Indeed, Kienholz acknowledged that "adrenalin-producing anger carried me through that work."[1]

It was during this period that he developed the format for which he is best known—the large-scale tableau, or environment, that re-creates a scene from American life. These tableaux are frequently composed of assemblages—sculptures made up of found objects. This use of found objects lends an air of reassuring familiarity and often provides a veneer of whimsy or humor.

However, the subjects on which Kienholz chose to focus were rarely amusing. From abortion and race relations to politics, Kienholz presented pointed and biting commentary on the contradictions and problems of American society. His works, though generic and often cryptic, possess an immediacy and are suffused with a palpable pathos or horror that is difficult to ignore.

Kienholz's tableaux are effective because they are both visually compelling and conceptually strong. While clearly focused on social commentary, his works do not offer pat solutions and are fairly open-ended. The tableau format works especially well in this regard; not only does it create a more participatory relationship with viewers by drawing us in, but it also makes us part of the scene, thereby compelling us to feel responsible for resolving the problems presented.

The Opti-Can Royale, although executed on a smaller scale than most of Kienholz's works, is similarly incisive in its ability to comment on the American way of life. Kienholz has transformed a common rectangular metal can into a television, complete with screen, image, channel selector, and antenna. While this sculpture can be seen as a statement about the creative use of materials that a sculptor must consider, it can also be interpreted as a statement about the pervasiveness of this form of mass media in our lives. In the 1960s Kienholz produced a number of works that focused on television in an attempt to call attention to the desensitizing effects and deceptive nature of the mass media. This work does not necessarily prompt such an indictment—indeed, it seems to charm us with an old-fashioned, nostalgic air before enticing us to reconsider the role of television in our lives.

CHRISTIN J. MAMIYA

NOTE

1. Quoted in Robert L. Pincus, *On a Scale That Competes with the World: The Art of Edward and Nancy Reddin Kienholz* (Berkeley and Los Angeles: University of California Press, 1990), 12.

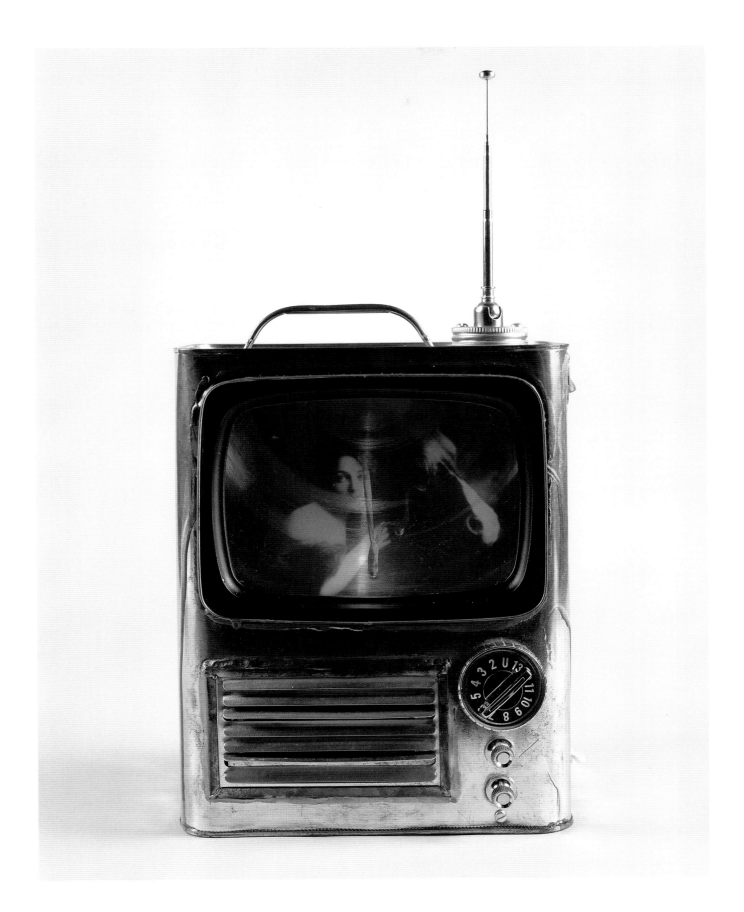

CARL ANDRE (b. 1935)

Magnesium-Copper Dipole (East/West), 1978

Carl Andre came to prominence in the 1960s and was a seminal figure in the growing challenge to fundamental tenets underlying sculptural traditions. Andre's work visualizes the doctrine being asserted by art critics during the postwar era that artists should strive for a greater aesthetic purity. In particular, Clement Greenberg, arguably the most influential critic of the time, insisted that exemplary, progressive, modern art should not only acknowledge but also highlight the tangible reality of the art object, rather than emphasize illusionism.

Andre, like other Minimal artists with whom he is often associated, illustrated this premise by developing a sparse, reductive visual vocabulary that forces the viewer to deal directly and honestly with the object. However, while other Minimalists created sculptures that were resolutely three-dimensional, Andre developed a visual idiom that emphasized flatness. Most of his works produced after 1967 run along the ground in a horizontal format. In *East/West*, this horizontality is emphasized further by the title, which suggests an east-west horizontal geographical orientation. Andre chose this flat visual idiom in order to challenge a long-standing sculptural tradition—the anthropomorphic verticality of three-dimensional free-standing art objects.

Andre's minimal vocabulary consists of flat metal plates that serve as the building blocks for his sculptures. Each standard industrial plate is a unit in a sculpture that is assembled much as one would lay a Formica floor. Andre's sculptures lie on the ground in a methodical, gridlike pattern. *East/West*, composed of two identically sized plates of magnesium and copper that combine to form a perfect square, highlights the simplicity, austerity, and purity of Andre's art.

While the plates exhibit the passage of time—the oxidation process and aging—there appears to be little transformation or modification involved. Andre's sculptures do not engage in pretense or illusion, and do not suggest extravisual referents. They present the viewer with a deceptively simple visual experience. Andre's art is, on the one hand, difficult because it challenges traditional notions of creative process and input. Yet his works are also defiantly democratic—one is expected to interact with them in a very straightforward and direct way. Claims Andre: "My work is atheistic, materialistic, and communistic. It's atheistic because it's without transcendent form, without spiritual or intellectual quality. Materialistic because it's made out of its own materials without pretension to other materials. And communistic because the form is equally accessible to all men."[1]

Andre has reduced sculpture to its bare elements, thereby revealing the true essence of the medium, and has played an important role in the continual reassessment of artistic traditions.

CHRISTIN J. MAMIYA

NOTE

1. Quoted in David Bourdon, "The Razed Sites of Carl Andre," *Artforum* 5 (October 1966): 17.

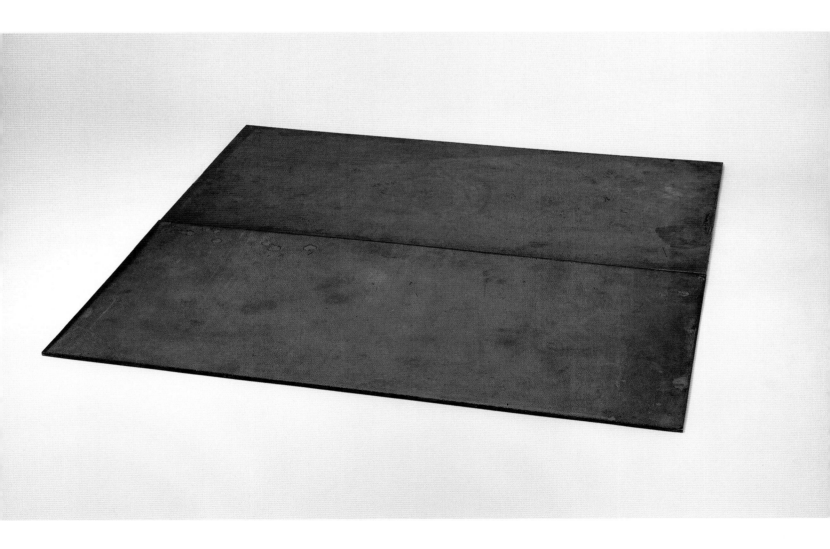

BRYAN HUNT (b. 1947)

Arch Falls, 1980–81

BRONZE WITH BLACK PATINA ARTIST'S PROOF 1 (FROM AN EDITION OF 4) 94 X 42 X 18 IN. UNIVERSITY OF NEBRASKA, OLGA N. SHELDON ACQUISITION TRUST
AND THE NATIONAL ENDOWMENT FOR THE ARTS 1989.U-4187

Bryan Hunt's work engages, in a rather unique way, twentieth-century sculpture's dialogue with the natural world. Born in 1947 in Terre Haute, Indiana, Hunt grew up in Tampa, Florida. He studied architecture for two years at the University of South Florida and then worked as an engineer's aid at the Kennedy Space Center at Cape Canaveral. After spending the summer of 1968 in Europe, he decided to move to Los Angeles and study art. He worked as a draftsman with a structural engineer in Beverly Hills and took night classes at the Otis Art Institute. After receiving his degree from Otis, Hunt received a Whitney Museum of American Art study fellowship in 1972, and so moved to New York before returning to California the following year.

Hunt first came to public attention in California with two works: *Wall of China,* a replica of the Great Wall cast in bronze and hung vertically from the ceiling, and *Empire State* (1974), an eight-foot model made from balsa wood and silk paper and with a model of the Hindenburg tethered at the top of the building, one of the expected locations for the landing of the dirigible. Hunt then moved from these Super Realist objects to mounting various airships or dirigibles on the walls of exhibition spaces.

After his Super Realist representation of the Hoover Dam, Hunt began modeling bodies of water and casting them in bronze, titling them his "Lakes" and "Quarries" series. The curator Barbara Haskell wrote that "these images were free-standing forms whose shapes were defined by the land mass which once surrounded them."[1] About his new direction, Hunt said, "I wanted to make art objects that referred conceptually to the problems earthwork artists addressed. . . . I was creating a vision of site-specific sculpture."[2]

By the late seventies, Hunt had moved from lakes to waterfalls, cast in bronze, which revealed a new, although not completely unrelated, direction in his career. Rather than take human-made objects from the world and place them in the exhibition space, Hunt began "modeling" waterfalls, experiences from the natural world, and placing them in exhibition spaces, thus further complicating and refining a dialogue he had established in the early seventies, but with an added anthropomorphic dimension. Eric Gibson writes that these waterfalls are modeled "so as to be both a convincing equivalent of water and richly sensuous in [their] own right. At the same time, their height and broken surface—which has the quality of drapery—give the waterfalls a distinctly human aspect."[3]

The complexity of these waterfalls is revealed quite clearly in *Arch Falls,* in which Hunt achieves a precarious balance between sculpture's representational capacity, its symbolic potential, and the twentieth-century interest in sculpture's own status as an object.

First, *Arch Falls* offers a representation, derived in part from David Smith, of the natural landscape. Haskell asserts that "Hunt was alone in successfully translating the sublimity and grandeur of the American landscape into an indoor idiom."[4] However, this mimetic representation, as in his *Empire State Building* and other works of the mid-seventies, is transformed from a conventional representation to a more iconic, symbolic image when placed in the context of the gallery. *Arch Falls* then becomes a hieratic, or even shamanistic, form in its mysteriously anthropomorphic quality reminiscent of Barnett Newman's *Obelisk* or his bronzed "zips." And lastly, *Arch Falls* offers a unique interpretation of modern sculpture's increasing awareness of its own status as an object, with no mimetic capabilities.

Hunt's most recent waterfalls have become less and less referential and, with their theatrical gestures, more and more autonomous structures, which is brought out by his drawings, which are often exhibited with the waterfalls. Like William Tucker's

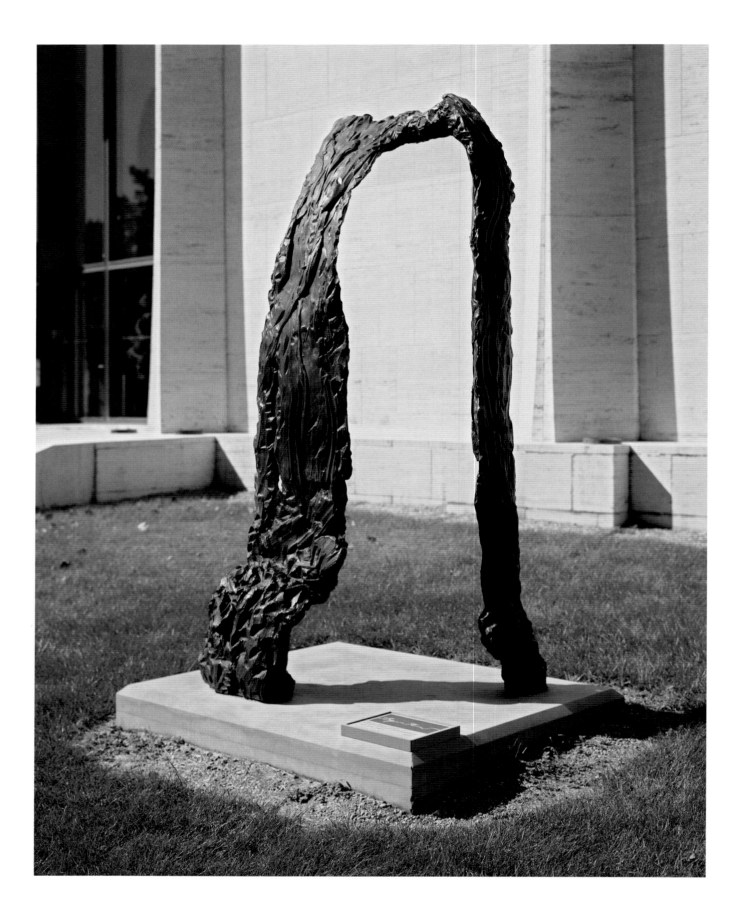

works, Hunt's waterfalls exploit the sculptor as a creator of forms. *Arch Falls*, for all its ambiguous associations with the natural landscape or with symbolic totems, is a sensuously modeled form with a life and integrity of its own. As Gibson rightly noted, "Where other sculptors have sought to set form in motion (sometimes literally), Hunt arrests it. He brings motion—and with it, time—to a halt, holding both in a permanent state of suspension."[5]

DANIEL A. SIEDELL

--

NOTES

1. Barbara Haskell, *Bryan Hunt: New Masters* (Berlin: Amerika Haus, 1983), n.p.

2. Quoted in Phyllis Tuchman, "Bryan Hunt's Balancing Act," ARTnews 84 (October 1985): 68.

3. Eric Gibson, "Bryan Hunt at Cornell," *New Criterion* 7 (October 1988): 64.

4. Haskell, n.p.

5. Gibson, 64.

RICHARD SHAW (b. 1941)

Mrs. Partch, 1981

CERAMIC WITH UNDERGLAZE, GLAZE, AND OVERGLAZE TRANSFERS 37 ³/₄ X 9 ³/₄ X 15 ³/₄ IN. NEBRASKA ART ASSOCIATION 1984.N-665

© RICHARD SHAW

Throughout his influential career, the California ceramic sculptor and teacher Richard Shaw has been faithful to an enduring tradition in art history that is defined by such various labels as trompe l'oeil, Realism, or Super Object. His parents were artists, and Shaw grew up in Hollywood, where his father was employed as a cartoonist at the Disney Studio. From childhood, Shaw knew that he wanted to pursue a career in fine art, to be "a real artist . . . a serious painter."[1] After studying at Orange Coast College in Costa Mesa, California, he enrolled at the San Francisco Art Institute to study painting, aspiring to "be Nathan Oliveira, Elmer Bischoff or David Park." Ultimately realizing the need to find his own way, Shaw switched to ceramics, an area where he could work in three dimensions. He graduated with a BFA in 1965, spent a semester at Alfred University in Upstate New York in the highly esteemed ceramics department, then returned to California to earn his MFA at the University of California–Davis in 1968.

Acknowledging nineteenth-century American painters William M. Harnett, John F. Peto, and John Haberle as conceptual sources for his work, Shaw says that for him, trompe l'oeil is a way of dealing with common objects and making them into art. His work is also informed by imaginative and technically proficient eighteenth- and nineteenth-century European ceramists, although he has a technical edge over earlier artists with his complete control of surfaces and textures.

Shaw works with porcelain, a difficult branch of ceramics that requires firing at a very high temperature and demands precision and technical mastery of the ceramic process. He had already perfected a meticulous mold-casting process when his interest in transfer printing led to further expertise in reproducing the crisp, printed images faithful in color and presence to their sources, which have been so important to the general trompe l'oeil character of his work. *Mrs. Partch,* one of Shaw's carefully conceived and painstakingly crafted assemblages, is a witty, whimsical sticklike figure. Named after a childhood friend of the artist, *Mrs. Partch* is composed of porcelain components imitating a tin can, flexible metal pipe, ball of twine, and various wood elements. The process of forming the objects from clay varies: some, such as the tin can, are thrown on the wheel; others are cast from molds. Imbued with the artist's poetic sensibility, the appealing *Mrs. Partch,* seemingly gleaned from a trash heap, is an object of gentle humor as well as a complex abstract composition.

NANCY H. DAWSON

--

NOTE

1. All quotations are from Richard Shaw, interview by Cameron Cartiere, in *Falkirk's Sixth Annual LifeWork Award: Richard Shaw,* exhibition catalogue (San Rafael CA: Falkirk Cultural Center, November 25, 1995), n.p.

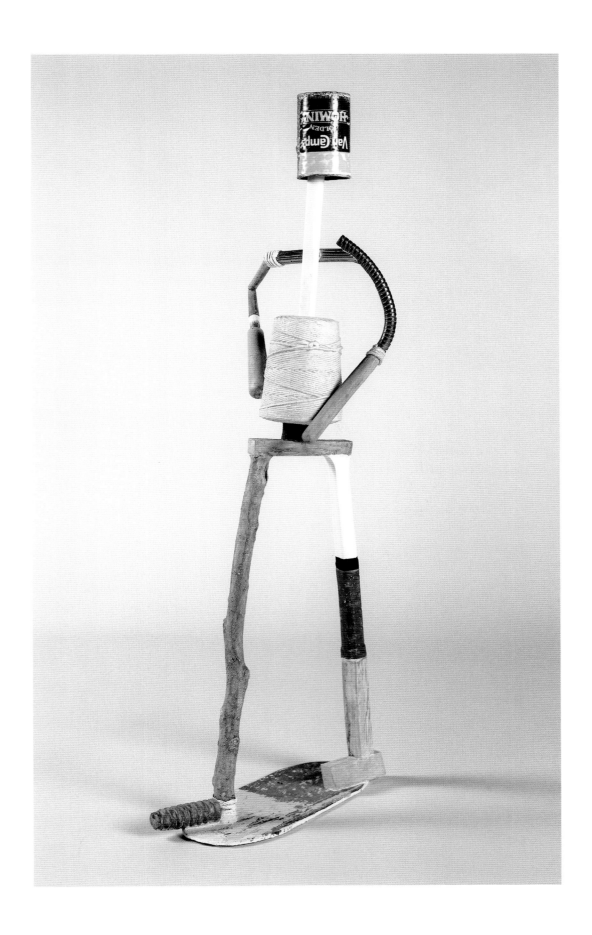

MICHAEL TODD (b. 1935)

Daimaru XV (Great Circle), 1981

LACQUERED STEEL 137 1/2 X 131 1/4 X 40 IN. NEBRASKA ART ASSOCIATION, FUNDING PROVIDED BY THE NATIONAL ENDOWMENT FOR THE ARTS AND THE COOPER FOUNDATION 1981.N-646

Daimaru XV is an outstanding example of an important period in Michael Todd's oeuvre. Born in Omaha, Nebraska, Todd was reared in Chicago and attended Notre Dame University, where he received a BFA in 1957 and won the prestigious Woodrow Wilson Fellowship, which allowed him to pursue graduate work at UCLA, where he received an MA in 1959. While at UCLA Todd won the even more prestigious Fulbright Fellowship, which enabled him to study in Paris from 1961 to 1963.

Upon his return from Paris, Todd moved to New York, where he lived until 1969. During this period, Todd became strongly influenced not only by the sculptor Anthony Caro but by the painters Helen Frankenthaler, Morris Louis, and Frank Stella. In addition, Todd's teaching experience at Bennington College in Vermont brought him into direct contact with the sculpture of David Smith, whose Bolton Landing sculpture park was near the college. To fulfill his teaching obligations Todd taught himself how to weld, which would subsequently become his chosen means of working. During his New York period, he came under the heavy influence of a pictorial conception of sculpture articulated by both Smith and Caro, Todd explicitly refers to Monet and his late paintings, which, as expounded by Clement Greenberg, were an important source for post-painterly abstraction, in both painting and sculpture. Todd himself admitted, "I think my work does relate a lot more to painting than it does to most of the sculpture of the sixties."[1] This kind of pictorial composition was engaged, however, by both sculptors and painters, who emphasized the "objecthood" of sculpture and its self-referential capacity.

In 1968 Todd was invited to establish a metal shop at the University of California–San Diego, and his return to the West Coast initiated a shift in his conception of sculptural form that resulted in what could be called his mature work. Although he continued to be inspired by painting (he claims that he is "trying to paint with steel"), Todd now engaged painting in a much less narrow way. In addition, he began to make sculpture intended for outdoor environments. In effect, Todd's work began more and more to allude to something beyond itself; and in so doing, he emphasized painting's inherent gestural and painterly qualities, characteristics that had been suppressed on the East Coast during the early sixties, culminating in an art of "entropy and nullity."[2] In 1970 Todd began to incorporate the circle into his compositions, which loosened his formal vocabulary considerably. By the late seventies, he was using the circle as his basic sculptural form, which further imbued his work with the organic and calligraphic qualities that he valued in Oriental philosophy.

Daimaru XV (*daimaru* means "great circle") represents this shift in sculptural sensibilities. Whether they are large outdoor works or gallery-space pedestal pieces, Todd's circles consist of a series of one to two dozen works. His "Daimaru" series, begun in the late seventies, is an excellent example of his larger outdoor works. As Phyllis Tuchman claims, "Although each work is independent, indeed stands on its own, the subtle inflections to be discovered from one sculpture to another offer viewers a richness of effects to be experienced."[3] True to Tuchman's statement, *Daimaru XV* is unique within the context of the series in that it is relatively quiet and calm with the assembled "accents" kept to a minimum in comparison with the explicit dynamism that charges other works in the series, in which the circular structure is punctured and animated with large and various geometric appendages. *Daimaru XV* offers, by stark comparison, a calm, almost understated composition, which speaks not in the shout of his other works but in a whisper, which makes even more explicit the simplicity and compositional unity Todd has achieved in the series in general, and in *Daimaru XV* in particular.

DANIEL A. SIEDELL

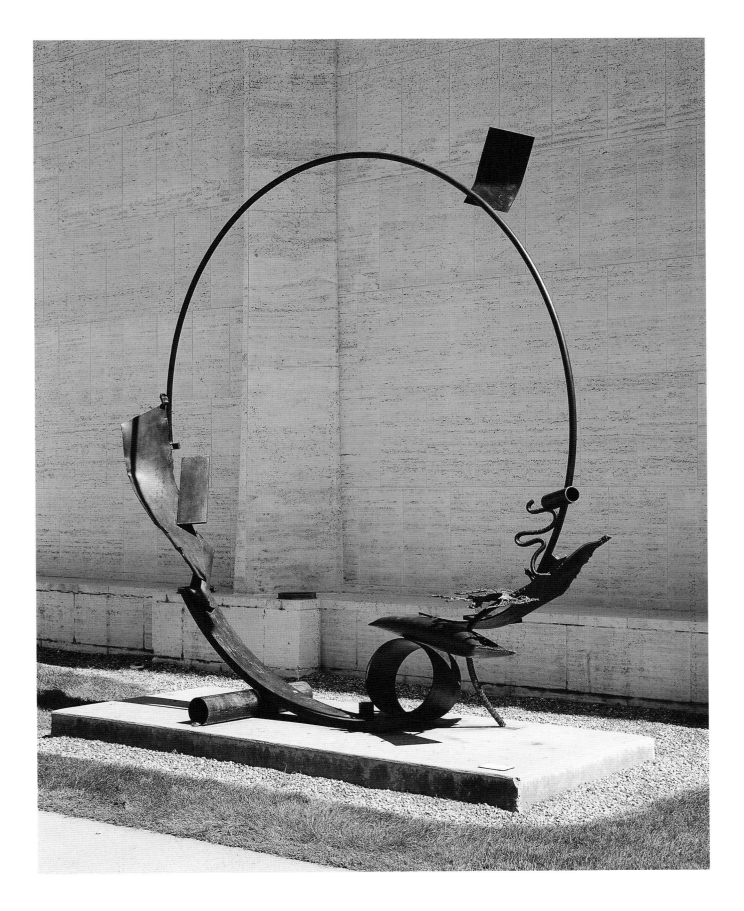

--

NOTES

1. Charles Kessler, "Michael Todd: Painterly Sculpture," *Arts Magazine* 49
 (June 1975): 86.

2. John Fitz Gibbon, "Still Point of the Turning World," in *Michael Todd:
 Sculpture 1983*, exhibition catalogue (Dominguez Hills: University Art
 Gallery, California State University, 1983), n.p.

3. Quoted in "Michael Todd," in *Michael Todd: Painted and Patinated
 Bronze and Steel* (Chicago: Klein Gallery, 1985), 4.

MANUEL NERI (b. 1930)

Rosa Negra #1, 1982–83

BRONZE WITH OIL-BASED ENAMEL EDITION 3/4 67 ¹/₂ X 34 ¹/₄ X 17 IN. UNIVERSITY OF NEBRASKA, OLGA N. SHELDON ACQUISITION TRUST 1985.U-3710

© MANUEL NERI

The sculptor Manuel Neri can be said to speak a "body language." His figurative sculptures are emphatically about the human condition. His evocative works are not intended to depict individuals or focus on particulars; rather, he asserts, "I'm not interested in dealing with personality or character in my sculpture. The figure is primarily a vehicle for ideas."[1] Neri's anonymous, rather amorphous figures are archetypes and span both centuries and cultures. His work can be seen as the result of a number of influential sources: the ceramic work of Peter Voulkos, Abstract Expressionism, Bay Area figuration of the 1950s, Funk art, and Neri's own Chicano heritage.

Neri, born near Fresno in 1930, abandoned plans to become an electrical engineer after stumbling into a ceramics class at San Francisco City College in 1949. This opportunity gave him exposure to the influential Peter Voulkos, a graduate student at the California College of Arts and Crafts at the time but soon to become a seminal figure in the ceramic world. Neri was impressed by the way Voulkos rejected traditional limitations that had been imposed on ceramic production. Neri recalled that Voulkos "forced himself onto the material . . . instead of taking the kind of sacred approach toward ceramics that most people did."[2] However, there were aspects of ceramics that bothered Neri. He complained, "Too much of the process is out of your hands—the firing, the glazing. And it takes so much time."[3] As a result, he turned increasingly to painting. By that time the so-called Bay Area figurative painters, such as Richard Diebenkorn, Nathan Oliveira, and David Park had established themselves. These artists produced paintings characterized by both an adherence to figuration and agitated application of pigment, and Neri was taken by the immediacy and expressiveness of their work.

The Abstract Expressionists, such as Willem de Kooning, had advanced the importance of process; the critic Harold Rosenberg christened their work "Action Painting." The affinity of Neri's sculptures to that aspect of Abstract Expressionist work is revealed by the occasional reference to his work as "action sculpture."

Being around the Beat poets and Funk artists in San Francisco in the 1950s also contributed to Neri's development. What he derived from Funk was not its vocabulary but its spirit. Neri remembered first hearing the term "funky": "I liked the term because it was a put-down term—it meant something that was old-fashioned and corny. It fit with what we were doing—re-examining old ideas, throwing out new ideas, getting back to basics. . . . We treated everything equally—painting, drawing, sculpture, everything was important."[4] Neri has maintained this democracy with respect to mediums and materials throughout his career; everything, in Neri's eyes, has expressive capabilities.

Neri's own ethnic background is surely a factor in his art. His parents moved to California from Mexico during the Depression, working as farm laborers in the Central Valley. Reared bilingually, Neri continues to utilize Spanish titles for many of his works, and he developed his bronze-casting techniques in 1980 after receiving a National Endowment for the Arts grant to work at Fundadores Artisticos in Mexico City.

By the late 1950s, Neri had abandoned ceramics and, after being urged by Diebenkorn to pursue sculpture rather than painting, soon gravitated to plaster, which became his medium of choice. Working with great speed, he created figural forms that are fairly amorphous but powerful in their boldness and rawness. Plaster appealed to Neri because it allowed him great spontaneity and was inexpensive. He painted the rough, unfinished-looking surfaces with splashy swaths of bright, contrasting enamels, the placement of which rarely conformed to the figure's features.

Rosa Negra #1 illustrates many of these characteristics. Although it is bronze (Neri later produced bronze and marble sculptures that retain the same features as his plaster works), it is, like most of Neri's sculpture, energetically painted. This activates the surface and highlights the tension between form and color, mass/volume and surface, abstraction and representation, the passivity of the form and the action of the brushstrokes, and, ultimately,

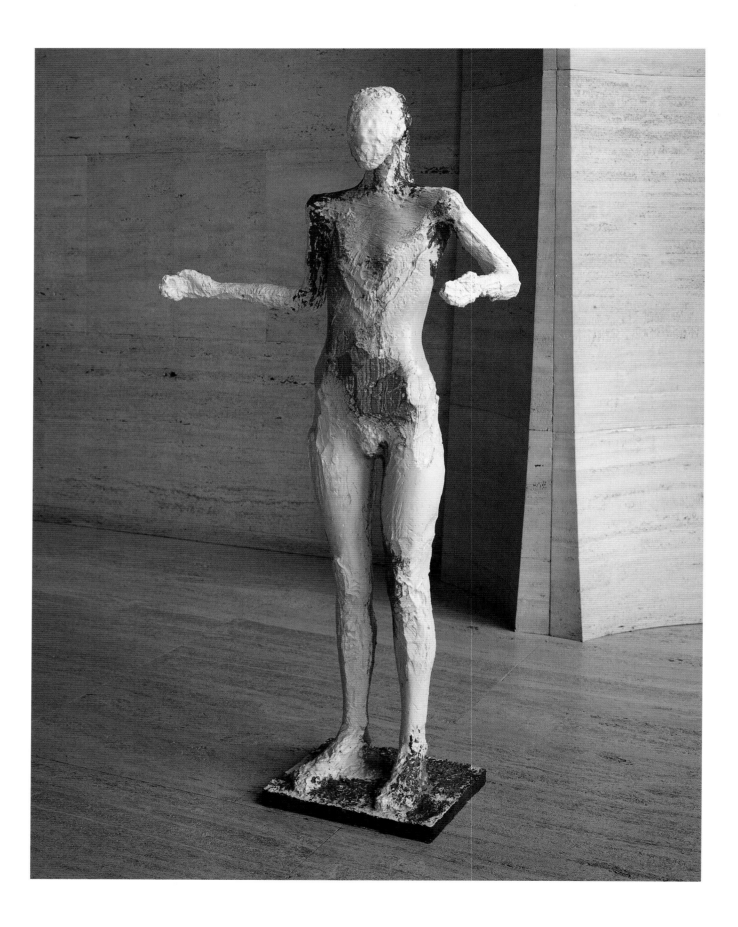

the ancient and the modern. It is these tensions that challenge viewers and draw them into dialogue with Neri's work. Further, *Rosa Negra #1* reveals his commitment to his Chicano heritage (in his titling of the sculpture), to the agitated brushstroke of Bay Area and Abstract Expressionist painting, to the irreverence of Funk, and to the ambition of Voulkos. And these works are ambitious: Neri intends his sculptures to encapsulate a wide range of ideas and emotions. Above all, *Rosa Negra #1* demonstrates Neri's commitment to the figure, an attachment that runs deep. Neri admits that "the figure is very important to me, not just because it is traditional. I've always been very intrigued with the spirit that the figure conveys. . . . It is this thing inside of us that I want to talk about in the figure. I find it very hard to talk about those feelings, perhaps because I don't even want to question them. I can deal with them only through the work."[5]

CHRISTIN J. MAMIYA

--

NOTES

1. Quoted in Thomas Albright, "Manuel Neri's Survivors: Sculpture for the Age of Anxiety," *ARTnews* 80 (January 1981): 55.

2. Quoted in Albright, 55.

3. Quoted in Albright, 55.

4. Quoted in Caroline A. Jones, *Bay Area Figurative Art, 1950–1965* (Berkeley and Los Angeles: University of California Press, 1990), 134.

5. Quoted in Jan Butterfield, "Ancient Auras—Expressionist Angst: Sculpture by Manuel Neri," *Images & Issues*, Spring 1981, 43.

GEORGE SEGAL (1924–2000)

Nude Torso, 1982

PRESSED PAPER AND PLASTER EDITION 17/30 27 ¹³/₁₆ X 12 ⁵/₈ X 7 ³/₈ IN. UNIVERSITY OF NEBRASKA, MERCEDES A. AUGUSTINE FUND 1987.U-4040

George Segal's art is inextricably bound up with the human body. He has argued, "Expressions of spirit are completely dependent on the flesh."[1] In fact, he abandoned painting for sculpture precisely because he felt that the medium could not sufficiently express physicality. Segal's transition from two to three dimensions can be located in his striking *Legend of Lot* (1958), in which he placed a lumbering plaster figure in front of one of his large expressionist paintings. Like his contemporary Robert Rauschenberg, Segal turned the energy of Abstract Expressionist brushwork into an explicit—even literal—assertion of physical presence. "I felt I honestly couldn't perform without referring to my physicalness."[2] And for him, this "physicalness" meant the repudiation of abstraction on a flat surface and the return to the human figure situated in a three-dimensional environment.

After his conversion to sculpture, Segal began constructing environments that consisted of plaster figures—often cast from a live model—that solemnly participate in mundane daily activities. Not only is the physical presence of his figures reasserted in these constructions, but their placement in the gallery space acknowledges and interacts with the viewer's as well.

Despite his attempt to transcend traditional pictorial and sculptural limitations, Segal's art training at Rutgers (MFA, 1963) instilled in him a strong commitment to tradition. Although his plaster figures were radical departures and reappraisals of the expressive powers of the visual arts, Segal's keen understanding of the history of art makes itself strongly felt in much of his work. In an interview, Segal claimed: "I have to confess. I love the history of art and I haunt museums every chance I get. I spend a lot of time with friends talking art theory. At that time, I began to look at my own body of work and realized there was no reference in my own work to big chunks of my mental life. I decided to make room in my work for things I was thinking about."[3]

Nude Torso is one of these works where evidence of his thorough understanding of the history of art exerts itself. His choice of subject emerges directly out of the Renaissance topos of the idealized female nude. Segal, however, refuses to idealize his female subject. Rather than neutralize the sensuality of the female nude, Segal's plaster method makes the sensual allure and physical reality of the model explicit.

Nude Torso can thus be read as an important reminder of Segal's devotion to the history of art as well as his debt to the sensual dynamism of Abstract Expressionism. Segal's *Nude Torso* can be compared fruitfully to Willem de Kooning's "Woman" series. The dynamic, almost violent energy of de Kooning's women is transposed into sensuous, full-bodied sexuality in Segal's relief. *Nude Torso* is an excellent example of his profound awareness of tradition, which is manifest even in his most seemingly antitraditional works.

DANIEL A. SIEDELL

NOTES

1. Quoted in Martin Friedman and Graham W. J. Beal, *George Segal: Sculptures*, exhibition catalogue (Minneapolis: Walker Art Center, 1978), 10.

2. Quoted in Friedman and Beal, 10.

3. Quoted in Friedman and Beal, 49.

JOEL SHAPIRO (b. 1941)

Untitled, 1984

BRONZE 11 ¹/₈ X 6 ¹/₂ X 11 IN. UNIVERSITY OF NEBRASKA, OLGA N. SHELDON ACQUISITION TRUST 1985.U-3780

© JOEL SHAPIRO/ARTISTS RIGHTS SOCIETY (ARS), NEW YORK

Joel Shapiro's sculptures of the 1980s typically oscillate between the poles of abstraction and representation. Viewed from some angles, they appear as nothing more (or less) than tilting, abstract assemblies of boxy geometric forms. Seen from other vantage points, however, they snap into focus as delightfully childlike images of unstable human figures in wildly acrobatic postures. Their figuration remains suggestive rather than descriptive, however. As Shapiro has remarked, "I think it is important that a convincing piece of sculpture could be put together so simply and be figurative without having to get involved with literally describing human movement, but rather it describes one's idea of movement or one's internal feeling of movement."[1]

The blocky, geometric components of works such as the Sheldon's *Untitled* are Shapiro's inheritance from Minimalism, the austerely literal mode of abstraction that dominated American sculpture of the 1960s. Born in New York City and trained as an artist at New York University, which granted him an MFA degree in 1969, the young Shapiro assimilated the Minimalist commitment to the use of basic, unexpressive materials deployed in real physical space; typically, Shapiro would place his works directly on gallery floors. At the same time, he countered the Minimalist preference for monumental, factory-fabricated objects by crafting small, handmade sculptures that revealed the process of their making. *One Hand Forming/Two Hands Forming* (1971, private collection), for example, consisted of two piles of diminutive fired-clay forms squeezed into potato-shaped logs and lumpy balls by one and two hands, respectively. *Untitled* (1971, private collection) was a pile of 104 nutlike forms carved out of pine. These works explored in rudimentary fashion the traditional sculptural processes of modeling and carving. In a further departure from Minimalist literalism, Shapiro was by 1972 working with simple imagery, making cast-iron and bronze representations of miniature bridges, coffins, chairs, tables, and houses.

Shapiro's diminutive metal chairs and houses hugged the floor in the midst of the vast surrounding gallery space, signifying physical isolation and emotional withdrawal. In Shapiro's words, they dealt with issues of "memory and sorrow."[2] The sculptor finally turned to figuration in the late 1970s out of a desire to "get the work up off the floor" and to "make sculpture that functioned more in the present where you really were not involved with issues of memory . . . sculptures that physically functioned in the room, in the space we occupy, not in projective space."[3] In 1980 he produced, on the same small scale as his house sculptures, a group of stick figures in "depressed, dormant poses."[4] He then imparted more-active postures to his figures and enlarged them to human scale as they began to stretch, pivot, stride, dance, tumble, and collapse, definitively overcoming Minimalist stasis and formal restraint.

Even as he made life-size figures, however, Shapiro also continued to work on the smaller scale he had embraced throughout the 1970s. For example, the Sheldon's *Untitled*, recognizable as an upside-down figure performing a handstand, rises just eleven inches off the floor, and so retains the qualities of isolation and vulnerability that characterized Shapiro's earlier small-scale chairs and houses. Evident as well in this and other figurative pieces is his abiding concern for preserving in the completed work evidence of the literal character of its materials and process of manufacture. Shapiro obviously fashioned this sculpture initially from simple pieces of wood, sawed and glued together; the grain of the wood and the indications of joinery are faithfully preserved in the cast bronze of the finished piece. At the same time, by using bronze, he has unified disparate compositional elements, made process over into permanence, and, even while working in an up-to-date, postminimalist idiom, ultimately joined in the tradition of bronze figurative sculpture that stretches back through several millennia of Western art.

DAVID CATEFORIS

NOTES

1. Joel Shapiro, interview by Richard Marshall, in *Joel Shapiro*, exhibition catalogue (New York: Whitney Museum of American Art, 1982), 101.

2. Joel Shapiro, interview by Deborah Leveton, in *Joel Shapiro: Tracing the Figure*, exhibition catalogue (Des Moines: Des Moines Art Center, 1990), 46.

3. Quoted in Roberta Smith, "Joel Shapiro," in *Joel Shapiro*, Whitney catalogue, 29; quoted in Leverton interview, 46.

4. Quoted in Leverton interview, 60.

LARRY BELL (b. 1939)

Glass Cube Cal #8, 1985

MIRRORED CUBE ON PLEXIGLAS BASE 20 $^1/_{16}$ X 20 $^1/_{16}$ X 20 $^1/_{16}$ IN. (BASE: 32 X 20 $^1/_{16}$ X 20 $^1/_{16}$ IN.) UNIVERSITY OF NEBRASKA, OLGA N. SHELDON ACQUISITION FUND
1994.U-4549

© LARRY BELL

Born in Chicago in 1939, Larry Bell moved with his family in 1945 to Los Angeles, where he lived until 1973. From 1957 to 1959 Bell studied at the Chouinard Art Institute, where he was influenced initially by the gestural style of Jackson Pollock but soon began painting in the Hard-Edge style of East Coast painters Frank Stella, Jules Olitski, and Kenneth Noland. Bell's "lightweight version" of the Hard-Edge style was exhibited in his first solo show, at Los Angeles's Ferrus Gallery in 1962.[1] These paintings, in which he explored the relationship between painted geometric shapes and the geometric shapes of the canvas, "were efforts to define the cubic volume by the canvas shape."[2]

In the same year as the Ferrus Gallery show, Bell began to experiment with glass and canvas constructions. According to Bell, "These two-dimensional shapes were not strong enough for me. They needed something else to strengthen the imagery, and glass came to mind."[3] Bell's interest in glass, however, was sparked several years earlier. As an art student during the late fifties, he worked at a picture framing shop where he took scrap glass, cut it, and mounted it in shallow shadow boxes sold in the shop. Bell used this experience with glass and, as he says, "began by incorporating glass into the canvas structure and making constructions shaped like the cubic diagrams." These canvases, with glass planes superimposed in the center as a means of reflecting and refracting both light and pigment, became important transitional works for him. "It wasn't long before I realized that volume was my main concern, but sadly it was still only an illusion. So I moved away from canvas and diagram altogether, made a complete transition from painting to sculpture, and began creating the cubes."

These cubes, begun while he was in New York in the mid-sixties, became for Bell his most mature work and gave him the opportunity to flex his creative aptitude. Constructed with six panes of glass, the cubes are vacuum-coated with various vaporized metals and mounted on Plexiglas bases. According to Bell, "The color is determined by the thickness, or degree of interference with light, of the thin films deposited in layers on the surface." *Glass Cube Cal # 8* is an excellent example of this form in Bell's fertile and diverse oeuvre, which has continued to change and develop. *Glass Cube Cal # 8* expresses Bell's concern, not with the Minimalist aesthetics of matter and presence, but with the West Coast tendency toward dissolving surface through use of light and reflective materials.

By the eighties, Bell had begun to experiment with his pedestal cubes by exploring the potential of the entire gallery space through environmental installations of panes of glass, two of which were part the Sheldon Memorial Art Gallery's exhibition of Bell's work in 1983.[4] For Bell, "Reflection, transmission and edge, these elements still are dynamic forces in my work," and these interests have made themselves manifest in quite different ways during the last ten to fifteen years, including large-scale mirror and glass installations incorporating furniture he has built himself; a series of games, both tabletop and gallery-space "environments," incorporating Bell's chair designs placed in relation to panes of glass on checkerboard surfaces; and foil paintings. "A person does the art he does because he needs to believe in something in the face of all that is unacceptable in the world." Bell's art, then, is less an attempt to extend or transform modern art than it is to extend or transform his own creative vision.

DANIEL A. SIEDELL

NOTES

1. Fidel A. Danieli, "Bell's Progress," *Artforum* 5 (June 1967): 69.

2. Larry Bell, *Larry Bell: The Sixties,* exhibition catalogue (Santa Fe: Museum of Fine Arts, Museum of New Mexico, 1982), 12.

3. Larry Bell, "Another Lesson," in *Larry Bell: The Sixties,* 4. All subsequent quotations from Bell come from this essay.

4. Donald Bartlett Doe, *Larry Bell: Major Works in Glass,* exhibition catalogue (Lincoln NE: Sheldon Memorial Art Gallery, 1983), n.p.

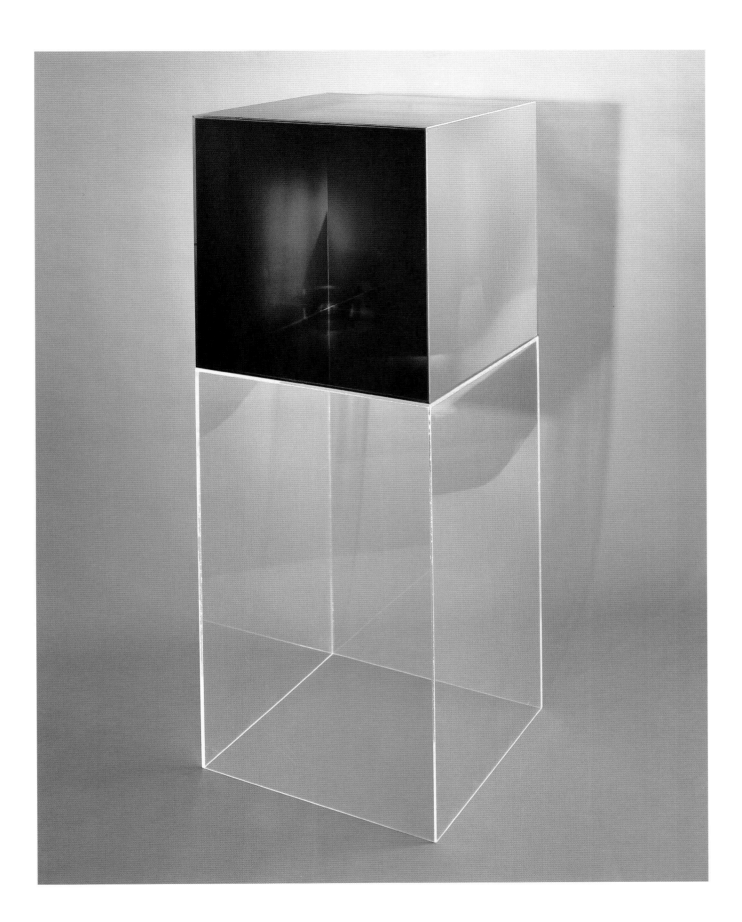

DEBORAH BUTTERFIELD (b. 1949)

--

Derby Horse, 1985

BRONZE ARTIST'S PROOF II (FROM AN EDITION OF 5 WITH 4 ARTIST'S PROOFS) 31 X 47 X 9 IN. UNIVERSITY OF NEBRASKA, F. M. HALL COLLECTION
1986.H-2845

© DEBORAH BUTTERFIELD

From the equestrian statues of ancient Rome to the contemporary paintings of the American artist Susan Rothenberg, the horse has been a consistent presence in art. For Deborah Butterfield, it serves as the central image of her sculpture. Born in San Diego, Butterfield's early life revolved around both art and horses. Weekly riding lessons deepened her understanding of equine anatomy and behavior, and at one point she contemplated a career as a veterinarian. Yet her enduring commitment to artistic expression led her to a career in art, one in which her love for horses resonates. Initially, using horses as her subjects served as self-portraiture: "I first used the horse images as a metaphorical substitute for myself—it was a way of doing a self-portrait one step removed from the specificity of Deborah Butterfield."[1] Appropriately, all of her early sculptures were of mares.

Currently residing in Bozeman, Montana, along with her family and horses, Butterfield continues to explore the expressive capabilities of equine imagery. She has expanded the scope of her inquiry—no longer are these horse sculptures to be understood solely as self-portraits. Rather, Butterfield intends her work to facilitate a connection between viewer and animal, and to encourage an acknowledgment of the differing experiences of living beings. "The point about my work," she states, "is the empathy of shared gesture between horse and human. My work is about creating the empathy so that we can step into the form—if only for a split second—and have feeling for the 'other.' Most of the world is 'other,' and once we can step out of 'self,' we are more likely to be able to do so again."[2]

The form her sculptures often take is that of a standing horse (in a few sculptures the horse is lying down). The scale is smaller than life-size but sufficiently large to have a commanding presence in a gallery or museum setting. Over the years, Butterfield has expanded the materials out of which she creates her horses. She constructed early sculptures of plaster over a steel armature; she has since built her sculptures of mud and sticks, wire and steel, folded and crumpled scrap metal, and wood and plant materials (cast in bronze) as well.

Sheldon's *Derby Horse* is one of four artist proofs for an edition of five commissioned and distributed for the 1985 Kentucky Derby Arts Festival. Like many of Butterfield's sculptures, it is cast bronze, but despite the formality of the casting process, *Derby Horse* retains compelling evidence of the artist's hand. For Butterfield, working on these artworks is a way of animating material that has often been discarded as industrial scrap. In working on each sculpture she forms the body first, suspending it from cables in the ceiling. Legs are added next, followed by the head, neck, and tail. The artist poignantly observes: "Sometimes I am so brutal in making the pieces. I beat them with hammers and cut them. At times there seems to be no tenderness until the piece is finished and gone."[3] For cast bronze works such as *Derby Horse*, the original sculpture is disassembled to create models for the lost-wax method of bronze casting; once the pieces are cast, the artist welds the sections together.

Despite the seeming brutality of the production process, the finished sculptures convey a grace and humanity that draw viewers to them. They are indeed more than insights into the connection of the artist with the animal world; they speak to larger issues of empathy for other living beings, of the primacy and innate beauty of materials, and of the compelling nature of sculptural presence.

CHRISTIN J. MAMIYA

--

NOTES

1. Quoted in Randy Rosen and Catherine C. Brawer, *Making Their Mark: Women Artists Move into the Mainstream, 1970–85* (New York: Abbeville Press, 1989), 107.

2. Quoted in Thomas H. Garver, *Mind and Beast: Contemporary Artists and the Animal Kingdom* (Wausau WI: Leigh Yawkey Woodson Art Museum, 1991), 25.

3. Quoted in Garver, 25.

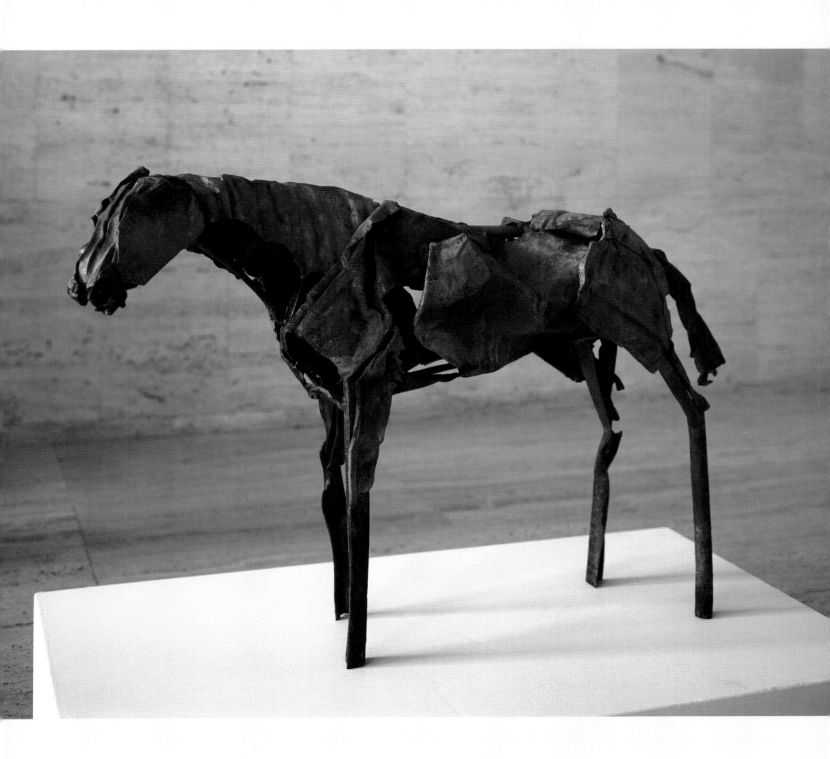

CHARLES GINNEVER (b. 1931)

Shift, 1985

STEEL 114 X 272 ¼ X 33 IN. UNIVERSITY OF NEBRASKA, GIFT OF MR. AND MRS. GERALD D. KOHS 1992.U-4440

© CHARLES GINNEVER

Shift, part of the series aptly named "Flat Illusion," challenges the notion that sculpture is, by definition, nonillusionistic. It is exemplary of Charles Ginnever's long exploration of three-dimensional spatial contradiction and embodies his mature style—at least one of them. Ginnever was born in San Mateo, California, in 1931 and was drawn to sculpture as a young boy. He studied at the Académie de la Grand Chaumière in Paris from 1953 to 1955 under Ossip Zadkine, a member of the School of Paris. Upon returning home he enrolled in the San Francisco Art Institute, then known as the California School of Fine Arts. In postwar U.S. culture, however, New York City was arguably the only place in the country to endeavor the serious pursuit of art. Abstract Expressionism reigned as "triumphant,"[1] American style having finally broken the hold of European ascendancy. So when he graduated in 1957, Charles Ginnever and an acquaintance named Mark di Suvero packed up their lives and made the long pilgrimage east.[2] Ginnever received his MFA degree from Cornell University in 1959, moved to New York City, and came of age as a sculptor during a remarkable period in the history of American art.

Ginnever's earliest works combine the intensity and emotion of Abstract Expressionism with the attitude of Constructivism. Using found materials such as scrap wood and salvage metal, he began what was to become his lifelong investigation of perception. Ginnever created illusions of spontaneity in much-labored constructions. Layered and intertwined, like Action Paintings, his early sculpture can be seen as expenditure of energy.[3] The dramatic gestures of Franz Kline were especially influential for Ginnever, who transposed Kline's physicality from painting to sculpture, into his own strong gestural constructions.

Although the early echoes of that personal, introspective style soon faded from Ginnever's art, the legacy Abstract Expressionism left for artists in general had far-reaching consequences. Throughout the 1960s the air in New York City was rife with the cross fire of aesthetic ideologies, each vying for dominance in the era of post-war consumer culture. Second-generation Abstract Expressionists were still championed by the keepers of high modernism, critics such as Clement Greenberg and Michael Fried, while such radically different movements as Minimalism and Pop converged on a similar goal—to dismantle the very notion of high art and the hegemony of power it had come to represent.

In addition, there was a war going on between modern painting and sculpture. Interestingly, the pivotal issue around which the two, ostensibly opposite, poles converge is illusionism. Greenberg and Fried were deeply invested in historically situating Abstract Expressionism as canonical high modernism. Modernism, as interpreted by Greenberg, was at odds with sculpture. His doctrine dictates that art must be purified so that its only index is art itself. Since he defined Modernism through the pure opticality of painting, there was sparse latitude left for sculpture. He wrote, "Where the Old Masters created an illusion of space into which one could imagine oneself walking, the illusion created by a Modernist is one into which one can only look, can travel through only with the eye."[4]

The Minimalist sculptor Robert Morris, reacting to the criticism of Greenberg and Fried, also described the rift between painting and sculpture. "Painting dematerializes itself in an act of illusionism," wrote Morris, "as opposed to sculpture which rests firmly in the object—out of space, light and materials which have always functioned concretely literally."[5] This kind of rhetoric can almost be read as a call to arms, a challenge, to which Ginnever responds. In 1966 Ginnever created the first of his illusory sculptures, *Midas and Fog*, which began the "Flat Illusion" series. It was in the mid-1970s that Ginnever looked back at the corpus of works he had created and decided to group his sculpture stylistically into four series he called "Historic," "Linear," "Planer," and "Flat Illusion."[6] He has continued to work within them ever since.

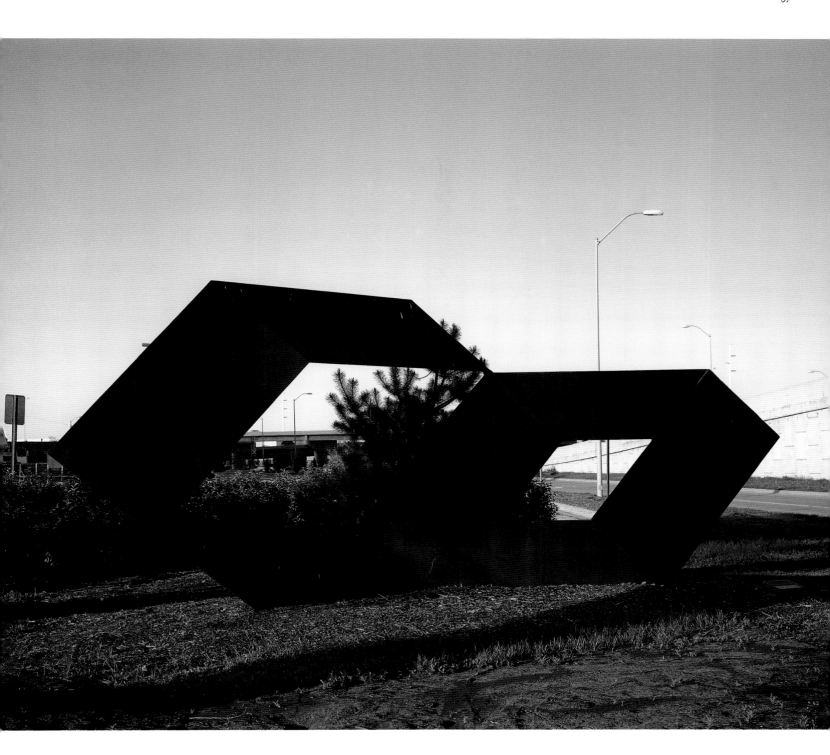

Shift consists of two flattened, interlocking parallelograms of steel configured in contradictory planes. Approaching *Shift* from the front, the observer is presented with an almost two-dimensional surface. It thus calls attention to itself as an object in space—rather, it calls attention to space itself. Ginnever has quoted Einstein: "'Physical objects are not in space, but these objects are spatially extended.' In this way the concept of empty space loses its meaning."[7] Using the traditional Western conventions of perspective, the viewer must attempt to resolve an impossible puzzle. To walk completely around the sculpture is the only way to understand the conceptual disruption. Each angle presents a different work of art. "The logic of the sculpture constantly oscillates between two (at least) partial readings of its space neither of which can be sustained without contradiction."[8] The confusion M. C. Escher creates comes to mind—stairways that lead up and down simultaneously but go nowhere, and shapes that turn in on themselves only to flip back out. Ginnever's sculpture plays with the connotation of shifting from positive to negative and from open to closed. He has stated, "My purpose now is to subvert the notion that we in the West know how to see objects in space. We really don't because we have a conditioned reflex that causes us instantly to translate everything in front of us into a Renaissance idea of perspective . . . we are unable to see implied space."[9] *Shift* not only explores the relation of space to object and object to viewer's field of vision but questions the conventions of perspective in Western ideology by disrupting our senses, challenging the complacency of our perception, and contradicting the assumptions of historical dogma.

INGRID A. SEPAHPUR

--

NOTES

1. Irving Sandler, *The Triumph of American Painting: A History of Abstract Expressionism* (New York: Harper & Row, 1976).

2. Carter Ratcliff, "Taking Off: Four Sculptors and the Big New York Gesture," *Art in America* 66 (March/April 1978): 100.

3. Ratcliff.

4. Clement Greenberg, "Modernist Painting," *Arts Yearbook* 4 (1961): 101. Reprinted in *Clement Greenberg: The Collected Essays and Criticism*, vol. 4, *Modernism with a Vengeance, 1957–1969*, ed. John O'Brian (Chicago: University of Chicago Press, 1986), 90.

5. Robert Morris, "Notes on Sculpture," part 1, *Artforum* 4 (February 1966): 42–44. Reprinted in *Continuous Project Altered Daily: The Writings of Robert Morris* (Cambridge: MIT Press, 1995), 3.

6. Ronny Cohen, *Charles Ginnever*, exhibition catalogue (San Francisco: Anne Kohs & Associates, 1987), 39.

7. Mary Maggini, "A Conversation with Charles Ginnever," in *Charles Ginnever*, exhibition catalogue (Woodside CA: Runnymede Sculpture Farm, 1993), n.p.

8. Britton Schlinke, "Illusions of a Different Space," *Artweek* 18 (July 11, 1987): 6.

9. Charles Ginnever, statement in "Charles Ginnever," exhibition flyer, ConStruct, Chicago, n.d., n.p.

WILLIAM TUCKER (b. 1935)

Ouranos, 1985

BRONZE EDITION 1/3 78 X 83 X 55 IN. UNIVERSITY OF NEBRASKA, FUNDING PROVIDED BY THE OLGA N. SHELDON ACQUISITION TRUST AND THE NATIONAL
ENDOWMENT FOR THE ARTS 1989.U-4250

COURTESY MCKEE GALLERY, NEW YORK

One of the most articulate and intelligent sculptors of his generation, William Tucker has, through his critical writings, explicated a unique and compelling history of modern sculpture that not only establishes the historical context for his own sculpture but redefines the significance of such early modern sculptors as Auguste Rodin, Edgar Degas, Henri Matisse, and Constantin Brancusi.

Born in Cairo, Egypt, in 1935, Tucker was reared in London and studied at Oxford University and at St. Martin's School of Art with Anthony Caro, one of the most influential sculptors in postwar European and American art. He and a number of Caro's students made up the core of young British sculptors whose works were shown together at the Whitechapel Art Gallery's "New Generation" exhibition in London in 1965.

Tucker moved to the United States in 1978, and through 1984 his work consisted of open structures inspired by Constructivism, which he learned under Caro. However, by 1984 he began to explore what one critic called the "modeled monolith," which was "a form that was favored by such early modern sculptors as Rodin, Degas, and Matisse."[1] Although this development, of which *Ouranos* (1985) is an outstanding example, is not foreshadowed in his pre-1984 Caro-inspired work, it is strongly implied in his important book *The Language of Sculpture* (1974). For Tucker, modern sculpture represents "the independence of the work from specific subject-matter or function, its 'internal' life, the concern with material, structure, and gravity as ends in themselves."[2] Tucker offers an alternative way of understanding the origins of modern sculpture. Departing from the formalist modernism of Clement Greenberg–inspired art history—which emphasizes an optical or pictorial orientation and so often denies sculpture's status as an object in favor of its status as an "image" (made manifest in the work of Pablo Picasso, and later David Smith and Anthony Caro)—Tucker posits Matisse, Degas, Rodin, and Brancusi as the authentic foundation of modern sculpture, premised on sculpture's natural characteristics, gravity and volume. Dore Ashton keenly observed that Tucker possessed the "courage to revive a traditional view of the nature of sculpture."[3] "Gravity unites sculpture and the spectator in a common dependence on the resistance to the pull of the earth."[4] These values are nowhere more manifest than in his *Ouranos,* which, in the gradually sloping monolithic slab of modeled clay cast in bronze, communicates nothing if not the gravity and volume about which Tucker wrote a decade earlier. Andrew Forge singled out *Ouranos* as "a representation of Tucker's recent work and as the heir to what has gone before it."[5] For Forge, *Ouranos,* like the artist's other monoliths, creates a unique "topography of a place," with its complex modeled surface and myriad of bodily associations, including fist, foot, penis, and torso.

Although his title for the piece is rather obscure, it is far from random and serves to underscore Tucker's concern with the process of creation. The Greek God Ouranos (the Romans called him Uranus) is the father as sky or heaven, who, with Gaea, the mother as earth, sired the world's first creatures, the Titans and Cyclops. Tucker's own interest in sculptural matter finds an analogue in the ancient Greeks' preoccupation with origins, as demonstrated in Homer's epic poems and the philosophy of the pre-Socratics and the Neoplatonists, which endeavored to discover the process of how living form was created from inert matter.

Tucker is likewise concerned with the creative process, or how the sculptor creates form from inert matter, and his post-1984 work suspends and exploits this tension between sculpted form and inert matter. As Forge has written, his recent work "is both an object and an image, both thing and representation."[6]

In fact, these modeled monoliths are very much about metamorphosis, or the process of matter becoming form. As one critic

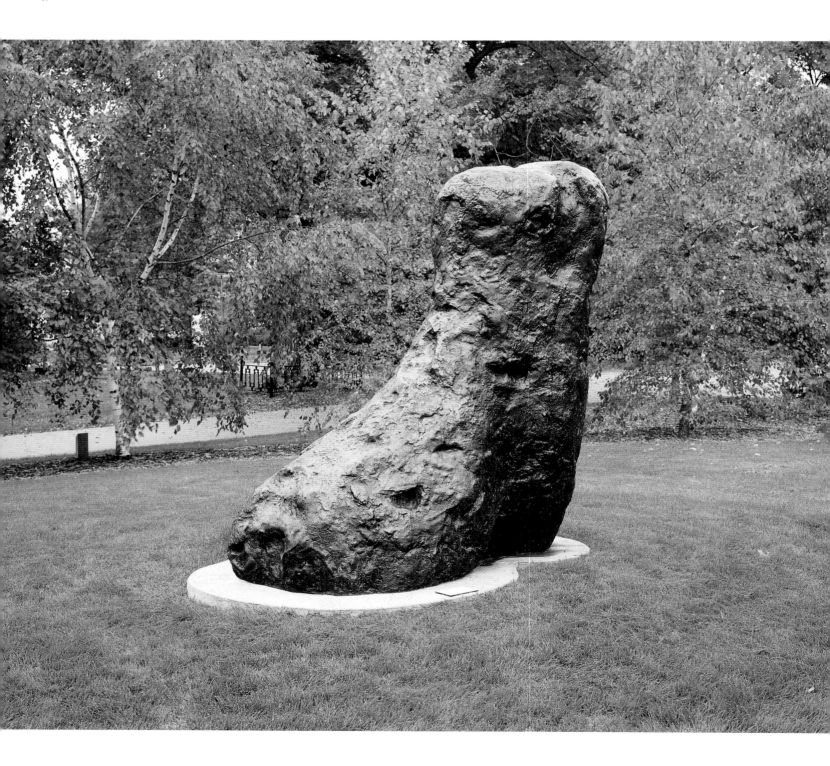

wrote, Tucker is "giving us a sculptural form that appears so minimally worked as to be little more than raw material, yet a form possessed of the most forceful emotive power."[7] Volume and gravity, for Tucker the most basic of elements for sculpture, are not denied, negated, or otherwise deemphasized in *Ouranos*, as in so much postwar modern sculpture, but made its subject matter in as explicit a manner as possible. "The content of *Ouranos* lies deep in its carnal presence, its energy, its stillness and its unending plasticity."[8]

DANIEL A. SIEDELL

--

NOTES

1. Eric Gibson, "William Tucker's American Decade," *New Criterion* 7 (September 1988): 45.

2. William Tucker, *The Language of Sculpture* (London: Thames and Hudson, 1974), 16.

3. Dore Ashton, *William Tucker and the Mind's Desire* (Miami: Florida International University, 1988), n.p.

4. Tucker, 145.

5. Andrew Forge, "As Many Dimensions As We Have Muscles," in *William Tucker: The American Decade 1978–88*, exhibition catalogue (Mountainville NY: Storm King Art Center, 1988), n.p.

6. Forge.

7. Tucker, 145.

8. Forge.

MARK DI SUVERO (b. 1933)

Old Glory, 1986

PAINTED STEEL 420 X 360 X 144 IN. UNIVERSITY OF NEBRASKA, GIFT OF OLGA N. SHELDON ACQUISITION TRUST AND FRIENDS OF SHELDON MEMORIAL ART GALLERY AND SCULPTURE GARDEN 1987.U-3930

© MARK DI SUVERO

Heir to the tradition of Pablo Picasso, Julio González, and David Smith, Mark di Suvero is a contemporary master of open-form steel sculpture. His enormous I-beam constructions, executed on an architectural scale and situated in the open landscape, rank among the most powerful sculptural creations of the late twentieth century. Di Suvero was born in Shanghai, China, where his father, a former Italian naval officer, worked as an agent for the Italian government. In 1941, following the outbreak of World War II, the family immigrated to San Francisco. Di Suvero attended San Francisco City College, the University of California–Santa Barbara, and the University of California–Berkeley. Although he majored in philosophy, he also studied sculpture, with Robert Thomas at Santa Barbara and Stephen Novak at Berkeley. Shortly after graduating from Berkeley in 1957, di Suvero moved to New York City.

For his first solo exhibition, at the Green Gallery in October 1960, di Suvero assembled rough-hewn wooden beams and planks, steel rods, chains, and ropes into enormous asymmetrical structures, sprawling across the floor and thrusting aggressively into space, like three-dimensional counterparts of the gestural "Action Paintings" of Franz Kline and Willem de Kooning. The awesome physical power of these sculptures stood in contrast to di Suvero's own bodily infirmity at the time of the exhibition: while delivering a load of lumber seven months earlier, he had been crushed on top of an elevator and suffered a broken back. His doctors feared he would never walk again, much less continue to make sculpture. But within two years, di Suvero was able to move with braces and crutches, and by the early 1970s he had regained full, if painful, mobility.

While confined to a wheelchair during the first years of his recuperation, di Suvero made small sculptures in wood and welded steel. Moving to California in 1964, he freed himself from the confines of the studio and began to work on a much larger scale,

building twenty-foot-high works in the out-of-doors. His pieces of the mid-1960s combined massive wooden and steel components with occasional kinetic elements such as swinging tires or plywood beds. Viewers were invited to ride them and become active participants rather than passive observers. In 1966 di Suvero employed sculpture itself as a medium for activism when he constructed a fifty-five-foot-high *Peace Tower* in Los Angeles as part of an artists' protest against the Vietnam War.

Ultimately, di Suvero's opposition to U.S. involvement in Vietnam led him into voluntary exile in Europe from 1970 to 1975. He lived and worked successively in Italy, Holland, Germany, and France and forged his classic style of steel I-beam construction. Di Suvero had made his first I-beam sculptures in 1967, hoisting the beams into the air with a crane and then bolting, riveting, and welding them together into exuberant, sprawling arrangements. In Europe, di Suvero pared down the baroque complexity of the earlier I-beam sculptures to achieve greater structural clarity and compositional elegance.

The Sheldon's *Old Glory* descends from his works of the European period such as *K-Piece* (Kröller-Müller Museum, Otterlo, 1971) and *Ave* (Dallas Museum of Art, 1973), which rise from the ground on three legs, gather their energies at a central knot, and then fling their beams out into the unbounded space above. Defining the center of *Old Glory* is a pair of open, semicircular planes that meet at right angles. One is flush with the K-joint that unites three of the beams, and appears to provide some structural reinforcement. The other, springing from the fourth beam and arcing through space to meet the first, has no evident structural function but plays the important visual role of providing a curving, planar counterpoint to the rigid rectilinearity of the beams. Another, more subtle, compositional addition is the slender steel tension wire that spans two of the upper beams. Like the second semicircular plane, it serves no structural

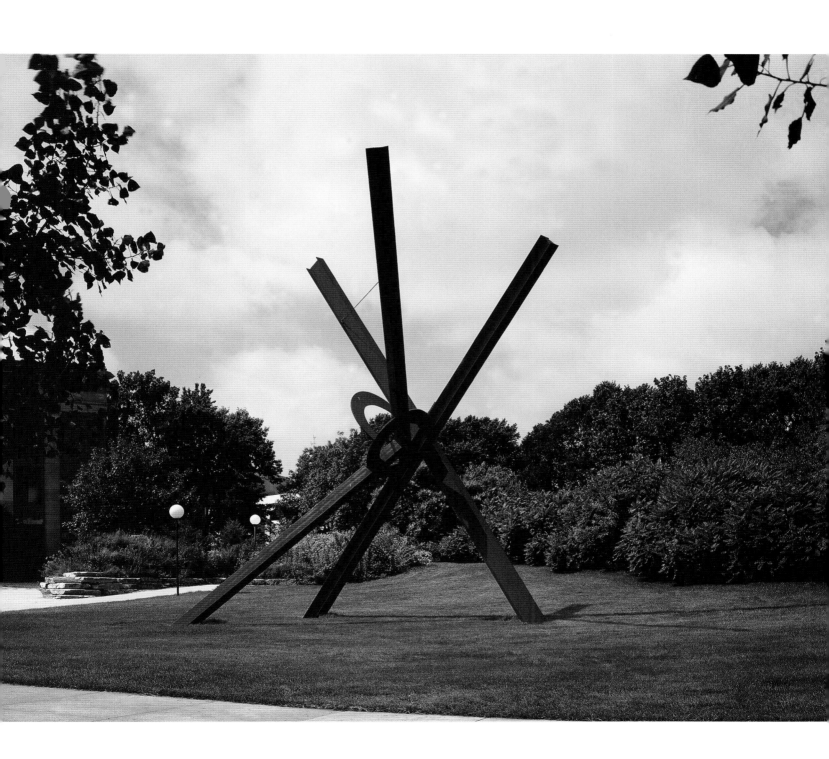

purpose but operates purely formally, as a taut line that zips horizontally through space to throw into relief the heavier, diagonal thrusts of the I-beams.

Like many of di Suvero's large outdoor sculptures, *Old Glory* is painted bright red, a color that distinguishes it from the surrounding landscape, sky, and architecture while imparting to it a cheerful personality quite in keeping with its generous, open-handed form. Though it stands almost thirty-five feet tall and weighs close to eight tons, *Old Glory* is remarkably buoyant and transparent, a welcoming rather than intimidating presence. Di Suvero himself conceives of his works as positive and liberating, and hopes that their audiences will take the same view, remarking, "I would like to see people participate with the work in a way that is joyous and healthy."[1] Unleashed from the confines of the museum and accessible to everyone, di Suvero's sculpture stretches and extends itself heroically into free space, ultimately becoming, in Barbara Rose's words, "a metaphor for human liberty of thought and action" with which all of us are invited to identify.[2]

DAVID CATEFORIS

--

NOTES

1. Mark di Suvero, interview by Emilio Mayorga, in *Mark di Suvero*, exhibition catalogue (Valencia: IVAM Centre Julio González, 1994), 119.
2. Barbara Rose, "On Mark di Suvero: Sculpture outside Walls," *Art Journal* 35 (Winter 1975–76): 120.

JUN KANEKO (b. 1942)

Dango, 1986

Born in Nagoya, Japan, in 1942, Jun Kaneko has lived in the United States since he moved, at the age of twenty-one, to Los Angeles and into an artistic community that was experiencing the emergence of ceramics and other so-called functional arts as appropriate mediums for serious artistic expression. Although he studied at some of the finest institutions on the West Coast, including the Chouinard Art Institute, Cal-Berkeley under the tutelage of Peter Voulkos, and the Claremont Graduate School, and has taught at such important art schools as the Rhode Island School of Design and the Cranbrook Academy, Kaneko's development into one of this country's finest ceramicists was a highly individualistic, idiosyncratic, and nonconventional journey throughout which his exclusive goal was—and continues to be—the achievement of intimacy with his medium.

Whether they are his huge seven-foot "dangos" (of which the Sheldon's piece is one), massive mural constructions, smaller tabletop forms, or his "slabs," Kaneko's work reveals an engagement and successful negotiation of the most challenging technical and aesthetic problems in the art of ceramics. He has been so successful in this quest that it has become a significant part of his aesthetic language. This technical facility has not been lost on his critics. In her essay for Kaneko's solo show at the Sheldon Gallery in 1987, Daphne Anderson Deeds wrote, "His respect for the natural pace of time as it effects [sic] the clay is an integral component of the integrity of each piece."[1] And Kyle Mac-Millan wrote, in a 1989 review of a solo show at the New Gallery in Omaha, "Beneath the deceiving simplicity lies an incredible technical facility and knowledge of glazes that permits Kaneko to create some subtly spectacular events."[2]

Kaneko's desire for technical mastery, which is derived from his profound respect for the entire process of creating a successful ceramic piece, has not been achieved at the expense of spontaneity and intuition, values that he cherishes. For Kaneko, spontaneity and intuition provide a necessary antithesis to the technical aspect and seem to pervade all his work, large or small, with a dynamism unusual for the ceramic medium. And it is through the process of painting these forms that Kaneko's spontaneity is most strikingly manifest. About this process, he has said, "Finally I give up thinking and just sit in front of my piece, trying to catch what the shape is saying to me. I walk around the studio and try to make conversation with the works I've made. When I hear what the form has to say, I start seeing marks and colors on the surface."[3]

But this spontaneity, which reveals itself in diverse decorative patterns, requires an intimate knowledge of the form as well, of which the technical aspect is an important part. Kaneko's oeuvre reveals the same patient search for maximizing spontaneity and intuition through the determination of how much control and technical precision is required to make spontaneity and intuition most effective. In this way he seems to transcend his dialectic between control and spontaneity, producing an almost gestalt-like unity of the overall shape and its decorative pattern. This is revealed quite powerfully in the Sheldon's *Dango,* which seems to be the product of a technical and creative mastery derived from an intimate relationship between the artist and the form at every stage in the process. Nearly six feet tall, *Dango* communicates on an anthropomorphic level; the viewer is forced to experience it relative to his or her own bodily presence as the striking simplicity of the form further underscores one of the most elemental principles of aesthetic experience: our own physical presence. In spite of its imposing size, its intricately crafted decorative pattern, which wraps the form in bands of color, breaks up the monolithic form and animates the surface with glossy shades of gray and red.

Kaneko has observed that "the bottom line of being a visual artist is to be alive and to make something visual. All other issues of ideas and values that might come out of this art-making process are relatively stable."[4] His devotion to the individual and solitary

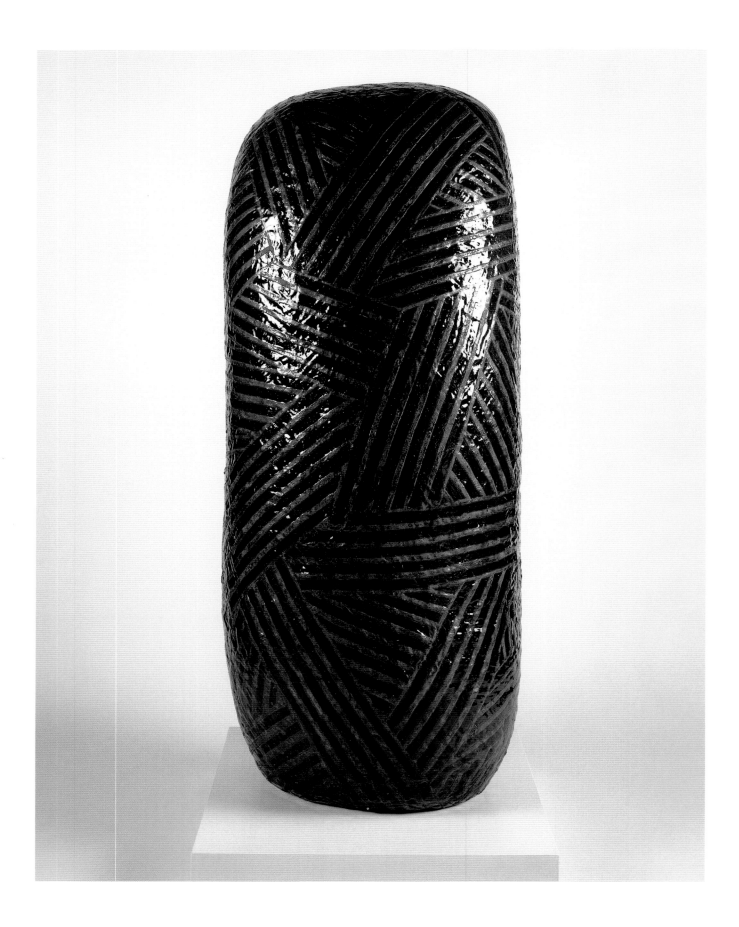

quest for intimacy with the form and content of the art-making process seems to transcend the often discussed "cultural" aspect of his work—that is, the relationship between the "East" and the "West"—by revealing that Kaneko's quest to achieve full intimacy with his art consists of making everything he comes into contact with his own, no matter what cultural tradition it stems from. Kaneko's forms do not make one think about "cultures"; rather, they make viewers feel that they are in the presence of highly personal objects that are the result of an almost obsessive search for undiluted intimacy, intimacy with the technical, creative, and intuitive processes—but above all, intimacy with his own being as an artist. Kaneko seems to express this when he states, "Doing makes me think, makes me do more."[5] Perhaps experiencing art that is the product of "thinking" and "doing" is what makes *Dango* so compelling. Such single-mindedness is both naive and sophisticated—and therein lies the power of Kaneko's pieces.

DANIEL A. SIEDELL

--

NOTES

1. Daphne Anderson Deeds, *RHYTHMIC CLAY: A View of Jun Kaneko's Process*, Resource/Response Series (Lincoln NE: Sheldon Memorial Art Gallery, 1986), n.p.

2. Kyle MacMillan, "Visual Poet Strives for the Energy to 'Shake the Air,'" *Omaha World-Herald*, March 19, 1989, sec. H, p. 21.

3. Jun Kaneko, *Jun Kaneko: The Dutch Series—Between Light and Shadow* ('s Hertogenbosch, The Netherlands: European Ceramic Work Centre, 1996), 12.

4. Jun Kaneko, quoted in MacMillan.

5. Kaneko, *Jun Kaneko: The Dutch Series*, 8.

TOM RIPPON (b. 1954)

Still Life with Dice, 1986

CERAMIC 65 ⁵/₈ X 29 X 28 ⁷/₈ IN. UNIVERSITY OF NEBRASKA, F. M. HALL COLLECTION 1987.H-2859

© TOM RIPPON

Tom Rippon's *Still Life with Dice* is a witty, humorous balancing act of stacked forms, a slightly surreal assemblage devoid of geometric symmetry. Resting on a grid distorted in forced perspective, the serpentine curves of the base ascend in an ensemble of cones and spheres so perfectly formed they could have been turned on a lathe. A fanciful pitcher on the tip-tilted table dominates precariously clinging dice and other objects of eccentric figuration. Completing the tableau, a gray sprig and pale blossom appear to sprout from the table surface. The artist's color palette, softened and muted with half-matte lusters of metallic luminosity, contributes to the intriguing imagery.

Assembled from separately formed and fired porcelain segments attached with epoxy adhesives, Rippon's figural sculptures are often mounted on metal armature rods concealed within the form. Like Picasso, who claimed all artists are thieves, Rippon appropriates his images from a variety of sources: contemporary ceramists as well as classical sources including Joan Miró and Giorgio de Chirico.

Native Californian Tom Rippon has been described as an iconoclast of the ceramics world. His attitude toward making art, reinforced during an unofficial apprenticeship with the ceramist Robert Arneson, allows him to take liberties with form and materials. Eccentric figuration and muted palette indicate Rippon's familiarity with the work of the Chicago Imagists, developed during time spent in Chicago in the late 1970s.[1]

Functioning as an architect working with clay, Rippon deals with the formal concerns of visual and structural balance and durability, achieving images of real objects slightly transformed, such as *Still Life with Dice.*

Rippon was born in Sacramento, California, in 1954. Following an unofficial education with Arneson at the University of California–Davis, he received his MFA from the School of the Art Institute of Chicago. At that time he had already begun a distinguished professional exhibition career. Since 1990 Rippon has served as chair of the Department of Art at the University of Montana–Missoula.

NANCY H. DAWSON

NOTE

1. Nancy Bless, *Tom Rippon: A Poet's Game,* exhibition catalogue (Sheboygan WI: John Michael Kohler Arts Center, 1993), n.p.

FRANK STELLA (b. 1936)

- -

Knights and Squires, 1986–87

STAINLESS STEEL, CARBON STEEL, ALUMINUM, BRONZE 59 X 52 ¹/₂ X 25 ¹/₄ IN. UNIVERSITY OF NEBRASKA, GIFT OF OLGA N. SHELDON ACQUISITION TRUST AND
JOHN BERGGRUEN GALLERY, SAN FRANCISCO 1992.U-4434

Famous in the 1960s for his reductive minimalist paintings, in the 1970s Frank Stella turned to the creation of mixed-media reliefs in a "maximalist" style that infused abstract painting with unprecedented coloristic exuberance, structural complexity, and sculptural presence. Born in Malden, Massachusetts, Stella attended Phillips Academy, Andover, where he studied painting with the abstractionist Patrick Morgan, and Princeton University, where he took painting classes with William Seitz and Stephen Greene. After earning a degree in history from Princeton in 1958, Stella moved to New York City. Reacting against the impulsive brushwork, intuitive composition, and spatial ambiguity of the reigning style of "Action Painting" practiced by Willem de Kooning and his followers, Stella embarked on his epochal series of "Black Paintings," in which he laid down parallel bands of black enamel paint on unprimed canvases, in flat, symmetrical arrangements that forced "illusionistic space out of the painting at a constant rate by using a regulated pattern."[1]

To further stress the literal "objectness" of his paintings, Stella began in 1960 to work with opaque metallic paints on shaped canvases whose framing edges echoed the configuration of their internal stripes, and vice versa. For the "Aluminum" series (1960), he cut notches in the edges and centers of standard rectangular formats. He executed the "Copper" series (1960–61) on canvases with rectilinear shapes such as a Greek cross, L, T, U, and H; the "Purple" series (1963) on polygonal canvases with hollowed-out centers; and the "Running-V" series (1964) on canvases structured by horizontal and V-shaped bands. Meanwhile, Stella continued to work on conventional square formats and experimented with bright colors in the "Benjamin Moore" series (1961), named for a commercial alkyd paint, and in the "Moroccan" series (1964–65), painted with fluorescent Day-Glo acrylics.

Stella moved toward greater structural and coloristic complexity in the "Irregular Polygons" (1965–67), his first works to employ large geometric planes of bright color abutting each other but not consistently relating to the framing edge of the shaped canvas. For the Day-Glo-colored "Protractor" series (1967–71), he laid down protractor-shaped arcs that conformed to the circular and semicircular edges of the large canvases while intersecting and overlapping one another on the interior. The overlapping of the bands and the juxtaposition of optically advancing and receding colors created unavoidable suggestions of spatial depth, which Stella chose to manifest literally in his "Polish Village" paintings (1971–73), a series of geometrically eccentric reliefs constructed out of such materials as paper, canvas, felt, cardboard, and wood.

By the mid-1970s, Stella had become convinced that abstract painting, in order to survive, needed to rediscover the kind of "projective" pictorial space created by Old Masters such as Caravaggio and Rubens.[2] He began to incorporate real space within his paintings by actively building them out from the wall, like sculptures. Beginning with the "Exotic Birds" (1976–80) and continuing with such series as the "Indian Birds" (1977–79), "Circuits" (1980–84), and "Shards" (1982–83), he made increasingly complex and dynamic relief constructions out of industrially fabricated metal components whose freewheeling, curvilinear shapes were derived from drafting templates such as French curves, ship curves, and protractors. Stella animated the surfaces of these reliefs with bold strokes of high-keyed color and vigorously scribbled calligraphy, applied with a gestural bravado worthy of the very Action Painters against whom he had reacted so strongly in the late 1950s. He even incorporated brushy, Abstract Expressionist–style canvases into his "Cones and Pillars" series (1984–87), in combination with eccentrically shaped metal cutouts and giant cones and cylinders that were illusionistically modeled by graduated, hard-edged stripes.

Knights and Squires, an early work in the subsequent "Moby-Dick" series (1986–95), is unusual in that Stella has left its metal

elements unpainted, thereby emphasizing the undeniably sculptural character of its swelling volumes and projecting planes. However, insofar as it has been built up from the wall and is designed to be seen from the front, *Knights and Squires* remains pictorial in its organization. One even senses the eye of a painter at work in the sensitive orchestration of the gently contrasting hues and values of the different metals.

Knights and Squires reveals its connection to the preceding "Cones and Pillars" series in the stubby, striated cylinders, now in actual three-dimensional relief, that meet to form a V-shape that anchors the work to the wall. Meanwhile, the sinuous "wave" form that is the leitmotif of the "Moby-Dick" series flows over and between the cylinders, and from this cylinder-wave nucleus the other elements of the composition expand outward. At the base hangs a large, flat triangle, perforated by a circular opening. Hovering in front of the triangle are a thin, planar French curve and two ship curves, one made of honeycombed metal and the other of steel tubing. The latter passes gracefully through an opening in the large circular protractor that dominates the center of the composition. Finally, from the top of the protractor springs an irregularly shaped metal cutout that is probably a residual piece left over from the cutting of a template curve. All these disparate elements are brought together into a remarkably fluent whole whose visual impact greatly exceeds the sum of its parts.

Like every work in the "Moby-Dick" series, *Knights and Squires* takes its name from a chapter in Melville's great novel. It is tempting to identify its six foremost elements with the characters introduced by Melville as "knights" (Starbuck, Stubb, and Flask—the *Pequod*'s first, second, and third mates) and "squires" (Queequeg, Tashtego, and Daggoo—their respective harpooners), but ultimately we cannot establish exact one-to-one correspondences between Stella's pictorial "actors" and Melville's fictional ones. Indeed, though its bold composition may be justly admired as an attempt to capture in pictorial terms something of the epic drama of Melville's prose, the aesthetic power of *Knights and Squires* finally is purely sculptural.

DAVID CATEFORIS

NOTES

1. Frank Stella, lecture at the Pratt Institute, New York, winter 1959–60. Reprinted in Robert Rosenblum, *Frank Stella*, Penguin New Art 1 (Baltimore: Penguin Books, 1971), 57.

2. See Frank Stella, *Working Space* (Cambridge MA: Harvard University Press, 1986), 4.

RICHARD SERRA (b. 1939)

--

Greenpoint, 1988

COR-TEN STEEL 189 ¼ X 205 ¾ X 150 ½ IN. UNIVERSITY OF NEBRASKA, GIFT OF THE OLGA N. SHELDON ACQUISITION TRUST 1992.U-4485

Richard Serra is widely known for his large-scale steel sculptures—hard-edged, monolithic, and resolutely abstract—that radically redefine the environments they inhabit and challenge viewers to interact with them spatially and temporally. Born in San Francisco, Serra was educated at UC Berkeley and UC Santa Barbara. He earned his way through college working in steel plants. After receiving a degree in English literature in 1961, Serra entered Yale University to study painting, earning an MFA in 1964. He studied in Paris on a Yale Traveling Fellowship in 1964–65, and spent 1965–66 in Florence on a Fulbright grant. Moving to New York in the autumn of 1966, Serra met Donald Judd, Carl Andre, and other leading Minimal sculptors, who encouraged him to work in real, three-dimensional space with simple, nonillusionistic forms and raw industrial materials. Simultaneously, he developed an interest in asserting the process through which the work of art comes into being, a concern he shared with such friends as Eva Hesse, Bruce Nauman, and Robert Smithson.

In 1966–67 Serra made a number of sculptures out of strips of vulcanized rubber, which he hung from the wall or scattered on the floor, allowing gravity to determine the work's ultimate form. In 1968–69 he produced a series of splashing pieces in which he flung molten lead against the right-angle juncture of the wall and the floor, allowing the lead to cool and harden before pulling it away from the wall, and then repeating the process until he had created a row of irregular metal strips revelatory both of the splashing procedure and of the physical space in which it was carried out. In other works of 1968–69, Serra propped massive lead plates and pipes against one another or against gallery walls, producing simple configurations that the force of gravity simultaneously held together and threatened with collapse.

Both the physical weight and sense of imminent physical danger inherent in Serra's prop pieces increased substantially when he began using hot-rolled steel in the 1970s to work on a greatly augmented scale. Leaning huge steel plates against one another both in interior spaces and in the open landscape, Serra created assertive "anti-environments" that demanded bodily involvement. Viewers were invited not only to walk around the sculptures but also to enter their interior spaces, where the canted steel walls would by turns convey sensations of shelter and of menace. By 1980 Serra was also fabricating sweeping steel curves that carved space into convex and concave sections. The most famous of these was the 12-foot-high, 120-foot-long *Tilted Arc,* commissioned by the General Services Administration and installed on the Federal Plaza in New York in 1981. Intensely disliked by many of the local federal workers, who petitioned for its removal, the work was, after much bitter debate, dismantled by the government in 1989. Because *Tilted Arc* had been designed specifically for the Federal Plaza site, Serra contended that its removal amounted to its destruction.

More modest in scale than *Tilted Arc* and consequently lighter and less imposing is the Sheldon's *Greenpoint,* named for the section of Brooklyn in which Serra's warehouse is located. *Greenpoint* is composed of two curving, three-inch-thick Cor-Ten steel walls, each sixteen feet three inches by nineteen feet four inches and weighing twenty tons. The walls face each other like a pair of giant parentheses, one leaning in at a 3 degree angle, the other leaning out at the same grade.[1] Despite the impression of instability created by *Greenpoint's* tilt, its plates rest firmly on the ground and are in fact securely fastened in place by steel girders welded to their bases and sunk twenty feet into the earth.

Unlike the ill-fated *Tilted Arc, Greenpoint* was not designed for a specific public location. Serra did, however, choose to site it on a concrete plaza on the UNL campus at the intersection of several walkways, with a view to encouraging interaction between pedestrians and the sculpture. Like all of Serra's public works, *Greenpoint* is meant to be not just perceived optically but encountered bodily, from both outside and inside. Standing close

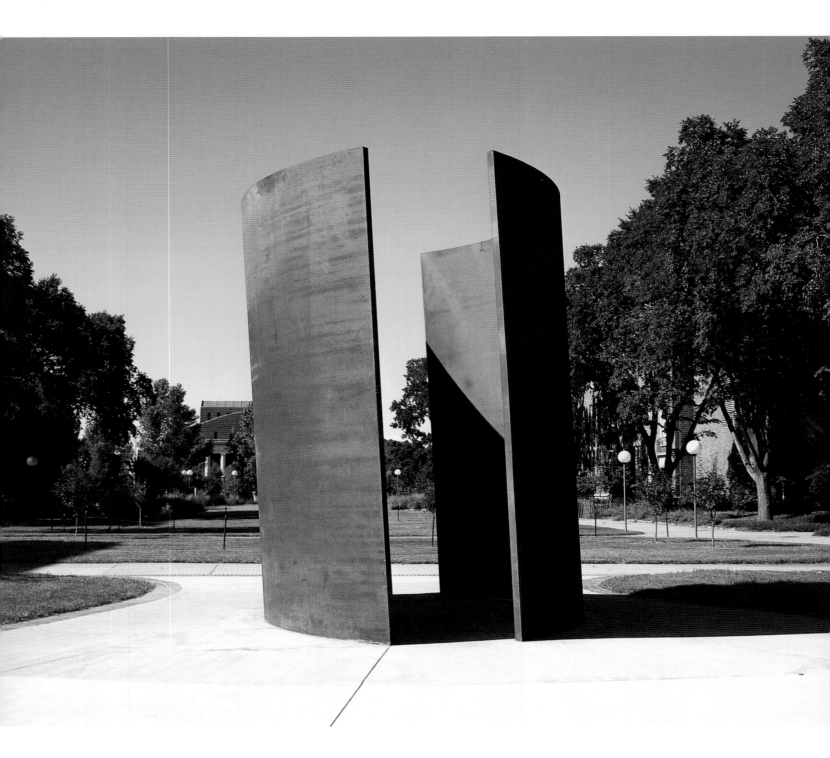

to the external, convex side of the sculpture, one perceives space receding infinitely along the disappearing arc of the curving steel wall. Standing on the inside, embraced by the walls, one experiences space contracting, wrapping inward. The tilt of the walls also exerts a powerful physical effect. "Because it's leaning," the artist remarks, "your basic coordinates are thrown off, right and left, up and down, no matter how slight. So, you enter a spatial experience that's really different in kind. If you're open to it . . . you can really enjoy it for what it is—the sense of compression, the sense of echoing, the sense of being in a contained space that's different from anything you've been in before."[2] Constantly changing as we experience it over time and from a variety of positions, *Greenpoint* boldly embodies Serra's ambition for sculpture "to create its own place and space,"[3] while encouraging in us, its viewers, a heightened awareness of the place and space that we ourselves inhabit.

DAVID CATEFORIS

--

NOTES

1. When viewed directly from the south *Greenpoint*'s tilt is thrown into sharp relief by the verticality of the nearby Mueller Tower, which appears framed in the opening between *Greenpoint*'s two leaning steel plates.

2. Quoted in Tom Ineck, "Artist Wants Public's Eye Riveted on His Sculpture," *Lincoln Journal*, December 17, 1992, sec. B, p. 19.

3. Richard Serra, "Extended Notes from Sight Point Road" (1984), in his *Writings/Interviews* (Chicago: University of Chicago Press, 1994), 171.

BRUCE BEASLEY (b. 1939)

- -

Bateleur II, 1989

BRONZE EDITION 4/9 39 ¹³/₁₆ X 46 ¹/₈ X 52 ¹/₄ IN. UNIVERSITY OF NEBRASKA, GIFT OF ANONYMOUS DONOR 1993.U-4536

© BRUCE BEASLEY

Born in Los Angeles in 1939, Bruce Beasley studied sculpture at the University of California–Berkeley, graduating in 1962 after two years of general liberal arts study at Dartmouth College in New Hampshire (1957–59). A major center for sculpture in the late fifties and into the sixties, the Berkeley studio program and the nearby experimental foundry called Garbanzo Works provided both the intellectual and aesthetic foundation for Beasley's work.

The Bay Area was affected greatly by the presence of Clyfford Still, Mark Rothko, and Ad Reinhardt at the San Francisco Art Institute in the forties and by sculptors such as Wilfried Zogbaum and Peter Voulkos who were influenced by the spontaneity and dynamism of Abstract Expressionism. In the 1960s it evolved into a major center for the reinterpretation of the gestural aesthetic through assemblage. It was in this context that Beasley's work as an undergraduate drew the attention of William Seitz, who included a piece that Beasley constructed from scraps of cast-iron sewer pipe in his influential "Art of Assemblage" exhibition at the Museum of Modern Art in 1961.

A prizewinning shop metalworker in high school, Beasley's technical mastery and expressive facility in metalwork provoked him to abandon the urban junk culture aesthetic of assemblage because it relied too much on "found" objects and too little on his talent as a metalworker. Beasley began to make his own sculptural compositions from styrofoam and then cast them in steel and aluminum at a foundry he had built in his studio. In the late sixties, Beasley began to work in acrylic, which gave his compositions a translucent quality that exploited the expressive capabilities of sunlight. His work in acrylic began in earnest with the completion of *Apolymon* (1968–70) for the California State Capitol in Sacramento, a piece for which he worked closely with DuPont Chemical, the company that manufactured the acrylic material he utilized.

After devoting most of his energy to acrylic and his own interpretation of the West Coast "fetish finish" aesthetic in the seventies, Beasley returned, albeit in a much more sophisticated and individualized way, to the exploration of process and gesture through bronze casting. Ironically, to facilitate spontaneity, Beasley began to utilize computer programs, with which he could work quickly and with greater control in the development of spatial relationships.

Bateleur II is one of the bronzes resulting from Beasley's ingenious use of advanced technology to exploit spontaneity, process, and gesture to the fullest. *Bateleur II* is an excellent example of Beasley's interest in dynamic movement: "I want my work to create the sense of space as a palpable entity through which masses and volumes cut, reside, and move." In addition, it is significant that his interest in Abstract Expressionism as a student at Berkeley has remained in the language he uses to discuss the impact of his work, especially these bronzes. For example, for him, his work is about the process of spontaneity: "I discover the piece as I create it," and "I feel my process has a life of its own." However, Beasley believes that his work is closest to that of Eduardo Chillida because of "his purity of form, the strength of both the negative and positive shapes, and the deep emotional reaction his work engenders."[1] *Bateleur II* is a highly sophisticated and innovative interpretation of the deeply personal and dynamic aesthetic of Abstract Expressionism through the utilization of all available tools drawn not only from the medieval metal shop but from the space-age computer lab.

DANIEL A. SIEDELL

- -

NOTE

1. All quotations in this paragraph from Marlena Donohue, "An Interview with Bruce Beasley," in *Bruce Beasley: Sculpture*, exhibition catalogue (Mannheim, Germany: Stadtische Kunsthalle Mannheim, 1994), 44.

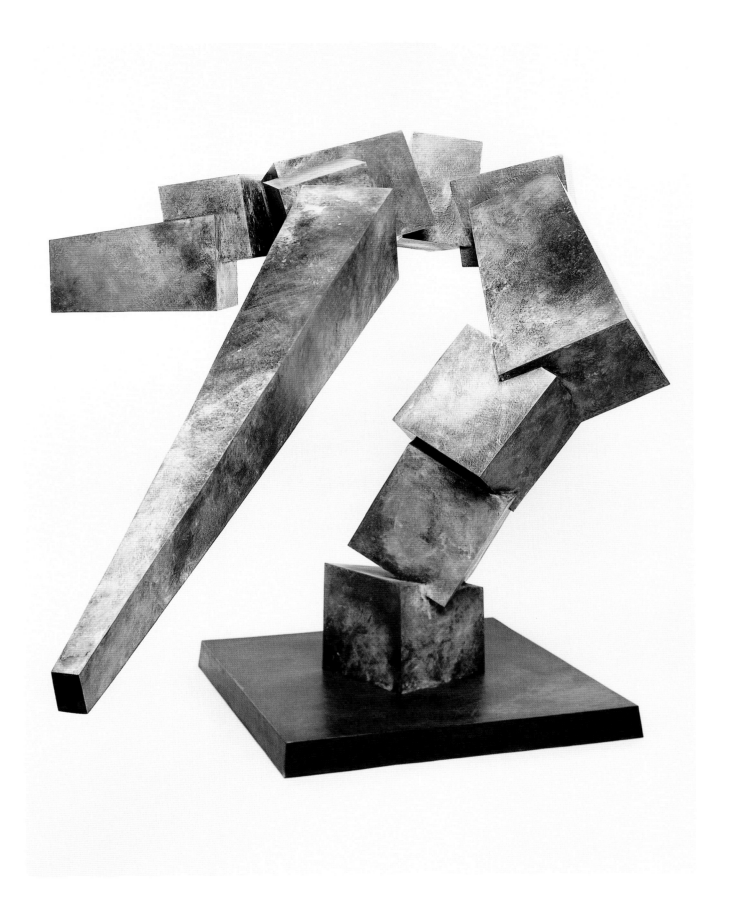

SCOTT BURTON (1939–1989)

Two-Part Table, 1989

POLISHED NEW IMPERIAL RED GRANITE 20 X 60 X 40 IN. UNIVERSITY OF NEBRASKA, PARTIAL AND PROMISED GIFT OF JANE AND CARL H. ROHMAN THROUGH THE

UNIVERSITY OF NEBRASKA FOUNDATION 1995.U-4588

Born in Greensboro, Alabama, in 1939, Scott Burton studied painting with Leon Berkowitz in Washington DC and Hans Hofmann in Provincetown, Massachusetts, from 1957 to 1959. In 1962 he received his BA from Columbia and the next year his MA from New York University. Extremely intelligent and articulate, Burton began writing criticism for ARTnews in 1966 and served as a contributing editor for *Art in America* from 1973 to 1976.

Burton's first solo show at the Droll/Kolbert Gallery, New York, consisted of what he called "pragmatic structures," two tables and two chairs. Although his previous artworks consisted of what Lynne Cooke has called "virtually invisible" street performances, until his death in 1989 Burton would concern himself exclusively with so-called furniture/sculpture hybrids consisting of tables, chairs, and chaise lounges. Burton himself explained, "I want furniture to be a factor in the behavioral dynamic of a social situation."[1] Although several of his early furniture works, such as *Behavior Tableaux,* served as props for performances, Burton often accomplished a theatrical environment without the use of actors or performers, as exemplified by his *Pastoral Chair Tableau,* in which a stage set of chairs was grouped in anthropomorphic ways.

Burton's interest in furniture was not a half-hearted one. He was extremely accomplished as a designer, and many of his furniture-sculpture hybrids, although they functioned within the gallery space, were patented for mass production. His pieces reveal an insightful understanding of the history of modern furniture, encompassing Thonet, Josef Hoffmann, Frank Lloyd Wright, Le Corbusier, Gerrit Rietveld, Mies van der Rohe, and Marcel Breuer.

By the 1980s Burton began to investigate outdoor environments, and his so-called rock chairs became a central theme in both his "art" pieces and his public commissions. Lynne Cooke has argued that these rock chairs reveal "a crucial shift in his aesthetic in that

thereafter, the overtly social not only informs, but finally takes over from the conceptual." These rock chairs form the basis for his public commissions, such as *Viewpoint* (1983), located at a site overlooking the bay in Seattle, and *Atrium Seating* (1986), at the Equitable Center, New York. Burton, Cooke writes, is "among a small group of artists who rethought public art for their generation." Peter Schjeldahl has gone so far as to claim that Burton was "the best sculptor the world has known of places to sit down."[2]

Although he learned from the Constructivist/Bauhaus innovations in modern furniture, Burton was also deeply engaged in the history of modern sculpture, in what one critic called rather "spirited, sometimes testy dialogues with Minimalism in general and Tony Smith and Donald Judd in particular."[3] By engaging in two distinct (but not unrelated) traditions (modern furniture and modern sculpture), Burton's pieces subsequently blurred the traditional distinctions between the high and applied arts, between the gallery space and "lived" space.

Burton's *Two-Part Table* makes manifest one of his most important influences, Constantin Brancusi, more specifically, his three-part Tirgu-Jiu installation in Romania, which consisted of *The Endless Column, The Gate of the Kiss,* and *The Table of Silence* (1937–38). Burton's *Two-Part Table* engages Brancusi's environmental "sculpture/furniture" format of *The Table of Silence,* and also quotes from the incisions and geometry of *Gate of the Kiss.*

Fabricated in 1989, the last year of his life, *Two-Part Table* is a product of Burton's last two public statements. First, he was invited by Kirk Varnedoe of the Museum of Modern Art to inaugurate the museum's "Critic's Choice" exhibitions, and he used the opportunity to celebrate his debt to Brancusi. Second, Burton completed elaborate and detailed plans for an artistic summa of his career, entitled *The Last Tableau,* a four-piece installation that he intended to be fabricated posthumously and which was

subsequently installed at the Whitney Museum in 1991. *Two-Part Table*, conceived while he was working on *The Last Tableau*, refers explicitly to one piece of the format, *The Bench Goddess*. According to Robert Rosenblum, "Burton's final tableau is also a Proustian recall of his own two-decade-long career, a fusion of images and ideas that concerned him through the seventies and eighties."[4] Part of the flurry of activities that occupied the last few years of his life, Burton's *Two-Part Table* offers a unique glimpse of the artist's tragic, but highly productive, last few years.

DANIEL A. SIEDELL

NOTES

1. Quoted in Lynne Cooke, *Scott Burton/Early Work*, exhibition catalogue (New York: Max Protetch Gallery, 1990), n.p. Additional quotations from Lynne Cooke are from this catalogue.

2. Peter Schjeldahl, "Concrete and Burton," in *Scott Burton/The Concrete Work*, exhibition catalogue (New York: Max Protetch Gallery, 1992), n.p.

3. Richard Kalina, "Figuring Scott Burton," *Art in America* 80 (January 1992): 96.

4. Robert Rosenblum, *Scott Burton: The Last Tableau*, exhibition catalogue (New York: Whitney Museum of American Art, 1991), n.p.

JUDITH SHEA (b. 1948)

Shield, 1989

BRONZE WITH LIMESTONE BASE ARTIST'S PROOF (FROM AN EDITION OF 3 WITH 1 ARTIST'S PROOF) 55 ³/₄ X 14 X 11 IN.; BASE: 15 X 14 X 14 IN.

UNIVERSITY OF NEBRASKA, OLGA N. SHELDON ACQUISITION TRUST AND THE NATIONAL ENDOWMENT FOR THE ARTS 1990.U-4272

Shield is a splendid example of Judith Shea's use of hollow clothing to suggest a human body, "establishing the presence of the figure in the actual absence of it."[1] Shea's signature motifs, the woman's sheath and man's overcoat, are sculptural stand-ins for the bodies that usually wear them. In formal terms, these clothing forms explore the relationship between interior volume and exterior space. In metaphorical terms, they become vessels into which the viewer may project a variety of feelings and ideas. Rich in allusive potential, Shea's dresses and coats encourage reflection on clothing and gender, male and female bodies, and their representation in art.

Shea was born in Philadelphia and grew up in New York, where she earned an AA degree in fashion design from the Parsons School of Design in 1969. While working professionally as a clothing designer, she went on to receive her BFA degree from Parsons in 1975. Her early artworks were simple, flat pieces of cloth, adapted from patterns used in clothing design. Their basic shapes—squares, rectangles, triangles—conformed to the prevailing aesthetic of Minimalism, which stressed clear structure and geometric form. However, their implicit relationship to clothing and, by extension, the body countered Minimalism's rigorous denial of content. References to clothing became more explicit at the end of the decade, as Shea crafted sewn fabric silhouettes in the shapes of dresses, sleeves, bodices, and trousers. Hung from the wall on rods or pins, they substituted for the human figure.

In the early 1980s Shea began to stiffen her cloth forms with plaster, paste, paint, wax, or Rhoplex, which allowed her to create three-dimensional reliefs. After studying medieval armor at the Metropolitan Museum of Art, she became interested in the idea of "metal clothing" and decided to experiment with cast metal.[2] She cast her first pieces in iron in 1982 and later made extensive use of bronze. The sculptures were initially modeled in felt saturated with melted wax, which after cooling would hold its three-dimensional form. A ceramic mold was built around the felt-and-wax original, and this original was then burned away in the process of casting the bronze. Shea's first cast sculptures were fragments rather than complete articles of clothing. The artist observed that the "truncated clothing forms provided an essence—no extremities, no movement. It was a way to express the essence of human presence."[3]

A trip to Greece in 1983 aroused Shea's interest in archaic and classical sculpture. Her work became more fully figurative, and evocative of ancient Greek as well as Egyptian sculpture. She also began to work with pairs of clothing forms—male and female, child and adult—creating new layers of narrative and psychological complexity. A series of works made in the mid-1980s juxtaposed figurative presences with smaller geometric elements such as rectangular solids and pyramids, which Shea saw "as symbols of history, or art, of a specific period or a specific place."[4] The simplified dress forms recalled ancient statuary, but their sleek stylization also suggested contemporary fashions. Strongly dualistic, these sculptures invited speculation about contemporary art's relationship to the historical past. They also communicated Shea's desire to make figurative art while at the same time acknowledging her continuing respect for Minimal abstraction.

In 1989 Shea produced a series of works that she characterizes as "fake antiquities."[5] In these pieces, the artist addressed "the issue of the pedestal, or the device by which sculpture is shown." Stimulated by the pedestals and mounts that she had observed in antiquities collections, Shea devised "fake museum mounts" to display truncated, nude torsos (the cast stone *Venus* and the bronze *Apollo*), a cast-iron skirt (*Armor*), and a bronze dress (*Shield*). Through the use of incomplete, ragged-edged figures and clothing forms, she also investigated the aesthetics of the fragment, noting that "oftentimes the broken forms of classical figurative

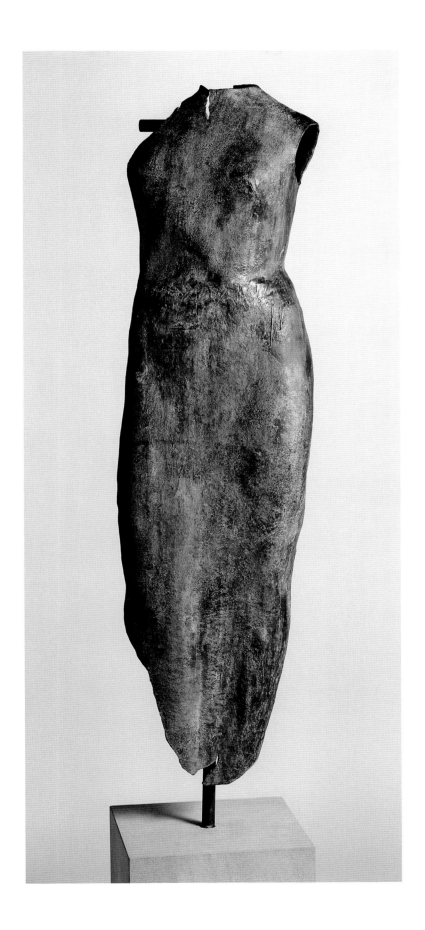

sculpture are more poetic and more beautiful . . . than the few ones that have remained intact or managed to be put together." *Shield* is in fact a broken version of one of Shea's own earlier sculptures. To create it, she made a wax cast from a mold for one of her dress forms, and then manipulated the wax, tearing and removing sections of it to create the incomplete and seemingly damaged figure cast in bronze as *Shield*.[6]

The ragged edges of *Shield* offer a poetic contrast to the smooth and sensuous curves of the implied body, whose relaxed and graceful pose calls to mind an ancient Greek kore (maiden) figure. The hollow dress/body adopts the characteristic contrapposto stance of classical Greek statuary, with the right leg slightly bent, the left hip slightly elevated, and the waist gently turned. The rough-textured, green-patinated surfaces and torn edges of the bronze evoke a weathered and broken classical statue, such as might have been unearthed at the Acropolis or dredged up from the bottom of the sea. The limestone base and vertical bronze pole and crossbar evoke the type of museum mount that might be used to display such a classical artifact.

And yet, even as it suggests classical antiquity and the context of the art museum, *Shield* also refers to "classic" clothing design of the twentieth century in its use of the sleek, sleeveless sheath popular in the post–World War II era. The simple pedestal and crossbar from which the dress hangs also suggest the pared-down display hardware of a contemporary boutique. And still another level of meaning is suggested by the sculpture's title, which refers not only to the artist's interest in medieval armor—which spurred her first attempts at metal casting—but also to a conception of clothing as a form of protection. Clothes, the artist remarks, provide "a layer between you and the world." The dress of *Shield* is "female armor." Both the absent woman and the dress she has left behind are "a little battered" and the sculpture itself is "a relic of doing battle in the world."[7] This reading of *Shield* as a subtly feminist comment on the condition of modern women is entirely in keeping with Shea's wish to have her "fake antiquities" speak as much to contemporary concerns as they do to our continuing fascination with the classical past.

DAVID CATEFORIS

NOTES

1. Judith Shea quoted in Katy Kline, *Robert Moskowitz: Recent Paintings and Pastels/Judith Shea: Recent Sculpture*, exhibition catalogue (Cambridge MA: Hayden Gallery, List Visual Arts Center, Massachusetts Institute of Technology, 1985), n.p.

2. Judith Shea, lecture at the Nelson-Atkins Museum of Art, Kansas City, Missouri, October 22, 1999.

3. Judith Shea quoted in Deborah Emont Scott, *Judith Shea*, exhibition brochure (Kansas City MO: Nelson-Atkins Museum of Art, 1989), n.p.

4. Judith Shea, interview by Donna Harkavy, June 15, 1987, quoted in *Sculpture Inside Outside*, exhibition catalogue (Minneapolis: Walker Art Center, in association with Rizzoli, 1988), 213.

5. Quotations in this paragraph from Shea's lecture at the Nelson-Atkins Museum.

6. Judith Shea, conversation with the author, Nelson-Atkins Museum of Art, October 23, 1999.

7. Quotations from Shea, conversation with the author.

HAIM STEINBACH (b. 1944)

Untitled (Halco and Tour d'Argent salt and pepper shakers), 1989

STAINLESS STEEL SHELF, GLASS AND SILVER SALT AND PEPPER SHAKERS EDITION 10/15 (WITH 6 ARTIST'S PROOFS) 8 1/4 X 13 X 3 3/8 IN.
UNIVERSITY OF NEBRASKA, F. M. HALL COLLECTION 1991.H-2963.1-2963.5

© HAIM STEINBACH

Haim Steinbach's well-known sculptures of the 1980s consist of sleek, wedge-shaped shelves that hold a variety of carefully arranged objects, from mass-produced consumer products to rare collectibles. Transplanting desirable consumer items from the marketplace into the art gallery or collector's home, Steinbach confers on them the status of art and invites consideration of their aesthetic and expressive value.

Steinbach was born in Rechovot, Israel, near Tel Aviv, and moved with his family to New York in 1957, becoming a U.S. citizen in 1962. He earned a BFA from the Pratt Institute in 1968 and an MFA from Yale University in 1973. From 1973 to 1977 he was an instructor in studio art at Middlebury College and from 1977 to 1980 he taught at Cornell University. Steinbach worked as a minimalist painter during the 1970s before abandoning painting near the end of the decade to make a fresh start working with objects.

After making gallery installations with found and purchased items in 1979 and 1980, Steinbach turned to the creation of individual sculptures, each composed of a quirky shelf assembled from disparate elements and bearing a single item, such as a plastic clock or a stuffed raccoon. By 1984 he had adopted a standard shelf type: a wedge built of wood and laminated with Formica, with the ends left open in order to expose the shelf's structure from the sides. This simple, geometric form was flexible enough to permit variation in size and color even as it was distinct enough to serve as the artist's "signature." In a canny fashion it also referred simultaneously to commercial display, streamlined home decor, and the Minimalist wall sculpture of Donald Judd.

On his uniform shelves Steinbach displayed objects procured from supermarkets and department stores, flea markets and antique shops, usually juxtaposing two or more different kinds of objects in a single work in order to suggest narrative relationships between them. Mass-produced items and brand-name products were presented in quantity to underscore their manufactured nature, while antique and collectible artifacts were presented as unique. Steinbach also often combined in a single work objects reflecting different levels of taste and social status, throwing such distinctions into relief.

Steinbach was compared to the Dadaist Marcel Duchamp, whose "readymades" were manufactured objects that the artist simply designated as works of art, and to the Pop artist Andy Warhol, who used brand names such as Coca Cola and Brillo in his art. Unlike Warhol, however, who made paintings, prints, and sculptures of consumer products, Steinbach used the actual products themselves. And unlike Duchamp, who professed aesthetic indifference toward the items he selected, Steinbach chose objects that appealed to him on the basis of their design, color, and function.

By reducing the creative process to selecting, purchasing, arranging, and displaying objects, Steinbach mirrored in his art the activities of the shopper and decorator. Critics were divided over whether his work represented an ironic critique of consumer society or an unalloyed celebration of it. Steinbach himself claimed to be unconcerned with this either/or distinction and professed to feel toward capitalist culture both "fascination and revulsion."[1] His principal artistic aim was to immerse himself in that culture and investigate the "socially linguistic function" of its objects.[2] "What I do with objects," Steinbach said, "is not unlike what anyone can do, what anyone does anyway with objects, which is to talk and communicate through a socially shared ritual of moving, placing and arranging them."[3]

Although unusual in being an editioned rather than a unique sculpture, *Untitled (Halco and Tour d'Argent salt and pepper shakers)*

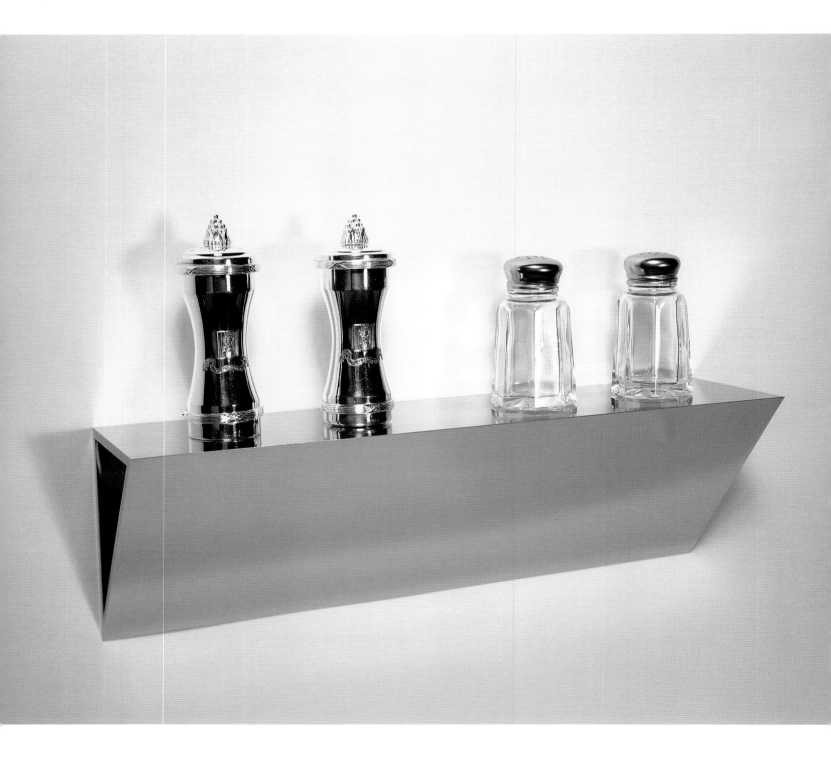

is a characteristic example of Steinbach's work of the 1980s. The sculpture comprises a wedge-shaped, mirror-finished stainless steel shelf that supports two pairs of salt and pepper shakers. One pair, of simpler design, is made of glass and stainless steel; the other, more ornate, is of silver. This juxtaposition creates a study in formal contrasts between open and closed form, lightness and weight, and encourages close examination of the style of each pair of shakers. Their designs connote different levels of taste and class. The glass and stainless steel shakers are manufactured by Halco, a major producer of restaurant wares, and can be found in ordinary restaurants and diners across the United States. The fancier silver shakers come from the gift shop of the famous and expensive Tour d'Argent (tower of silver) restaurant in Paris, and are the same sort used in the restaurant itself. According to the artist, this pairing of objects with different origins, but with equally "classic" styling and the same function, creates "a kind of analogy between two kinds of authority and history"—one widely available, the other more rarefied.[4]

In considering the salt and pepper shakers, Steinbach was also interested in the idea of doubling, "where each object in each pair is a copy of the other, even though they are supposed to contain different things."[5] The Halco shakers are in fact identical—a further sign of their mass production—while, in the Tour d'Argent pair, one container is actually a pepper grinder. "One may consider these objects in terms of typological orders," comments Steinbach.

> Their functions are clearly different, although they out-
> wardly look the same. . . . However there is a play on the
> way we distinguish between doubles and singles, a pair
> as opposed to yet another kind of grouping. This is also
> a play on all projections that we make on pairs, as in
> "male/female," etc. Grouping as an idea is always a term
> of communication. It seems to be very transparent, yet it's
> a very essential gesture about the sameness and difference
> through which we identify conditions of types.[6]

The shakers in *Untitled (Halco and Tour d'Argent salt and pepper shakers)* are not attached to the shelf and may be removed by the owner for cleaning or storage; when displayed, the shakers are to remain paired by style, but either set may be placed on either side of the shelf. Steinbach likens the shelf to a game board, "a place upon which objects sit and may be moved or interchanged. . . . The work solicits the viewer to . . . participate in the creative act."[7] Of course, in the museum setting this impulse is frustrated by the prohibition against touching the art, which only heightens the desire to do just that. "Everyday objects produced by our society may be turned into objects of desire more than one time," remarks Steinbach. "I am trying to demonstrate that an object may be consumed more than one time and desired in more than one way."[8]

DAVID CATEFORIS

NOTES

1. Haim Steinbach, "Joy of Tapping Our Feet," *Parkett*, no. 14 (1987): 17.

2. Quoted in Joshua Decter, "Haim Steinbach," *Journal of Contemporary Art* 5 (Fall 1992): 120.

3. Quoted in Tricia Collins and Richard Milazzo, "Double Talk: McDonald's in Moscow and the Shadow of Batman's Cape. Haim Steinbach," *Tema Celeste* 25 (April–June 1990): 36.

4. Phylis Floyd, "An Interview with Haim Steinbach," *Kresge Art Museum Bulletin* 7 (1992): 71.

5. Floyd interview, 71.

6. Floyd interview, 71.

7. Quoted in Elizabeth Sussman, "Haim Steinbach," in David A. Ross and Jürgen Harten, *The Binational: American Art of the Late 80s*, exhibition catalogue (Cologne: Dumont Buchverlag, in association with the Institute of Contemporary Art and Museum of Fine Arts, Boston, 1988), 192–93.

8. Quoted in Decter, 117–18.

FLETCHER BENTON (b. 1931)

Balanced/Unbalanced Wheels #2, 1990

PAINTED STEEL 426 X 220 ⁷/₈ X 89 IN. UNIVERSITY OF NEBRASKA, GIFT OF AN ANONYMOUS DONOR IN HONOR OF CAROL AND SAUL ROSENZWEIG 1994.U-4571

© FLETCHER BENTON

Born in Jackson, Ohio, in 1931, Fletcher Benton began his career as a sign painter. He received a BFA degree from the University of Miami (Oxford, Ohio) and moved to San Francisco in 1956. After spending a few years in New York and traveling abroad, Benton returned to the Bay Area and began to experiment with three-dimensional work, especially kinetic sculpture. In 1974 he abandoned this direction—which he had pioneered and which had brought him international critical acclaim—in order to explore the structural implications and expressive potential of larger three-dimensional sculpture through the pared-down vocabulary of Minimalism. In the process, Benton, like many contemporary sculptors, developed a unique relationship between the traditional "hands-on" art-making process within the intimate context of his studio and the prefabricated industrial context of comparatively "impersonal" foundries. His ability to retain his "touch" and personality while utilizing the foundry distinguishes Benton's work from many other contemporary sculptors working today.

Although Benton did spend time on the East Coast, his mature work bears little sign of the preoccupation with a modernist tradition that has characterized the New York art world since the late fifties. His work melds, in a way perhaps only an outsider could accomplish, the two dominant modern sculptural traditions: the Cubist/Constructivist language of David Smith (whom Benton has openly admired) and the autonomous, anti-descriptive, sculptural syntax of Minimalists such as Tony Smith and Donald Judd. In Benton's hands, these two competing traditions are treated in an uncharacteristically lighthearted and playful manner reminiscent of his Bay Area aesthetic environment.

A massive but graceful sculpture over forty feet high, *Balanced/Unbalanced Wheels #2,* is a physically imposing but gentle piece consisting of a tumbling composition of brightly colored geometric shapes such as circles, beams, and cylinders balanced precariously in a refreshingly whimsical manner. Playful, yet formally coherent, *Balanced/Unbalanced Wheels #2* offers a unique admixture of modernist styles without the heavy-handed theoretical baggage associated with them. Although he moved away from kinetic sculpture two decades ago, Benton's lingering interest in sculpture movement, whether explicit or implied, is revealed in *Balanced/Unbalanced Wheels #2.*

DANIEL A. SIEDELL

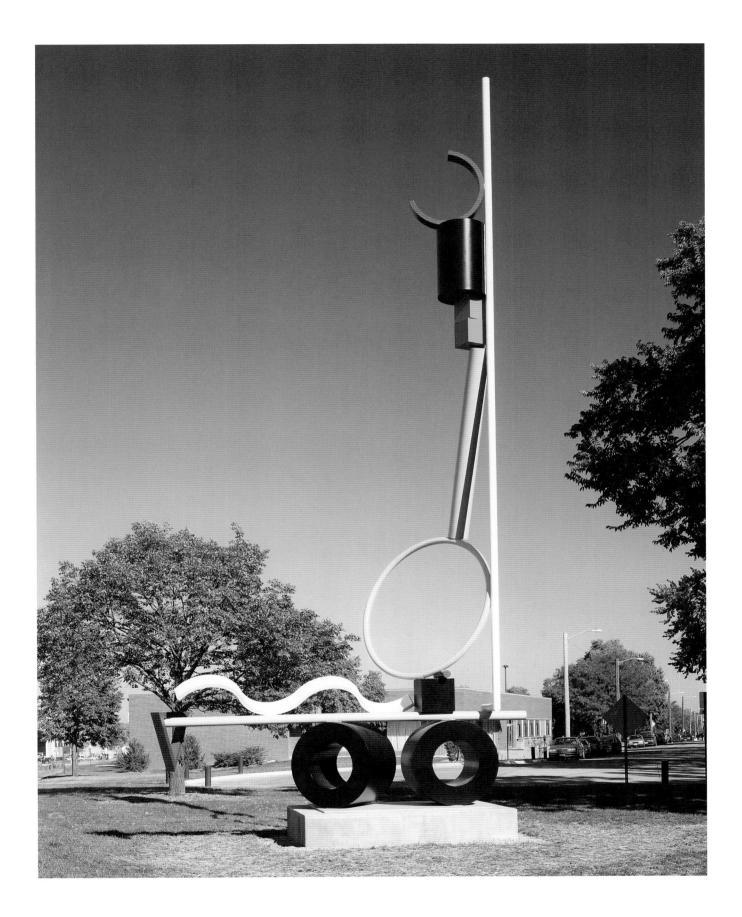

TONY BERLANT (b. 1941)

Lily After Dark No. 58, 1990

FOUND-METAL COLLAGE ON PLYWOOD WITH STEEL BRADS 8 $\frac{3}{16}$ X 8 $\frac{1}{8}$ X 6 $\frac{7}{8}$ IN. UNIVERSITY OF NEBRASKA, F. M. HALL COLLECTION 1991.H-2968

© TONY BERLANT

Since the early 1960s, Tony Berlant has made artworks composed primarily of sheets of commercially printed tin tacked over wooden armatures. With their use of bold color and flat patterned areas, his work displays a painterly sensibility in the Matissean tradition. "These are dimensional objects, but made much more with a painter's way of thinking than a sculptor's way of thinking," he has said, "like a painter decorating an architectural space that you move around and can't see it all at once."[1] While he generally snips out images or fields of color, Berlant will also cut out elaborate gestural squiggles.

As an undergraduate at UCLA in the late 1950s, Berlant had been influenced by artists such as Bruce Conner, George Herms, Robert Rauschenberg, Joseph Cornell, and John Chamberlain, who were creating hybrid works that defied conventional categories of painting and sculpture. "It was a moment when the blurring of distinctions between painting and sculpture was very big," Berlant recalls. But while many of these artists, particularly Californians such as Conner and Herms, favored the use of detritus, the unvalued castoffs of a consumer culture, Berlant was more in tune with a younger generation of artists—Andy Warhol, Roy Lichtenstein, and James Rosenquist on the East Coast, and fellow Californians like Billy Al Bengston and Craig Kauffman—who appreciated the vibrancy and polished surfaces of contemporary commercial culture. Berlant was included in the Oakland Museum's "Pop Art, USA" (1963), one of the earliest exhibitions of East and West Coast Pop art.

In the early 1960s, printed tin was in abundant supply. In the era immediately preceding the widespread use of plastics, it had been a common, inexpensive decorating material. But as plastics became increasingly common, tin lost its popularity. Berlant originally used old advertising signs for his source materials, but he quickly expanded his resources to include TV trays, wastebaskets, lunch boxes, cookie boxes, and footlockers. Today he has access to one of the largest tin printing factories in the country, occasionally even manipulating the machinery to print his own designs.

The house form found in *Lily After Dark* is one of two shapes—the other is a simple cube—that have been consistent motifs in Berlant's work since 1963. His first house sculpture was made by tacking tin over a birdhouse. For many years he nailed his tin skins over hollow wooden cores, but since the early 1980s his houses have been made from solid blocks of laminated wood cut into a basic peak-roofed form. Berlant refers to this simple shape as "a gestalt house, like on a Monopoly board" that stands as "a cultural icon for one's personal space." Berlant plays with this theme of privacy or interiority by endowing his house with windows and doors in the form of pieces of blank tin that contrast to the pictures and patchwork of the structure's "outside." Paradoxically, the blankness of these openings prevents the viewer from ever seeing "in."[2]

Berlant favors an open-ended allusiveness to his imagery and generally only titles his works after they are completed. Individual works, however, may be grounded in specific memories and associations. In *Lily After Dark*, the juxtaposition of a pair of shapely legs and a pair of champagne glasses on two of the sculpture's surfaces reminded Berlant of a nightclub entertainer, Lily St. Cyr, who performed in Palm Springs when he was young. As part of her act, St. Cyr cavorted in a giant champagne glass/bubble bath. The image of a chanteuse in a champagne glass also appears in the large-scale mural Berlant made for the convention center in Palm Springs in 1992.

Typical of Berlant's large, mural-scale works, the Palm Springs work takes on a landscape format, with clear horizon line. By contrast, the images in *Lily After Dark* seem free-floating—there is no up or down—consistent with the elusive, Cornell-like sense of reverie that Berlant often seeks. Berlant notes that many of his houses and cubes are roughly head sized: the images can

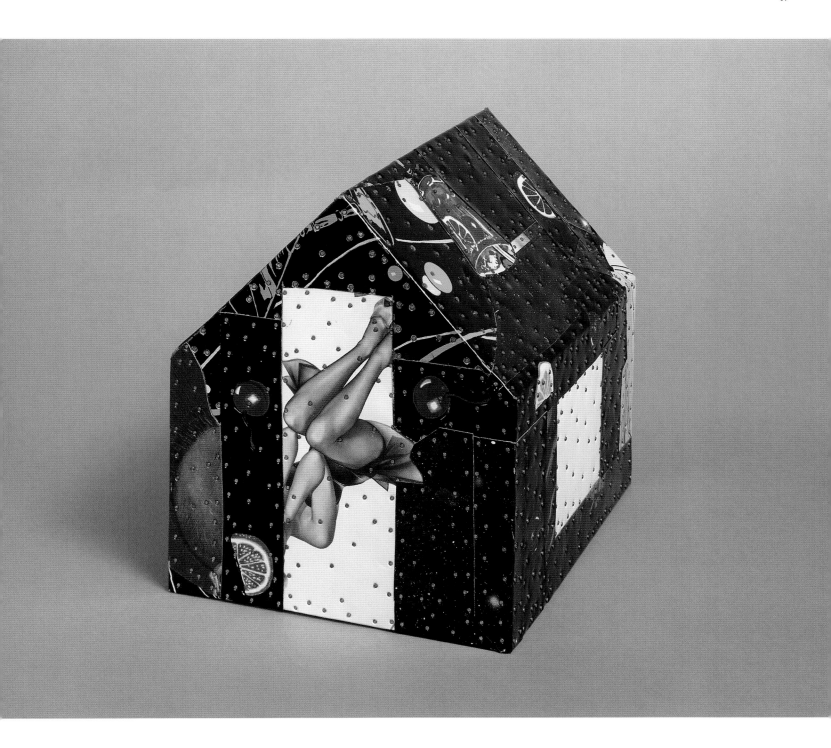

therefore be interpreted as images floating in the imagination. On a more concrete level, he also intends for people to interact with his sculptures by picking them up, manipulating them, and looking at all sides. In keeping with this, Berlant often puts surprising or engaging images—like the "B" that seems to act as a signature in *Lily After Dark*—on the "bottom" sides of his houses.

PETER BOSWELL

NOTES

1. This and subsequent quotations from Tony Berlant, interview by the author, February 1, 1993, Venice, California.

2. Related to his houses are a series of "shrines" he has made, which feature cutaway windows and small, iconic objects placed inside them. Berlant acknowledges a similarity between these works and medieval reliquaries, but says his inspiration for them came instead from Native American and African fetish objects that he admired.

MICHAEL HEIZER (b. 1944)

Prismatic Flake Geometric, 1991

MODIFIED CONCRETE, GRANITE, STEEL 67 X 420 ½ X 18 IN. UNIVERSITY OF NEBRASKA, OLGA N. SHELDON ACQUISITION TRUST 1991.U-4310

© MICHAEL HEIZER

Possibly the most important development in American sculpture in the past quarter century has been the movement away from the idea of a sculpture as an art object confined to the audience in the private home, the dealer's gallery, or the museum. Scale and mass have been enlarged far beyond the limits of conventional venues of display. Inevitably artists have moved their efforts into the natural landscape, producing what have come to be called earthworks.

Michael Heizer has been an important contributor to this development. His *Double Negative* in the Nevada desert required the displacement of 240,000 tons of rhyolite and sandstone. His current and ongoing project, *The City,* in the Garden Valley of Nevada, still only in its first stage, will create a monumental composition site suggestive of the ceremonial site of a vanished culture. In these works he explores the human relationship to the environment.

Prismatic Flake Geometric, specially commissioned for the Sheldon Gallery's Sculpture Garden, has as its inspirational source the tools of prehistoric man, which although practical in their motivation are at the same time vehicles for the expression of sensory judgments of a purely aesthetic kind. Frequently carved from obsidian, a lustrous black and very hard stone, such tools often have the elegance and refinement of sculpture. *Prismatic Flake,* in its combination of concrete, granite, and steel, is a respectful facsimile of such a tool. Its superhuman scale is belied by the subtlety of its curvature and the glint of quartz or mica.

NORMAN A. GESKE

Michael Heizer, born in Berkeley, California, in 1944, came of age and developed his artistic values in the 1960s—an era of radical rebellion and societal upheaval. Consequently, his anti-authoritarian attitude and rejection of tradition are understandable. "Art had to become radical," Heizer has asserted. "Basically, what I'm saying is that the European option is closed. The European tradition has to be honored, but that area is finished—it's over with."[1]

Further, Heizer objected to what he perceived as the excessive preciosity with which art was endowed—a preciosity (and commodification) that was reinforced by the art market. As a result, Heizer rejected conventional models of sculpture. When he came to prominence in the late 1960s, he was producing monolithic works in the landscape, mostly in the Nevada desert. For Heizer, the western desert provided the kind of "peaceful, religious spaces artists have always tried to put in their work."[2] These large-scale projects often involved carving into the land to create sculpture that exists as space—sculpture as void rather than as mass.

Because these works involved manipulation of the land itself, and because Heizer arrived on the art scene at a time when ecological concerns were prominent, critics and art historians usually associate him with other Environmental artists such as Robert Smithson, Nancy Holt, and Robert Morris. Heizer resists such categorization and does not consider his projects to be earthworks. More recently, much of his work has been resolutely object-oriented, as is *Prismatic Flake Geometric.*

Despite his outspoken rejection of tradition, his work does incorporate connections to the past. Son of an archaeologist specializing in pre-Columbian civilizations, Heizer traveled to Egypt and the Yucatan with his father, and the scale and format of his work call to mind ancient Mayan and Egyptian monuments.

217

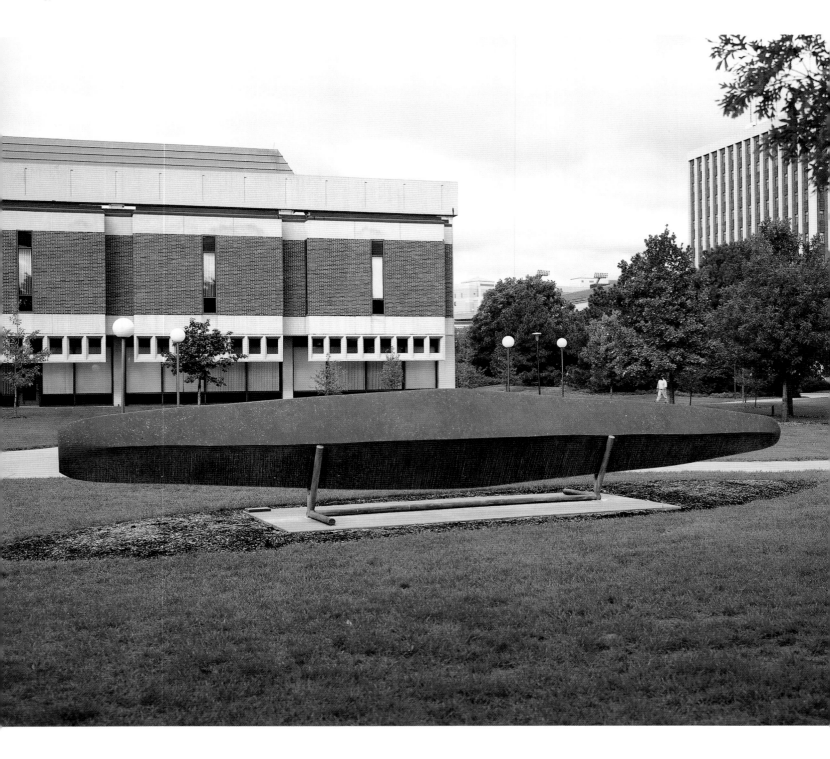

Rather than suggest built structures of past cultures (as do some of Heizer's other works), *Prismatic Flake Geometric* monumental-izes a Mesoamerican object—something that enabled human agency, as opposed to being a product of that action. Consisting of nearly six tons of modified concrete and galvanized steel rein-forcements and extending to thirty-six feet in length, *Prismatic Flake Geometric* rests on a steel armature, a presentation that sug-gests that of an archaeological specimen collection. The oblong shape of the elongated sculpture mimics that of an obsidian pris-matic blade. This rudimentary Mesoamerican "tool" was flaked off an obsidian core and was valued for its sharp cutting edge. This work was one of a series of Paleolithic hand tools (including hooks and charm stones) sculpted by Heizer.

From his early works in the Nevada landscape to his object sculpture, Michael Heizer's work challenges sculptural tradi-tions while engaging viewers in dialogue with the past. Since his emergence on the art scene in the late 1960s, his work (despite its changing form) has consistently addressed archaeo-logical, anthropological, ecological, and cultural issues. Indeed, this wide-ranging investigation is the point of Heizer's art. The artist insists: "What I'm after is investigation and explor-ation. It's not about leaving remnants or making something that's beautiful."[3]

CHRISTIN J. MAMIYA

--

NOTES

1. Quoted in John Beardsley, *Earthworks and Beyond: Contemporary Art in the Landscape* (New York: Abbeville Press, 1984), 13; and in John Gruen, "Michael Heizer: 'You might say I'm in the construction business,'" *ARTnews* 76 (December 1977): 98.

2. Quoted in Howard Junker, "The New Sculpture: Getting Down to the Nitty Gritty," *Saturday Evening Post*, November 2, 1968, 42.

3. Quoted in Gruen, 99.

CLAES OLDENBURG (b. 1929)
AND COOSJE VAN BRUGGEN (b. 1942)

Torn Notebook, 1992 (fabricated 1996)

The unique artistic collaboration between Claes Oldenburg and Coosje van Bruggen, which began in 1976 with the installation of *Trowel*, a colossal hand tool installed permanently on the grounds of the Kröller-Müller Museum in Otterlo, The Netherlands, has resulted in more than twenty-eight large-scale public sculpture projects around the world. These large sculptures, which are derived explicitly and unapologetically from everyday objects, are examples of Oldenburg's career-long desire to make art "that takes its form from the lines of life itself, that twists and extends and accumulates and spits and drips, and is heavy and coarse and blunt and sweet and stupid as life itself." Such public sculpture as *Bat Column* in Chicago, *Clothespin* in Philadelphia, and *Shuttlecocks* at the Nelson-Atkins Museum of Art in Kansas City reveal their common interest in the familiar objects of life as worthy of monumental commemoration. These and many other large-scale public sculptures demonstrate Oldenburg and van Bruggen's firm and steady commitment to Oldenburg's well-known statement, made over thirty years ago, that he wanted to make art "that does something other than sit on its ass in a museum."[1]

Born in Stockholm in 1929, Oldenburg grew up in Chicago and graduated from Yale University in 1950. In 1956 he moved to New York, where he became involved with a number of artists such as Jim Dine, George Segal, and Allan Kaprow, all of whom were attempting to break down the barriers, as it were, between "art and life," a phrase used by Robert Rauschenberg that became a mantra for the New York avant-garde throughout the sixties, from the Pop artists to the Happenings

performers and Fluxus, groups with which Oldenburg enjoyed fruitful associations.

In 1959, at the Judson Gallery, an alternative space in the basement of Judson Memorial Church, Oldenburg had his first exhibition, which consisted of environmental drawings and wood and newspaper constructions, all interspersed with his own poems. To celebrate his opening, he wore a papier-mâché elephant mask through the streets of New York. Oldenburg was deeply influenced by the writings of the critic Harold Rosenberg, whose concept of "Action Painting" emphasized the spontaneity and integrity of the creative process and the act of creation itself, and by Marcel Duchamp's "readymades," which transformed ordinary objects into "art." Both of these influences prompted Oldenburg to explore the banal products of American culture as well as to participate in performance art.

Oldenburg's fantasy, humor, and ironical wit are evidenced in his famous installation in 1962 called *The Store*, in which he re-created the commodities—fashioned out of plaster, muslin, and chicken wire, then covered with drips and spatters of bright enamel house paint—for sale in a typical grocery store. In the exhibition's statement, Oldenburg writes, "This store will be constantly supplied with new objects which I will create out of plaster and other materials in the rear half of the place. The objects will be for sale."[2] In the early sixties, Oldenburg began fabricating objects from American consumer culture, from hamburgers to toy airplanes to shirt and tie ensembles from painted burlap and plaster. At the same time he began to make

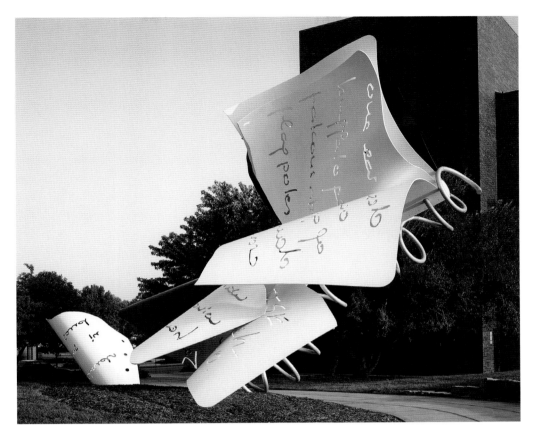

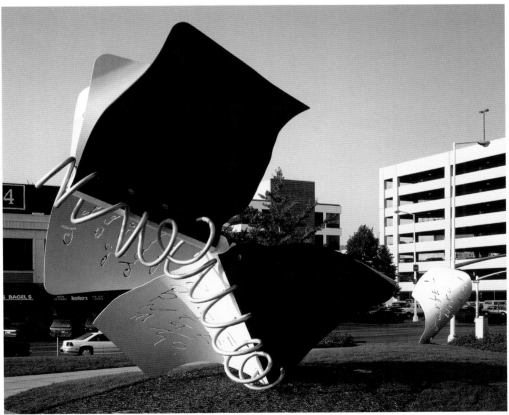

soft sculptures—sewn canvas stuffed with foam rubber and painted with liquitex depicting hamburgers, ice cream cones, drum sets, and typewriters. One of these objects, *Soft Drum Set* (1969), is in the Sheldon Gallery's collection. Oldenburg's interest in breaking down the barrier between art and life led him to explore the performance space, and he played an important role in *Ray Gun Theater*, a series of ten Happenings that took place from February to May 1962.

In 1965 Oldenburg initiated a series of drawings of proposed "colossal monuments" for New York, such as a half-peeled banana, soft Good Humor bar, teddy bear, and a lipstick intended for London. The latter was ultimately fabricated in America and mounted on tractor treads at Yale University, in 1969.

Oldenburg's relationship with Coosje van Bruggen, an art historian from The Netherlands who taught at the Academy of Fine Arts in Enschede, began in 1970 when they met at the Stedelijk Museum in Amsterdam, where she was an assistant curator. They were married in July 1977. Van Bruggen has observed about their collaboration: "We did not set out one afternoon to work together. It grew that way. Working at home and raising two children is very difficult for a woman. This atmosphere allows that everything can happen here. Our art has roots in daily life."[3]

Torn Notebook (1996) is one of the finest of their collaborations. Its unique blend of abstract and representational qualities has ensured it a wide and diverse audience. It offers a dramatic transition from downtown Lincoln to the University of Nebraska campus and aesthetically reaffirms the close relationship between the university and the community. Depicting a spiral-bound notebook and two torn pages tumbling away in a gust of wind, *Torn Notebook* is the result of a commission by the Sheldon Memorial Art Gallery and Sculpture Garden that lasted nearly three years and included several visits to Lincoln by the artists. Not only does the subject refer to its academic surroundings, it also speaks to the artists' working processes and is thus autobiographical in nature. (The artists donated to the Sheldon's collection sixty-nine works that were produced during the three-year commission, including drawings, notebook sketches, and maquettes, documenting their creative process.) Both Oldenburg and van Bruggen carry small notebooks with them when they travel to potential project sites, collecting ideas, notes, impressions, and sketches to assist them in developing their ideas. It is this notebook, the artists' notebook, to which *Torn Notebook* refers. For the art historian van Bruggen, such note taking has been part of her research methods for many years, and note taking has also been an important working method for Oldenburg since the 1950s.

Although it is quite literal, *Torn Notebook* is also highly symbolic, evoking associations with the artists' impressions of Nebraska. The notebook being playfully tossed about by the wind alludes to the frolicking ducks that had great impact on the artists during their visits to Lincoln. Moreover, the wire notebook spine binds both white and black pages, an allusion to the power of education not only to "hold" opposing ideas but to "bind" racial and gender identities. The outline of the torn pages reproduces the Platte River, which forms the state's natural central waterway as it appears on a map. And on the notebook pages are actual notes, in both Oldenburg's and van Bruggen's handwriting, recording their direct and quite poetic observations. One of the upright pages reads:

Wind clouds
straws in
the sand.

And another page reads:

barbed
wire
L-bow

These notes range from the obvious "wind," "clouds," and "barbed wire," all of which are quite prevalent in the Midwest, to the obscure "L-bow," which refers to the sharp angle of the *Sower*'s elbow that stands atop the State Capitol and caught the eye of the artists.

In 1962 Oldenburg wrote, "Art or idea is not the point of my work, but illumination, through whatever means. . . . I stop when the piece has autonomous power."[4] Throughout his over forty years of artistic activity, including the last twenty with Coosje van Bruggen, Oldenburg has been engaged in "illumination" in powerfully diverse ways. And *Torn Notebook*, with its

graceful literalism and abstract forms, and its interaction with its "concrete" and "conceptual" environments, is no exception.

DANIEL A. SIEDELL

--

NOTES

1. Quotations from Barbara Rose, *Claes Oldenburg*, exhibition catalogue (New York: Museum of Modern Art), 190.

2. Claes Oldenburg, "THE STORE DESCRIBED & BUDGET FOR THE STORE," in *Claes Oldenburg: An Anthology* (New York: Guggenheim Museum, 1995), 104.

3. Quoted in Richard B. Woodward, "Pop and Circumstance," *ARTnews* 89 (February 1990): 119.

4. Quoted in Rose, 192.

TOM OTTERNESS (b. 1952)

Fallen Dreamer, 1995

BRONZE EDITION 1/3 32 X 42 X 44 IN. UNIVERSITY OF NEBRASKA, OLGA N. SHELDON ACQUISITION TRUST 1998.U-4951

© TOM OTTERNESS

Tom Otterness developed his spare, iconic visual vocabulary—figures reduced to basic spheres, cylinders, cubes, and cones—in the 1980s in a series of cast bronze sculptures. Particularly influential for the development of his art was his participation in the late 1970s in COLAB, an artists' collaborative comprising about forty-five artists. From this effort came his staunch commitment to reaching a broader audience.

Much of Otterness's cast bronze work to date has been sited in outdoor public locations and has consisted of simply rendered human forms in a variety of poses, often presented in groups, tableaux, or friezes. *Fallen Dreamer,* a colossal head, retains the simple figurative vocabulary of his other sculpture, but as a fragment of the human body, *Fallen Dreamer* is synecdochic—a part that serves to represent the whole. Its fragmentary nature encourages viewer speculation about its totality. The artist has noted: "I like the idea that we only have a partial memory of the past. You get a fragment and you never know the rest of the sculpture."[1]

The placement of the head on its side suggests connections to ancient sculptural ruins—evocative of long-gone civilizations—and calls to mind parallels to works such as the colossal head of the Roman emperor Constantine (c. AD 315–30), a remnant of a monumental sculpture in the Basilica Nova in Rome. This reference is due in part to Otterness's experiences: a stint as a night watchman (and later curatorial assistant) at the Museum of Natural History in New York City nurtured the artist's interest in other cultures. Accordingly, he draws on many sources, such as Greek friezes and Indian temple sculptures, for inspiration. Although *Fallen Dreamer*'s inflated size and Otterness's reductive focus on the head may suggest individual portraiture, the work's simplified facial features endow the sculpture with a placid universality.

Fallen Dreamer's magnified scale contributes to its impact and elevates it to iconic status. "I always think of large monuments as being symbols of society," commented Otterness.

Despite the ostensible clarity and directness of *Fallen Dreamer,* it retains a degree of ambiguity and mystery. Otterness revels in this: "People coming upon this piece of sculpture, as if upon a fragment from another society, will have to make sense of it for themselves."

CHRISTIN J. MAMIYA

NOTE

1. All quotations from "A Conversation with Tom Otterness," in *Tom Otterness,* exhibition catalogue (Urbana-Champaign IL: Krannert Art Museum and Kinkead Pavilion, 1994).

Tom Otterness is a notable exception among contemporary American sculptors in his deliberate avoidance of any dependence on the dominant stylistic trends of the last fifty years. There are no echoes of Rodin or David Smith or Mark di Suvero. His concerns have to do with the social and psychological reality of the human figure.

Otterness's concept of the figure borders on the playful and at times the satiric. There are overtones of a serious awareness of the complexities of human society. The only comparable artist among his contemporaries is the Colombian painter Fernando Botero. Both artists are devoted to the celebration of the unpretentious yet profound round of everyday human activity.

Fallen Dreamer is actually a somewhat unusual work having as its probable source the giant heads of Mexico's long-vanished Olmec culture. In this instance Otterness is like many of his contemporaries, seeking the confirmation of ancient cultures wherein ordinary life is both simple and complex, embracing both the mundane and the spiritual.

Fallen Dreamer is, in a sense, a warning.

NORMAN A. GESKE

DAVID IRELAND (b. 1930)

- -

Box of Angels, 1996

David Ireland began focusing on art relatively late in his life, although the artistic inclination was always there and has only been clarified and deepened with time. Not until the 1970s, as he approached his early forties, did he fully devote himself to art. His commitment was made at a stimulating and provocative time as art veered off in multiple directions, such as Conceptual and performance art, earthworks, Minimalism, and video and installation art. But Ireland was well poised to step into this artistic farrago, given the benefits of time and maturity that were on his side, his extended education, and the experiences that had enriched his life up to that point.

Born in 1930 in Bellingham, Washington, Ireland became interested in art in his late teens. He initially attended Western Washington University in his hometown (1948–50), but then moved to northern California, where, in 1953, he received his bachelor's degree in industrial design and printmaking from the California College of Arts and Crafts, in Oakland. For almost two decades following his graduation, Ireland pursued a variety of work as an architectural draftsman, carpenter, insurance salesman, and African safari guide and dealer. But the siren's call to art ultimately could not be ignored. In the early 1970s he returned to school to study art at Oakland's Laney College (1972–74) and received his master's degree from the San Francisco Art Institute in 1974. At the time, Conceptual art was establishing a strong foothold in the San Francisco Bay Area as well as nationally, and Ireland became an active participant in the community of artists drawn to this form of art making.

Like other Conceptual artists with whom he feels a kinship—among them Marcel Duchamp, Joseph Beuys, and Jannis Kounellis—Ireland works with humble everyday materials and advocates the primacy of ideas. His work is rooted in a thought process that continually questions the very nature of art by presenting alternative propositions. Among them is the notion that aesthetics and beauty are irrelevant to art. Hence Ireland's

various "sculptures" include lumps of gray cement pierced with bent wire, a dismembered television set, and a three-legged wooden chair saved from the previous owner of his home. The implied premise from which Ireland works is that art's "art condition" is a conceptual state—any object, any situation, can be art if so chosen and so experienced.

Perhaps the best known of Ireland's work in this light is his San Francisco Victorian home at 500 Capp Street, which he purchased in 1975 and worked on for several years. Although he did not initially intend to create a piece at the time, in retrospect Ireland perceived his work on the house—stripping wallpaper, sanding floors—as as important and as valid as any action of a painter or sculptor. Dark streaks of tobacco smoke and water stains found along the windows were carefully varnished and preserved; wadded balls of stripped wallpaper became sculptural forms. Through such examples Ireland establishes the opportunity to consider that when something is purposely altered or removed from its intended context it can assume a further, perhaps even higher, significance. As the curator Linda Shearer has observed, Ireland works in the world of evocation.[1]

In claiming a refurbished Victorian house or dismantled television set as a work of art, Ireland has sometimes been described as an urban archaeologist. Indeed, the artist himself acknowledges the important roll history often plays in his work, as in the case of *Box of Angels,* which was first installed in a 1996 solo exhibition titled "Bedlam."[2] The history Ireland refers to in this piece is multilayered: personal, religious, social, and cultural.[3] First there are Ireland's vivid childhood recollections of seeing taxidermy animals carefully staged in glass cases—a fascinating if not bizarre experience where the corporeal form is so vivid but the spirit is completely dead. Ireland also readily acknowledges the religious symbolism of the cherubs, although, in fact, there are also included in the piece reproductions of Venus de Milo, classical nudes, and other cast statuary that slyly

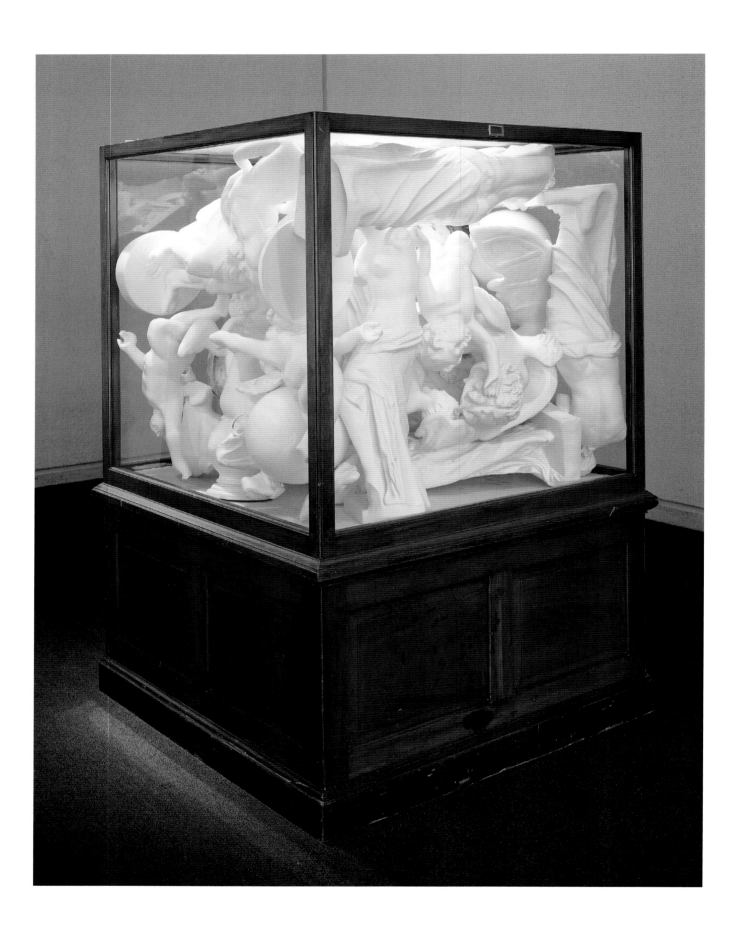

comment on the mass production of culture and religion. Traditionally seen as mediators between heaven and earth, Ireland's winged angels are intended to signify thoughts of divine spirituality as their beseeching eyes look skyward and their arms reach for the heavens. But at the same time, their jumbled and chaotic state suggests things totally run amok.[4] The symbolism of the vitrine as a protector for that which is precious and valued by society and culture is equally important to the artist.[5] Ergo, with his encased piece Ireland makes clear the importance of caring for one's angels, no matter the sorry state they may represent.

KAREN TSUJIMOTO

- -

NOTES

1. Linda Shearer, *Projects: David Ireland* (New York: Museum of Modern Art, 1989), n.p.

2. The exhibition took place at the Arts Club of Chicago, April 10 to June 28, 1996.

3. David Ireland, interview by the author, March 23, 2001, in San Francisco.

4. In commenting on the piece, the critic Alan G. Artner saw references to the lunacy found in William Hogarth's series of engravings "The Rake's Progress." Artner, "Ireland's 'Bedlam' Makes Sense," *Chicago Tribune*, April 25, 1996.

5. Ireland acquired the vitrine from the Field Museum of Natural History in Chicago.

CATHERINE A. FERGUSON (b. 1943)

Arietta II, 1998

PAINTED STEEL 120 X 12 TO 72 (TOP) X 12 TO 36 IN. UNIVERSITY OF NEBRASKA, OLGA N. SHELDON FUND 2000.U-5056

Born in 1943 in Sioux City, Iowa, Catherine Ferguson studied literature at Creighton University and has been working as an artist in Omaha since 1970. Ferguson's aesthetic activities cross diverse media, from drawing, photography, and sculpture to installation art. However, all are related: her photographs document installations, her drawings initiate and rework compositions that are often realized as sculpture, and her sculptures are often created to work within various installation situations she constructs. Ferguson's aesthetic diversity serves her long-standing interest in working in series, or projects, thus unifying a body of work through the articulation of a governing idea.

The ideas that have interested Ferguson have not been purely aesthetic; they have much to do with geography, both literal and ideological. More specifically, they emerge from and interact with contemporary cultural politics, from the politics of gender to those of history, race, and space. The last concern has manifested itself in her lifelong interest in Iowa's Native American burial mounds, which have become a battlefield on which competing ideologies clash over land, tradition, and memory. Like tradition and memory, Ferguson's art is evocative, buoyed by metaphor and reliant on the viewer's capacity to add layers of association from his or her own experience. And in much of Ferguson's sculpture and installation work, that experience is literal, inviting the viewer to engage with and experience the space created by her work, bringing the viewer, the artwork, and the environment into relationship with one another.

Arietta II addresses a number of the concerns that have interested Ferguson for thirty years. Based on a small sculpture that she called *Arietta,* which means "little aria," *Arietta II* was designed for and exhibited in 1998 at the International Sculpture Exhibition at Navy Pier in Chicago. As with the small sculpture, *Arietta II* employs a bird motif, a motif that has been of considerable importance to Ferguson. In describing her sculpture in a recent interview, she observes, "*Arietta II* is a vase-like volume defined by birds in flight, wings extended to 'embrace' the space and shape it."[1] She continues, "*Arietta II* is also on point—like a dancer could be on point, even though it's made out of steel. I was trying to give the illusion of flight and lightness and lifting, lifting upward. At the same time creating a very definite volume where there's almost a wall that's a veil the bird's holding, just very delicately defining the space inside that vase form." The bird imagery derives from Ferguson's deep interest in Iowa's burial and effigy mounds, built by Native Americans between AD 1000 and 1300 to commemorate their dead. These mounds were created in the shapes of various animals, including deer, bears, turtles, lizards, and birds—shapes discernible only from the air, a fact that has added to their mysteriousness. Ferguson has studied hundreds of effigy maps. "I have been replicating these effigy shapes in a variety of materials intermittently for fifteen years. When I first started employing them I was testing their longevity, their potency today as visual symbols, but now I know them intimately and draw them only for the pleasure of it. . . . I have enjoyed using the lightness of the birds to delicately define volumes that open upward."

The bird forms in *Arietta II* serve a twofold function for Ferguson. First, they evoke, suggest, perhaps even access a symbolic power inherent in these mysterious forms. Second, they are a delicate formal device that gracefully shapes form and moves the viewer's eye upward. These two functions are not mutually exclusive. Both the form and the content of *Arietta II* refer not only to a lost culture's attempts to sacralize space but also to Western culture's use of sculpture to serve a similar function. The totemic and hieratic form of *Arietta II* suggests a ceremonial or liturgical function as well, a function that also sacralizes the space the work occupies.

Perhaps this is the most powerful meaning expressed by *Arietta II.* While accessing a lost culture's attempts to use form to

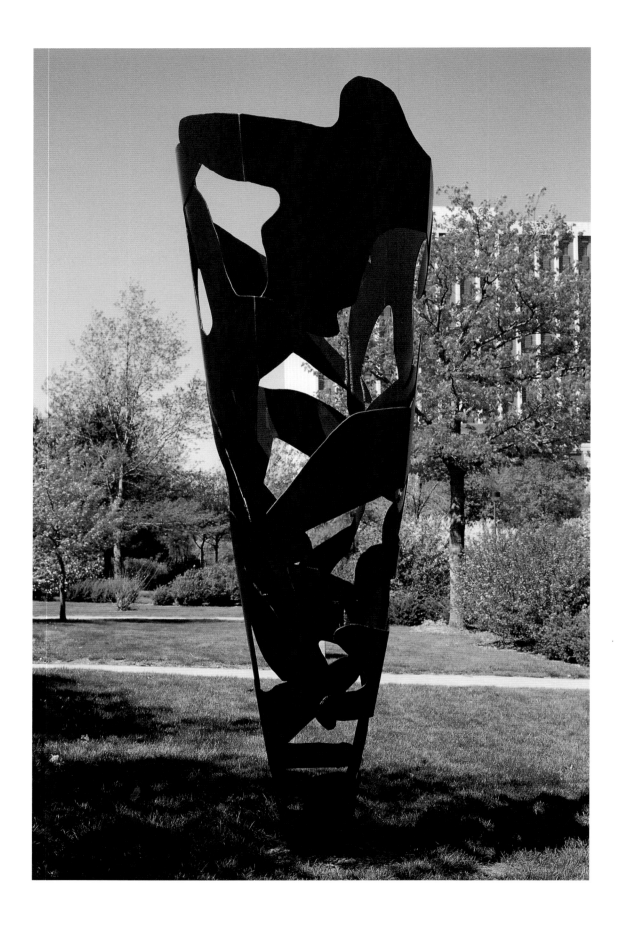

communicate deep meaning, Ferguson brings out the sacred, even mystical, function of sculpture as a Western artistic medium, a medium that has been employed by artists to serve as monuments, memorials, and sacred spaces. Ferguson shows that the cultural difference between the Native American civilizations that produced the burial mound effigies a thousand years ago and her own modern sculptural tradition is much less wide than we might think.

DANIEL A. SIEDELL

--

NOTE

1. All quotations from Catherine Ferguson, conversation with the author, Omaha, May 2001.

ANNE TRUITT (1921–2004)

Still, 1999

ACRYLIC ON WOOD 81 X 8 X 8 IN. NEBRASKA ART ASSOCIATION, PURCHASED IN PART WITH FUNDS FROM THE COOPER FOUNDATION AND THE RICHARD FLORSHEIM ART FUND 2003.N-779

The columnar wood sculptures for which Anne Truitt is best known have been associated with Minimal art in their spare forms, placement directly on the floor, and architectural character. However, as signaled by her use of the natural material of wood, lush color, and allusive titles, Truitt's intentions are distinctive from those of such artists as Donald Judd, Dan Flavin, and Carl Andre, whose work also came to attention in the early 1960s.

Born on Maryland's Eastern Shore and raised there and in North Carolina, Truitt did not initially aspire to be an artist. She studied at Bryn Mawr College and worked as a psychological researcher following her graduation. Truitt left nursing to write, and later enrolled in sculpture classes in Boston, Dallas, and Washington DC. During the 1950s, she made abstract drawings as well as life-size figures that bore little resemblance to her later sculpture.

In late 1961, following her move back east, Truitt visited the Guggenheim Museum. Her encounter there with works by Nassos Daphnos, Ad Reinhardt, and Barnett Newman's *Onement VI* proved decisive. She returned home to Washington and proceeded to construct *First*, a fencelike form with vertical components that are uneven in height and spacing. This sculpture and those that followed, recall white picket fences and graveyards the artist encountered as a youth.

Truitt's exhibition at Andre Emmerich Gallery in 1963, which featured boxlike forms painted in dark or earthen tones, earned the artist entry into such seminal exhibitions as "Black, White and Grey" (Wadsworth Atheneum, 1964) and "Primary Structures" (Jewish Museum, 1966). These showings were instrumental in defining Minimal art and thus fostered discussion of Truitt's work in the context of that movement.

By the time these exhibitions opened, however, Truitt was living in Japan (1964–67). There she was immersed in a strikingly different culture and physical environment, and worked in metal for the only time in her career. Upon returning to the United States, she developed her signature form: the vertical wood column, square or rectangular in cross section, that rests on a small plinth so as to appear to hover slightly above the floor. Although three-dimensional, Truitt's monoliths also serve as supports for her painted surfaces.

From childhood Truitt displayed a sensitivity to the hues and values of her surroundings. She resided in Washington, away from the artistic mainstream, in part because of its proximity to the latitude and longitude—and thus the quality of light—of her birthplace. Her colors, mixed to capture "a feeling" rather than as hues in and of themselves, often relate to specific, if private experiences.[1] Her titles convey associations, albeit often personal references, and may reflect the influence of writers on the artist.

Truitt's columns are at once remarkably varied and expressive. *Still* represents her most ambitious work in its scale (81 inches tall, or the height the artist can reach from the floor) and development. The delicate colors result from her application of twenty to thirty layers of paint on a surface prepared with increasingly dilute coats of gesso, each sanded down before the next is added. The resulting resonance allows Truitt to realize her aim of "color . . . set free into three dimensions, as independent of materiality as I can make it."[2]

JANICE DRIESBACH

NOTES

1. Anne Truitt, *Prospect: The Journey of an Artist* (New York: Penguin, 1996), 23.

2. Anne Truitt, *Turn: The Journey of an Artist* (New York: Penguin, 1986), 57.

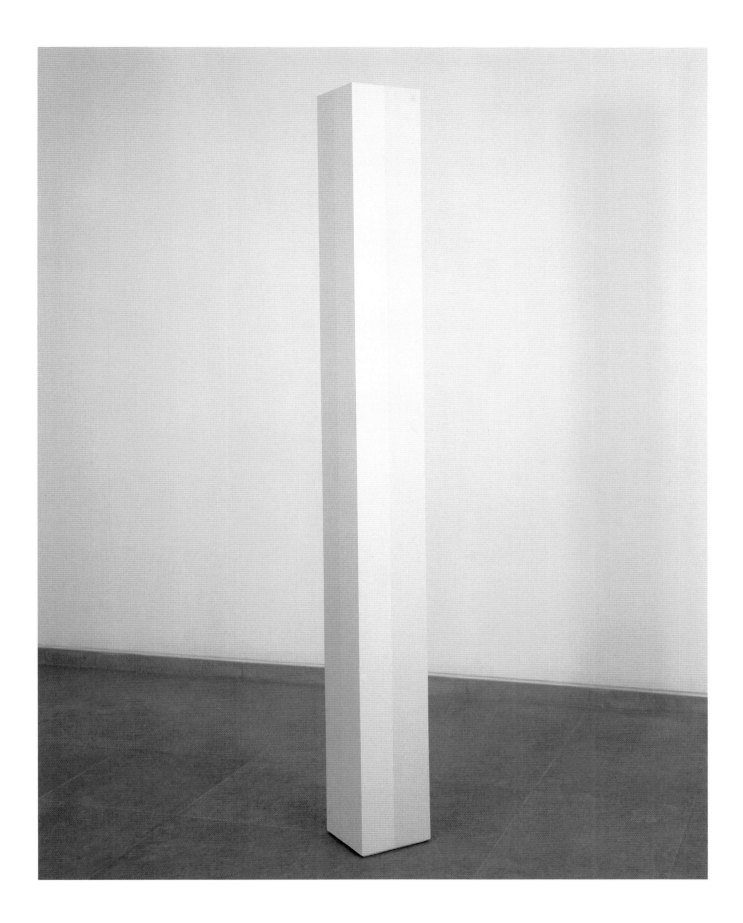

JOSEPH HAVEL (b. 1954)

- -

Silk Drape, 2000

BRONZE WITH PATINA 100 X 24 X 11 IN. UNIVERSITY OF NEBRASKA, GIFT OF MR. AND MRS. ARTHUR GOLDBERG BY EXCHANGE 2002.U-5085

© JOSEPH HAVEL

Born in Minneapolis in 1954, Joseph Havel received a BFA from the University of Minnesota in 1976 and an MFA from Pennsylvania State University in 1979. Trained in ceramics, as well as painting and drawing, the Houston-based artist has worked primarily in and through the Duchampian "readymade" sculptural tradition while resisting specializing in a single medium. After graduation, he went to Texas to teach at Austin College. He moved to Houston in the early nineties to direct the visiting artists program at the Glassell School of Art, Museum of Fine Arts, Houston, an important aesthetic and cultural resource in the Houston community.

Havel's art is concerned with what Flannery O'Connor once called "the habit of being," which for the artist is always about how art participates in the practices and disciplines of becoming, about turning "nouns" into "verbs," and the constant flux and entropic impulse that defines and shapes our identities. David Pagel observes, "The beauty of Havel's art resides in the effectiveness with which it disentangles wonder from transcendence, simultaneously reuniting mystery and the ordinary world as it rescues fascination from otherworldly transport."[1] Havel's fascination with revealing the extraordinary in the mundane and the ordinary brought him gradually to sculptural installations. His first exhibited works were ceramic pieces, but he abandoned ceramics in 1985 in favor of drawing, painting, and making "assemblages from existing objects as a way to address more personal narratives."[2] Most of these assemblages incorporated fabrics and textiles, primarily men's business shirts and collars—laden with gender and social associations—into fabric columns, balls, or other extremely subtle configurations. While not abandoning his work in fabric, Havel began to devise ways to cast these fabric pieces in bronze, in part because "the technical work slowed down the process and made the work resist quick edits and changes." And this resistance—both the technical challenges and the traditional connotations of bronze—provides Havel with new means to manifest flux and process, or, as

he says, turning "nouns" into "verbs." One way that he accomplishes this is by defying gravity and emphasizing the process of the fabric's transformation. "I thought about all the effort, all the heat, all the energy—all the calories—that go into transforming something into bronze. . . . I wanted you to be able to feel the calories, to feel the transformation in the final piece."[3]

Add to these interests in process, action, transformation, and instability Havel's preoccupation with doubt, vulnerability, and intimacy and you have a sculptor whose influences are found in the humble aesthetic understatements of Felix Gonzalez-Torres and Robert Gober more than in the boldness of Richard Serra and Mark di Suvero. Even when called on to make large-scale public pronouncements, as in his commission to adorn the renovated entrance to the Museum of Fine Arts, Houston, Havel focuses on simplicity. He observed, "There's something so pompous about doing bronze panels for doors."[4] Finished in 1999, *Curtain* is a two-part bronze cast of a muslin curtain, each piece ten by ten feet, which flanks the entrance. It offers a subtle celebration of the presence of fabric in the history of art, either as the omnipresent subject in Old Master paintings or in the very painting surface of so many modern paintings.

Drawing continues to play an important role in the development of Havel's plastic language. The Sheldon's *Silk Drape* emerged out of numerous drawings he made of a muslin curtain hanging in his studio. These drawings focused attention on opacity and translucency, which he began to explore sculpturally by shaping the drape.

Because it is committed to exploring the subtle shifts of perception over time, Havel's work is deeply embedded in concerns of installation and presentation. The drapes that hung in Havel's studio came from a 1999 installation at Project Row Houses, a community-based series of house exhibitions in Houston in which Havel "transformed the interior of the house primarily

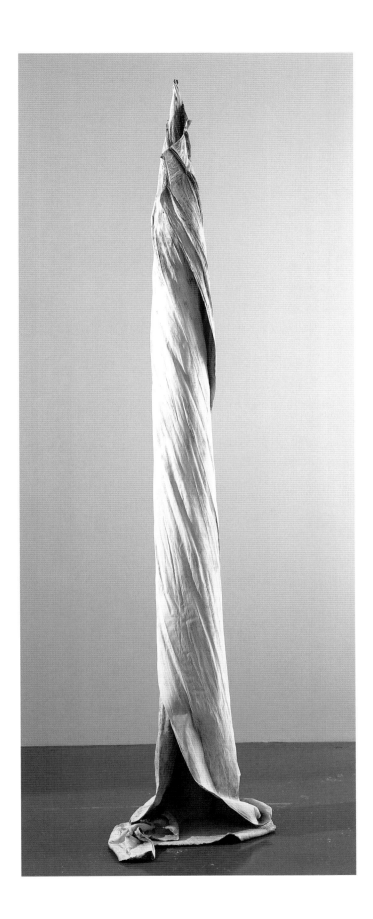

through dressing the windows," which activated the space with flowing drapery. This interest in transforming space with these drapes carried over into his 2001 gallery exhibition "One Dozen Veils," which, in addition to *Silk Drape*, included a molded urethane bedsheet and twelve drawings, all of which explored the shifting nature of perception.

Although the original drape was made of heavy muslin, Havel changed the name to "silk" to "cue a more delicate translucent association that was in keeping with the transformative metaphor." Although it bears a superficial—if ironic—resemblance to the great bronze monuments that mark the tradition of large-scale sculpture, *Silk Drape* has a more modest concern, to balance "hollowness and transparency on one hand and density and opacity on the other." Although his recent move toward the direction of bronze sculpture has made him more self-consciously a sculptor, Havel regards this limitation as an opportunity to plumb the depths of sculptural form as well as to explore how these forms interact with each other in an installation space, at once activated and stabilized through the experience of sculptural form. "This narrowing of focus actually is enabling me to think about issues of presence and the concrete in relation to metaphor and narrative."

In the last analysis, *Silk Drape*, like the rest of his oeuvre, was conceived as part of Havel's emerging "verb view" of the world, a view that celebrates action, process, transformation, the flux of life, and the important role that art objects play as we work out our identities.

DANIEL A. SIEDELL

--

NOTES

1. David Pagel, "Now You See It, Now You Don't: Joseph Havel's Mundane Magic," in *Joseph Havel*, exhibition catalogue (Huntington Beach CA: Huntington Beach Art Center, 1996), 15.

2. Joseph Havel, e-mail conversation with the author, April 16, 2003. Unless otherwise noted, all quotations from the artist are from this conversation.

3. Quoted in Michael Ennis, "Joseph Havel," *Texas Monthly*, September 2000, n.p.

4. Quoted in Ennis.

MARTIN PURYEAR (b. 1941)

The Nightmare, 2001–2

WOOD (DOUGLAS FIR, RED CEDAR, PEAR, APPLE, CHERRY, EBONY, REDWOOD), PAINTED BLACK 53 3/4 X 74 5/8 X 51 IN. UNIVERSITY OF NEBRASKA, OLGA N. SHELDON ACQUISITION TRUST 2003.U-5255

Considered one of the foremost American sculptors of our time, Martin Puryear is best known for his large-scale works in wood or mesh and tar. These evocative sculptures, which gain power from their inherent contrasts, are often ambiguous forms that lend themselves, as does *The Nightmare,* to multiple interpretations. Puryear's wood sculptures are also impressive in how they challenge and extend the possibilities of their medium. The artist eschews the established approach of carving from a block of wood in favor of constructions from materials that may be soaked, bent, woven, or laminated—using traditional craft practices to create ambitious works of art.

Initially trained as a painter, Puryear returned to his youthful practice of making things while serving in the Peace Corps in Sierra Leone. There, in addition to teaching English, French, biology, and art, he observed African carpenters at work. Puryear subsequently traveled to Sweden, where he studied printmaking and for a short time assisted a master cabinetmaker. His interest in woodworking, along with his enthusiasm for and knowledge of nature and wildlife, also inspired him to undertake a study of boatbuilding as practiced by many cultures, a source of information for constructing many of his own sculptures, including *The Nightmare.*

Stockholm's Moderna Museet presented strong contemporary art exhibitions while Puryear was there, and he also visited the 1968 Venice Biennale before leaving Europe. In Venice he was particularly impressed by the display of American Minimalist sculptures in the International Pavilion. Thus Puryear was able to draw on a variety of experiences when he entered the graduate program in sculpture at Yale University in 1968. Not only did his teachers include Al Held and visiting faculty members Richard Serra and Robert Morris, but Puryear also had access to New York City to observe new developments in sculpture during an exciting time. In addition to his interest in the groundbreaking ideas to which he was being introduced, Puryear retained his admiration for such early twentieth-century sculptors as Constantin Brancusi, Jean Arp, and Isamu Noguchi. These diverse sources are reflected in Puryear's simplified forms, which have been described as Minimalist in their austerity but depart from that style in being organic, "metaphoric," and constructed by hand.

In the late 1970s Puryear was accorded his first one-person exhibition at the Corcoran Gallery of Art in his native Washington DC. That same year, he lost much of his work in a studio fire and resettled in Chicago to teach at the University of Illinois. During the next decade, he had sculpture featured twice in Whitney Biennial exhibitions, received a Guggenheim Fellowship (which he used to travel to Japan), and received the Grand Prize at the São Paolo Bienal (where he was the first African American artist to represent the United States). A MacArthur Foundation Fellowship in 1989 allowed the artist to quit teaching and move to Upstate New York, where he maintains his studio.

The Nightmare exemplifies Puryear's work in being an "exquisitely-crafted, enigmatic object."[1] Although the imposing form is inspired by a calabash, or a gourd used as a drinking vessel in South American Indian cultures, its nurturing associations are undermined by the capped "neck" and numerous punctures in and forms appended to the surface. Black paint contributes to the ominous or threatening character of the object, and the shape suggests a grenade or a large animal head. As is frequent for Puryear, *The Nightmare* is hollow, with smooth strips of untreated cedar laid over a ribbed wood armature. Marks from the staples used to hold the thin layers of cedar in place remain on its surface, bearing evidence of its construction. Although they are not immediately apparent, many of the oppositions Puryear favors are present in *The Nightmare*—the visually heavy but physically light weight; the seemingly solid but in fact largely empty

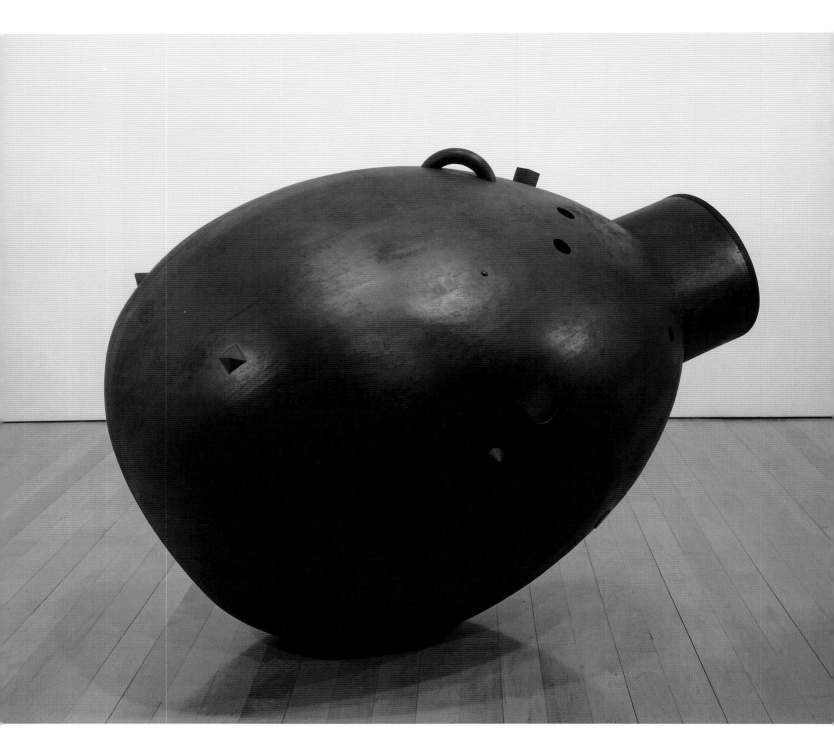

interior; elegant surface and aggressive form; representational references and abstraction. Although the artist draws on many motifs and techniques he has used over the past decade and is reluctant to address the content of his sculptures, *The Nightmare* may function as a contemporary response to the political uncertainties that followed the terrorist attacks on September 11, 2001.

JANICE DRIESBACH

--

NOTE

1. Margo A. Crutchfield, *Martin Puryear*, exhibition catalogue (Richmond: Virginia Museum of Fine Arts, 2001), 25.

CONTRIBUTORS

Peter Boswell, *Assistant Director for Programs/Senior Curator, Miami Art Museum, Florida*

David Cateforis, *Associate Professor of Art History, University of Kansas–Lawrence*

Nancy H. Dawson, *Community Programs Coordinator, 1992–2001, Sheldon Memorial Art Gallery and Sculpture Garden, UNL*

Janice Driesbach, *Director, Sheldon Memorial Art Gallery and Sculpture Garden, UNL*

Lonnie Pierson Dunbier, *publisher AskArt.com; Community Programs Coordinator, 1991–92, Sheldon Memorial Art Gallery and Sculpture Garden, UNL*

Charles C. Eldredge, *Hall Distinguished Professor of American Art and Culture, University of Kansas–Lawrence*

Norman A. Geske, *Director Emeritus, Sheldon Memorial Art Gallery and Sculpture Garden, UNL*

Wendy J. Katz, *Associate Professor, Department of Art and Art History, UNL*

Christin J. Mamiya, *Professor, Department of Art and Art History, UNL*

Ingrid A. Sepahpur, *Art Historian, and Instructor, Department of Art and Art History, UNL*

Daniel A. Siedell, *Curator, Sheldon Memorial Art Gallery and Sculpture Garden, UNL*

Robert Spence, *Professor of Art Emeritus, Department of Art and Art History, UNL*

Michael R. Taylor, *The Muriel and Philip Berman Curator of Modern Art, Philadelphia Museum of Art, Philadelphia, Pennsylvania*

Karen Tsujimoto, *Senior Curator of Art, Oakland Museum of California, Oakland, California*

INDEX